Candid Creatures

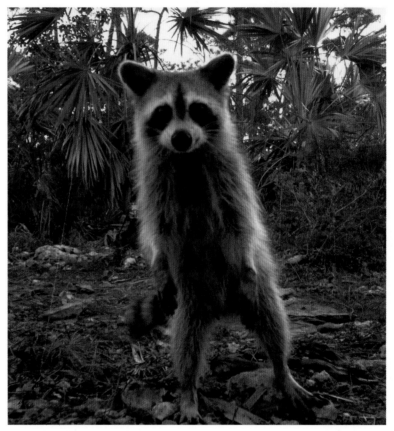

HOW CAMERA TRAPS REVEAL THE MYSTERIES OF NATURE

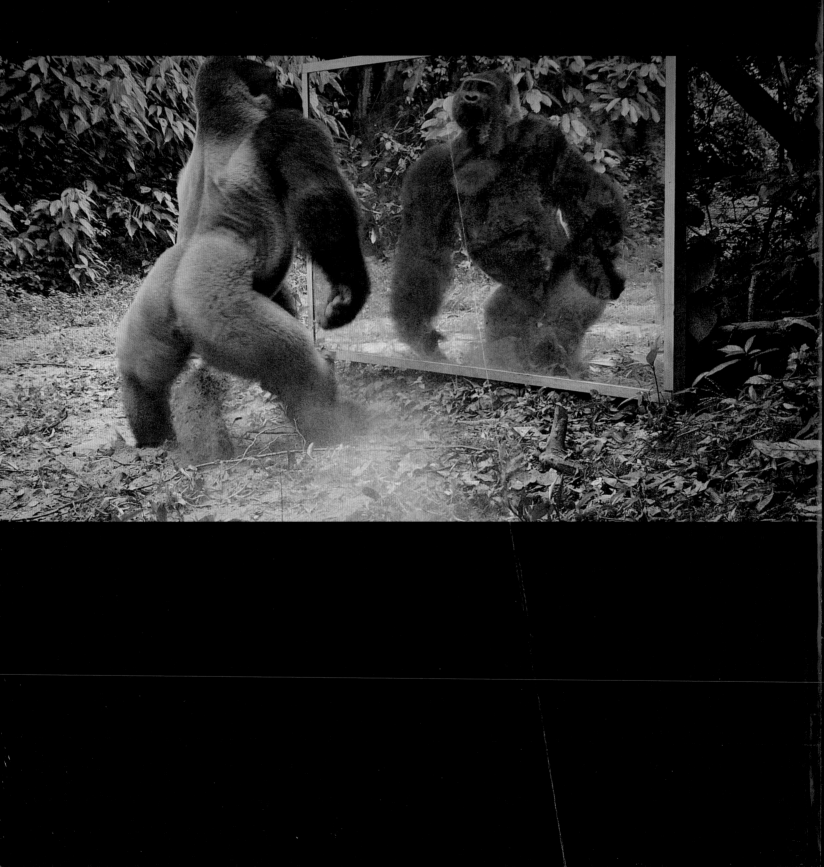

Candid Creatures

ROLAND KAYS

JOHNS HOPKINS UNIVERSITY PRESS Baltimore

Johns Hopkins University Press

2715 North Charles Street

Baltimore, Maryland 21218-4363

www.press.jhu.edu

Library of Congress

Cataloging-in-Publication Data

Names: Kays, Roland, 1971–. author.

Title: Candid creatures : how camera traps

reveal the mysteries of nature

Roland Kays.

Description: Baltimore : Johns Hopkins

University Press, 2016. | Includes

bibliographical references and index.

Identifiers: LCCN 2015017512 | ISBN

9781421418889 (hardcover : alk. paper) |

ISBN 9781421418896 (electronic) |

ISBN 1421418886 (hardcover : alk. paper) |

ISBN 1421418894 (electronic)

Subjects: LCSH: Animals—Pictorial works. |

Animals. | Animal behavior—Pictorial

works. | Wildlife photography.

Classification: LCC QL46 .K39 2016 |

DDC 590—dc23 LC record available at

http://lccn.loc.gov/2015017512

A catalog record for this book is available

from the British Library.

Special discounts are available for

bulk purchases of this book. For more

information, please contact Special Sales at

410-516-6936 or specialsales@press.jhu.edu.

To

Judy,

Eli, and

Fletcher

CONTENTS

ACKNOWLEDGMENTS

First and foremost, I am completely indebted to the hundreds of camera trappers who shared their photographs and discoveries with me. This book could never have happened without their hard work in the field setting many thousands of camera traps around the world. The 613 photographs come from 153 different research groups, many of which represent large teams, meaning that many thousands of people helped run the cameras that generated the photos and discoveries featured here. Hiking through the woods to the next camera is only part of the work; these camera trappers also sorted through many millions of photographs, tabulating each as a data point for their research and saving just a few in their folder of "greatest hits." They graciously shared these collections of their best photos with me, from which I picked the very best that I could find to tell the stories of their discoveries.

This book is more than just pretty pictures—it also represents a summary of the scientific discoveries and conservation accomplishments of these research projects. The literature cited has 240 citations referencing the scientists' original work, which I have tried to summarize in the text, graphs, and maps. I am grateful to many colleagues who were willing to share preliminary results or raw data to help me accurately represent their latest discoveries. I also am greatly indebted to the staff and volunteers of the eMammal project, a citizen science camera effort that I work with, which contributed many photographs and findings. Eric Knisley helped convert some of this science into art by creating the original artwork in the Animal Neighborhood Watch section. Many thanks to him for his creativity and patience to make sure the pieces were both accurate and interesting.

A number of people helped read the text, and their attention greatly improved the accuracy and flow of the writing. Thanks for reviews from Laila Bahaa-el-din, Danielle Brown, Iain Gilby, Matt Gompper, Klaus Hacklaender, Patrick Jansen, Judy Kays, John Perrine, Robin Sandfort, and Stephanie Schuttler. Three undergraduate students from North Carolina State University helped with the early phase of this book; thanks to Summer Higdon, Rebecca Owens, and Gabriella Quinlan for their research and ideas. Thanks to Kathryn Marguy and Vincent Burke at Johns Hopkins University Press for helping bring this book to fruition. Finally, thanks to my family, Judy, Eli, and Fletcher, for helping me run cameras and chase critters.

Candid Creatures

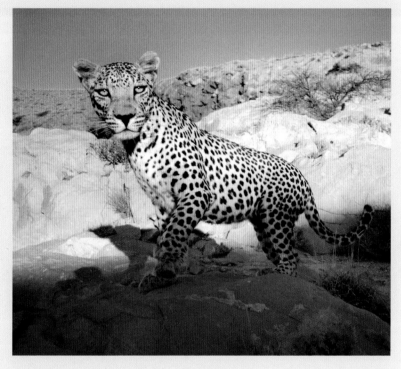

The world is alive with animals that we virtually never see with our own eyes. Most wildlife, especially mammals, hear or smell us long before we see them. Some hide out in holes or thickets as we pass by. Others run away to avoid us before we can catch a glimpse. Many species are nocturnal, starting their activity right when we are winding down our day, hiding under the cover of darkness. The rarest and most elusive species live in remote corners of the world that are difficult to access.

The near impossibility of seeing some wildlife species frustrates nature lovers and exasperates zoologists. How can we study or count animals we can't see? Some are rare and listed as "Endangered Species"; others we know so little about we can't assess them, instead classifying them as "Data Deficient." The scientist's solution to this problem is the camera trap—a motion-sensitive camera that can be left alone in nature to quietly record photographs of any animals that pass by.

CAMERA TRAPS REVEAL NATURE'S SECRETS

Like microscopes for microbiologists or telescopes for astronomers, camera traps give zoologists a new way to observe the subjects they study. Each of these inventions created new ways of seeing, opening windows on the natural world and leading to rapid scientific development in their fields. Not only are camera traps a unique way to look at critters, but the tool has transformed the way wildlife science is conducted and is having important implications for our understanding of these animals. The photos are translated into data, which are used to ask questions and test hypotheses. Modern studies use dozens of camera traps over hundreds of locations to collect many thousands or millions of photographs. Each image registers which species are living in a given place at a given time. The identity of the species in the photo can be checked and verified, an important part of the scientific process. Indeed, the camera trap photograph offers a way to measure biodiversity, a testament to life on earth similar to the traditional animal skins and skeletal specimens stored in the collections of our great natural history museums. These new digital libraries of camera trap pho-

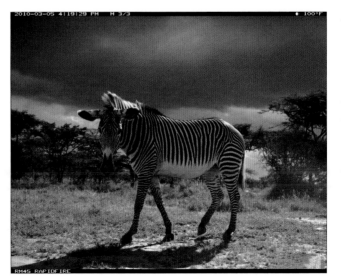

An endangered Grévy's zebra is caught on camera on a hot day in Kenya. Text at the top of the photo records the date and time, that this was the third of three consecutive photos after the animal triggered the motion sensor, and that the temperature was 100°F. The text at the bottom records the camera make and model, and sometimes a customizable code.

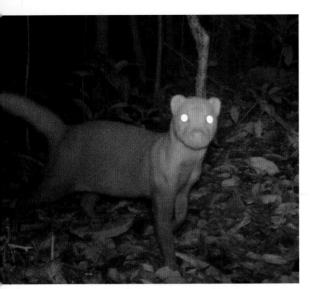

Almost nothing is known about the ecology of the black-footed mongoose. Camera traps have recorded them in African rainforests, such as this one from Korup National Park in Cameroon.

An Indian porcupine raises its quills and scurries toward safety with a tiger on its tail. Tigers generally prefer larger prey without quills, but they are known to kill and eat porcupine, presumably if they are hungry enough.

tos provide a snapshot of the abundance and diversity of animal communities around the world.

The stories in this book are about the discoveries made by scientists probing the secrets of nature with camera traps. The mere existence of a species, documented with a camera trap photo, can be a discovery on its own. Sometimes it can be a species new to science, or it may be the rediscovery of a rare animal feared extinct. Unique behaviors can also be documented by cameras, which wait soundlessly with more patience than any human observer possibly could. Often the discoveries come later, once the images have been converted to numbers and summed up in a database. The resulting patterns of where animals are and are not present can reveal the forces of nature, and of humans, in determining which species survive where.

Truth be told, most of the millions of camera trap images collected each year are rather boring. Camera traps capture anything and everything that triggers their motion sensor, often recording the rear end of some common mammal or a blurry shot of a small bird passing through the frame. But the mindless persistence of automated cameras and the considerable quantity of images being amassed in the name of science eventually result in some pretty amazing photographs. The memory card of each camera has at least a few good animal shots, and every camera trapper has a folder full of his or her own greatest hits. The goal of this book is to pull these few amazing photographs out of the scientific archives to show a new perspective on wildlife and to highlight the scientific discoveries they enable.

THE HISTORY OF CAMERA TRAPPING

The basic principles of camera trapping are simple. Set a camera someplace you want to monitor for wildlife, rig up a motion sensor, leave it to silently record images for a few days or weeks, and then come back to see what you got. Although the use of camera traps has skyrocketed recently, the concept has been around for more than 100 years. The inventor was a wildlife photographer from Pennsylvania named George Shiras, who used to hide in his boat and use a string to trigger his camera when deer came to the shoreline. Shiras realized he could set up his camera to have the animals pull on the same string as they walked by, thus creating the first automatic camera trap. This new kind of close-up wildlife image was hugely popular and was first published in *National Geographic* magazine in 1913 (in their second issue featuring photographs).

Shiras's photographs were both curiosities and works of art. Another decade would pass until a scientist adapted the method, when Frank Chapman started using a camera trap to document the rainforest mammals of Barro Colorado Island, Panama. His photographs, published in *National Geographic* magazine in 1927, stand up today as not only beautiful but also useful for science. For example, his photographs prove that white-lipped peccaries were present on the island in his time, although they are now extinct at this site.

Advancement in the method was slow for another half century. The technical challenges are obvious when considering Chapman's rainforest

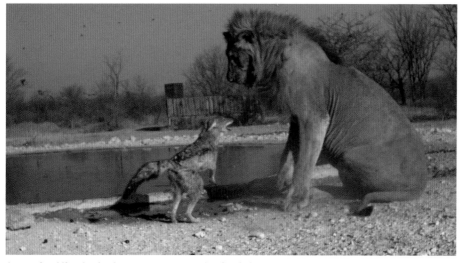

A surprised lion looks down on an overenthusiastic jackal in Namibia. Jackals are typically a nuisance to lions, stealing scraps from the larger carnivore's kills. This jackal's aggressiveness suggests that it might have rabies, which would be dangerous for the entire animal community, including humans, if passed on to the lion after this encounter.

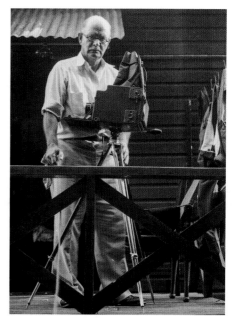

Frank Chapman was an early pioneer of camera traps. He is pictured here on the porch of his lab on Barro Colorado Island, Panama, with the latest technology of the 1920s: a large-format camera with a single glass plate.

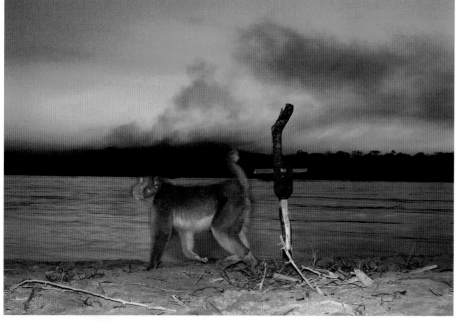

A rhesus macaque takes a walk along the river at sunset in Manas National Park, India.

Frank Chapman used a trip wire set across the trail to trigger his camera, which had two cakes of magnesium powder wired to explode as a flash. Explosions illuminated the image well, but they were also as loud as a "small cannon," according to Chapman's notes, and certainly gave animals a fright.

setup: a large-format glass plate as film and cakes of magnesium flash powder. The explosive flashes made as much noise as light and must have frightened animals for miles around. Commercially available photography equipment remained bulky and complicated for years; a 1964 article in the *Journal of Mammalogy* bragged that their new equipment weighed "only 47 lbs."

By the late 1980s, 35 mm "point-and-shoot" film cameras had become small and inexpensive enough to create large numbers of affordable camera traps. For the first time, zoologists could send out field crews with dozens of camera traps to get the sample sizes needed for proper scientific

The use of camera traps in scientific papers has grown rapidly in the past decade, with an annual growth rate of about 25%, which is a faster growth rate than most other scientific fields.

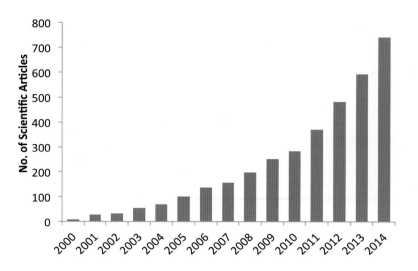

surveys. Early pioneers of this approach include Ullas Karanth and his tiger research in India and the Pacific Northwest Research station of the US Forest Service, which used cameras to survey for lynx and wolverines. In both cases, scientists were improving on existing camera trap designs to survey species that were otherwise almost impossible to see.

Around this same time, American hunters started using camera traps to scout for deer, trying to learn the movement patterns of the largest bucks to plan their fall hunts. A new crop of companies sprung up to make camera traps for the hunters, and scientists were eager to try out these lunchbox-sized units. Photos and data rolled in, and their use in scientific papers increased; a 1999 review covered 78 journal articles reporting results from camera traps, dating back to Chapman's Panama work.

Camera trappers were probably the last group of photographers to totally switch from film to digital. Although having only 36 frames per roll of film was a huge limitation, early digital camera traps were so unreliable that most scientists decided that they just weren't worth the time and money. Early designs weren't completely sealed to the environment; it is amazing to see the damage that moisture and insects can wreak on electronics left tied to a tree for a few weeks, especially in the tropics. Another problem with early digital cameras was that it took them a few seconds to wake up and take a photograph once they were triggered. This trigger delay resulted in many empty frames as the moving animal passed out of the field of view before the photograph was taken.

Digital camera traps finally became field worthy by around 2008. Whereas the earlier digital equipment failures had simply wired a point-and-shoot digital camera to a motion sensor, these new companies started creating integrated systems with extra weather proofing specifically for use in camera traps. The hunter and researcher market continued to grow, and new discoveries filled the pages of journals. The number of scientific articles reporting results from camera traps has grown at a rate of about 25% per year over the past decade, with 741 articles published in 2014.

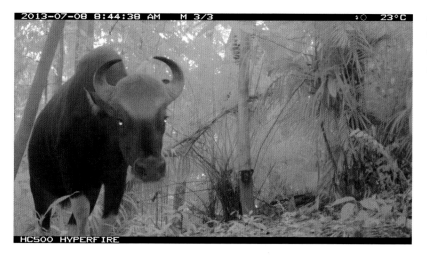

An infrared flash illuminates a gaur walking through the dark forests of Malaysia; cameras in forests with thick tree canopies often need to use flashes even for daytime photos.

CAMERA TRAPS TODAY

Although camera traps go by a variety of names (e.g., remote camera, game camera, trail camera), most have the same design, with a passive infrared (IR) motion sensor triggering a digital camera and flash inside a water-proof box that also holds the batteries and a memory card on which to save the photos. This type of motion sensor is triggered by moving heat, typically a warm-blooded animal moving through a colder environment. Other triggering devices that have been tried over the years have mostly been abandoned because of the complexity of setup and unreliability of triggering, including active IR sensors (aka break-beam or laser beam sensors), pressure pads, and a piece of string tied to bait.

Most cameras used by scientists save images to a memory card that must be retrieved to view the photos. There are networked cameras available that send the images instantly through cellular or satellite networks, but these are expensive and typically not worth the cost for a scientist who might be running dozens or hundreds of cameras. However, the live images from these cameras are quite fun and have been developed into out-reach tools through smartphone apps (e.g., Instant Wild) or Twitter feeds (@CamtrapLive). A live feed can also be useful for catching poachers.

A leopard walks through a paired set of cameras with white flashes. Setting two cameras facing each other allows scientists to capture both sides of an animal, which helps identify unique individuals by their stripes or spots.

Scientists are increasingly running camera traps in video mode. This provides more detail about the animal's behavior, although often in lower resolution than still photos. Video files also take longer to review and are harder to store and organize, which becomes a problem for larger projects.

Most mammals are nocturnal, requiring some illumination for the camera to capture a photo of them. The flashes of camera traps can be either a normal incandescent "white" light or an IR light. The white flash captures better photographs that are color and always sharp, whereas IR images are black-and-white and sometimes blurry (depending on the strength of the light). However, an IR flash is typically not noticed by animals, whereas the white flash has the potential to frighten animals away from an area.

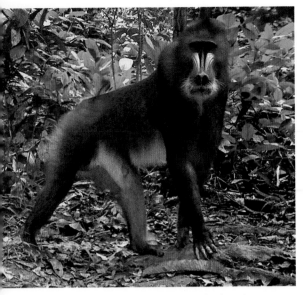

A male mandrill pauses to look at the camera as it passes through the African rainforest.

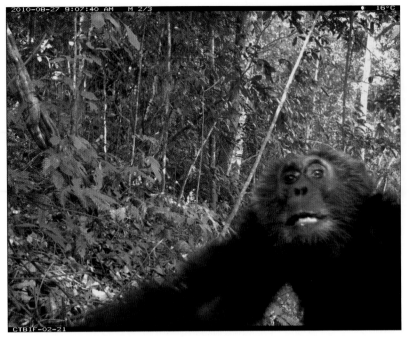

A chimpanzee reaches out to touch the camera trap and triggers its motion sensor, taking an apparent selfie.

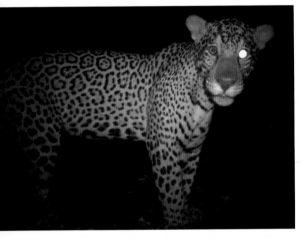

This young jaguar has eyeshine from only one eye, suggesting that it has a damaged tapetum lucidum, possibly from some prey animal trying to defend itself.

DO CAMERA TRAPS BOTHER ANIMALS?

Scientists refer to camera traps as a "noninvasive" survey technique because they generally don't disturb animals, especially if they have an IR flash. Certainly camera trapping is less invasive than traditional methods that physically trap an animal. Nonetheless, some animals clearly do notice the camera. Any piece of plastic strapped to a tree in the woods would probably attract the attention of wildlife passing by just because of its novelty or unique smell. Some camera traps make faint noises or have IR flashes that glow a dull red, which might attract a bit more attention. Occasionally, animals look right at the camera or approach it for a sniff. These instances make the best photographs and so are overrepresented in this book. However, in the typical scientist's database, such close-up photos are actually a rarity, as most animals that pass by act naturally, probably without even noticing the device.

Camera traps with white (incandescent) flashes are more likely to affect animal behavior. This isn't surprising given the blinding effect a flash of light can have on the eyes, especially when they are adjusted for night vision. A study in India found that tigers avoided a site for five days after triggering a white flash. Scientists always want to minimize their impact on the animals they study, and thus more and more researchers are adopting IR flash cameras.

All types of camera flashes can light up the eyes of mammals looking at the camera. This eyeshine is a reflection off a layer in the back of the eye called the tapetum lucidum. This layer reflects light back through the retina, improving the collection of light and therefore the animal's night vision, although slightly blurring the image. Humans, as well as many other

A white rhino sniffs a camera trap in Kenya.

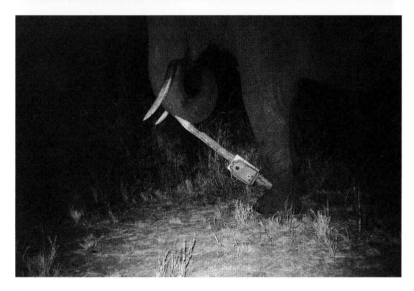

An elephant vandal is caught on one camera as it tips over the post holding up another in this paired set.

diurnal animals, do not have a tapetum lucidum, but we still sometimes have glowing eyes in photographs, which is known as the red-eye effect. This phenomenon is similar to eyeshine, but in this case light reflects off a blood-rich (and thus red-colored) part of the eye known as the fundus.

Occasionally, animals not only notice the camera but walk up and destroy it. Elephants and bears are the most problematic camera vandals. Bears are known to take advantage of the hard corners of a camera to scratch their backs, and then sometimes they chew on the camera. Elephants can easily wreck the normal plastic casing, forcing some camera trappers to reinforce their setup with metal enclosures.

CAMERA TRAP DISCOVERIES

Scientists translate the images recorded by camera traps into data that can be used to test hypotheses and answer questions about wild animals. In recent years these cameras have become one of the core methods in the field

Camera traps are more difficult to secure in environments without trees. Here a mountain deer known as a taruca passes by a pair of camera traps set in the rocks in the Bolivian Andes.

biologist's toolbox, alongside traditional traps, tracking collars, binoculars, and mist nets. Typical motion sensors will occasionally trigger on mice or rats when they run close to the camera, although the smallest animals are difficult to identify from photographs. Most camera trap research focuses on terrestrial animals larger than a rat, which are easier to identify and more reliably trigger the cameras.

The most basic question one can address with a camera trap is where a species lives. A good camera trap image can offer proof that an endangered species survives in an area, as in the case of the Angolan giant sable antelope, found by camera trap after not being documented for two decades. Likewise, photos often extend or modify the known geographic ranges of animals.

Once you know that an animal lives in the given area, the next natural question is, "How many?" Counting animals in person is surprisingly hard because of their amazing skills at hiding from us. Counting animals in camera trap photos is much easier. If animals have stripes, spots, or other unique marks, they can be individually identified in photographs, allowing a straightforward census of a study site. Since the right and left sides of an animal can have different patterns, camera trappers often put a pair of cameras along a trail to record both sides of each animal that walks by.

Scientists spread their cameras throughout the study area and generate photo libraries of all the known individuals, and then they translate this into a matrix of zeros and ones. This is known as a capture history, with a one indicating that a given animal was photographed on that day, and a zero showing that it was not detected. These data can then be analyzed using a method traditionally known as "mark-recapture" to estimate the proportion of animals counted, the proportion missed by the cameras, and thus the total number of animals in the population. Usually the goal is to

An African wild dog begins its activity at sunset. This animal is wearing a tracking collar, which allows scientists to collect more detailed data on its movement and activity.

estimate the density of animals (animals per square kilometer), so once the animals are counted, the next step is to estimate the size of the area covered by the camera traps. A second analysis on the spatial arrangement of the capture history can provide this component, resulting in a final estimate of the number of animals per square kilometer.

It is safe to say that most camera trappers have spot or stripe envy, because most species recorded by camera traps are not uniquely marked and thus cannot be individually identified in photos. Tigers, spotted cats, and hyenas have patterns that are relatively easy to match up between photographs, and some species of deer have unique branching patterns in their antlers, allowing males to be counted during certain parts of the year. Unfortunately, bears, canids, female deer, and most other mammals have too little variation in their appearance to be recognized individually. In these cases, scientists can use alternatives to true counting that allow the relative abundance of an animal to be estimated and compared over years to show population trends (up, down, or stable). Camera traps are quite effective for answering questions of "how many," estimated precisely as density, or generally as relative abundance.

The important "why," "what," and "how" questions come next. Why are there lots of animals here but fewer over there? What is the effect of cattle grazing on the wildlife community? How does the animal community change from the foothills to the mountaintop? How does coyote abundance vary from the city to the suburbs to the countryside? What is the population trend of lynx over the past decade? These are important questions because they ask what factors are causing changes to animal numbers and distribution. In some cases there are natural phenomena at work, but other times these studies show the effects of humans on wild animals. In either case, knowing what drives changes in animal numbers is critical

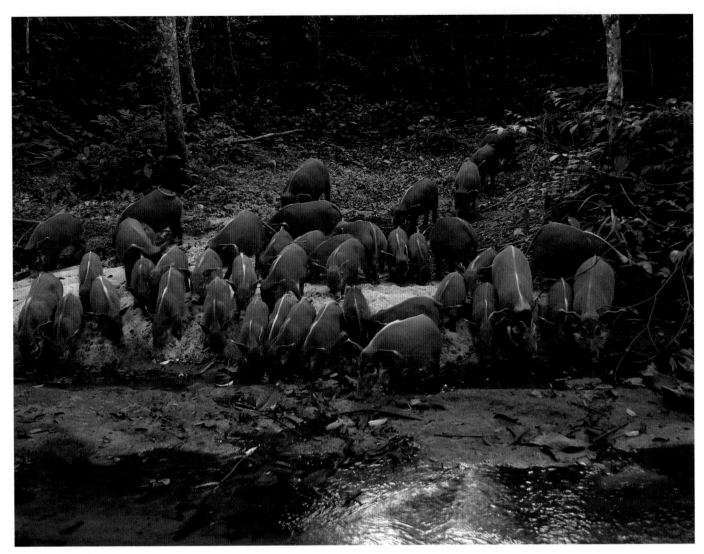

A group of red river hogs come to drink from a river in Gabon.

to managers and conservationists tasked with saving species whose populations have declined, and camera traps are a key tool in this important area of study.

Camera traps can also help scientists answer the "when" question because they record the time of day at which each photo is taken. These temporal data points can be strung together to document the daily activity pattern of a species, be it diurnal, nocturnal, crepuscular (dusk and dawn), or some other activity pattern. Comparing these across species or across sites can show interesting ways that species avoid each other to reduce competition or the chances of being eaten.

Finally, camera traps can be placed at a specific feature to document "who" uses it. For example, camera traps have been essential in studying which species use which underpass to cross roads. Other studies use cameras to monitor fresh carcasses to see what predator will return to finish its meal, what fruit eaters visit a particular tree, what animals drink from a water source, or what subterranean creature uses a certain hole in the ground.

The exact spatial arrangement of camera traps across the landscape is known as the "study design," and this varies depending on the species and questions motivating the research. Designs that space cameras out along regular grids or at randomly selected points within the study area are commonly used with unbaited cameras to capture a snapshot of the entire terrestrial animal community. However, these might not get enough photographs of the rarest species; studies focusing on the scarcest animals use cameras set strategically to have the highest chance of detecting their target species, often putting them along trails or using bait to lure animals in. Bait will likely increase the number of photographs you get of some species, but it may scare others away and thus overly inflate the number of images of animals who hang around to chew on whatever morsels were set as bait.

CAMERA TRAPPING FOR FUN

Scientists aren't the only ones running camera traps today. Hunters likely make up the largest portion of the camera trap market, judging from the advertisements of most camera trap companies. Hunters are typically interested in the "where" and the "when" questions as they relate to the largest bucks on their hunting lands. These photos help them decide where to put tree stands for the best chance of taking a trophy deer.

Camera trapping is starting to spread further as a fun hobby for naturalists and animal lovers. More and more enthusiasts are using camera traps to get their own personal view of the animals using their yard, the woods nearby, or their favorite park. Just as binoculars open a new perspective on nature for bird watchers, camera traps can do the same for mammal watchers, with the photos helping them connect with animals through images that they would never be able to see in person. The thrill of checking a camera trap is often likened to Christmas morning—an exciting moment of mysterious delight.

The thrill of scientific discovery from camera traps has been extended to the public through a citizen science project called eMammal. This project allows amateurs to contribute their camera trap images to a public database at the Smithsonian Institution, as well as to compare their results with others around the world. Automated analyses and graphs at eMammal help citizens find the patterns in the data to make their own camera trap discoveries.

The Critters

The animal species highlighted in this book include a mix of some of the most familiar species in the world and some of the most obscure. Any kid can recognize the elephants, tigers, and rhinos captured in camera trappers' photographs, but who knows about the striking coloration of the ring-tailed vontsira, the bizarre daytime activity of the orange Malay weasel, or the fierce nature of the tamaraw? This section of the book describes what scientists know—and sometimes what they don't know—about some of the most amazing animal species on the planet, through the lens of the scientist's camera trap. Each species account includes a range map showing where the species is thought to live and the conservation status from the International Union for the Conservation of Nature (IUCN) Red Data List assessment. This global list of all animals ranks their conservation status, starting at "Least Concern" for common species and "Near Threatened" for those that might be declining. "Vulnerable" and "Endangered" categories describe species of greater conservation concern, while species in the "Critically Endangered" category are judged to be closest to extinction and the most in need of critical conservation action.

While thumbing through the first few pages of this section, you might find yourself asking, "What's with all the cats?" Learning more about wild felids has long been a focus of camera trapping, starting with tigers. The world's largest cat, the tiger is also one of the most dangerous and most endangered. Scientists quickly learned that they could identify individual tigers by the pattern of their stripes, allowing for accurate counting of their populations and new discoveries about what limits their numbers. Smaller cats such as the clouded leopard and the marbled cat were also photographed at some of the cameras set for tigers, and new field studies have since spun off around the world. It's safe to say that, by this point, every cat species in the world has been photographed by a camera trap, although some remain mysterious and poorly understood. While there are a lot of cat photos in this book, this is just the tip of the iceberg of new discoveries about wild felids stemming from this technology.

Carnivores are usually the most difficult mammals in the world to observe in person, so camera traps have also been set to study other predators, including canids, mongooses, weasels, civets, and bears. Ecological principles suggest that prey species will always be more abundant than their predators. True to this observation, camera traps typically catch dozens of herbivores for each predator photo. Back in the day of film cameras, these common plant eaters were considered a nuisance because they used up the film too fast. This isn't a problem with modern digital cameras, which have enough memory for many thousands of photographs, and scientists now use these counts of available prey to add new dimensions to their understanding of predator populations. Even more, many of these herbivores themselves are becoming the primary target for camera traps, especially rare species such as wild Asiatic buffalo, pygmy hippos, pudú, and striped rabbits.

The final sign that camera traps have become an indispensible tool for field biologists comes from their use in studying elephants and primates.

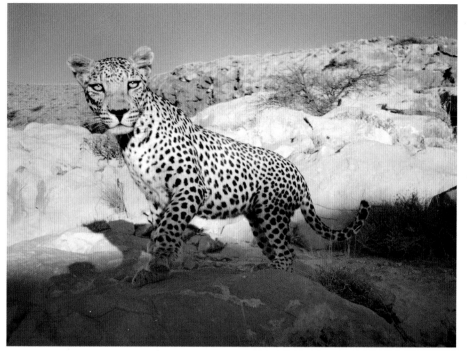

Much of the early research using camera traps targeted wild cats like this leopard in Yemen. Scientists continue to learn more about these species as the images accumulate and are used to ask scientific questions about the secretive lives of the wild cats.

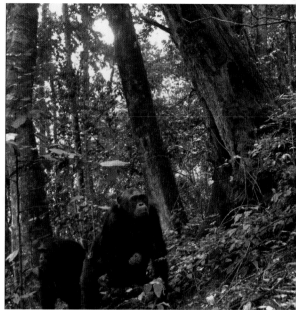

Jane Goodall pioneered a generation of observer-based science on chimpanzees that showed how similar their cultures are to ours. Primatologists have now added camera traps to their field toolbox as an unobtrusive way to study unhabituated groups, evaluate their habitat needs, document crop raiding, and record their use of tools to forage on termite mounds or break open nuts.

These species have been studied for decades by patient observers who habituate social groups and follow with their binoculars and cameras all day to record the details of their ecology and behavior. What more could we possibly learn about these species from a few seconds of footage captured by camera traps? In recent years these noninvasive little plastic boxes strapped to trees have indeed offered something new, even to elephant and primate biologists.

Each of these studies has yielded two important products. First, the scientists have published their exciting discoveries in scientific and conservation journals. Second, their best camera trap photos have been shared far and wide, allowing thousands of people to see the camera trap's unique perspective on these charismatic species. Data and images are the two most important results of any camera trap study, working together to help in the fight to conserve animals and their habitats.

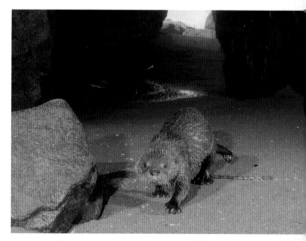

Almost nothing is known about marine otters from the Pacific coast of South America. They are thought to spend most of their time at sea, although a camera trap caught this one foraging on the rocky shore.

Tiger *Panthera tigris*

CONSERVATION STATUS: Critically Endangered

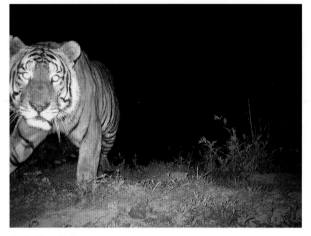

An Indian tiger.

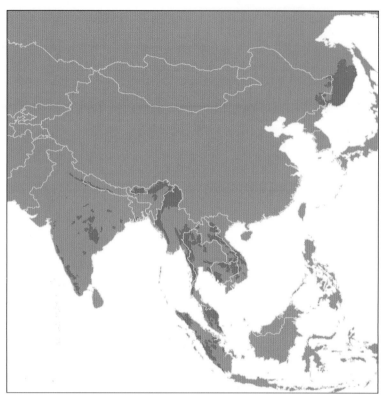

Camera traps have helped us learn more about tigers than any other animal. Tigers are the largest cat species in the world, as well as one of the most endangered. They are rare across their range and shy, making them difficult to study with direct observation. Furthermore, actually capturing and handling such a large predatory cat is dangerous to both the animal and the trappers. However, scientists can "capture" photographs of them patrolling their territories along roads and trails. Because each animal has a unique pattern of stripes, we can also identify individual animals in photos, enabling a booming field of tiger science in the past quarter century. Thus, camera trapping for tigers has not only helped us learn

more about their biology and conservation but also benefited dozens of other species around the world through the development of improved survey methods and analytical techniques.

Tigers originally lived across most of Asia, from Russia to Iran, using dense tropical forests, arid grasslands, and even snowy temperate woodlands. Unfortunately, their range has collapsed and fractured to a remnant constellation of populations scattered across the continent. Human hunting is a big cause of this collapse. The black market wildlife trade drives much of the poaching, and there are also occasional retribution killings after tigers kill livestock or people. Outright habitat destruction is another

big problem, as people replace nature in more and more of wild Asia. Camera traps have been critical for documenting exactly where tigers have disappeared from the forests and where they still survive and need increased protection.

Their big size allows tigers to kill just about anything they can catch. Dozens of studies have turned up hundreds of potential prey species for tigers across their range, but on average, they obtain their daily food needs by killing various types of wild cattle, deer, and pigs. Larger prey are generally preferred since they produce more food per kill, but tiger diets vary from site to site. Tigers will adapt their behavior and activity patterns to target locally abundant species. For ex-

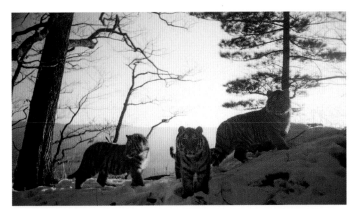

A trio of cubs represents the next generation of tigers in Russia.

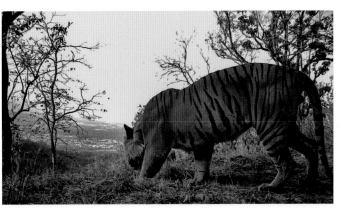

A tiger pauses its patrol to overlook a village below its preserve in the Terai Arc region of India. Conflict between people and tigers remains a daily concern in many parts of their range.

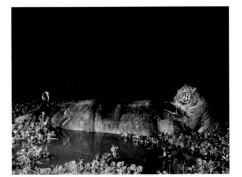

Tigers are the only natural predator of Indian rhinoceroses, as illustrated by this tragic battle between two endangered species in India's Kaziranga National Park. In this case the tiger won.

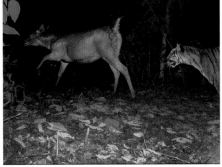

Tiger stalking a sambar deer in India.

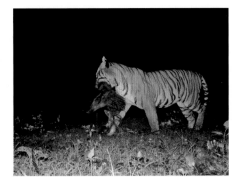

Tigers will often drag or carry their prey to a secure hiding place to eat in peace. This tiger's boar head meal won't hold him over for long, as tigers eat 37 to 70 lb (17 to 32 kg) of meat in a single day.

ample, tigers are active at dusk and dawn in southern rainforests to match with small muntjac deer, but they are more active throughout the night in the Western Ghats of India, where they focus on the larger and more nocturnal sambar and gaur. Tigers are not long-distance runners; instead, they use cover to sneak up as close as possible to their quarry and then pounce after a short, intense chase.

Scientists found that rainforest tigers (*solid line*) adjust their activity patterns to match the dusk-and-dawn pattern of muntjac (*dashed line*), one of their favorite prey.

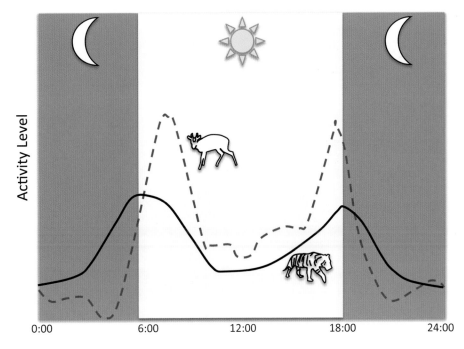

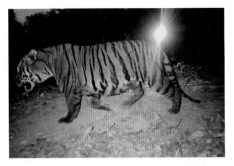

This well-fed tiger lives in a preserve with abundant prey and is likely to have a large litter of healthy cubs.

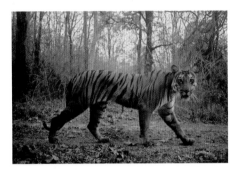

This skinny tiger lives in an area with low prey densities, will have to travel farther to find its next meal, and will be more likely to run into trouble with local people and their livestock.

A tiger emerges from cooling off in a mud bath at Manas National Park. The mud obscures most of the stripes, but the individual can still be identified from the unique marks on its neck.

Thanks to camera traps, scientists have better estimates of tiger density and distribution than for just about any other large mammal. The sum of all photographic records of a tiger can be analyzed with "mark-recapture" analysis, which gives an estimate of the total number of animals living in a given area. Wildlife biologist Ullas Karanth pioneered this method with tigers and used it to compare 11 sites in India, discovering that tiger abundance is directly related to prey abundance: more food, more tigers. Predators are always scarcer than their food, and in this case prey densities of 5 to 64 prey animals per square kilometer resulted in tiger densities of 0.03 to 0.017 per square kilometer. A related pattern was found across 13 sites in Thailand, where tiger abundance was highest in areas with abundant gaur, wild pigs, and sambar.

Reductions in prey densities, due to hunting by people, cause a drop in tiger numbers, even if the forest is still intact and tigers are not directly hunted. This has happened in some parks in India where illegal hunting has driven key prey species to local extinction, or to very low abundance, and tigers are scarce or nonexistent.

Tigers also need habitat, and lots of it, given the large distances they cover in each night's hunt. Within a forest, camera traps show that tigers tend to avoid the edges of a preserve. This is positive in that it reduces potential conflict with humans living alongside park borders, but it is negative in that it further reduces the available good habitat for tigers.

Some tigers have adapted to living in the same space as humans by shifting their activity patterns to be more nocturnal, thereby avoiding the diurnal activity of humans. For example, conservation biologist Neil Carter photographed tigers and tourists in Nepal's Chitwan National Park at exactly the same sites, but at different times of day. The same behavior was found outside the park, where tigers avoided local residents by hunting only at night. These types of adaptations by tigers to coexist with people will be essential for their survival in a world with more and more humans.

MATCH THE STRIPES

The unique stripes of tigers let researchers identify individuals and calculate precise counts of how many animals are in an area. These patterns don't change over time, allowing some studies to follow the fate of individual animals over many years. One such study recorded between 17 and 31 individual tigers each year in Nagarahole National Park, India, over nine years. The population was healthy, with a 77% annual survival rate and a 3% annual increase. This study showed that these preserves are effective in protecting tigers.

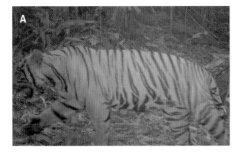

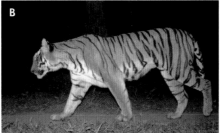

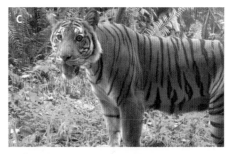

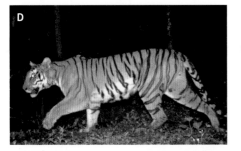

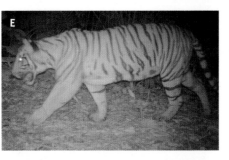

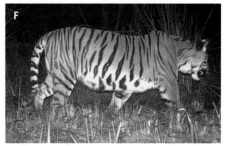

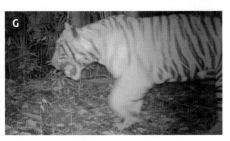

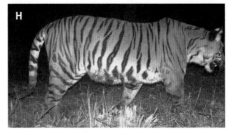

See if you can match these eight photos of four individual tigers based on their stripe pattern.*

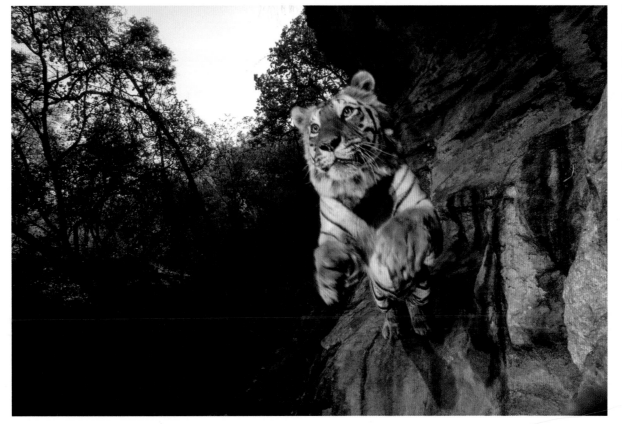

It took professional photographer Michael Nichols three months to capture this dramatic frame of a tiger leaping from a cliff.

African Lion *Panthera leo*

CONSERVATION STATUS: Vulnerable

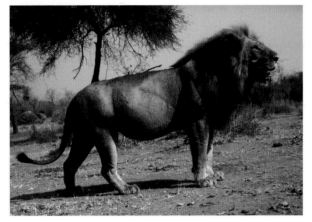

This well-maned male was photographed in Ruaha National Park. This is the largest park in Tanzania, second largest in Africa, and is a stronghold for lion populations.

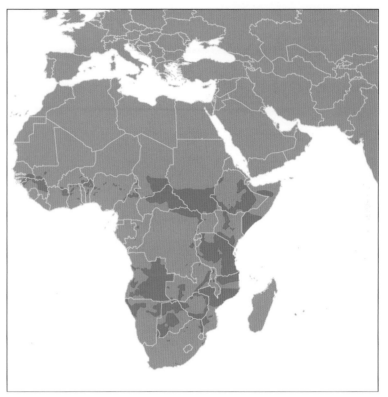

African lions are the second-largest cat species, with big males nearly as large as tigers and females just a bit smaller. They are also the most social cat species, with prides of multiple females and their young typically attended by one or more males. These ferocious cats lead violent lives, and their group battles with large prey such as buffalo and zebra are the stuff of safari lore and prime-time television.

Lions are one of the few predatory species that can be watched in person through binoculars, at least in some open habitats, and numerous studies have documented their ecology and behavior that way. But lions are not always easy to watch from a Land Rover. They are mostly active at night, when flashlights or night vision goggles would be needed to see them, and they are not always in open habitats. Camera traps are especially useful in woodlands or bushy areas, where visibility is limited and it is too thick to drive through and too dangerous to walk in.

The male lion's famous mane serves as an advertisement of its vitality, attracting females and warning away males. The variety of color and length of manes, combined with the various scars acquired in the course of their violent lives, means that camera trappers can often identify individuals in photographs.

Lions prefer large prey such as zebra and buffalo. Lions generally avoid the largest species such as elephants, giraffes, rhinos, and hippos, although they will attack a young animal left undefended. They will also chase down smaller antelope or wart hogs if hungry enough. In open habitats, males are less likely to participate in a hunt and more likely to steal their meal after the pride's females have brought something down. However, in more dense habitats where they can't keep track of the females as well, males do more of their own hunting.

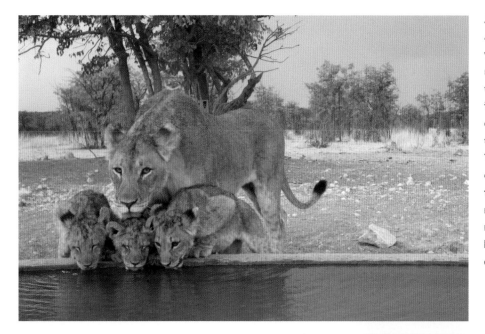

A female lion brings her cubs to drink from a water hole on a ranch in Namibia. Males will protect their own offspring but are notoriously brutal to any cubs not related to them. This can lead to infanticide, which is most common when new male lions take over a pride of females after vanquishing the previously dominant males of the area. The reproductive physiology of lions actually encourages this rogue behavior because females quickly become reproductively receptive once their cubs are gone. New males in a pride are impatient to breed, knowing that they too could soon be overthrown.

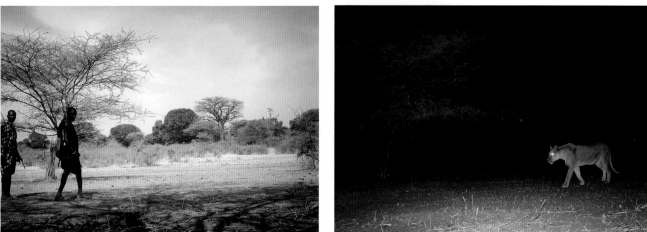

A camera trap from Tanzania shows the same trail being used by people during the day and lions at night. This documents just how close people and lions live in much of Africa, as well as how the natural separation of diurnal and nocturnal activity might help the two species coexist.

LIONS IN CONFLICT WITH PEOPLE AND CATTLE

The coexistence of lions and people in the same space is a difficult balance between two species used to living at the top of the food chain. Depredation of livestock by lions is the most widespread problem, which can lead to retribution killing of the lion through poisoning or direct hunting. Lions also still occasionally attack people, especially those out alone at night. Conservationists are working with local communities to try to discover how to reduce the costs of these big carnivores to local communities, especially through simple livestock management innovations that could reduce attacks. This approach can also be balanced by helping locals receive some financial benefit to living with lions, such as through tourism revenue.

Unfortunately, much of the damage to lion populations has already been done. Lions have been eradicated from 80% of their historic range, with fewer than 35,000 animals left, scattered across 27 African countries. Some East African parks remain strongholds, with many thousands of lions each, but the situation in West Africa is far more tenuous. Camera trap surveys have been key in documenting

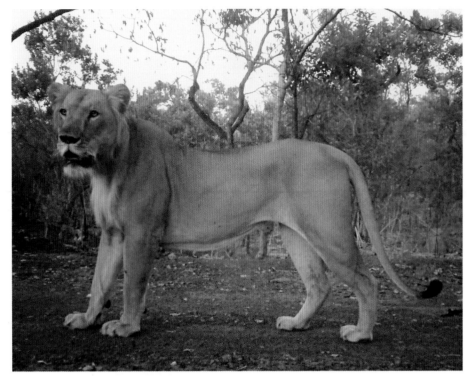

One of the less than a dozen lions thought to survive in Niokolo Koba National Park, Senegal.

where lions survive in West Africa and which parks have lost lions.

Documenting the absence of a species in an area is difficult—how can you be sure you didn't just miss them? Camera traps are ideal for this goal because you can easily quantify the survey effort (the number of nights the cameras were deployed in the field) and because the photographs can be verified by other experts. This was recently important in Ghana's Mole National Park, where an animal seen in a video was initially identified as a lion but was later judged to be a wart hog, leaving no evidence that lions survive there. Another survey in Waza National Park, Cameroon, estimated that the park holds 14 to 21 lions but that the number had declined over the five years of the study. Furthermore, the same camera traps detected humans or cattle inside the park at 30% of the survey locations, highlighting the continued potential for conflict between lions and people. Lion expert Philipp Henschel synthesized survey data from around the region and concluded that, in total, only about 250 lions survive in West Africa, having disappeared from the other 99% of their range in this region. These animals are scattered across four protected areas, and only one of these populations has more than 50 lions.

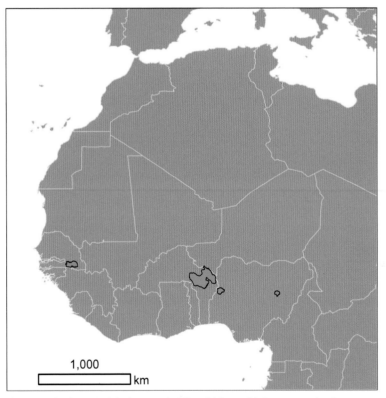

Lions survive in 1% of their range in West Africa, with just 250 animals counted across four parks (green areas on map).

Leopard *Panthera pardus*

CONSERVATION STATUS: Near Threatened

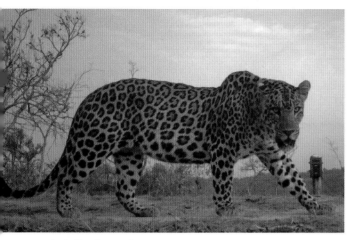
An Indian leopard.

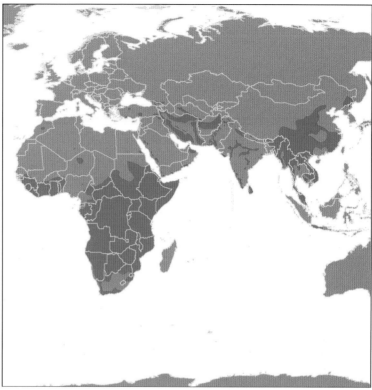

The leopard is one of the world's most adaptable carnivores, ranging from South Africa to Russia and using habitats from desert to tropical rainforest. Each population adapts to local conditions, and the nine subspecies can look slightly different from each other. Local conservation issues vary as well, with the Amur and Persian subspecies being particularly endangered, while most of the African populations are apparently secure.

Leopards coexist with lions and tigers in some parts of their range and must avoid them or face a fight they cannot win. Camera traps have revealed the leopard's strategies for coexistence, shifting their activity to be more nocturnal and yielding the best hunting grounds to the larger species, making do with suboptimal habitat.

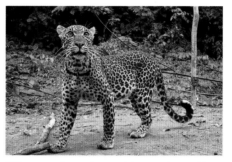
This young forest leopard from Gabon will grow up to hunt a diversity of prey types available in African rainforests, especially monkeys and chimpanzees.

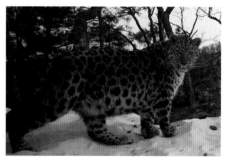
This Amur leopard is one of a few dozen that survive in northern China and eastern Russia; it sports a thicker coat of fur than other subspecies.

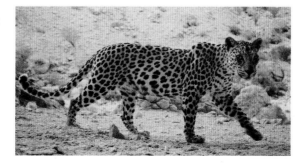
This Arabian leopard from the Dhofar Mountains of Oman survives by hunting small and medium-sized mammals, as well as avoiding people, in the deserts of the Arabian Peninsula.

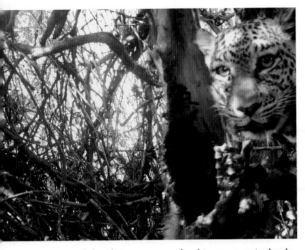

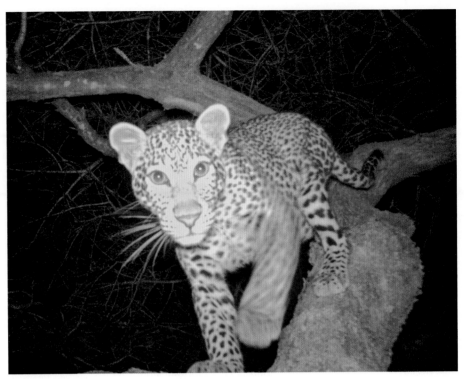

Scientists were surprised to see a waterbuck carcass in an acacia tree, so they put a camera trap next to it. They got photos of this leopard returning to feed on the kill for two days, apparently not bothered at all by the camera, and happy to be up out of reach of the hyenas that the biologists saw prowling around the base of the tree for scraps.

Leopards are good climbers and will often haul their prey up into a tree to keep it away from larger thieving predators such as lions and hyenas.

Leopard attacks on livestock or people sometimes result in eradication campaigns that have driven the species from much of its range in Asia. This endangered Persian leopard bares its teeth at a camera trap in Afghanistan.

PRIMATES ON THE MENU

Leopards are ambush predators, leaping from hiding spots or sneaking up to within a few meters before launching their attack. This strategy works on a variety of prey: they are capable of killing hooved animals the size of zebras and are known to feast on many monkey species. Archeological evidence shows that leopards also terrorized our prehistoric human ancestors, and attacks are still known today, especially in India and Nepal.

Given their evolutionary specialization for killing primates and hooved animals, leopards might seem destined to run into problems with humans and our livestock. Modern conservation efforts are focused on reducing this conflict, especially for the various endangered Asian leopard subspecies.

However, leopards are adaptable, and there is hope for peaceful coexistence with humans. In fact, conflict with humans is most likely only after other events such as drought or overhunting by people reduce the amount of available prey, leaving leopards with few other options. In some parts of India with little native prey, leopards have even switched to eating a large number of feral dogs, which cause their own problems with local villages, attacking livestock and biting people.

BLACK PANTHERS OF KRA

The "black panther" is a mythical beast for many, but camera traps show they do exist, at least in some parts of the world. These darker (aka melanistic) animals contain a genetic variation that changes their coat color but leaves faint spots of

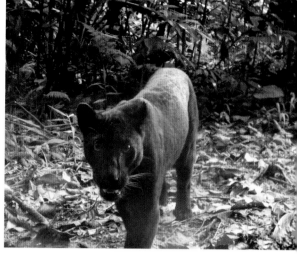

A black leopard walks the forest of Malaysia.

Black coloration, known as melanism, may offer better camouflage for predators hunting in dark rainforests like this one in Pasoh, Malaysia.

shading beneath the black. About one-third of all cat species have melanistic forms, but this seems to be especially common among leopards. Using remote cameras, scientists have mapped leopards with this color form, finding them rarely in Africa, occasionally in India, and commonly in Asia, especially Thailand and Malaysia.

By combining the data from 22 surveys across the region, Kae Kawanishi showed that all leopards south of the Isthmus of Kra, a narrow point on the Malay Peninsula, were melanistic. Some biologists think that the black coloration offers better camouflage in the dark rainforests of the area. This advantage would help black animals survive better over the years and pass their genetic variation on to more offspring. However, melanism is rare in other forest leopard populations, so this may not fully explain this phenomenon.

The narrow geography of the Malay Peninsula must also play a role by isolating these leopards

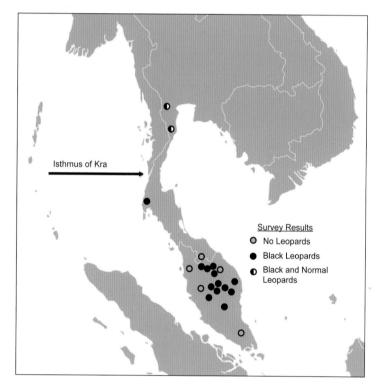

Isthmus of Kra

Survey Results
○ No Leopards
● Black Leopards
◑ Black and Normal Leopards

Camera traps across 22 parks on the Malay Peninsula have shown that all leopards south of the Isthmus of Kra are black, while both normal and black forms are known from parks to the north.

from their neighbors to the north. Given that only a handful of leopards could live on this small strip of land at a time, statistical models suggest that only 1,000 years would be necessary for a gene to spread throughout the population. These estimations presumed that

the gene gave no advantage, so if the black variant did offer a slight advantage of camouflage, it would spread even faster. Like many evolutionary stories, the black panthers south of Kra seem to have resulted from a combination of genetics, geography, and ecology.

CAMERA CAUGHT IN A CATFIGHT

Leopard cubs are nearly adult size by the time they are one year old, but some may not disperse until the age of three. During this brief period, big playful siblings can be seen together, such as in an amazing sequence of 444 photos of a group of young animals recorded by the Tropical Ecological Assessment and Monitoring (TEAM) network in Nouabalé-Ndoki National Park, Republic of Congo. These three overgrown kittens were probably from the same litter and will soon split up. As the aggression of these play fights escalates, each animal will head its own way toward the solitary life typical of adult leopards.

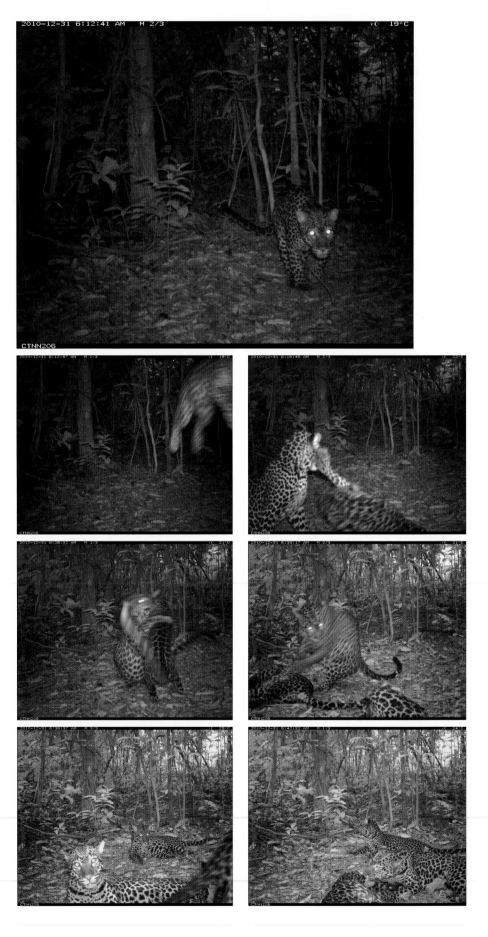

Snow Leopard *Panthera uncia*

CONSERVATION STATUS: Endangered

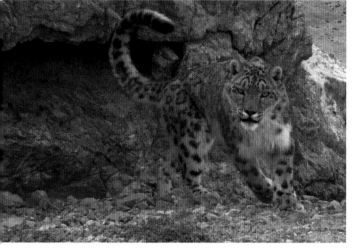

A snow leopard in Tajikistan gives the camera a hard look.

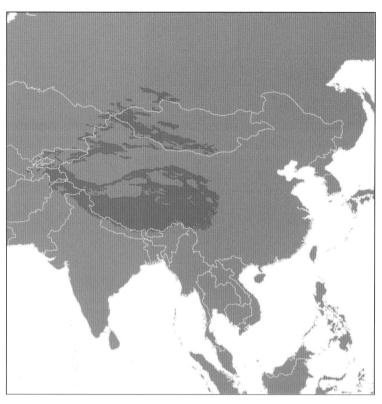

Snow leopards are one of the most mysterious big cats on the planet. Even among carnivores, snow leopards are amazingly secretive and almost never seen in person. To make things worse for researchers, they specialize in the high mountains of the Himalayas, ranging in elevation from 11,000 to 23,000 ft (3,500 to 7,000 m), where it is extremely difficult to conduct field surveys. Simply walking through these mountains is a major physical challenge for scientists. Camera traps have been indispensable in evaluating the conservation status of this species because the equipment can be set in one place for weeks or even months, waiting for a snow leopard to wander by.

The hard work of setting camera traps thorough the Himalayas has paid off in giving an improved map of where snow leopards live and the first counts of their population sizes; scientists have estimated that 3,500 to 7,000 animals remain across their range. This is imprecise because many areas have not been surveyed. Another factor that scientists are learning about, which complicates an estimate of their numbers, is that the habitat quality for snow leopards varies greatly. There appear to be hot spots of excellent habitat separated by many miles of poor habitat. Fortunately, snow leopards are willing to cross some of these lower-quality areas, allowing them to maintain some

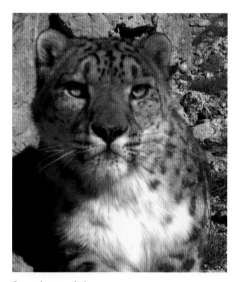

Snow leopard close-up.

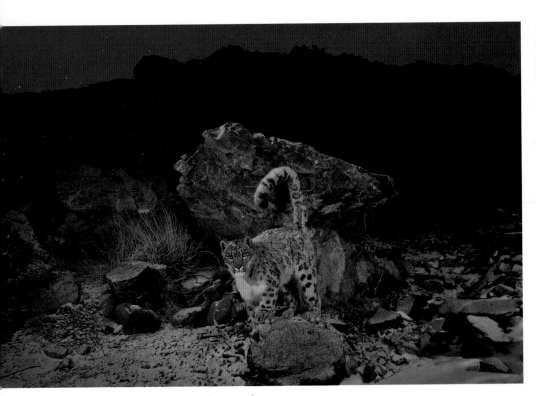

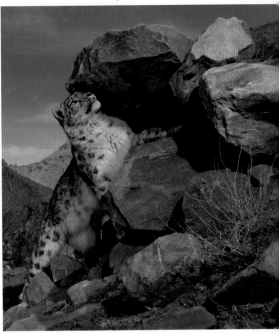

A snow leopard scales a pile of rocks in Ladakh, India.

Lightly falling snow accumulates on the back of a snow leopard as it scent-marks a rock. Scent stations like this are important communication tools for this wide-ranging carnivore that would otherwise rarely encounter other snow leopards while patrolling its immense territory.

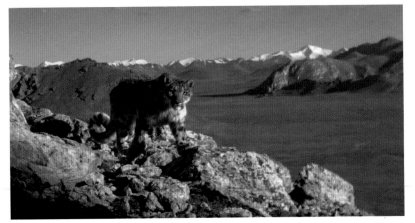

Snow leopards enjoy amazing views of the Himalayas from their preferred high-elevation habitat. Some animals migrate along the slope, following their prey up to higher elevations in the summer and then to lower elevations in the harsh winter. Dispersing animals are known to cross through the lowlands to reach a new mountain range.

genetic connectivity between distant populations.

Like other big cats, snow leopards prefer medium and large ungulates, especially the wild goats that inhabit these high mountains. Snow leopards can kill prey three times their own size, often chasing them downhill in a series of giant leaps. Despite the remoteness of their habitat, snow leopards overlap with people in parts of their range and sometimes create conflict if they attack domestic goats or sheep. Although this is less of a problem than with other large predators, it does threaten the snow leopard's existence in some areas.

Jaguar *Panthera onca*

CONSERVATION STATUS: Near Threatened

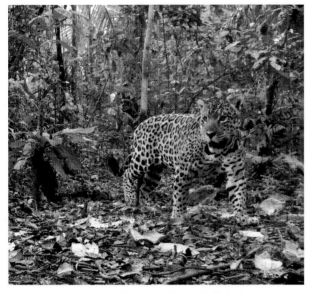

A jaguar hunts in its rainforest habitat in Bolivia. Jaguars might be the best-studied large carnivore in the world through camera trap research.

Jaguars are the largest species of cat in the New World, and they roam a variety of habitats in their tropical realm, from the southern border of the United States to Argentina. They are mostly solitary and mostly nocturnal, although they are often active shortly before sunset in the evening. They eat a variety of prey, preferring larger species such as peccaries, but also taking substantial numbers of smaller animals such as pacas and armadillos. Jaguars use trails regularly, as documented by comparing the number of photos recorded by on-trail versus off-trail camera traps. These same comparisons show that pacas and armadillos avoid the trails, presumably to avoid the jaguars on patrol.

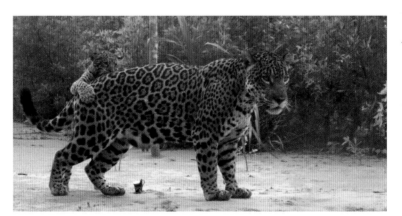

A frisky cub jumps on its mom, who appears to be uninterested in playing games.

Camera trap surveys in Belize by Rebecca Foster have shown that jaguars are more likely than cougars to leave large forest blocks to hunt in the rural countryside. Presumably this reflects a higher tolerance of humans in jaguars than in cougars. This could be a good thing, in providing more suitable habitat for jaguars. However, any big cats cruising through ranch lands can also get into trouble if they start killing cattle. This can turn locals against the species and lead to retaliatory killing of jaguars. As with other large cats, many of

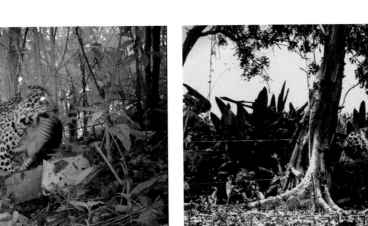

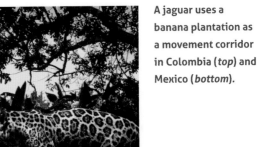
A jaguar uses a banana plantation as a movement corridor in Colombia (*top*) and Mexico (*bottom*).

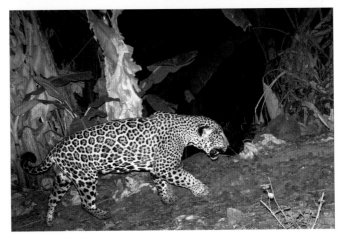

A jaguar runs through the Panamanian forests with an armadillo in its mouth.

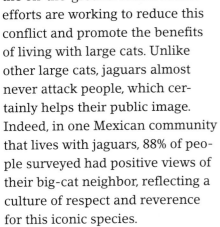

A jaguar cruises down a trail in one of its core habitats in Peru.

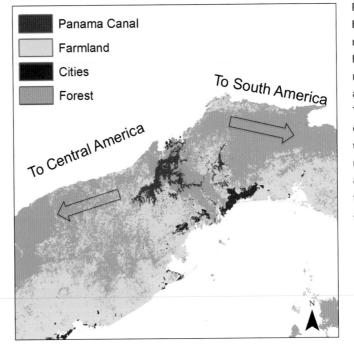

the on-the-ground conservation efforts are working to reduce this conflict and promote the benefits of living with large cats. Unlike other large cats, jaguars almost never attack people, which certainly helps their public image. Indeed, in one Mexican community that lives with jaguars, 88% of people surveyed had positive views of their big-cat neighbor, reflecting a culture of respect and reverence for this iconic species.

BIG CATS NEED BIG, CONNECTED, NATURAL AREAS

Apex predators like jaguars, living at the top of the food chain, are always going to be rare and typically require large natural areas to find enough prey. This makes conserv-

- Panama Canal
- Farmland
- Cities
- Forest

To South America

To Central America

Panama is a critical bottleneck in maintaining connected habitat for jaguars moving between South and Central America. This map shows how development around the Panama Canal makes this a difficult area for jaguars to traverse while still avoiding people.

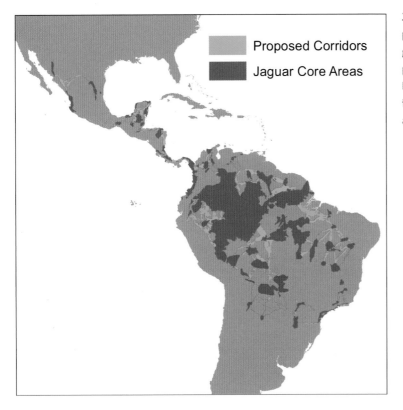

Proposed Corridors

Jaguar Core Areas

Jaguars were the first species to have movement corridors planned out across their entire range, led by the conservation group Panthera. Conservation efforts are now focused on protecting these areas to ensure that animals can disperse between widely separated core areas. Dispersal helps avoid inbreeding by maintaining gene flow between populations and also allows the recolonization of new habitats.

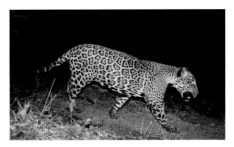

A male jaguar walks a road in the Santa Rita Mountains of southern Arizona looking for a mate. So far only male jaguars have colonized the area, where they find good hunting grounds but no mating opportunities.

ing their populations more difficult, as humans are occupying more and more of the planet, leaving fewer large, unbroken natural areas. At smaller scales, maintaining natural connections between smaller habitat patches aids the daily survival of animals moving through fragmented habitats.

At larger scales, we also need connections between separated protected areas to allow dispersing animals to move between them. These young dispersers represent the next generation of a species, providing valuable genetic exchange between regions, and sometimes recolonizing areas after local extinctions. These large-scale corridors are often many hundreds of kilometers long, requiring a coordinated effort to protect them from development. Jaguars were the first species to have corridors planned on such a large scale

across their entire range. Biologists at the Panthera organization mapped jaguar strongholds, as well as the places with the best chances to serve as linkages between them. In most cases, camera trap studies helped find these populations and suggest appropriate habitat for the best movement corridors between them.

THE ROAR RETURNS TO THE USA

Jaguars are primarily tropical but historically ranged along the southern edge of Arizona, New Mexico, and Texas. Cattle ranchers and predator hunters killed the last jaguars in the United States by the 1960s, and no breeding animals have been confirmed since then. However, in the past decade several individuals have been sighted in southeast Arizona, and camera traps have been useful in documenting this recolonization.

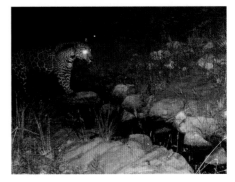

Creek beds are magnets for wildlife in a dry landscape and are good hunting grounds for jaguars.

This may be the only record of a jaguar walking through snow. The Santa Rita Mountains of New Mexico are the northern limit of the jaguar's range and the only place they are likely to leave their footprints in snow.

The nearest breeding population is about 125 mi (200 km) to the south in Mexico, and only a few animals have made the trip north and across the border. However, once they discover the mountains in Arizona, these big cats appear to find them suitable habitat and stick around. One famous male jaguar was photographed 64 times between its original photo in 1996 and 2007. Jaguars aren't the only tropical cat moving north: ocelots have also been recorded in this area. The 16 mountain ranges in southern Arizona and New Mexico have a variety of prey, and cameras set for cats mostly get images of these other animals. Out of about 1 million photographs of 41 different wildlife species captured by a study by the US Fish and Wildlife Service, only 65 were jaguars or ocelots.

To date, all of the jaguars and ocelots that have wandered into the southwestern United States have been males, and no breeding population has been documented. The roar may have returned to the United States, but so far it's just the call of a lonely bachelor tomcat.

NONINVASIVE MONITORING

Most camera traps are set to be as inconspicuous as possible, with no audible click or visible flash when they trigger. This method is considered to be noninvasive since most animals ignore the equipment as they walk by, or even sleep in front of it. Nonetheless, some animals do notice the plastic cameras strapped to trees, and sometimes they approach them for a closer look and even lick or bite them. In most of these cases, curiosity won't kill the

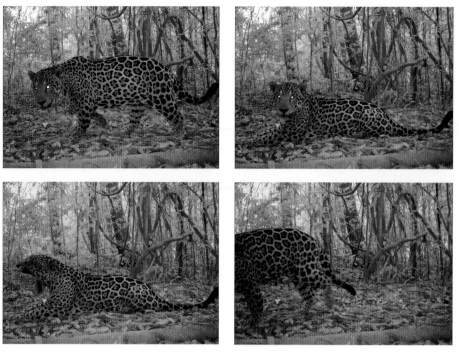

A jaguar from Caxiuanã, Brazil, takes a quick break in front of a camera trap, showing how unconcerned most animals are with the presence of a camera trap in the forest.

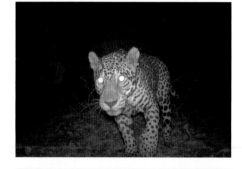

Please don't taste the camera—a jaguar from central Suriname walks up to sniff the camera trap and then puts his mouth over the lens, offering a photo of his tongue.

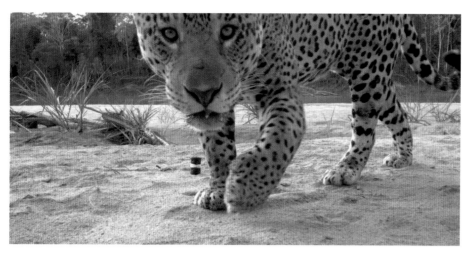

This large jaguar from Bolivia peers into the camera trap after initially approaching the black plastic canister on the ground, which contains a scent lure.

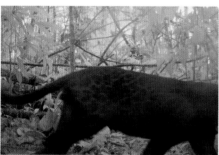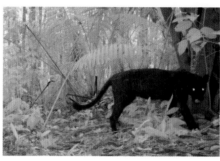

Like many other cat species, jaguars have a rare black form that is occasionally detected by camera traps. The animals still have the same spots (aka rosettes), which are subtler underneath the dark fur.

cat—in fact, by providing scientists with better images, it might actually help the cat by informing future conservation efforts.

THE POWER CAT

Jaguars are built for power, not speed. Their stocky shoulders and large paws help them tackle big, strong prey, such as tapirs and peccaries. Cougars, on the other hand, are built for short bursts of speed and eat more deer than peccaries. Neither cat is a true specialist, and both will sample from across the prey menu wherever they live. Size and speed are a classic evolutionary trade-off; it's hard to be big and fast. This fact is evident in the evolutionary history of these two cats and also reflected in their dietary tendencies.

Their broad head helps give jaguars the strongest bite of all cats,

and second among all mammals after the spotted hyena. This helps them break through turtle shells and make short work of rolled-up armadillos.

As the largest predator across its range, jaguars can have strong effects on smaller competing species. Anywhere they are abundant, smaller cat species take smaller prey to compete less with jaguars. However, in the absence of jaguars, surviving species of smaller cats are "released" from this competition and may change their diet, or even grow larger. For example, ocelots living with jaguars typically feed on mice, but in central Panama, where jaguars are rare, ocelots hunt more medium-sized animals such as agoutis, sloths, and armadillos.

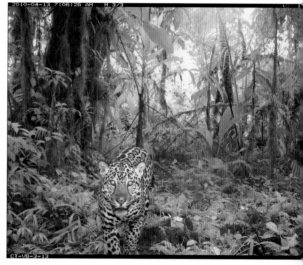

A jaguar stalks the slopes of Volcan Barva, Costa Rica. These solitary hunters are among the stealthiest of all cats and are rarely seen in person, making camera traps an essential tool for studying them.

Cougar *Puma concolor (aka Mountain Lion, Puma, Panther)*

CONSERVATION STATUS: Least Concern

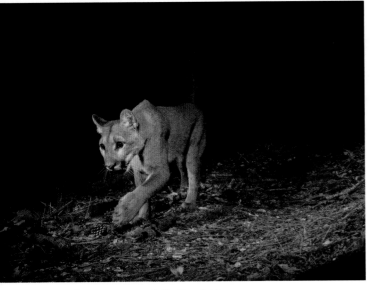

A young cougar stalks the night near Aptos, California.

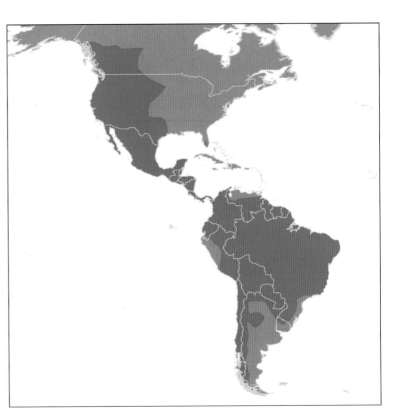

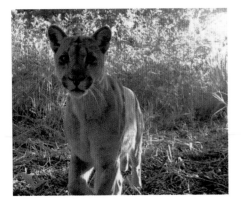

A cougar approaches the camera trap one sunny morning in the shrubby Pantanal of southern Brazil.

Found from Alaska to Argentina, cougars have the largest range of any mammal in the Western Hemisphere. Cougars specialize in hunting deer, but they can prey on just about any bird or mammal species they encounter. Similarly, they use just about any habitat type found on the two continents. If not hunted by humans, they can even survive in highly developed landscapes; for example, there is a small population living in the Santa Monica Mountains around Los Angeles, California.

Cougars are more active hunters than most other large cats. They prefer cruising trails to cutting through thick vegetation, but they will also hide out in rocky canyons to ambush prey with their excep-

tional leaping ability. Jumps of 18 ft (5.5 m) straight up or 45 ft (13.5 m) horizontally are possible as a result of their exceptional hind legs, proportionally longer than any other cat. Although fierce ungulate hunters, if caught in a fight with other carnivores, cougars are more likely to run away than put up a fight, and they are subordinate to other large predators in their range such as jaguars, wolves, and bears.

ANIMAL ACTIVITY

Why animals have different activity patterns remains a bit of a mystery. Likely explanations are that they are attracted to the times of day when their food is most available, or that they are avoiding the times when their predators and

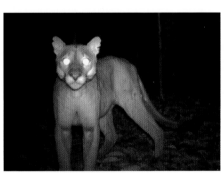

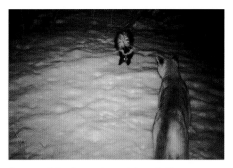

A cougar is surprised to find a camera trap on a tree at 11 a.m. in Manaus, Brazil. Although more active at night, cougars are not strictly nocturnal and can be found active at any time of the day or night.

As one of the largest predators in its range, cougars are capable of killing almost any prey species they encounter, and they are even known to eat skunks and porcupines. This photo captures a cougar and a striped skunk facing off in Waterton Lakes National Park, Canada. In this case, the camera trap records the skunk standing its ground and the cat walking away in search of a less stinky meal.

competitors are active. The time stamps recorded on each image make them a great tool for studying this question. Across the cougar's large range they are always found to be most active at night, but they can also be photographed in the daytime. The details vary between sites, and exploring these differences can help answer the question of what factors affect their survival.

For example, in Brazil, biologist Vania Foster found that cougar activity patterns are different across three habitats (see graph). The primary competitor in these areas is the jaguar, and the patterns of

A cougar on its nightly patrol at 2 a.m. in Caxiuanã, Brazil.

This graph shows the daily activity patterns of cougars living in three different Brazilian habitats. Animals living in forests showed a "crepuscular" pattern, with activity peaking at dusk and dawn. In shrubby habitats cougars' activity peaked at midnight, while in flooded grasslands they were steadily active throughout the night.

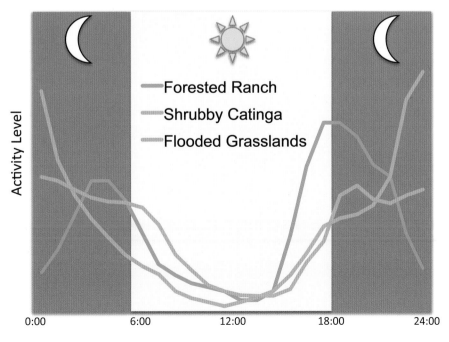

Forested Ranch
Shrubby Catinga
Flooded Grasslands

Activity Level

0:00 6:00 12:00 18:00 24:00

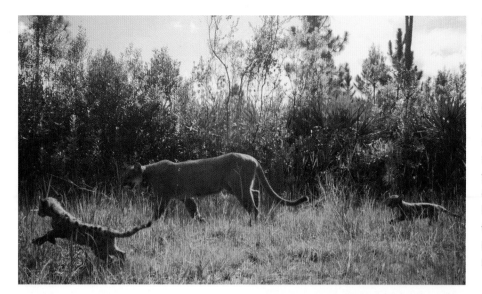

A radio-collared cougar and her cubs traverse a movement corridor in Florida. Florida has the only breeding population of cougars in the eastern United States, where they are locally known as panthers, and they are threatened by development and fragmentation of habitat. Crossing roads in Florida is dangerous, and many cougars get hit by automobiles and die each year. Conservation planners are working to develop a network of movement corridors, like the one in this photo, allowing cougars to move between the few remaining large hunting areas without crossing over busy roads.

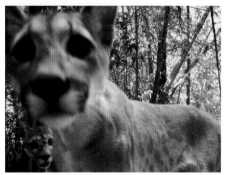

(*left*) Two young, curious cougars peer into the lens of a camera trap in Brazil.

(*right*) A Mexican cougar snarls at the camera as he passes by. This animal sports a fresh wound on its foreleg, probably caused by a fight with another cougar.

these two species actually overlapped quite a bit at each site, suggesting that these two species are not temporally avoiding each other. These camera traps also recorded the main prey items eaten by large cats, especially peccaries, capybaras, giant anteaters, and armadillos. By comparing the timing of activity of these prey with that of the cougars, researchers showed that the predators shifted their peak activity to synchronize with whatever prey was most abundant at a particular site. However, other studies in Mexico and Bolivia did find separation between the timing of activity of jaguars and pumas, suggesting that the relationship between these two cats could vary across their range and might be dependent on their local densities.

GROWING UP A COUGAR

Cougar cubs are adorable spotted kittens with blue eyes. These spots enhance their camouflage, are visible for about three months, and then slowly fade away as they mature into adults at around age two or three. Their eyes also change to a grayish brown or golden color. The young kittens stay with their mom for 12 to 18 months, learning how to hunt and receiving protection against unrelated males, which are known to be infanticidal if given the chance.

Violence between cougars continues throughout their lives, as they are highly territorial. These fights leave scars that can sometimes help identify individual cougars in photographs, but also sometimes lead to the death of an

animal. These cat fights increase in areas with lots of cougars, not surprisingly, but also where there is high turnover of males due to human hunting. Mature male cougars have smaller territories with well-established boundaries and little overlap. Younger males still settling their territorial boundaries roam over larger areas and are more likely to encounter and fight with others. These same troublemaking young male cougars are also more of a problem for local people, being more likely to encounter and attack livestock in their larger territories. Together, this research suggests that the instability in cougar social structure found in areas with lots of hunting of cougars by people actually causes more potential for fights

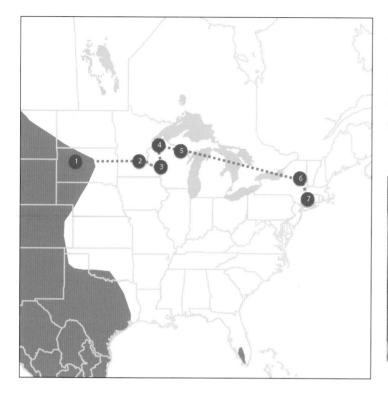

This map tracks the wandering dispersal of a young male cougar that started in South Dakota and moved through the Great Lakes to Connecticut. Verifiable evidence of this animal's movement was recorded throughout his remarkable journey, including extensive tracks in the snow, hair and scat samples, and camera trap photos. The brown shading in this map shows the known breeding range for cougars, while the numbers plot the confirmed locations of the dispersing animal.

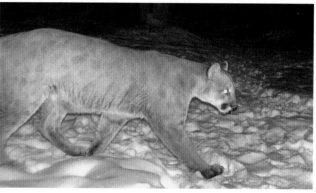

This Wisconsin camera trap photographed the male cougar on his record-setting 1,500 mi (2,400 km) dispersal from South Dakota eastward. Faint spots in the animal's coat can still be seen, revealing the young age of this otherwise large male.

between cougars and for more conflict with people.

1. Genetic tests confirmed that the animal originated from the breeding population in Black Hills, South Dakota.
2. First verified sighting (11 December 2009).
3. Camera trap photo (18 January 2010).
4. Tracks in snow (7 February 2010).
5. Probable sighting (20 May 2010).
6. Tracks and hair in snow (16 December 2010).
7. Hit by car (11 June 2011).

RECLAIMING THEIR OLD HUNTING GROUNDS

Dispersing juveniles are the key to a species' success; young travelers are how a species can colonize new lands or reclaim their old hunting grounds. Cougars were driven out of most of the eastern United States a century ago, but they have recently started moving back into these areas through a series of dispersing animals coming from the west. Most of these are young males, leaving home for the first time and looking for a new place to establish a territory. Young females are much less likely to disperse long distances; in fact, many establish new territories right next to their mothers. Truly reclaiming the east will require both a male and female to establish a breeding population together.

Although there were 178 cougars documented dispersing eastward out of their western range from 1990 to 2008, there have been thousands more unsubstantiated rumors of eastern cougars. Camera traps are important tools to distinguish fact from fiction in these cases, providing hard physical evidence that this elusive species was at a given place at a given time.

This snowy Wisconsin photo (*above*) is an amazing example of the importance of photographs as data—documenting a dispersing male in the middle of a record-setting journey that ended with him getting hit by a car in Connecticut. This single animal left a long trail of verifiable evidence, including photographs, scats, hair, and snow tracks all along its route. This shows that cougars are not ghosts that can hide forever in the forests, as well as how good scientific detective work can piece together the stories of remarkable animal journeys. This story ends sadly for this male cougar, but his survival for over 18 months, moving across at least five states and provinces, is also a hopeful sign for future colonizers.

Indochinese Clouded Leopard and
Sunda Clouded Leopard *Neofelis nebulosa & N. diardi*

CONSERVATION STATUS: Vulnerable

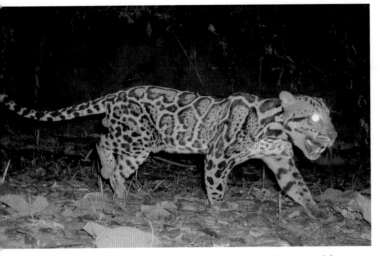

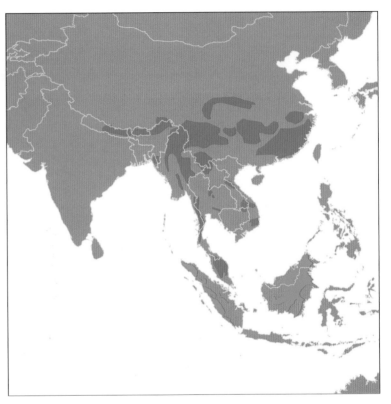

(*above*) The Sunda clouded leopard from Borneo and Sumatra has many small spots within the larger splotches in its coat pattern. Their cloud-shaped spots are usually smaller than in the mainland form, and they are typically grayer and darker.

(*right*) The blue shows the range for the Indochinese clouded leopard, while the green shows the range of the Sunda clouded leopard.

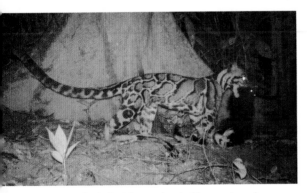

An Indochinese clouded leopard carries a young binturong it recently killed. The cloud-shaped spots on this mainland form are solid, with few smaller spots.

The clouded leopards are widespread, medium-sized cats of Southeast Asia. Across their range there are obvious differences in the cloud-shaped patterning of their large spots, and morphologists have also documented differences in their skulls and teeth. Genetic studies have recently confirmed that there are actually two separate species of clouded leopard: the widespread Indochinese form found in much of the mainland Asian tropical forests, and the Sunda (aka Diardi's) clouded leopard from Borneo and Sumatra.

Clouded leopards are forest animals, and camera traps most often detect them in evergreen forests.

In Thailand they are most closely associated with areas that have an abundance of their favorite prey: red muntjac and Eurasian wild pig. They are not overly sensitive to disturbance and were the most common of five cat species photographed in a survey of a forest with active commercial logging in Borneo. Male clouded leopards were actually attracted to logged areas, whereas females avoided them, perhaps trying to stay out of the way of the larger males. Two other commercial forests in Sabah which were certified for sustainable management practices had healthy clouded leopard populations, around one animal per 39

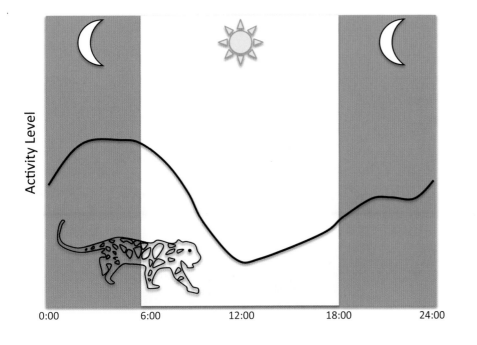

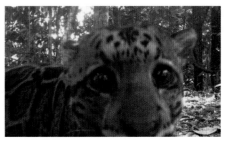

(*above*) A Sunda clouded leopard comes up to a camera trap for a closer look.

(*left*) Clouded leopards are mostly nocturnal; this graph shows their pattern in Sumatra, where their activity peaks just before dawn and has its low point around noon.

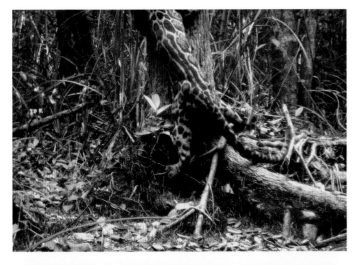

Their long tails help clouded leopards climb trees to chase prey or avoid a tiger. However, most of their movement through their big home ranges is along the ground, not jumping from tree to tree.

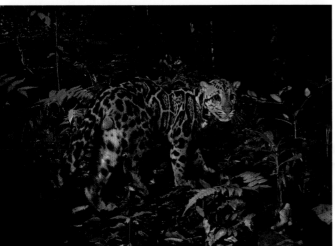

A male Sunda clouded leopard pauses for his portrait in Tawau Hills Park, Borneo.

mi² (100 km²). Clouded leopards are also tolerant of some level of hunting, as camera traps showed that they continued to survive in an Indian preserve after the tigers, as well as much of the prey, had been overhunted by illegal poaching.

CLIMBING OUT OF REACH

The clouded leopard is the third-largest felid in Southeast Asia, after the tiger and the leopard. Although large predators often affect smaller predator's distribution, this has not been found for clouded leopards. For example, scientist Dusit Ngoprasert found no difference in clouded leopard abundance in areas with or without leopards in Thailand. Clouded leopards are excellent tree climbers, with a long tail to help balance as they walk the various branches and vines of tropical forests. This climbing agility might help them coexist with the larger cats, which are more tied to the ground. It also gives them an advantage when attacking arboreal prey such as monkeys, binturongs, and young orangutans.

Cheetah *Cheetah Acinonyx jubatus*

CONSERVATION STATUS: Vulnerable

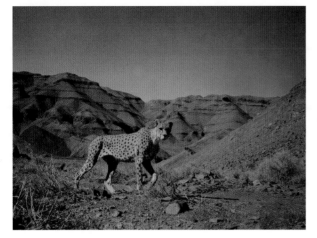

A cheetah hunts the arid central plateau of Iran.

Cheetahs are famous for being the fastest mammal on land. They can reach top speeds of 63 mph (102 kph) as they chase prey in short sprints that usually last a couple hundred meters. Cheetahs are well adapted to arid conditions and once ranged over most of Africa, the Middle East, and into India. Unfortunately, as humans and their herds of sheep and goats have spread into more and more of these dry lands, the cheetah has been forced out. It is now extinct in 20 countries in which it used to live. The African subspecies is still relatively secure, with populations scattered across preserves. However, the Asian subspecies is considered critically endangered, with

its one last population surviving in the Islamic Republic of Iran.

Camera trap surveys have helped scientist Mohammad Farhadinia count Iranian cheetahs, suggesting that there are now only 70 to 110 animals hanging on across a scattering of preserves in the country's central plateau. This is down from 200 animals in the 1970s and 400 in the 1930s. There are five protected areas within this plateau, separated by many miles of grazing lands and desert. Mohammad was surprised to find the same individuals, recognizable through their unique spotting patterns, moving between these parks. One female moved back and forth between two parks 100 mi (150 km)

apart, covering at least 2,200 mi (3,600 km) over three years. This nomadic life was successful for her, as she raised a litter of three sons, who continued these wide-ranging habits once they became independent from her.

Cheetahs specialize in hunting gazelles and smaller antelope. Some thought that Iranian cheetahs were surviving on rabbits and terrestrial birds, but recent analysis of their feces has shown that they mostly eat mountain ungulates such as wild sheep and Persian ibex. Jebeer and goitered gazelles were two other favorite native species, along with domestic sheep and goats. Domestic animals made up half of the diet of some

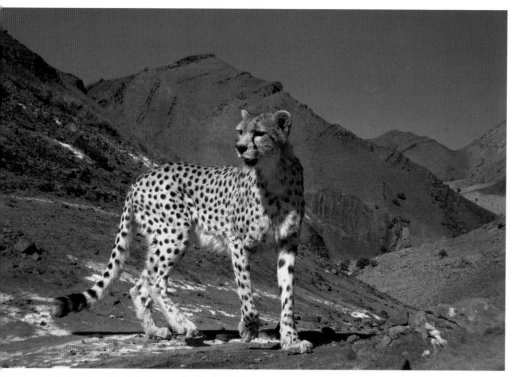

An Iranian cheetah, known in the local language as "yuz," peers down from a mountain pass. The species is protected as an important part of Iranian heritage, with hefty fines ($10,000) for killing one.

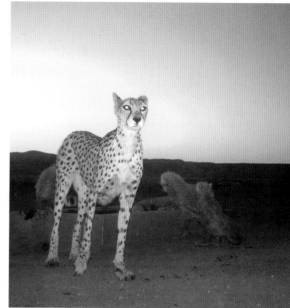

A mother brings her three young cubs to a water source created to help wildlife within Miandasht Wildlife Refuge, Iran. This female has to eat a lot to provide milk for her big litter, making her more likely to attack a sheep or goat left unprotected in the area.

cats. Although cheetahs prefer wild prey when available, herders bring livestock to graze inside parts of the nature preserves during winter, which forces wild herbivores out and gives fewer options to hungry predators. This potential for conflict with herders, combined with their wide-ranging patterns, explains why the cheetah population has declined and why new work with local communities is urgently needed to reverse the trend.

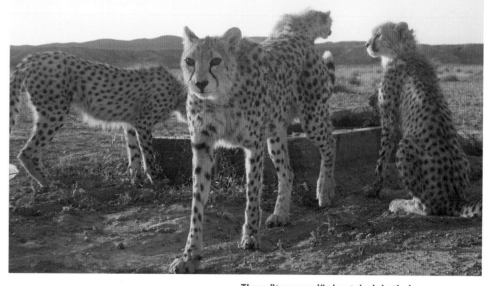

Three "teenaged" cheetahs join their mom at a watering hole. They are about the age, 18 months, when they should strike out on their own. Cheetahs are more social than most cats. Males, especially bands of brothers, are known to form coalitions that work together to defend larger territories.

Bobcat *Lynx rufus*

CONSERVATION STATUS: Least Concern

A wet bobcat in Virginia.

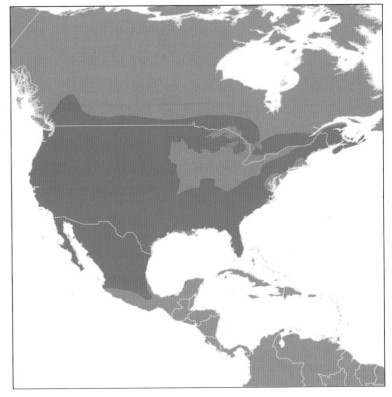

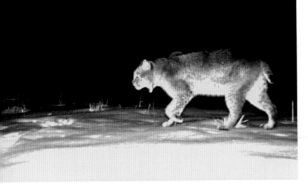

A bobcat stalks through a dark Pennsylvania night. Bobcats are visual predators and hunt mostly at dusk and dawn, or under full moon, when there is some illumination on the landscape.

Bobcats are the most common wild cat in North America and range across a variety of habitat types. On average, they prefer rugged rocky landscapes with dense cover that they can use for their ambush hunting style. Their favorite prey are rabbits and hares, but they will tackle almost any small or medium-sized animal. Camera traps show that bobcats are most active at dusk and dawn, matching the typical rabbit pattern, but they switch to more nocturnal activity in areas with a large human population. As visual hunters they are most efficient with some light to work with, and they increase their nocturnal hunting during a full moon.

SPOTS CAN BE HARD TO SPOT

The amount of spotting visible in the fur of bobcats varies across their range and is more conspicuous in western animals. Where the patterns are visible, scientists can use camera traps to recognize individuals and estimate densities. For example, in Northern California densities were about 0.14 cats per square mile (0.35 cats per square kilometer).

BOBCATS AND HUMANS

Across their range bobcats show different levels of tolerance to cities. Typical of much of the western United States, photographic surveys in suburban Southern California captured lots of bobcats. In one study compiled by Miguel

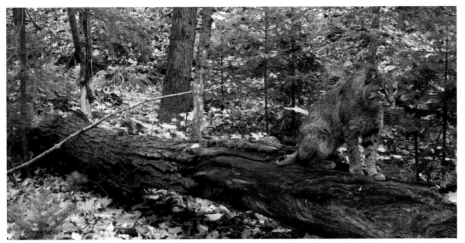
Bobcats often launch their attacks from perches on rocks or logs. Here a Wisconsin cat is poised to pounce on something that caught its attention off camera.

A bobcat shows off its face ruff, looking like sideburns, to the camera.

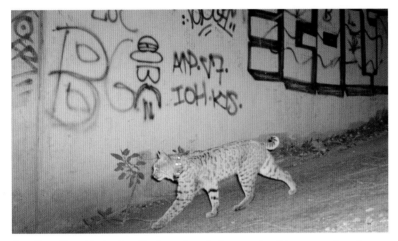
A radio-collared bobcat walks down to a drainage culvert to pass under a busy road in Southern California. Research shows that they are reluctant to enter small culverts but will use underpasses if they are high and wide enough, and especially if they have plant cover near the entrance.

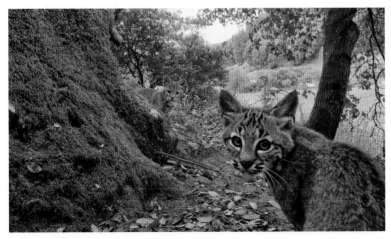
A pair of bobcat cubs play on a trail overlooking houses in California. Bobcats in the West are often photographed near development, while eastern bobcats are more sensitive to human development and are found primarily in wilder areas.

Ordeñana, bobcats were detected at 74% of 217 cameras run across five counties, being second only to coyotes in abundance, and 2.5 times more common than raccoons. Meanwhile, they appear to avoid urban areas in the eastern United States; for example, bobcats were captured by only a handful of cameras placed in Raleigh-Durham, North Carolina, and only in the wilder corners of the study area.

The importance of underpasses for urban bobcat survival remains a bit of a conundrum, exemplified in a study of animals on either side of the I-5 freeway in Los Angeles. Cameras recorded bobcats using culverts to get under the road, yet a genetic study found that the roads created a barrier to gene flow, in that there were genetic differences on either side of the road. Interestingly, the diseases carried by bobcats were not affected by this barrier. Thus, animals from the two sides of the highway appear to be moving back and forth enough to trigger camera traps and spread disease, but they are not actually mating with each other enough to blend the genetic patterns.

Chinese Mountain Cat *Felis bieti*

CONSERVATION STATUS: Vulnerable

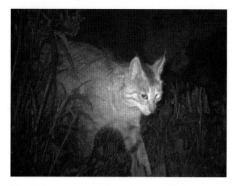

The Chinese mountain cat can easily be confused with a domestic cat.

This was the first camera trap photo of a Chinese mountain cat, captured in 2007 at an elevation of 11,000 ft (3,570 m). This animal is swishing his tail from side to side, so that it appears shorter than it actually is.

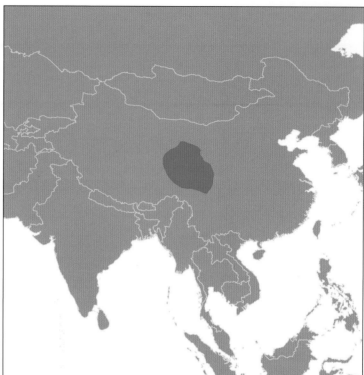

The Chinese mountain cat is a rare species that lives only in the high-elevation steppe grasslands in China. It is about the size of a large domestic cat and looks very similar to its close relative the Asiatic wildcat. This has led to confusion about its ecology and distribution. For example, it was once erroneously reported to live in the deserts of Mongolia and even given the common name "Chinese desert cat." Other reports suggested that it inhabited montane forests. However, a more careful evaluation of museum specimens and camera trap photos led by biologist Li He shows that this animal is a specialist of alpine shrubland and meadow habitats, surviving now in just the eastern Qinghai and northern Sichuan provinces of China.

Chinese mountain cats have dense fur to protect against the cold typical of their mountain homes. They have the unusual (for a cat) habit of using holes in the ground to sleep. They apparently seek out south-facing slopes for resting, where they take over burrows made by marmots or badgers, but do not dig themselves. Chinese mountain cats have excellent hearing. Judging from the size of the auditory bullae portion of their skulls, the bony protection around the inner ear, Chinese mountain cats probably have superior hearing to domestic cats, which must be important for its hunting strategy. Like most felines of this size, Chinese mountain cats hunt small mammals and birds. Pikas, a diminutive and small-eared cousin of the rabbit, are a favorite prey.

As a rodent hunter, the Chinese mountain cat is beneficial to people. However, they have suffered from humans' own efforts to control rodents. In particular, a poisoning campaign in the region from 1958 to 1978 is known to have killed many predators, in addition to the intended rodent victims. Although discontinued now, small-scale poisoning is still a problem for this rodent-loving cat. They are also hunted for their skins, which are used by some local communities to make traditional hats.

Domestic Cat *Felis catus*

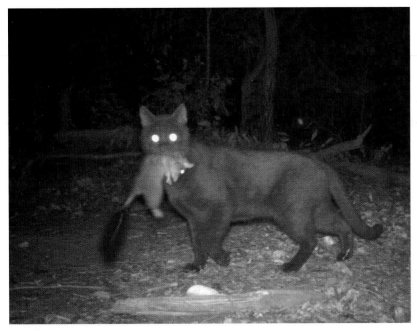

A domestic cat carries a brush-tailed phascogale it has just killed in western Australia. With no predators of their own, cats run rampant across many islands, large and small.

A pet cat stalks a little penguin at its nesting hole at Encounter Bay, Australia. The camera recorded this bird escaping back into its hole, but more aggressive cats have wiped out entire seabird colonies. This photo was used in a campaign to warn people of the damage cats can do, and this particular cat was not seen again, hopefully kept inside by its penguin-loving owners.

Cats were domesticated for their great hunting abilities and have helped humans by controlling rats in cities and farms. But they are indiscriminant hunters and live at very high densities in some places, where they can cause great harm to native wildlife. The situation is at its worst in places where native species have no evolutionary history with this type of mammalian predator and thus no fear of or innate ability to avoid domestic cats.

Cats are most harmful on the world's islands, where they have caused the extinction of one reptile, four mammal, and 13 bird species—that's 14% of the global extinctions of birds, mammals, and reptiles! In some cases conservationists have staved off extinction, for now, and are working to save

another 36 island vertebrates that are critically endangered as a result of predation by feral cats.

The island problem is caused not only by small prey not having evolved the behaviors to avoid cat-like predators but also by the cats themselves having no larger predators to worry about on the islands, thus allowing them to reach higher densities and range further into natural areas. This is particularly true in Australia, which has suffered the highest rate of mammalian extinctions over the past 150 years. With the extinction of the ~50 lb (~25 kg) Tasmanian wolf in the 1930s, the only remaining potential threat to cats would be the dingo, an offshoot of domestic dogs that arrived to the island with humans but went feral 5,000 to 10,000

years ago. A camera trap study in a region where they both occur, led by Yiwei Wang, found that the cats did shift their activity to avoid the time of night when dingoes were most active, but that the two used the exact same areas, creating a double threat to native prey species.

CONTINENTAL CATS

At first glance, the conservation risk of free-ranging domestic cats in the United States also seems dire, with recent extrapolations suggesting that cats kill ~2 billion birds and somewhere in the range of 7 to 20 billion mammals each year. However, American cats have more to worry about than those living on tropical islands, with coyotes, wolves, and cougars on the

(*left*) A domestic cat looks out for coyotes as it stalks through native habitat in New York State.

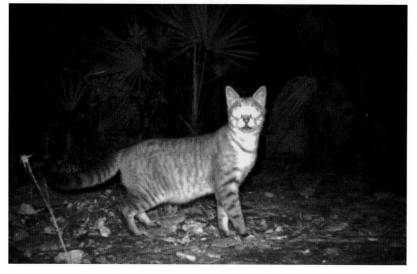

(*above*) Rock Creek Park is the largest park in the Washington, DC, area and is surrounded by high-density housing and, presumably, many thousands of cats. Scientists were surprised to find only this one cat in a camera trap survey of the park. The same effort returned 126 photos of coyotes patrolling the park at night, presumably keeping the cats out.

A well-fed domestic cat is a threat to three endangered subspecies of small mammals unique to the Florida Keys, including the Key Largo woodrat, the silver rice rat, and the Lower Keys marsh rabbit.

prowl across most of the continent. Indeed, a camera trap survey of 32 larger nature parks found almost no cats living in the preserves. These natural areas were teeming with coyotes, and cameras returned 33 times more coyote photos than cat photos. Thus, the coyotes appear to be protecting the parks from an onslaught of feral cats.

Cats and coyotes still mix in some small urban forests, although it's not clear how. The mix of forests and settlements might give cats safe places to hide if chased by a coyote. However, this cat-coyote tension is still changing. In some areas coyotes have become more accustomed to people and are

known to even snatch cats from the back porch.

Well-meaning citizens sometimes put out cat food for stray cats, and before long a colony of animals can live at very high density around this food source. These are sustained by immigration and continued breeding, despite cat lovers' efforts to spay and neuter animals. Although fed, these animals will still hunt native prey, and they can decimate the local fauna around their colony. This might not be a big conservation issue in some urban areas where they are hunting common birds and mammals, but there are some examples of cat colonies establishing near endangered spe-

cies that are of great concern. One example is near beaches, where water birds, such as the piping plover, are already threatened as a result of competition for their sandy nesting grounds. Adding dozens of feral cats to this situation is a conservationist's nightmare. Another example comes from Florida, where unique subspecies of woodrat, rice rat, and swamp rabbit survive in fragmented habitats between the highway and development of the Florida Keys. A nearby cat colony, combined with roaming neighborhood cats, has added to the problems faced by these endangered small mammals.

Flat-headed Cat *Prionailurus planiceps*

CONSERVATION STATUS: Endangered

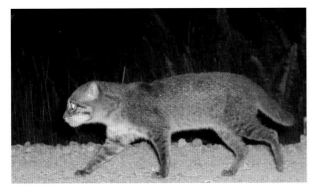

A flat-headed cat from Borneo.

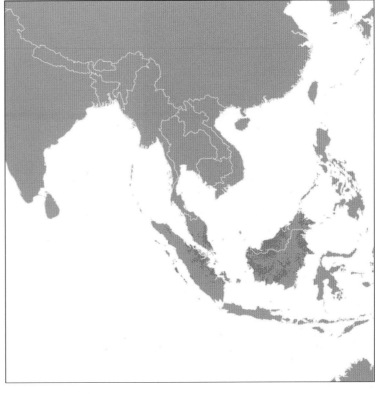

The flat-headed cat is one of the least known felids in the world and also appears to be highly threatened. It is rarely seen, sparse in museum collections, and only occasionally photographed by camera traps. In addition to its short tail and legs, the cat has two other features that suggested to scientists that it might be an aquatic specialist. First, its toes are webbed, although just slightly. Second, its first two upper premolars are sharper than in related cats, which some suggest is an adaptation to grab ahold of slippery fish. However, no single survey was able to obtain enough detections to perform an effective habitat use analysis, so the needs of this animal remained speculative for years.

Recently, a group of biologists led by Andres Wilting scoured museums and scientists' databases to collect a total of 88 records of where this species lived, including 14 from camera traps. They then compared these with the local habitat and weather to see what was special about these locations, to try to understand what conditions the flat-headed cat needed to survive. The most striking result, although perhaps not surprisingly, was the need this cat has for water. Almost all records were within 3 mi (5 km) of large bodies of water, most even closer. The seasonality of rainfall was also important, and any areas with strong dry seasons were not used by this species, presumably because it would result in its swampy habitats disappearing for a few months every year.

The scientists were able to summarize this result in a single map showing where conditions are likely to be suitable for the flat-headed cat. This is an important conservation tool to identify the strongholds for a species and the areas in need of more protection. Within this region, they estimated that ~60% of the forest had already been converted to agriculture and that only 10%–20% of the area was inside protected areas. Encouragingly, the species does seem tolerant to some human-caused disturbance in the region, as long as forested wetlands remain. New conservation efforts are aimed at protecting the remaining vulnerable areas as linkages between existing core habitats.

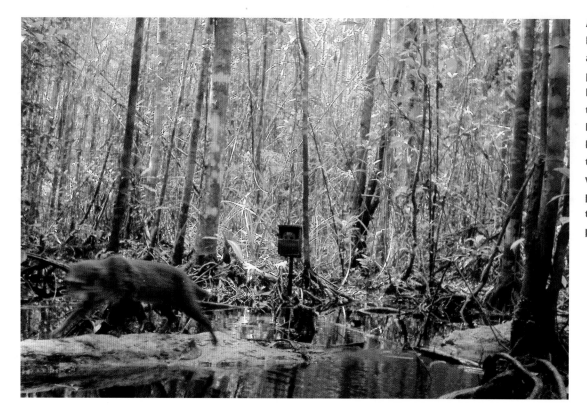

A flat-headed cat is a blur as it scurries along a log in the Sabangau peat swamps of Kalimantan. A camera trap on a post in the background illustrates how tricky it can be to run surveys in such wet areas, which may partially explain why this species is so rarely photographed.

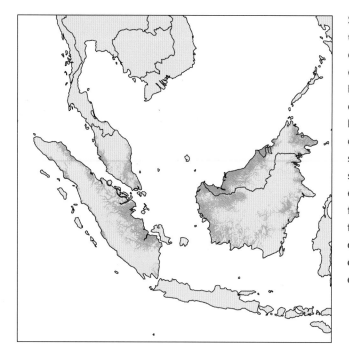

Scientists analyzed which habitat types flat-headed cats prefer by collecting vouchered records of locations where the cats had been detected from museum and camera trap databases. From these habitat associations, scientists could then predict the extent of suitable land across their range, shown here as darker shades of green. Forests with aquatic features year-round were key for this species, but this type of habitat was also found to be declining as a result of agricultural expansion in the region.

Leopard Cat *Prionailurus bengalensis*

CONSERVATION STATUS: Least Concern

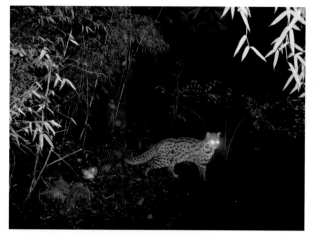

A leopard cat in the bamboo forests of China.

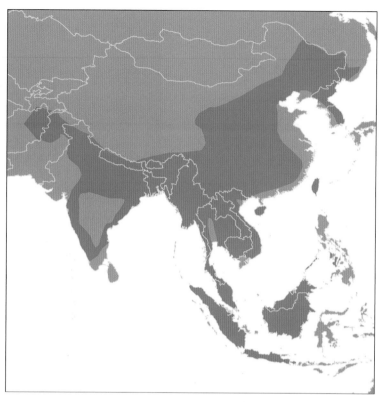

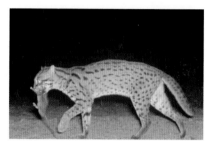

Leopard cats are great rodent hunters; this one was caught carrying its rat meal by a camera trap in Borneo.

In some ways the leopard cat is a smaller, mouse-eating version of the leopard. Like its larger cousin, the leopard cat is widely distributed across a broad spectrum of habitats, where it is typically the most common small cat. It does well in rainforests, temperate deciduous forests, and even shrubby or grassland habitats with sufficient cover. It is apparently limited to the north by snow cover, and it cannot survive in deserts.

The leopard cat is a good swimmer and has been reported catching fish and eels to supplement its primary diet of mice. Its swimming ability has also undoubtedly helped it spread throughout the region, as it occurs through most of the major islands of Southeast Asia

and has also colonized a number of smaller offshore islands. It is the only native cat species in the islands of Japan and the Philippines. The Iriomote cat was originally described as a unique species but is now recognized as an endangered subspecies of the leopard cat which has been isolated on Japan's remote Iriomote Island for over 100,000 years.

Like the larger leopard, the leopard cat is also adaptable to human disturbance. They do well in dense secondary growth, and camera traps have documented them using plantations of rubber trees and oil palms. They are one of the most strongly nocturnal cats in the area, which probably helps them live close to rural settlements.

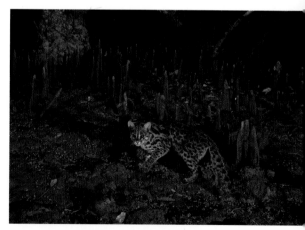

Leopard cats are not afraid of the water; they use their swimming skills to catch fish and even colonize islands. This cat was photographed hunting in the Mangroves of the Sundarbans of Bangladesh.

Marbled Cat *Pardofelis marmorata*

CONSERVATION STATUS: Vulnerable

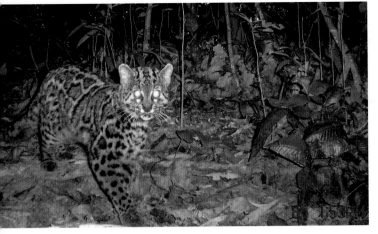

A marbled cat photographed walking the floor of an Indian rainforest in the early afternoon.

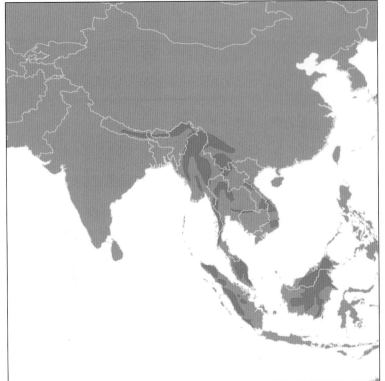

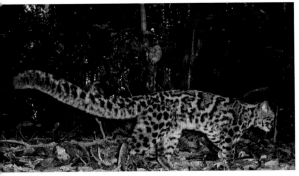

The long bushy tail is a striking feature of the marbled cat and may help it balance while walking along high branches hunting arboreal prey.

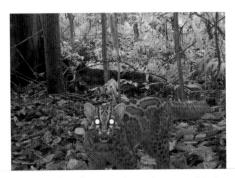

This morning photograph catches a marbled cat walking off-trails in Borneo, avoiding the logging roads that bisect the forest at this site.

The marbled cat is about the size of a house cat, but with a long bushy tail, black splotches on its head and body, and oversized canines. This is one of the least known cat species, and camera trap studies in its range have been able to obtain only a handful of photographs. It is mostly likely to be detected in rainforests. Although most cats are nocturnal, camera traps usually catch this species in the daytime. A collection of 10 marbled cat photographs made over 24 study sites in Thailand were all taken in the daytime, with most of them between sunrise and 10 a.m.

The long tail of this species is probably an adaptation for climbing trees, although no studies have been able to collect enough data to evaluate this. An arboreal lifestyle might help explain why ground-based camera traps so rarely detect marbled cats. Tree climbing would also help it catch the type of prey it is recorded to eat, such as squirrels, birds, and fruit bats. Another possibility is that this species avoids the trails and roads where scientists usually set their cameras. A study by Oliver Wearn using randomized camera trap locations found that the marbled cat avoided logging roads through the forest, unlike some larger cats.

Clearly, we have a lot more to learn about the marbled cat. Camera traps in the tree canopies, or placed off-trail on the ground, are most likely to help us discover more of this rare species' secrets.

African Golden Cat *Caracal aurata*

CONSERVATION STATUS: Near Threatened

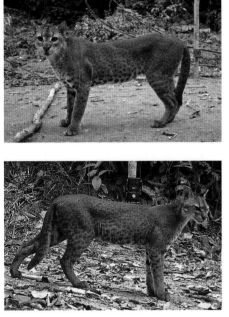

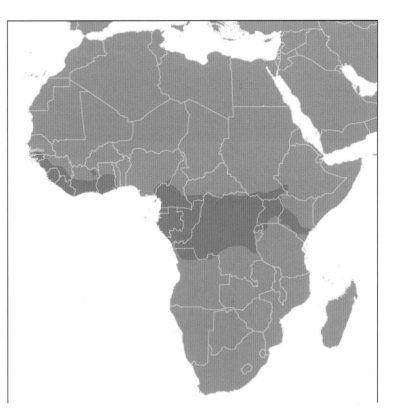

Golden morph and gray morph: these two African golden cats were photographed in the same area of Gabon, showing that both color morphs live together in the same population. The number and distribution of spots on the body can also vary between animals. This mess of color and spots initially led to confusion with multiple species described. Careful examination of skull shapes and genetic patterns confirms that all color variants can breed with each other, thus forming one beautifully variable species.

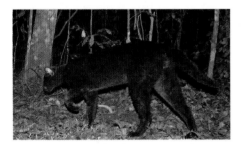

Like many cat species, the African golden cat also has a melanistic black form that results from a relatively common genetic mutation. Some scientists suggest that this black coat helps in their camouflage in the dark rainforests.

On a continent famous for its predators, the African golden cat remains the least studied and most mysterious feline. This is a cat of many colors, and early scientists presumed that each was its own species. Closer examination showed that the red and gray colors were just two variations of the same cat, which could also sometimes be black. Confusion continued as it was then presumed to be a close relative to the similar-looking Asian golden cat. However, a genetic analysis showed that these two species were not closely related; the African golden cat is actually most closely related to the caracal, a better-known cat of the African savanna. Thus, the similar appearance of these two unrelated cats is actually a case of convergence, a type of evolution that creates similar solutions for the same survival challenge at separate locations. In this case, evolution resulted in two independent lines of cats evolving a similar body form and camouflage strategy, one for hunting in tropical forests of Asia, and the other in Africa.

The African golden cat lives in equatorial rainforests and is the only African cat species completely dependent on forests. They are a sneaky predator and are almost never seen by people. This stealth has evolved not only to help them capture prey but also to help them avoid becoming prey themselves to the larger leopard, which is the largest predator of African forests.

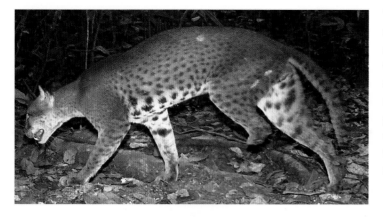

This three-legged cat almost certainly lost its limb to a wire snare, dangerously common in this Gabonese forest. Snares are one of the favorite tools for poachers because they are inexpensive and very effective at catching animals. These same characteristics make them a nightmare for endangered animals and the conservationists trying to save them. In well-patrolled parks, rangers regularly clear the forest of hundreds of illegal wire snares. In parks with few rangers, snares can sit for weeks or months waiting for an animal to walk by, before they finally rust away.

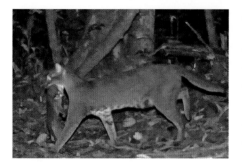

An African golden cat carries a red-tailed monkey meal.

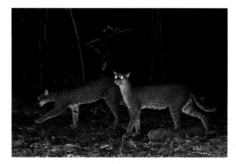

A pair of African golden cats patrol together, probably representing a mating pair or mother and oversized offspring.

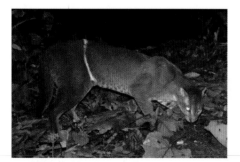

A white scar around the middle of this African golden cat shows that it was recently caught by a wire snare but managed to escape.

African golden cats have been found in the diet of leopards, so they have to be careful where and when they are active if they want to avoid these larger predators. There is some suggestion that African golden cats might become more common in areas where leopards have recently been extirpated, becoming the de facto top predator themselves.

African golden cats are medium-sized predators that seem to feed mostly on small rodents, but they are always ready to grab a larger meal when available. They can scamper up small trees, and they use this skill to grab squirrels and monkeys that come to the ground or lower branches of the forest. They are also able to tackle smaller forest ungulates such as duikers.

SNARE TROUBLE

The trade in animal meat, aka bushmeat, is devastating Africa's forest wildlife. Illegal (but almost never actively prevented), unregulated wildlife harvest is emptying many forests across the continent. New logging roads give men access to a dense forest, allowing them to enter with dogs and guns to hunt down their favorite antelope or pig species. However, the most trouble-some aspect of the trade is the use of wire snares.

Snares are inexpensive, indiscriminate, inhumane, and deadly. Almost any animal walking through a forest can get caught in a snare, not just the game species favored by hunters. Snares are not checked often, leaving some animals anchored to the ground for days. Snares are also inefficient: about one-third of snared animals die before the trapper returns, leaving a useless, rotten carcass; another one-third of snared animals escape, but with tragic injuries that jeopardize their survival. Although African golden cats are great at hiding from people, they cannot avoid their snares. The escapees photographed by camera traps are faced with a new compounded problem: not only do they have to survive with a new handicap caused by the snare, but they also have to find food in a forest being emptied of wildlife by humans and their snares.

Jaguarundi *Puma yagouaroundi*

CONSERVATION STATUS: Least Concern

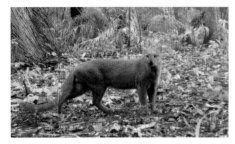

Sometimes called a "weasel cat," the jaguarundi has short legs and an elongated body.

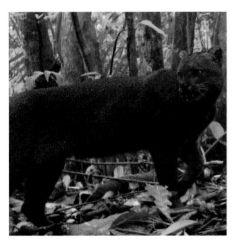

The jaguarundi has two distinct color morphs (dark brown and paler reddish yellow), which can be found mixed together in the same litter. There is also variation in the shades of these colors, with populations living in dry country having paler color and those in forests being darker.

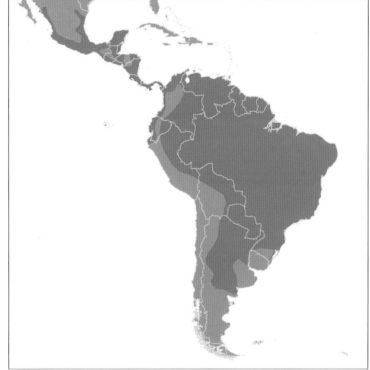

Given that the jaguarundi is widespread across South and Central America and is diurnal, it is amazing that we don't know more about this species. They are typically the most frequently seen cat in an area, owing to their activity in the daytime and their use of trails and roads. Yet there has never been a systematic study on their ecology.

Camera traps are helping us get a handle on the biology of this species, although we are just starting to scratch the surface. They appear to be more common in the drier and more open scrubland and grasslands than in rainforests, although they can also be found in most habitats from Mexico to Argentina. Their response to human disturbance seems to be variable, with some populations living quite close to people, but others being absent from developed areas such as cattle ranches. A five-year mammal survey in a Costa Rican rainforest by the TEAM project found jaguarundi populations to be steady during this period, although never common. The overall rarity of their photographs in systematic surveys has some scientists concerned that jaguarundis may be much less common than we presume based on our occasional visual sightings.

Although they historically occurred in Texas and Arizona, modern sightings of jaguarundis are scattered and not well documented. Camera trap photos could help confirm their presence, or absence, in the United States.

As this cooperative animal lounging in front of a camera trap shows, jaguarundis have one of the most unusual faces in the cat family. Analysis of their skull shape confirms this, showing that they are more similar to the cougar and cheetah than other cats.

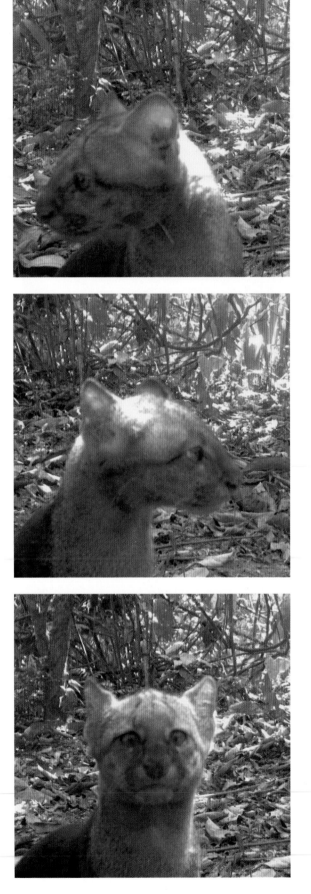

Ocelot *Leopardus pardalis*

CONSERVATION STATUS: Least Concern

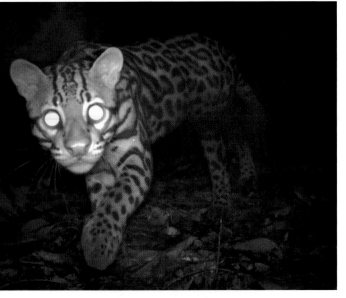

A trail-walking ocelot stops to peer into the camera on Barro Colorado Island, Panama.

A Bolivian ocelot walks between a pair of camera traps that simultaneously photograph its right and left sides. Their unique spots allow scientists to count individuals, but the patterns are not symmetrical, so paired photos are needed to match both sides to the same animal.

Throughout its large range, and across a variety of habitats, the ocelot is one of the most important predators in Latin America. Although smaller than jaguars and cougars, ocelots are usually the most common mammalian carnivore in an area and thus play very important ecological roles as predators. Rather than hunting in marshes, dry scrub, or rainforests, they spend most of their time resting or hunting in the thickest habitats, stalking vine tangles or thick bushes. However, when it's time to move a long distance, ocelots prefer using trails. One study in Panama got six times more photos of ocelots from camera traps placed on trails compared with those placed in random locations off-trail in the same rainforest.

Comparisons of density estimates show, not surprisingly, that ocelots are most abundant in highly productive forests—those in the tropics with a lot of rainfall. The "primary productivity" of these forests is thought to support more prey animals, which then can support more predators. Locally, however, logging and poaching can result in lower ocelot densities.

Although common through most of its range in the tropics, the ocelot is endangered at the northern edge, in Texas. Camera trap studies have estimated that less than 50 animals survive in the remnant thorn forests of deep-south Texas.

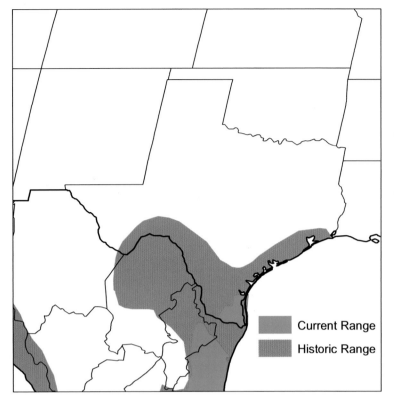

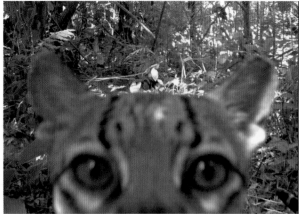

An ocelot peeks into a camera trap.

Ocelots are endangered at the northern edge of their range in Texas, where they survive in just three counties.

Current Range

Historic Range

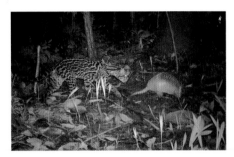

An ocelot follows behind a nine-banded armadillo in Peru. Unlike jaguars, ocelots don't often kill armadillos, as they are probably unable to penetrate their tough armor.

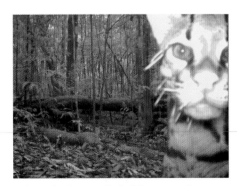

This ocelot has tangled with a porcupine and probably regrets it now.

Conversion of the dry scrub habitat favored by ocelots into farmland and housing has been the primary cause of their decline. Texan ocelots also get hit by cars as they cross roads when trying to move between fragmented remnants of natural habitat. Conservationists are working now to maintain a network of suitable habitat on public and private lands which ocelots can use to survive.

CAT NAPS AS SIT-AND-WAIT PREDATION

Ocelots employ two different hunting strategies to find a meal. Their active hunting involves quietly stalking through their habitat hoping to surprise a small rodent or other potential prey. This is especially effective at night, which is also when ocelots are most often photographed by camera traps. But ocelots can also be patient hunters, employing a sit-and-wait hunting strategy where they remain motionless and let the animals come to them. When waiting, ocelots will naturally mix in some catnaps. This strategy is used more in the daytime, which helps explain how this primarily nocturnal animal can still feed on diurnal prey such as iguanas and birds.

Diet studies across their range have found that most ocelots feed on rodents and other small prey. However, in areas where the larger cats are rare or completely gone, ocelots will eat up the food chain. For example, a study by Ricardo Moreno around the Panama Canal, where jaguars and cougars are rare, found ocelots to primarily eat sloths and agoutis. Although ocelots can climb trees, they are not thought to be very good at it—how they caught so many sloths in Panama remains a mystery.

Fossa *Cryptoprocta ferox*

CONSERVATION STATUS: Vulnerable

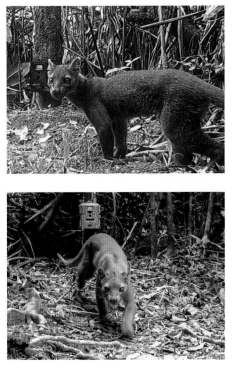

(*above*) Fossas are the top predator in Madagascar, weighing 12 to 19 lb (5.5 to 8.6 kg).

(*below*) Fossas travel through the forest on the ground, but they will climb into trees to chase prey, especially lemurs.

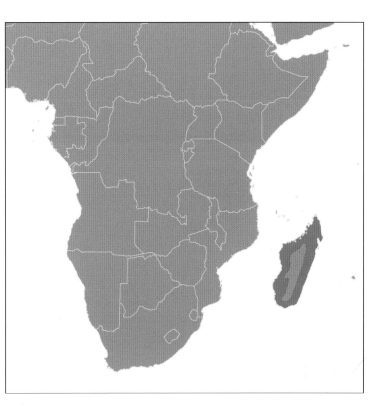

The fossa combines characteristics of civets, mongooses, and cats into one amazing predator. For years this unique combination of traits confused scientists trying to figure out which mammal the fossa was related to. Eventually, genetic evidence pointed to a new option—the fossa is part of a unique family of carnivores found only on Madagascar, the Eupleridae. This group includes the fossa and seven smaller predators that all evolved from one common ancestor thought to have crossed the ocean from Africa about 20 million years ago.

With its long tail, honey color, short legs, and catlike face, the fossa resembles a small cougar. Unlike the cougar, however, the fossa is an excellent tree climber and can leap from branch to branch in hot pursuit of a lemur, their favorite prey. Fossas are generalist predators, hunting a variety of smaller birds and mammals. One study even found them to kill the spotted fanaloka, another euplerid carnivore.

Although typically solitary, there are some accounts of pairs of animals hunting together, especially in the breeding season. These are presumed to be male-female pairs, and eyewitness accounts report one animal bounding through the trees and another sneaking along on the ground, ready to pounce on any lemur that climbs down or falls. Females and their older cubs may also cooperate as a group during a hunt.

The forests of Madagascar are under great threat from logging and agricultural expansion, leaving fewer habitats for wild animals like the fossa. The remaining forests are also scattered, with farmland in between. For wild animals to survive in Madagascar they will have to be able to use some degraded habitat and move across farmland to find additional forests. Camera trap surveys led by Brian Gerber found that fossas will cross up to 1.5 mi (2.5 km) of farmland to reach a remnant forest fragment, but that more isolated forests had no fossas. Encouragingly, fossas were also found to use logged forest, as long as prey populations were present. As with any top predator, the densities of fossas are always low, and scientists estimate that there are only two preserves in the country large enough to hold 300 or more animals.

Spotted Fanaloka *Fossa fossana*

CONSERVATION STATUS: Near Threatened

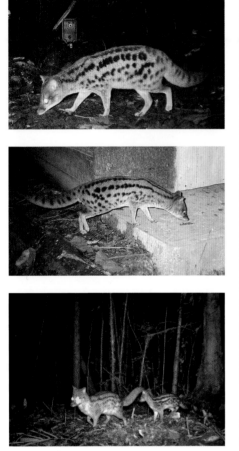

(*top*) The spotted fanaloka is one of eight members of a unique family of carnivores found only in Madagascar called the Eupleridae.

(*middle*) A spotted fanaloka sniffs around an outhouse at Ranomafana National Park.

(*bottom*) A young spotted fanaloka follows its mother through the forests of eastern Madagascar, where they are most common.

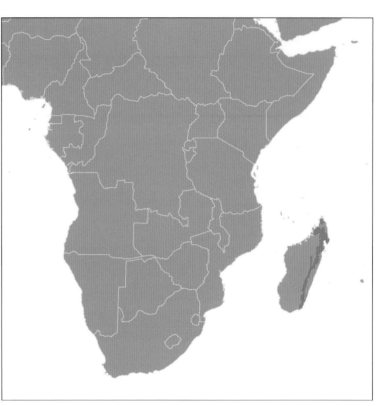

The spotted fanaloka is a member of the Eupleridae carnivore family that is unique to Madagascar. Like its larger relative the fossa, the fanaloka was confusing to many generations of biologists, who initially considered it a "Malagasy civet." The thick tail of the spotted fanaloka might help explain how the ancestor of the Eupleridae managed to cross the 250 mi (400 km) span of ocean between Africa and Madagascar. The fanaloka can store fat in its tail, which today helps it survive lean seasons when less food is available. This trait may have also helped its ancestor survive on some raft of vegetation as it crossed the open ocean as the first carnivore colonist of Madagascar 20 million years ago.

The spotted fanaloka is found in forests throughout Madagascar. It is most common in primary forests, especially eastern rainforests, but can survive in logged forests, although at lower densities. Camera trap surveys of isolated forest fragments did not detect any spotted fanaloka, suggesting that they will not cross over farmland, or simply can't survive in small forest remnants. They seem to forage mostly along watercourses, where they feed on crustaceans, eels, and other small prey. However, they are not restricted to wetlands, as they have also been found in dry forests without any permanent rivers. They eat more mammals in the dry season, presumably wandering away from the dried-up streambeds in search of alternative foods.

Their flexibility in natural habitat use means that they have a broad range in Madagascar. Owing to their small size, they are threatened by the introduction of feral dogs and cats into some Malagasy forests.

Ring-tailed Vontsira *Galidia elegans*

CONSERVATION STATUS: Least Concern

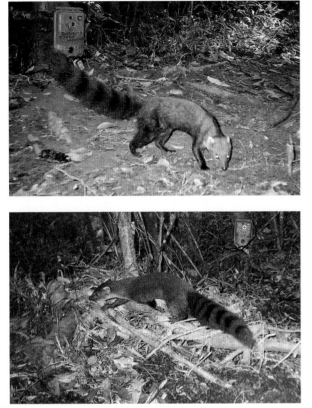

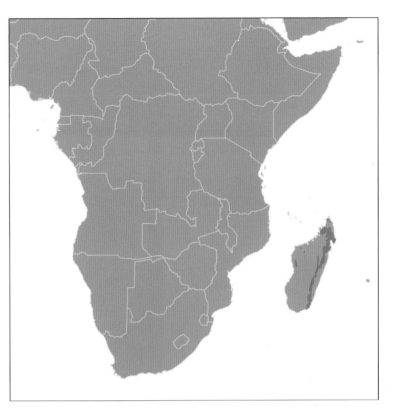

(*top*) The ring-tailed vontsira is a striking red-and-black carnivore unique to Madagascar.

(*bottom*) Ring-tailed vontsiras run along the forest floor hunting small prey during the daytime, but they are also decent swimmers and have even been seen scaling vertical tree trunks.

A ring-tailed vontsira hunts the forests of Ranomafana National Park.

This mongoose-like carnivore is the most diurnal of the Eupleridae family of carnivores that are unique to Madagascar. It may also be the most beautiful, with a huge bushy tail showing off red-and-black stripes that are reminiscent of those in red pandas. It is the most common and widespread native carnivore species on the island, using lowland tropical forests, montane forests, and even dry deciduous forests. It has also been documented hunting the edge of agricultural fields, which could be a key adaptation to survive in a country with rapidly disappearing forests.

This species hunts every inch of its habitat, running along the

ground, climbing trees, and even using its partially webbed feet to swim through creeks after prey. Not surprisingly, it eats a variety of small prey, from crayfish to insects, small mice, and birds. Camera trappers have also caught it raiding the trash of their forest camps in search of food. This species has been recorded quite often as pairs of adults, sometimes with up to three offspring in tow, suggesting that they might have a gregarious social structure.

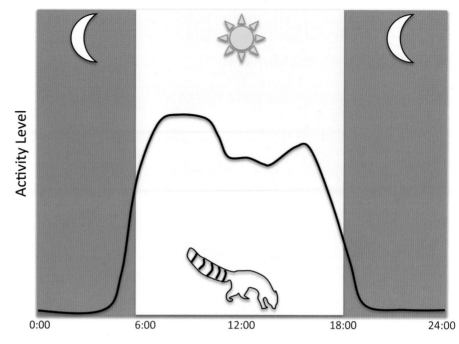

Like many diurnal hunters, ring-tailed vontsiras have a peak of activity in the morning, a midday rest, and then a second activity peak in the evening.

Broad-striped Vontsira *Galidictis fasciata*

CONSERVATION STATUS: Near Threatened

The broad-striped vontsira has a striking black-and-white color pattern that makes it stand out at night.

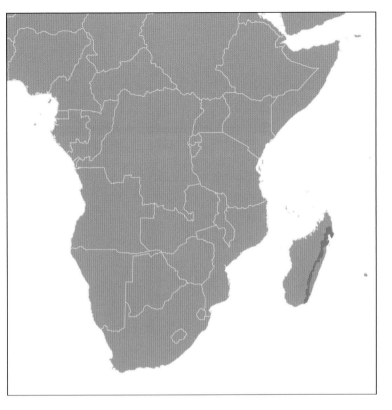

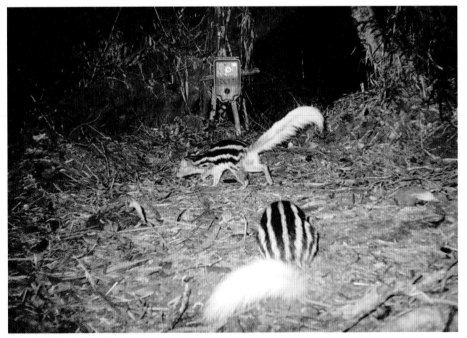

The broad-striped vontsira is often seen in small groups, although nothing is known about its social organization.

It would be easy to classify the broad-striped vontsira as a nocturnal version of its red-and-black cousin, the ring-tailed vontsira. They do have similar builds, and both have interesting black stripes, with the more colorful species being more active at day and the black-and-white broad-striped species being more active at night. However, much less is known about the broad-striped vontsira because it is so secretive and, presumably, so rare. They are thought to be generalist predators of small prey, but no data are available to confirm this. Some locals blame them for raiding chicken coops, which could be true, but again, no data are available to evaluate this claim.

The broad-striped vontsira is broadly distributed across montane forests in Madagascar but is never common. For example, one study by Brian Gerber obtained nearly 2,000 photographs of the ring-tailed vontsira but only about 100 of the broad-striped vontsira. Fortunately, these detections were both in larger patches of continuous forest and in smaller forest patches isolated in a matrix of farmland. This suggests that the broad-striped vontsira may be able to survive human modifications of the landscape, as long as some forest is left behind.

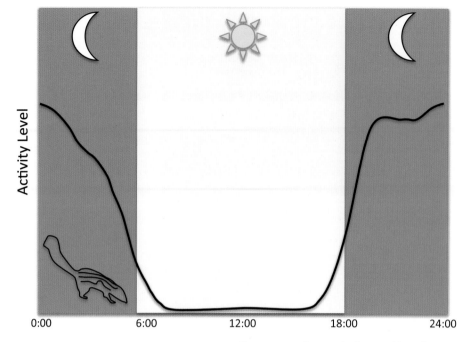

Camera traps have only detected broad-striped vontsiras at night, with activity peaking shortly after sunset and tailing off into the early morning hours.

Servaline Genet *Genetta servalina*

CONSERVATION STATUS: Least Concern

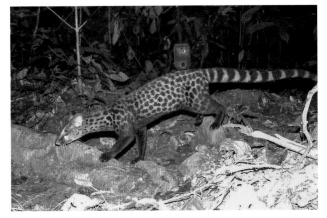

A servaline genet stalks the forest floor in Gabon, in the heart of its range in Africa.

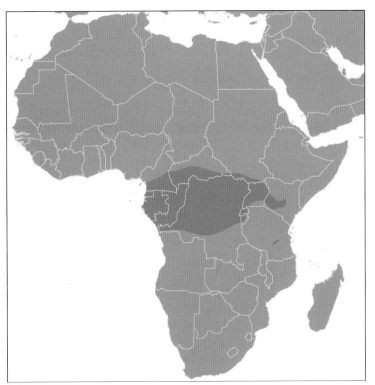

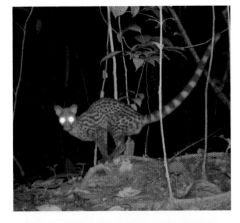

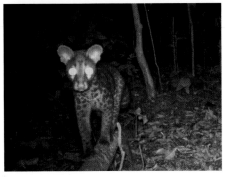

(*top*) The long tail of the servaline genet helps it balance as it hops from log to log and through low bushes, in search of its next meal, or to escape from a leopard.

(*bottom*) A curious servaline genet reflects bright eyeshine from the camera trap's infrared flash.

The servaline genet is an agile hunter of small prey in African forests. They eat equal parts insects and small mammals (mice and shrews), with a smaller amount of reptiles, amphibians, birds, and fruit rounding out their diet. They are widespread across the entire African rainforest zone, as well as degraded lowland rainforests, deciduous forests, and woodlands. Camera trap research has shown that this species also stretches east to the Eastern Arc Mountains of Tanzania and even the island of Zanzibar.

Although a terror to any mouse caught in the open on the forest floor or in low bushes, the servaline genet itself must be careful not to be caught by larger species such as leopards. This is the life of a medium-sized predator (aka mesopredator), which can play important ecological roles by limiting populations of small animals, but can also become prey themselves. The impact of this predation extends past the actual mortality of an animal because the element of fear also changes prey behavior. If larger predators are present, their potential prey, including mesopredators, change their activity periods and movement patterns out of fear of predation.

Judging from these surveys, the servaline genet is quite good at finding the balance between eating smaller prey and avoiding getting eaten by larger predators. They are typically one of the most common carnivores detected in a study, with nearly all photos coming at night.

Masked Palm Civet *Paguma larvata*

Conservation Stats: Least Concern

A masked palm civet from China.

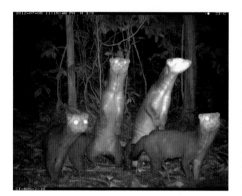

This compilation shot of four frames from the same camera trap shows a curious masked palm civet standing on its hind legs to get a new perspective, and a sniff, of the camera trap.

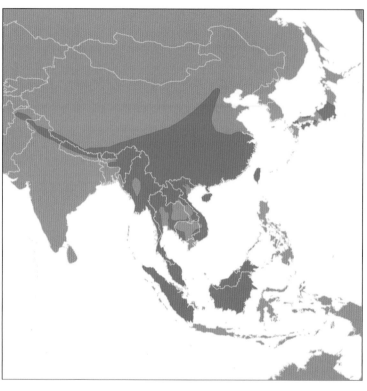

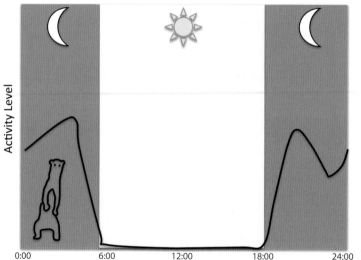

The masked palm civet is strongly nocturnal, even avoiding the dusk and dawn periods, when many mammals are at their peak activity. This species seems to prefer the darkest parts of the night.

The masked palm civet is a widespread species that uses a variety of forest types and is relatively tolerant of human disturbance. They primarily eat fruit and are important seed dispersers. Their digestive system does not harm most seeds, allowing them to pass in their scats unharmed, ready to germinate in a new site, far from their mother tree.

Masked palm civets are commonly detected by camera trap studies; for example, they were the most common carnivore detected in a two-year survey of a Chinese forest. They were also widely distributed across a gradient of disturbance levels in Borneo, including logged forests and those near villages. These studies should probably be considered minimum estimates, since the masked palm civet is partially arboreal, and thus the ground-based cameras may be underestimating their true abundances in forests.

Masked palm civets are also opportunistic feeders and have been recorded on camera scavenging on dead mice and also on monkey carcasses in the forest.

Otter Civet *Cynogale bennettii*

CONSERVATION STATUS: Endangered

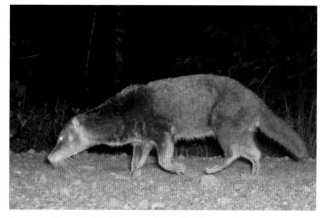

An otter civet plods along a trail, probably moving between creeks.

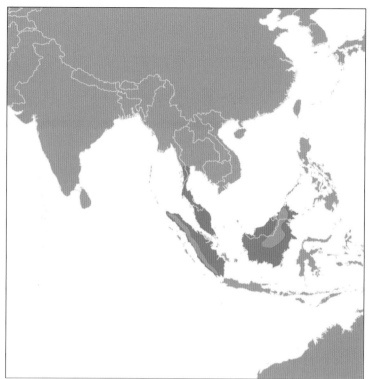

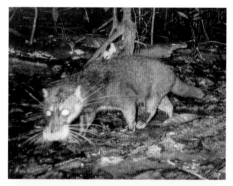

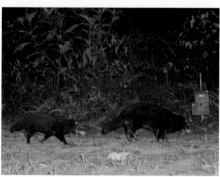

(*top*) The otter civet has a remarkably wide snout, with huge whiskers, helping it feel for prey in rivers and swamps.

(*bottom*) A young otter civet follows its mother in front of a camera trap in Borneo. Almost nothing is known about the social behavior of this species.

The otter civet is a remarkable carnivore adapted to hunt aquatic prey. They have evolved from the civet family but acquired otter-like traits. Their snout is enlarged at the end with many long whiskers, allowing them to feel their way along streams. Although their behavior has not been well studied, they must be active underwater foragers, as their nostrils and ears can both be closed with flaps. Their wide feet are webbed to aid in their swimming.

Their preferred habitat is lowland primary forests. They have also been recorded from secondary forests, bamboo and logged forests, although the long-term persistence in these less preferred habitats is unknown. There is concern about the conservation of this species because the peat swamps and streamside habitats they require are increasingly being converted to oil palm plantations. Furthermore, even in their best habitat, they are never detected often.

Some biologists wonder whether this low detection rate could also be the result of camera trappers not sampling the right habitats. Scientists often focus their camera surveys on game trails or roads since many species use these to move around at night. However, other species might avoid them, especially specialists like the otter civet, which is more likely to run a river than a road. Additional surveys taking these small-scale factors into account when choosing the exact site to place their traps are needed to confirm just how rare this species is.

Hose's Civet *Diplogale hosei*

CONSERVATION STATUS: Vulnerable

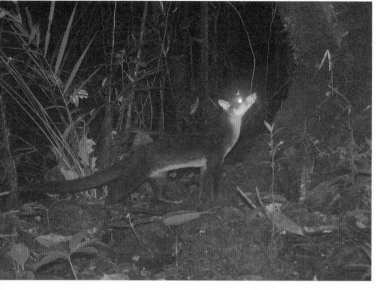

Hose's civets are one of the least studied carnivores in the world.

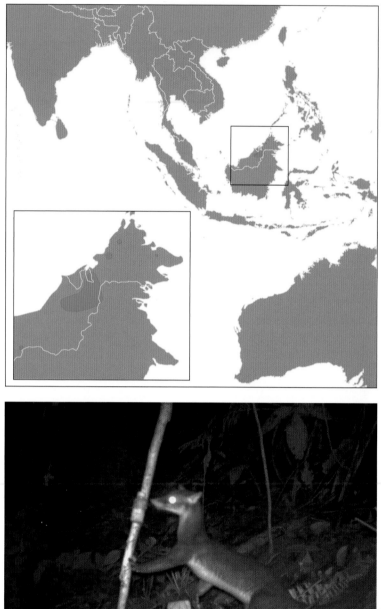

The Hose's civet from Borneo is one of the world's least known carnivores. There are only 17 specimens in the world's museums, and only one animal has been captured alive (and later released). There are no Hose's civets in captivity. They have partially webbed paws, a broad snout, and long whiskers, suggesting that they hunt along wet areas, probably for fish, shrimps, crabs, frogs, and insects. However, their habitat requirements have long been mysterious, with most records in the mountains but a few sightings in the lowlands.

Camera traps can catch Hose's civets, although any single study typically only obtains a handful of records. A group of scientists led by Andrew Jennings recently combined photos from dozens of projects to round up 23 camera

A Hose's civet investigates a scent lure placed on a tree to attract rare carnivores.

Camera traps and museum specimens provided verified locations for Hose's civets, which biologists used to create this predictive map of suitable habitat (green) across Borneo. Comparing this with the known range map suggests new areas where the species might occur but has not yet been documented.

trap records of this secretive animal. Combining these data with museum records, they were finally able to use computerized mapping models to get a better idea of the habitat requirements and likely geographic range of this species.

This study confirmed the mountain-loving nature of this species, with two-thirds of the records coming from above an elevation of 3,000 ft (900 m), and all coming from rainforest habitat. The resulting predictions from this work suggested new areas in the montane regions of Borneo which are likely to be suitable habitat for Hose's civet, but for which we have no records. These are now identified as priority areas for new surveys. More data would not only help test this large-scale model of habitat preference but also identify more fine-scale features, such as streams or swamps, that might be important hunting ground for this secretive, web-footed civet.

Banded Civet *Hemigalus derbyanus*

CONSERVATION STATUS: Vulnerable

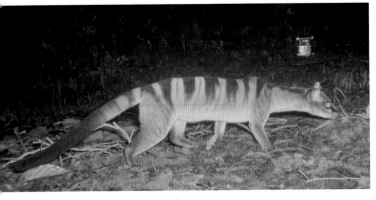

A banded civet from Borneo.

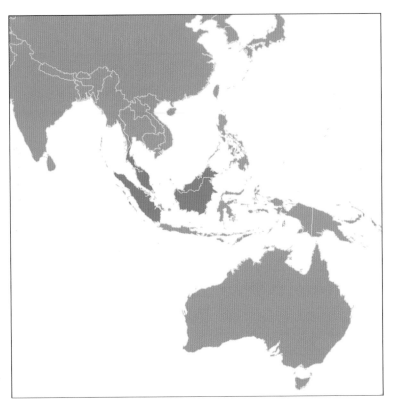

This beautiful striped civet is a swift hunter of small prey from Southeast Asia. Although they are sometimes called a "palm civet," they don't appear to actually eat any fruit. One study found their diet to consist of 65% insects, 22% earthworms, 9% other arthropods (spiders, crabs, millipedes, etc.), 2% mollusks, and 1% amphibians.

Animals in captivity prove to be good climbers, but in the wild they are mostly seen and photographed on the ground. They appear to find most of their food on the ground at night, but they climb to find a place to sleep during the day. Camera traps regularly detect them, and scientists recently collected over 100 of these records to get a better idea of their habitat needs. There were a few records in the mountains; the overall pattern was that banded civets prefer lower-elevation forests.

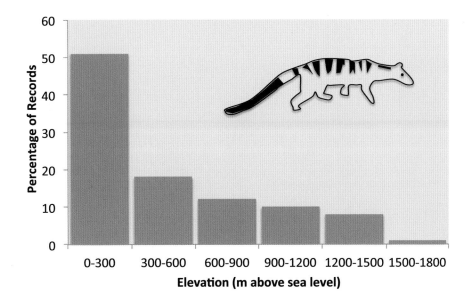

A collection of over 100 camera trap records from multiple studies showed the strong preference of banded civets for lowland forests, their being rarely detected at higher elevations.

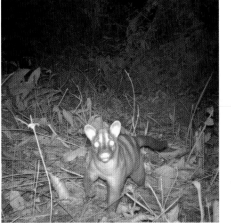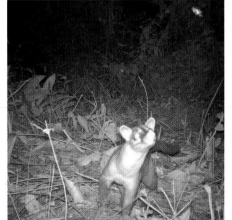

This civet takes its eye off the camera trap to home in on an insect that flies through the frame above. Banded civets are one of the most insectivorous members of the carnivore family.

Wolf *Canis lupus*

CONSERVATION STATUS: Least Concern

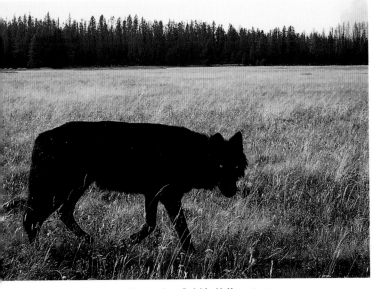

A black wolf patrols a field in Yellowstone National Park, where they were reintroduced by the government in 1995, 69 years after they had been wiped out by government predator control programs. Their populations have recovered and now spread throughout the region. Scientists are using the return of these wolves to study the impact of large predators on herbivores and, in turn, also learning how wolves affect plant communities.

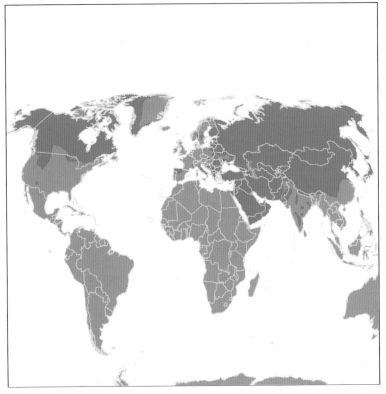

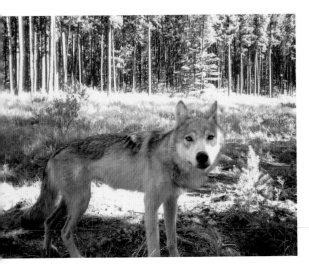

A skinny wolf interrupts its hunt for food to peer into the camera trap.

The wolf was the world's most widely distributed wild mammal. Although its range is now reduced by one-third, they still survive in most remote places across the Northern Hemisphere. Wolves are ungulate hunters, eating moose, caribou, deer, wild boar, and any other hooved animal they can catch, sometimes running into trouble with people when these are domestic stock. They will also snack on smaller prey items, scavenge on carrion, and even eat garbage in some places.

Wolves still survive in our midst because of their ability to avoid humans at the fine scale. Although they can be active any time of day, they become more nocturnal near people. Surveys of large national parks in Canada found that wolves avoid the trails with the most hikers. In Greece, camera traps showed that wolves choose rendezvous sites, places where they meet up to begin a group hunt, by their distance from people.

Unfortunately, the avoidance is not perfect, and wolves are sometimes attracted to our livestock. This often leads to retaliatory killing by people, through poisoning, trapping, or active hunts. Although rare, wolves are also known to attack people. This has been much more of a problem in the Old World than in the Americas, where there are only a handful of documented wolf attacks on people.

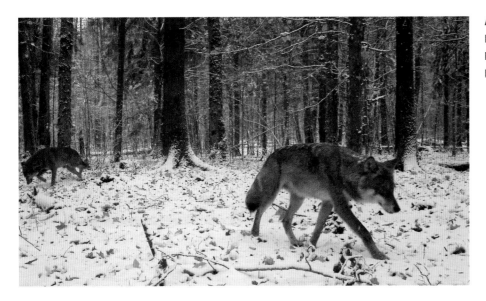

A pair of wolves hunt Białowieża Forest in Poland. Wolf density tracks that of their prey, being highest in areas with abundant wild hooved animals.

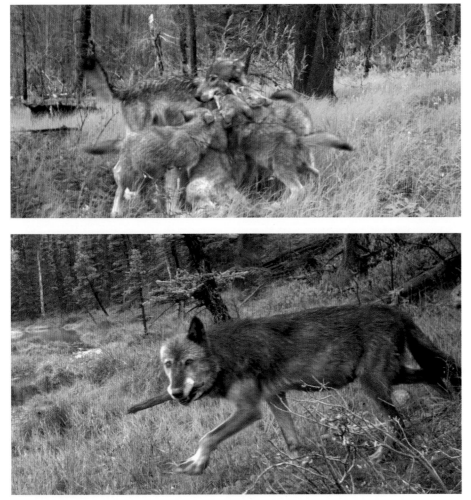

(*top*) When it returns to a den, an adult pack member receives an excited greeting from hungry pups looking for a regurgitated meal.

(*bottom*) This enthusiastic young adult didn't want to return to the den empty-handed, so it carries a stick in its mouth.

PACK LIFE

The wolf pack is one of the most famous animal social structures. The pack is an extended family group, typically led by an alpha male and female and including various offspring from previous years. Packs of 5 to 12 animals are typical, but they can range up to 36. Pack members spend much of their time hunting alone or in small groups in the summer, but they come together into larger groups for cooperative hunting of larger prey in the winter. Howls serve to reunite pack members and also to advertise the strength of a pack to neighboring wolves. Wolves are highly territorial, and howling typically works to keep separate packs apart. If packs do battle, wolves will kill each other for control of hunting grounds. Finally, pack members help feed the young pups at the den.

Helping to raise the pups might be the single most important function of the pack. When pups are very young, adults will "wolf down" food at a kill and then return to the den to regurgitate food for the

pups. As the pups grow, adults start to bring small prey for the pups to practice their killing skills. Pack members will also bring food to the pregnant or lactating alpha female and even babysit to give her a chance to go out and catch her own food. Wolves are also known to participate in one of the most extreme examples of helping at the den—allonursing, where females lactate to feed young pups that are not their own. Through life and death, the bonds of the wolf pack run deep.

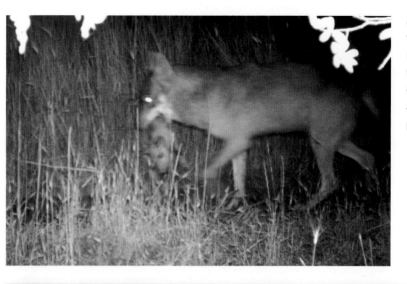
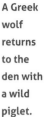

A Greek wolf returns to the den with a wild piglet.

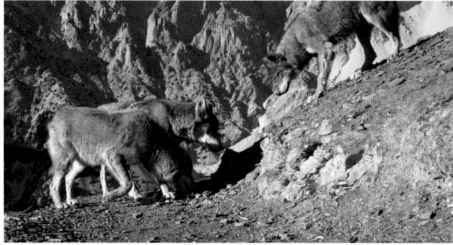

Three wolves reunite in the mountains of Pakistan, where biologist Jaffar Ud Din found them to be the third most common wild canid captured by his camera traps, after red foxes and golden jackals. Local pastoralist communities are concerned about wolf predation of their livestock, and most seek to reduce or eliminate wolves from the area. To survive here wolves will need to hide out and keep a low profile in these remote mountains.

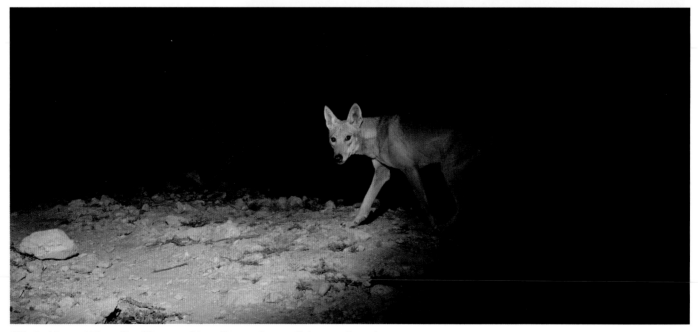

This Arabian wolf from Hawf Protected Area, Yemen, is a small desert-adapted subspecies that hunts wild goats, gazelles, and hares.

Coyote *Canis latrans*

CONSERVATION STATUS: Least Concern

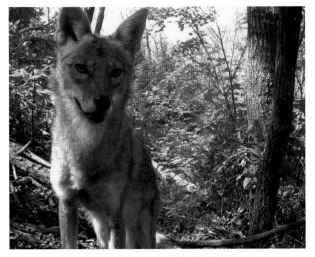

A coyote peers into the camera trap in South Mountains Game Lands, North Carolina.

A female is overrun by pups thirsty for milk. An average litter size is six, but it can be as high as 10 in areas with abundant food.

By some accounts, coyotes are the most intelligent, perceptive, and adaptable carnivores in North America. From their origins in the American open prairies and dry lands, coyotes have now spread over nearly the entire continent, including the great eastern deciduous forests and Central American rainforests. In some areas, they have also moved into towns, making a living off locally abundant rodents and deer, but also terrorizing domestic cats. Camera trap studies have found quite a bit of variability in how urbanized coyotes are across the country, being common in some cities (e.g., Los Angeles, Chicago) but rare in others (e.g., Fort Collins, Raleigh).

Coyotes are monogamous, breed once a year, and form small packs that help at the den but rarely cooperatively hunt together. If food is abundant, coyote populations can increase quickly. They also are great dispersers, with young animals trekking hundreds of miles in search of a vacant territory where they can start up their own family. This combination of traits—rapid reproduction and long-distance dispersal—has helped them colonize the continent, while also vexing human hunters who try to reduce local coyote populations, only to have them bounce back the next year.

Coyotes have one of the most sensitive senses of smell in the animal kingdom. This has evolved to help them sniff out their main

foods, a mixed diet of rodents, rabbits, insects, and fruit. Their keen senses also help them avoid hunters, trappers, and even camera traps strapped to trees. Coyotes are one of the species most likely to notice and stare right at the camera. Suspicious coyotes turn and run away, nervous that the human smell on the camera might mean that a trap or hunter is nearby. In some areas, coyotes have been shown to systematically avoid cameras on trails. Another study showed that the likelihood of capturing a photo of a coyote at a baited camera trap was not related to the local density of coyotes. This suggests that the local coyotes all notice the smell of the bait, but only the most curious—or hungry—animals walk close enough to trigger the camera.

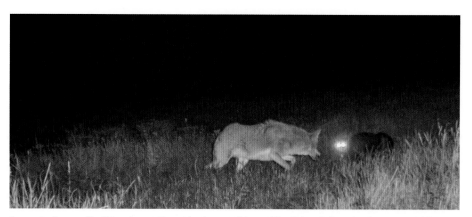

A coyote faces off with a domestic cat in the outskirts of Boulder, Colorado. Coyotes are the most likely predator to kill free-ranging cats in North America, although a large, tough cat might put up enough of a fight to keep a coyote at bay.

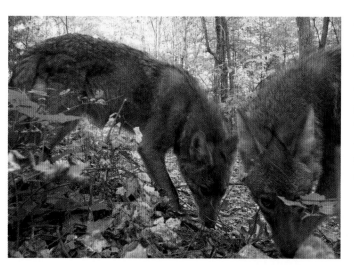

A pair of coyotes have their noses to the ground as they peer up to a camera trap. Their amazing sense of smell helps them find prey and also notice research equipment better than most species.

An exuberant coyote is in hot pursuit of a young deer in this montage photograph. The camera trap actually photographed the two animals in separate images five seconds apart. Deer typically make up roughly one-third of the diet of Eastern coyotes, and much of this comes from predation on fawns.

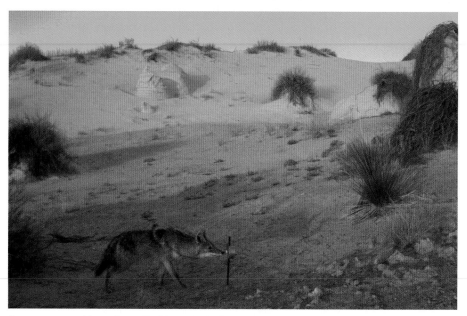

Coyotes use a wide variety of habitats, including deserts. This one is sniffing a scent lure on a post at White Sands National Monument, New Mexico.

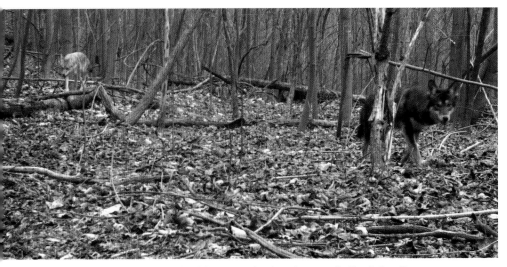

A darkly colored coyote hunts with a normal-colored partner in North Carolina. Eastern coyotes have hybridized with dogs and wolves, so that all eastern animals have a mix of genes from three species. The animal on the right appears to have some German Shepherd–like genes, giving him a dark coat that does not blend into the background as well as his wild-type pack mate.

CANIS SOUPUS

Genetic research has shown that coyotes expanding into the forests of eastern North America got a bit of help from wolves and dogs. All Eastern coyotes are hybrids, consisting mostly of coyote genes, but with a smattering of wolf and dog genes mixed in. The wolf genes are thought to have helped coyotes rapidly evolve a larger body size, including extra wide skulls. These traits undoubtedly help Eastern coyotes hunt deer, which typically make up about one-third of their diet in the East but are a rare prey item in the West. This genetic "Canis soupus" also results in some Eastern coyotes showing a variety of colors, including black, very pale, and reddish animals, presumably resulting from some combination of dog genes. What other unique traits Eastern coyotes inherited from this genetic mix-up remain to be discovered. The push of coyotes south into the ranchland and rainforests of Central America may also have interesting genetic underpinnings, although no studies have been conducted on this subject.

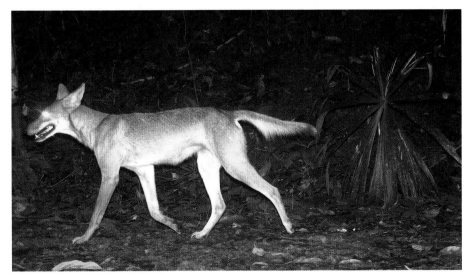

A coyote walks a trail through the rainforest in Soberania National Park, Panama. Coyotes used to live no farther south than the deserts of Mexico but have now expanded as far as the Panama Canal. These Central American coyotes look different from other populations but have not been studied to see whether hybridization with dogs or wolves aided their colonization. Camera trap photos such as this show that they not only hunt in farmland but also occasionally in rainforests.

A large Eastern coyote is surprised by the flash of a camera trap in the Adirondack Mountains of New York. Coyotes from the Great Lakes region that hybridized with wolves rapidly evolved a larger body size and then colonized eastern North America faster than those without wolf genes.

Dingo *Canis familiaris dingo*

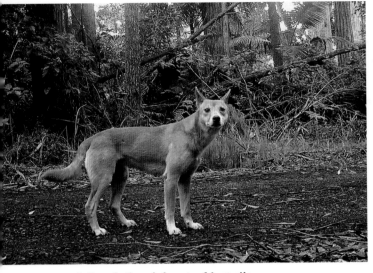

A dingo in the rainforests of Australia.

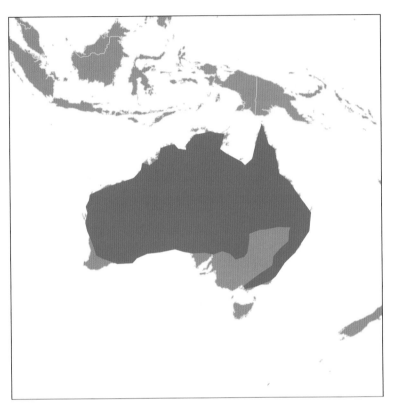

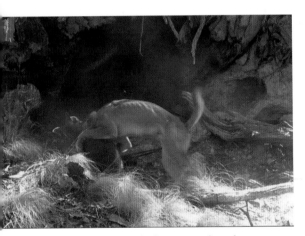

Dingoes are the largest predator in Australia and specialize in killing small and medium-sized animals. This camera trap caught a dingo killing a wallaby.

Dingoes are a breed of domestic dogs that have gone feral across the Australian rainforests and outback. They arrived ~5,000 years ago to the continent, presumably in the boat of some colonizing humans, and probably found the naive prey to be easy pickings. Since leaving humans behind, they have established permanent populations across the island and evolved into their own unique type of wild dog. They hunt a variety of bird and mammal prey, including livestock, and stir up a good deal of controversy.

Many Australians are against the dingo, because (1) they consider it a risk to their children, (2) it kills their sheep, or (3) they consider it an invasive species causing trouble for Australia's unique native fauna. Efforts to reduce the dingo population include eradication campaigns that employ trapping, poisoning, and the world's longest fence, stretching 3,488 mi (5,614 km), with the aim of excluding them from southwest Australia.

The pro-dingo camp, on the other hand, considers them an important part of Australian ecology, perhaps playing the predatory roles previously held by the now-extinct thylacine (aka Tasmanian tiger). They suggest that dingoes reduce the local populations of other, more problematic invasive

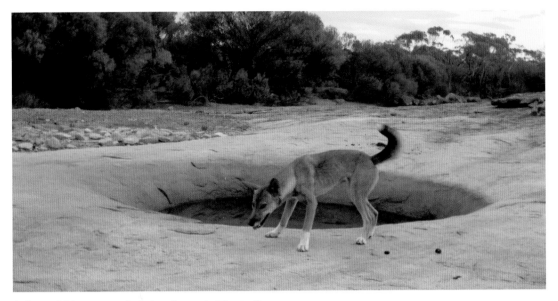

A dingo visiting a water hole in a dry part of Australia.

carnivores, such as the domestic cat and the red fox, and thus actually improve the situation for native prey species.

Most past research on these questions has used counts of tracks in the sand to determine the abundances of dingoes, foxes, and cats in an area. However, these measures have since been shown to be unreliable, and a new round of research is using more robust methods, including camera traps. One camera study found that dingoes did not exclude domestic cats from a natural area but did force them to change their daily activity pattern to avoid running into the abundant dingoes. Surely we will see more research in the coming years on this important question, with the fate of the dingo as a hero or villain hanging in the balance.

Dhole *Cuon alpinus*

CONSERVATION STATUS: Endangered

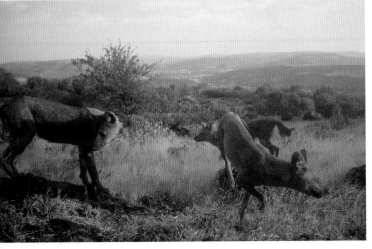

A pack of dholes reconnoiter in the Western Ghats of India.

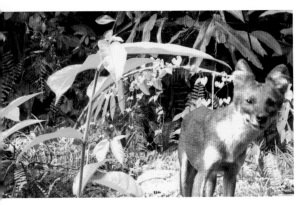

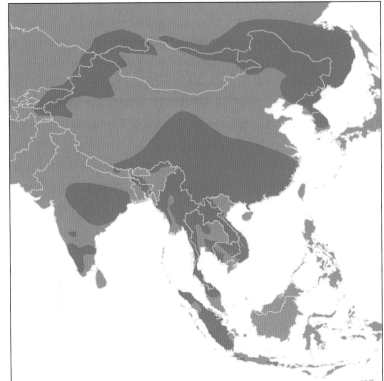

Dholes are always rusty brown on their back but have variable amounts of white on their throat and belly. They are highly social animals, typically living in packs of a dozen animals, although groups of 40 are known.

The dhole is a social, pack-hunting canid that can be found in many parts of Asia. They do not survive in deserts or high elevations, but they live in most other habitats that can sustain good populations of large ungulates, their main prey. The reduction of their hooved prey is a chief conservation concern, and one that is becoming more and more dire, with less than 2,500 dholes estimated to remain, scattered across their large range.

Unlike many other large carnivores, dholes do not typically cause conflict by attacking livestock and are not targeted for illegal trade of body parts. In fact, camera trap studies have found that dholes avoid livestock, preferring areas with higher densities of deer such as chital and sambar, their main prey in India. Studies in Thailand also documented a decline in dholes after poaching reduced local native prey populations. Thus, humans may not directly target dholes, but their hunting of other species and disturbance of the habitat through livestock grazing can drive dholes out of an area.

Dholes also have to watch out for tigers. In parks with healthy tiger populations, the big cat will monopolize the best hunting grounds for large prey, forcing dhole packs to hunt in the prey-poor zones where tigers are scarce. One study by Arjun Srivathsa in India also found that dholes are not strictly confined to protected wildlife reserves as was generally perceived, which may also be related to their avoidance of the tiger populations that are thriving inside preserves.

Red Fox *Vulpes vulpes*

CONSERVATION STATUS: Least Concern

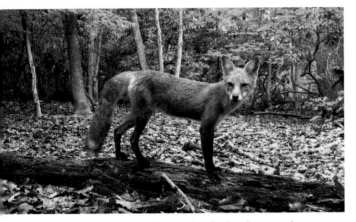

A red fox appears to pose on a log for its photograph in Rock Creek Park, Washington, DC.

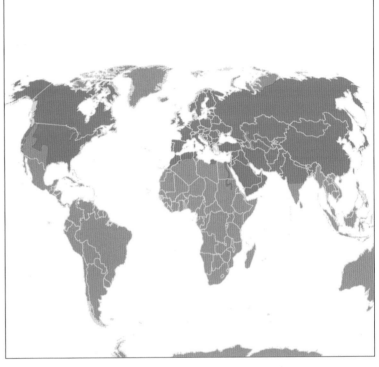

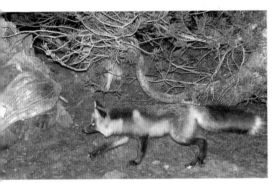

The red foxes of the Sierra Nevada Mountains in California are genetically distinct from lowland populations in the rest of North America, often having the "cross fox" coloration shown by this animal. They are one of the rarest and most elusive mammals in California, and camera traps have been essential for locating the few remaining populations. Why this subspecies is so endangered while other red foxes thrive remains a mystery.

Red foxes thrive in a wide variety of habitats and situations around the world, where they also endear the full spectrum of attitudes from local people. Recorded from deserts and grasslands, forests and tundra, they live in remote mountaintops and in central London.

They can hunt prey up to the size of a large rabbit, but they are more likely to feed on mice or insects.

These beautiful foxes are loved in much of their native range. They are frequently seen in many urban areas, especially residential suburbs with lower housing densities, and are drawn in even closer to houses by people who feed foxes. In some parts of the United Kingdom local foxes get a majority of their food from people. These animals make their nightly rounds moving from garden to garden to pick up whatever donations they can. This routine is important to people as well, giving them a charismatic ambassador of the wild to connect with in their otherwise urban existence.

Red foxes are hated in parts of the world where they are an invasive species, such as Australia, New Zealand, and Tasmania. Introduced in the 1830s to control rabbits (which were also introduced), they have spread over large areas of these islands and have contributed to the decline and extinction of dozens of native birds and mammals. The small native island species evolved for millions of years without being exposed to a carnivore like the red fox, and many have poor predator-avoiding habits, making them easy prey. Fox eradication campaigns, including poisoning, are sometimes seen as the only hope for native species survival.

Often fed by British animal lovers, red foxes are regular visitors to urban gardens in the United Kingdom.

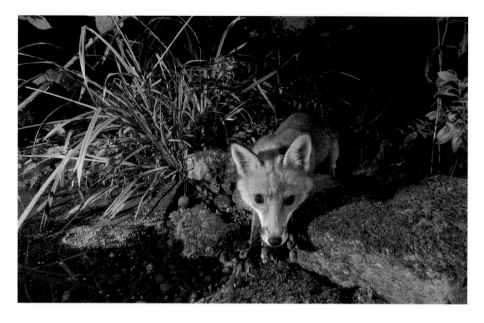

(*below*) An invasive red fox attacks a native echidna in Australia. Foxes were introduced to control rabbits, but they do real damage to populations of native species. In this sequence the echidna tries to hide in a rock crevice but is flipped over by the fox, which bites the echidna's underbelly and carries him away. Active management is aimed at reducing the fox population to give local native wildlife a break. Long-term survival will probably require native wildlife to adapt and evolve behaviors to thwart the fox.

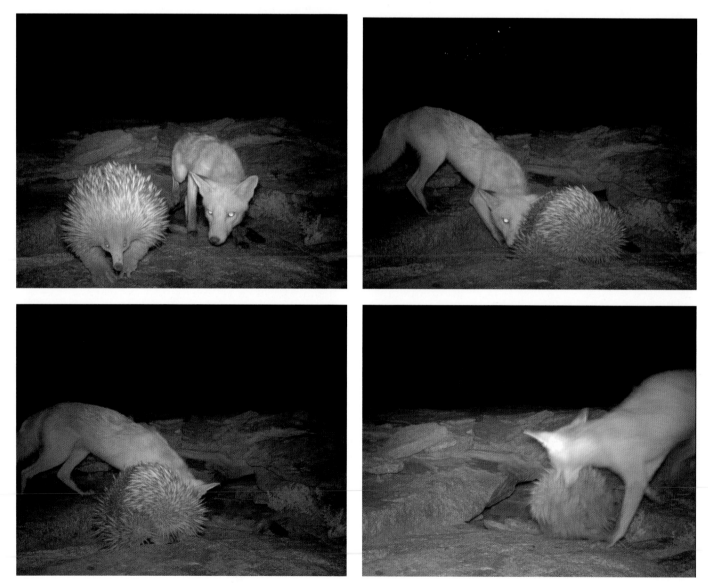

Bush Dog *Speothos venaticus*

CONSERVATION STATUS: Near Threatened

A Brazilian bush dog shows off its stocky build.

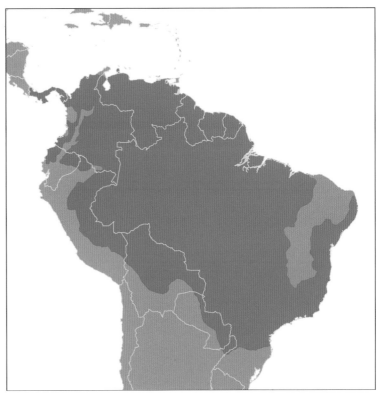

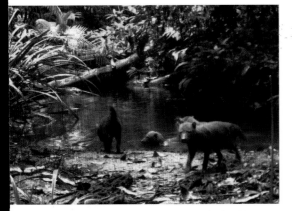
A pack of bush dogs enjoy a swim in this rainforest river in French Guiana.

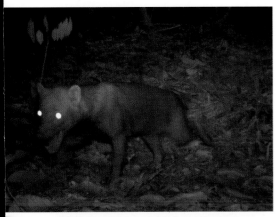
A bush dog sings out in the night. Bush dogs in captivity have been recorded making 10 distinct vocalizations, including whines, short screams, and long screams.

The bush dog is one of the most mysterious and poorly known canid species in the world. It is widespread across the forests and savannas of South America, but it is always rare and hard to locate. There are so few camera trap photos of bush dogs that some think that they must be noticing and avoiding the cameras. Alternatively, they might be avoiding the roads and trails usually used to set camera traps.

From scattered sightings and photographs we know that bush dogs hunt in packs of up to 12 animals, making them the most gregarious South American canid. These probably comprise a monogamous pair and their extended family. They seem to hunt mostly medium-sized mammals such as agoutis, pacas, and armadillos. The short legs of the bush dogs might help them pursue prey into holes, where they would be safe from any larger predator. Packs will hunt cooperatively, with some animals guarding escape routes while others dive into burrows, or working together to chase prey into deep water. Packs have even been recorded attacking deer, relentlessly biting their legs until the animal tires and falls down.

Short-eared Dog *Atelocynus microtis*

CONSERVATION STATUS: Near Threatened

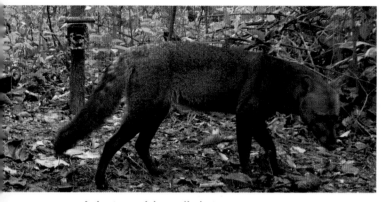

A short-eared dog walks between a pair of camera traps in Bolivia.

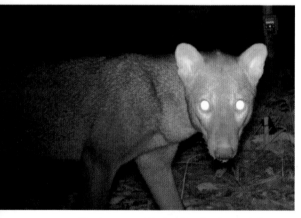

The long snout helps the short-eared dog sniff out fallen fruit to supplement its hunting and fishing.

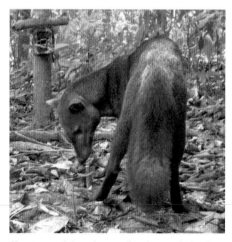

Short-eared dogs have a flamboyantly bushy tail, in contrast with the short fur on the rest of their body.

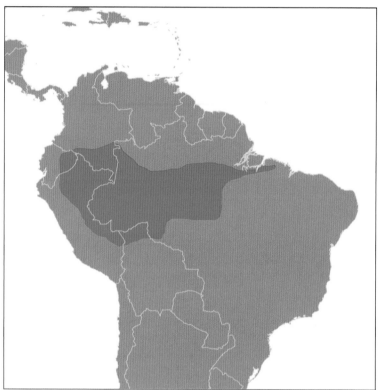

Early scientists in the Amazon basin reported short-eared dogs as common, but sometime around the 1970s they seemed to disappear. Anecdotal reports suggest that they might be making a bit of a comeback in recent years. The cause of their historic decline remains unknown, although disease spread from domestic dogs is a likely candidate.

Camera traps are providing important new data about their distribution and abundance. Short-eared dogs are forest animals, living primarily in lowland rainforests of the Amazon basin. They seem to avoid developed areas, although one study found that they could survive in the larger forest fragments on the agricultural frontier of Southern Amazonia, in the Mato Grosso state of Brazil. Another study found them to be most common in open forests with abundant Brazil nut trees. It was unclear whether they were eating the fruit themselves or the smaller seed eaters attracted to the trees.

Short-eared dogs are relatively omnivorous, eating fruit in addition to small prey. Some studies report a large amount of fish in their diet, which would be unusual for a canid. There are also numerous visual reports of them walking along riverbanks and even swimming in the water, giving additional credit to the fish-loving hypothesis.

Black Bear *Ursus americanus*

CONSERVATION STATUS: Least Concern

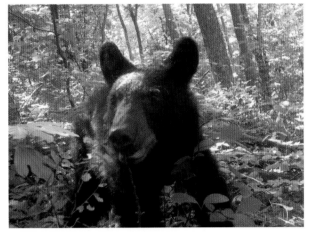

This black bear, photographed in Virginia, is alert, with its ears perked up.

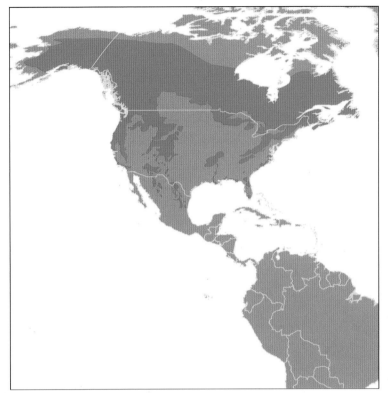

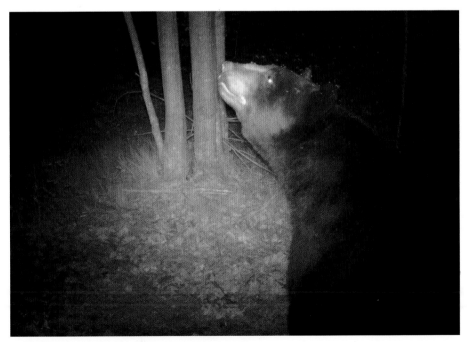

A large bear is harassed by mosquitos in Wisconsin.

Black bears are the most common bear in the world, estimated at almost 1 million across Canada, the United States, and northern Mexico. There are at least two times more black bears than all the other bears in the world combined. Black bears live in temperate forests of America, stretching south into subtropical forests of Florida and Mexico and north into the subarctic. Human hunters legally take about 50,000 black bears annually, and state agencies manage for population growth, which seems to be successful in most areas. Although some bear populations have adapted to humans, most animals prefer to avoid people. For example, one camera trap study by Adam Switalski showed that clos-

ing roads in remote areas helped the local bears.

Black bears are omnivorous, eating mostly vegetation in the early spring, dining on fruits and nuts in the fall, and getting protein from insects and larger prey whenever they can. They are also attracted to human-related food, causing havoc to bird feeders and unsecured garbage cans in many areas. Black bears are mostly diurnal but will increase their nocturnal feeding when fattening up for hibernation in the fall, or when feeding near people. Northern bears can't find food in the winter, so they hibernate for three to seven months. Some southern bears stay active year-round.

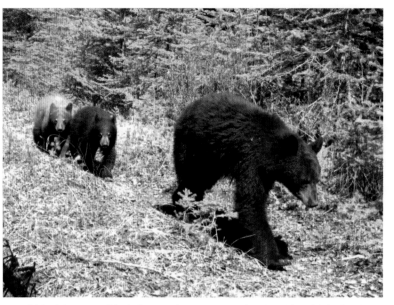

Not all black bears are black; here a cinnamon morph cub walks with its black litter mate in Kootenay National Park, Canada. Blond and white (aka blue) bears are also regularly seen in other parts of their range.

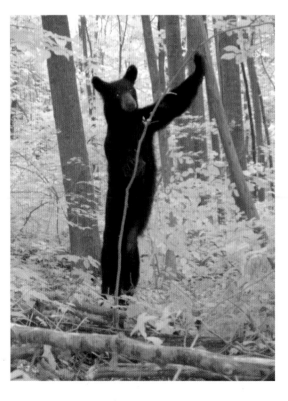

A young bear uses a sapling to keep its balance as it stands on two legs to get a better look around.

Brown Bear *Ursus arctos*

CONSERVATION STATUS: Least Concern

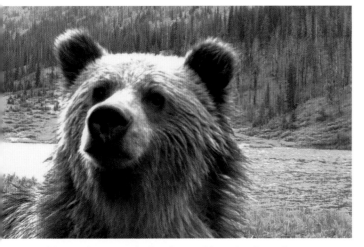

A brown bear pops its head up and into the view of a camera trap in Banff National Park, Canada.

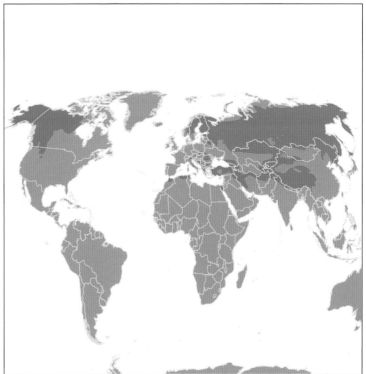

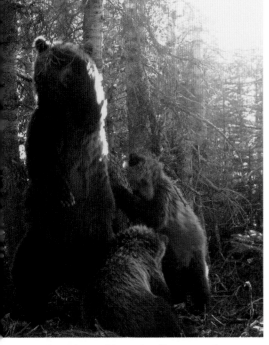

A mother and her cubs all scent mark on a "rub tree" as the sun sets in Alberta. Scientists use photos like this to track the breeding success of a population.

Brown bears are a wide-ranging, large omnivore that can live in a variety of forest and grassland areas. Vegetation forms the base of their diet, but this is always supplemented with protein they dig up, chase down, or catch in streams. The famous salmon-fishing bears from the Pacific coasts of North America and Russia are well fed and include some of the largest bears in the world. In arctic and alpine areas these bears dig rodents out of the ground and hunt hooved animals, especially during fawn season. Many European bears scrounge insects out of the ground, surprisingly finding enough to feed their giant ursine appetite.

Brown bears typically have two or three cubs in a litter but can have up to five. These youngsters stay with mom until she breeds again, usually two or three years, but sometimes up to seven years. These numbers are important—litter size, cub survival, and inter-birth interval are the most important factors determining whether a population is growing or shrinking. Camera traps often catch these bear families walking together, and scientists led by Jason Fisher found that these important breeding females had very specific habitat preferences within the Canadian Rocky Mountains. The mother grizzlies photographed with cubs were most common in an elevational strip of herbaceous vegetation that rings the mountains, but they avoided the more common low-elevation wetlands and mid-elevation conifer forests. Although

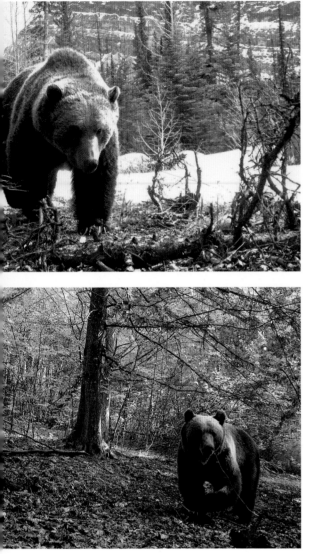

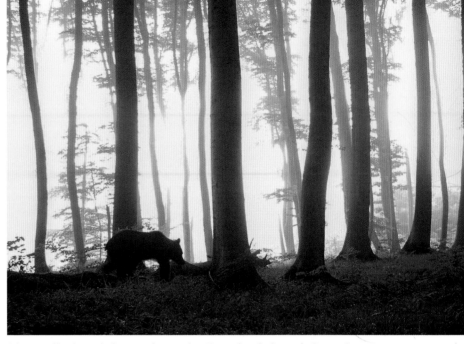

A bear walks through the morning sun in a Transylvania forest in Romania. Humans and bears coexist relatively peacefully here; people respect the bears and tolerate occasional conflicts.

(*top*) A large grizzled phase brown bear, aka grizzly bear, walks a trail in the Rocky Mountains of Canada.

(*bottom*) A European brown bear looks for food while walking down a trail. Alert for fawns that would be easy pickings, these bears are also good at finding underground ant nests that they can dig up for a meal.

this bear population is doing well now, there is some concern for the future, since these small and scattered herbaceous areas are predicted to shrink as tree lines advance up the mountains with future climate warming.

BEARS AND EUROPEANS

Europe is our planet's most densely settled continent and would seem to be the last place one would expect to find any large carnivore, let alone the big brown bear. Indeed, all carnivores were nearly driven out of the continent 100 years ago. But people and the animals are adapting to each other. Now lynx, wolves, and even brown bears are reclaiming their old hunting grounds in Europe.

The forests of Russia have long been strongholds for bears, and bears in other Eastern European countries have a long history of

coexisting with people. However, the big ursids living in the Alps and Pyrenees barely made it out of the previous century, with a handful of animals surviving in remote refuges. Fortunately, improved protection has allowed their numbers to recover, and they are now also expanding their range. If bears are to survive in central Europe, the new generations of carnivores and humans will both have to learn how to coexist. A carefree hike through the Alps is a completely different out-of-doors experience when bears are in the area, and hikers need to be more watchful. Likewise, farmers need to take additional measures to dissuade them from pursuing livestock or raiding beehives. Hopefully the bears will also do their part and stick to a diet of wild foods, which would be better for their health, in more ways than one.

Giant Panda *Ailuropoda melanoleuca*

CONSERVATION STATUS: Endangered

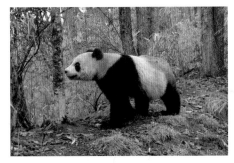

A giant panda walks a trail along a ridge in the mountains of south-central China.

A panda walking through the snow shows that they do not hibernate like some other bear species. Specializing on bamboo means that their main food is available year-round.

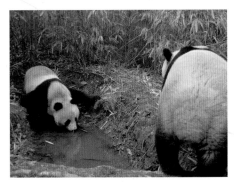

A pair of pandas stop for a drink in a bamboo thicket. Bamboo makes up 99% of this bear's diet, and they enjoy over 60 different species of it in these diverse mountains. Pandas are usually solitary, although pairs may hang out together for weeks prior to mating.

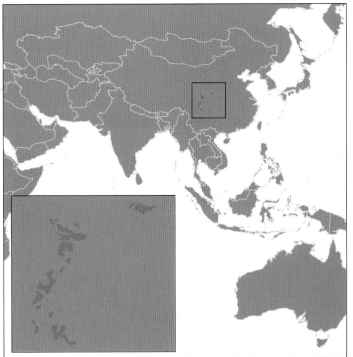

Giant pandas are one of the cutest mammals in the world, and this might have saved them from extinction. The species was disappearing quickly as its mountainous habitat was being turned into farmland and hunters penetrated their remaining hiding places. Fortunately, scientists and conservationists raised the alarm in time, and the charisma of this beautiful animal helped get the attention of the public and authorities. The Chinese rushed to save this unique species that lives nowhere else.

Harsh penalties and increased ranger patrols eliminated the poaching threat, while habitat improvements and protections shored up their forests and bamboo thickets in the isolated mountain ranges of south-central China. Scientists led by Xuehua Liu estimate that there are now about 2,000 pandas in total surviving across 60 panda reserves, with no single population having more than 250 animals.

With the panda's skid toward extinction apparently halted, conservationists are now looking for sustainable solutions for their long-term survival. Camera traps are important tools for monitoring their populations within the panda reserves. Conservationists are also starting to map the habitat linkages needed to connect the network of reserves to ensure that animals can move between them to maintain healthy gene flow and prevent any single population from becoming too inbred. Camera traps will also be useful to monitor their use of these areas and hopefully will continue to capture cute photos of these animals long into the future.

Spectacled Bear *Tremarctos ornatus*

CONSERVATION STATUS: Vulnerable

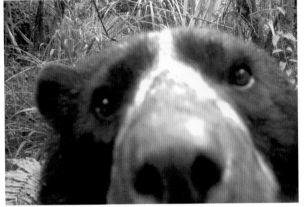

A spectacled bear gives the camera trap a sniff, showing the white markings on his face.

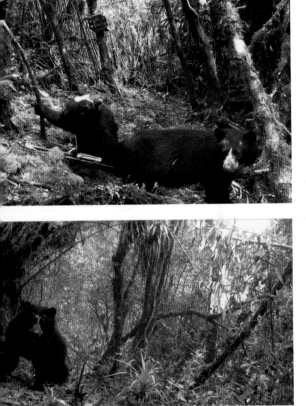

(*top*) A spectacled bear cub plays around while foraging in the forest with its mom.

(*bottom*) Spectacled bears are most common in high-elevation cloud forests like this one in Ecuador. They are also known to reside in humid grasslands and, surprisingly, dry forest scrub in north coastal Peru.

The spectacled bear from the Andes Mountains is the only bear in South America and one of the least studied bears in the world. Like most bears, they are thought to be omnivorous, eating mostly plants and fruits, but also taking meat when they can. Spectacled bears are also worrisome crop raiders, especially maize. Thus, the development of roads and advance of agriculture into the Andes are a double threat to bears because this diminishes their natural habitat and also provides the lure of maize. Crop-raiding bears are often killed by farmers protecting their crops.

Spectacled bears are actually quite shy, and few people have seen them. This elusiveness, combined with the steepness of their mountain homes, has made them very difficult to study. We know little about their present distribution and status, making it difficult to plan for the conservation of this species or monitor changes in their population size.

Scientists are just starting to deploy camera traps in spectacled bear range, and they show great promise because many animals can be identified as individuals based on the unique patterning on their head and neck. The next step will be expanding this bear-counting exercise into a region-wide population assessment, linking regional conservation parks and nature tourism areas to help the spectacled bear and other wildlife survive in healthy forests.

Sun Bear *Helarctos malayanus*

CONSERVATION STATUS: Vulnerable

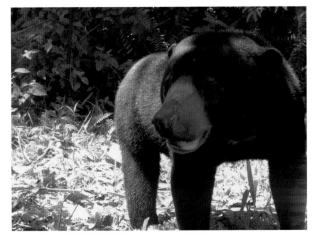

A sun bear in Malaysia enjoys a ray of sunshine.

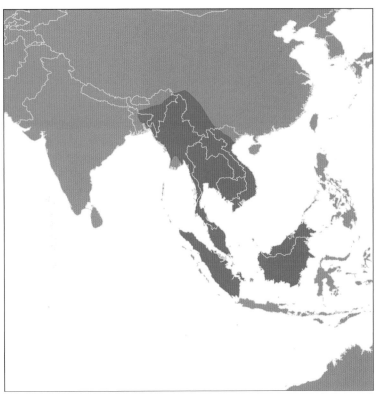

The sun bear eats a lot of insects, including termites and ants. They are also crazy for bee nests, where they get to eat both the sweet honey and the protein-rich larvae. Sun bears also eat a variety of fruit and are especially fond of figs. When not roaming the forest, their favorite sleeping sites are fallen hollow logs, but they'll also nap in hollow trees, small caves under tree roots, or even tree branches high above the ground.

Sun bears need forests. One recent study analyzed the types of habitats where bears are most photographed by camera traps and found that the highest-quality forests are those with cooler dry seasons. Mapping these areas in Malaysia showed that most (~80%) of these areas were not currently protected by parks, placing the bears at risk to logging and hunting.

Although clear-cut areas are useless to sun bears, surveys show that they will use forests that are selectively logged, those with some trees cut down but others allowed to stand. One study showed that bears were actually widespread in a logged forest, in that they were detected by many different cameras. However, these disturbed forests are lower-quality habitats, in that the overall activity rate was lower, with fewer photos of bears on each camera placed in logged forests in comparison with those placed in undisturbed forests.

Environmentalists are trying to convince logging companies to ad-just their practices to leave some fruiting trees for bears to feed on and some big hollow trees for them to sleep in, to help the bears persist in these modified forests. In fact, their presence could help the forest regrow, as they are important seed dispersers for trees. The bear's digestive track is gentle on the seeds of the fruits it eats, leaving them ready to germinate when they come out the other end in a pile of bear feces. Forests without bears stagnate over time. One study found that the diversity of fruiting trees in a forest with no bears declines after a few decades, and that new seedlings grow only in clumps around their mother trees, unable to escape her shadow.

Even in high-quality forests,

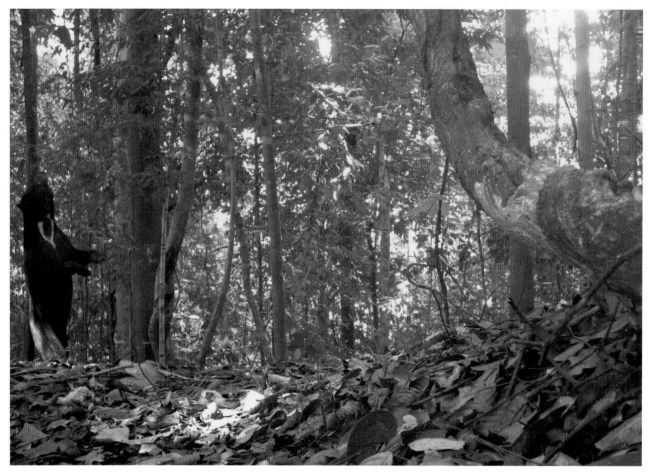

Like all ursids, sun bears use trees as scent posts, where they leave chemical messages in the form of scent marks. These trees also make good back scratchers, as this bear shows.

sun bears can face a serious threat from poachers wanting to sell bear body parts on Asian black markets. This commercial hunting has eradicated them from parts of their range and threatens them in other areas. Fortunately, bears may be learning how to avoid hunters. For example, a survey of 15 protected areas in Myanmar found that poachers had eliminated the tigers from all three of these parks, whereas sun bears were still encountered relatively frequently in 13 of these areas.

Hopefully, conservationists, loggers, and park rangers can work together to maintain healthy forests with plenty of bears eating fruit, sleeping in hollow trees, and defecating seeds far and wide.

Wolverine *Gulo gulo*

CONSERVATION STATUS: Least Concern

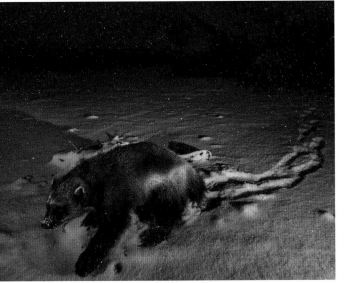

A wolverine triggers a camera trap as it crosses under the cold, dark Yukon sky.

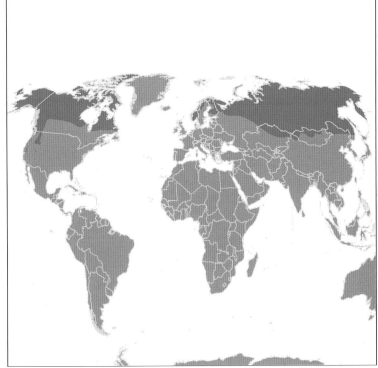

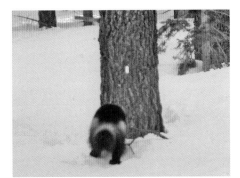

In 2008 camera traps set by Katie Moriarty documented the first wolverine to visit California after an absence of 86 years.

Wolverines are wide-ranging hunters and scavengers of remote tundra and mountains in the Northern Hemisphere. They regularly move over 18 mi (30 km) in one day and cover an enormous home range looking for food over the course of a year. They are always rare, making them one of the most difficult animals in the world to study. Baited camera traps have been critical to mapping out the distribution of wolverines and help us understand where this fierce species lives and what types of habitats it requires.

Being scavengers, wolverines are attracted to hunks of meat that camera trappers use as bait. Each wolverine has a unique splotch of yellow color on their neck, and biologists realized that they could use these to identify and count individual animals, but only if they could get a good photograph of their throat. After working with an animal in a zoo, Audrey Magoun figured out exactly how to set the camera and bait to get the shot they needed—by hanging a piece of meat over an angled wooden pole to get the animal looking up just as it entered the frame of the camera.

One important thing scientists have discovered is that a deep spring snow pack is critical for wolverines to survive in an area. Females make a den in snow to have their young, so areas without abundant snow provide fewer options to pregnant females. Most

wolverines live in very remote areas, and scientists are also using camera traps to evaluate their sensitivity to human disturbances on the landscape, including oil prospecting, snowmobiles, and other mountain recreation.

A positive side to the wolverine's incredible ability to cover huge distances is that they have the potential to recolonize distant areas, as recently happened in California. Wolverines were prized for their fur, and by 1922 trappers had wiped out all of them from the mountains of California. In the early 2000s hikers reported seeing wolverines in the Cascade Mountains, but scientists weren't able to verify this until a camera trapping team captured photos of one in 2008. They also obtained a hair sample, and subsequent DNA tests showed that this was a male that had immigrated from the western edge of the Rocky Mountains. Buddy, as the press named him, hung around and visited baited camera traps for at least five years, but he apparently never found a female with which he could start a new family in California.

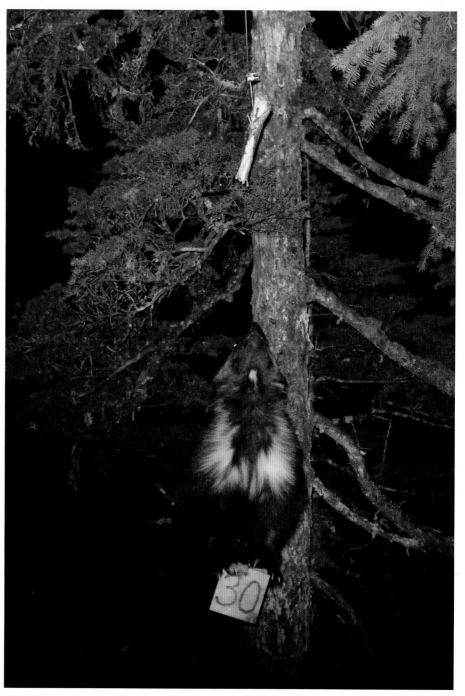

This wolverine gives a perfect view of its unique yellow throat patch as it reaches for a bone left hanging in a tree by a scientist.

Fisher *Pekania pennanti*

CONSERVATION STATUS: Least Concern

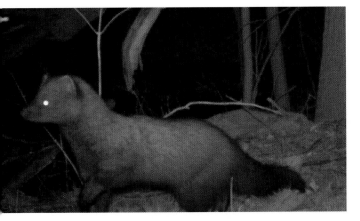

A fisher pauses to consider its route through the suburban woodlots of Albany, New York.

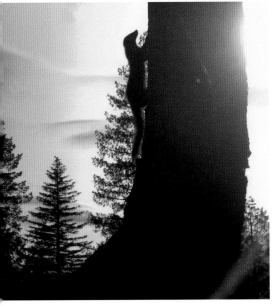

A fisher climbs a big tree in the Sierra Nevada Mountains in California, where they have recently been reintroduced.

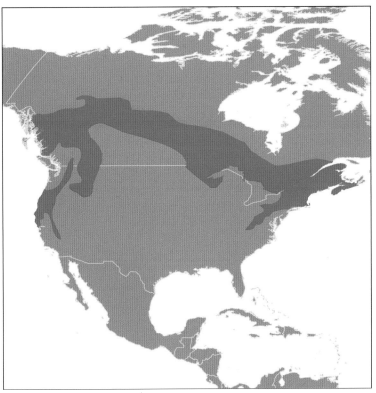

The tree-climbing fisher is as comfortable in the forest canopy as it is on the ground, but it seems to prefer eastern forests to western ones. In the eastern United States, fisher populations are expanding, while conservationists are concerned for the fate of western fishers. Unregulated trapping, combined with extensive forest destruction, drove fishers to historic lows in the late 1800s on both coasts. Trapping bans in the early 1900s stopped their slide toward extinction. Since then, camera traps and other survey techniques have shown that West Coast fishers have stabilized but not expanded the way that their eastern cousins have.

In eastern American forests fisher populations are booming, and they are rapidly reclaiming their old hunting grounds. Some of this expansion has been due to translocations by state game agencies, but some is just the fishers taking advantage of abundant prey. Fishers are generalist predators on small and medium-sized birds and mammals. They are famous for being one of the few predators willing to tackle a porcupine, but they might be even more important for their predation of squirrels and rabbits. Fishers can pursue both of these prey right into their hiding places, be they high up a tree or down into a briar patch.

Fishers seem to have followed these prey into suburbia. For most

squirrels and rabbits, backyards and small woodlots had been predator-free havens for decades, leading to high populations, often supplemented with bird food. Fishers recently colonized these same areas, exploiting the overabundant small prey.

Camera trap studies led by Scott LaPoint revealed that fishers are using small drainage culverts to cross under roads and avoid cars. Although small urban forests are not large enough to support a breeding fisher, tracking and camera studies have shown that animals use narrow movement corridors to move between hunting grounds separated by neighborhoods. Through culverts and corridors, fishers have been able to link multiple small forest fragments into one big squirrel- and rabbit-hunting heaven.

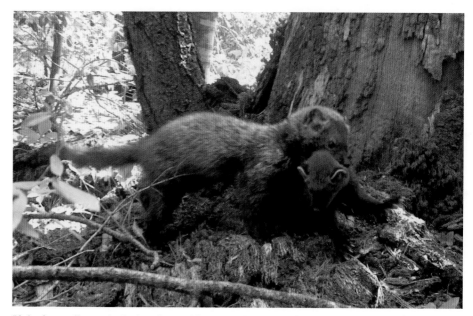

Biologists radio-tracked a female to a big tree and suspected that she had a litter high up in the canopy, probably in a small tree hole. They placed this camera trap at the bottom of the tree and eventually recorded her moving her kits. Fisher moms typically move their kits to new dens three to six times a season.

Tayra *Eira barbara*

CONSERVATION STATUS: Least Concern

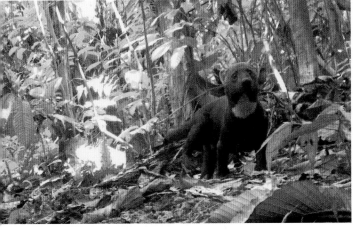

A tayra hunts the Yasuni forests in Ecuador.

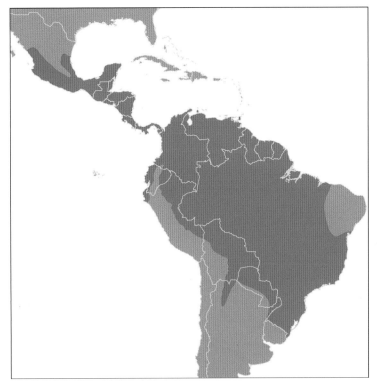

A tayra shows its weasel-like body shape as it hunts the buttresses of a large tree for small prey or bird nests.

Tayras are a mysterious, giant weasel species found throughout Central and South American forests. Related to fishers, martens, and other weasels, tayras are occasionally seen as they climb along vines or run along the ground during the day. To date, most of our knowledge of this species comes from these brief, lucky looks at this shy species. Naturalists have observed them eating fruit, chasing monkeys, and catching rats. Tayras have proven almost impossible to trap, and only a handful of animals have ever been radio-collared, leaving large gaps in our basic natural history knowledge of this species.

In Costa Rica Fernando Soley followed up on his brief glimpse of a tayra, discovering that these big weasels are much smarter than we thought. Soley saw the bizarre sight of a tayra running through the forest with a green plantain in its mouth. Curious as to why the animal would be interested in unripe fruit, he began monitoring the fruiting trees with camera traps and also hid radio transmitters inside some fruits to find out where they were being taken. Soley discovered that the tayras were grabbing plantains from the trees before they had ripened and then caching them in underground hiding places where other frugivores wouldn't look for them. The tayras were actually letting the fruit ripen in these hiding places and then returning later to eat the sweet plantain. This showed a surprising level of prospective thinking and future planning, for a weasel.

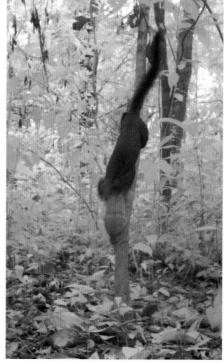

A camera trap catches a tayra climbing up a tree and then returning back down the same trunk 20 seconds later.

A tayra plucks an unripe plantain, which it will hide in a secret cache until it ripens.

Malay Weasel *Mustela nudipes*

CONSERVATION STATUS: Least Concern

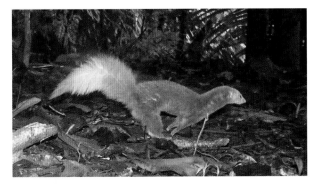

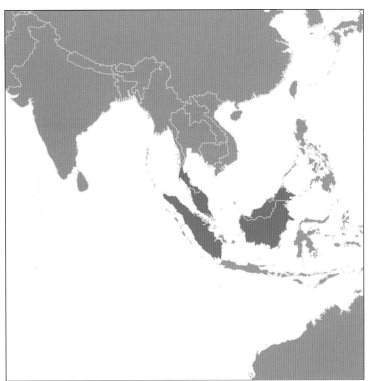

A Malay weasel bounds in front of a camera trap in Borneo.

The paucity of photos of Malay weasels does not seem to come from their avoidance of the cameras. As this animal shows, they are not shy, and sometimes they walk up to sniff the equipment.

For some reason, weasels are never common in camera trap surveys. In the case of the Malay weasel, the first camera trap photo came in 2000. Despite substantial survey efforts, there were only four more records of the weasel until a 2013 study by Joanna Ross reported 28 more photographs from Sabah, Borneo. The small size of weasels certainly contributes to their being rarely detected, as small animals trigger the camera only when they are close to the motion sensor. However, similarly sized mongooses are much more commonly detected, suggesting that other factors may also be at play for the Malay weasel.

Historically, camera trappers put their equipment along roads and trails, because these were used frequently by the large predators they were trying to survey. However, other species may avoid the roads, either because the lack of vegetation makes them feel vulnerable or because they are specifically trying to avoid large predators. Even when scientists set off-trail camera traps, they typically avoid thick habitat, because of the difficulty of seeing animals in the image, especially with flash photographs at night. Could the rarity of detections of the Malay weasel be due to its preference for the thickest parts of a forest, where scientists rarely put cameras?

The few dozen photos we do have of the Malay weasel have taught us some important things about its ecology. First, they are diurnal animals. This is a bit surprising since most weasels are active at night. However, most weasels aren't brightly colored like this one. The purpose of their amazing coloration, as well as any connection with their daytime habits, remains a puzzle.

These camera trap photos also show that the Malay weasel uses a variety of habitat types, including managed forests and oil palm plantations. Thus, their rarity in surveys probably isn't due to some habitat specialization. Like most weasels, the Malay weasel is thought to prey on rodents. It could be that their presence in an area has more to do with local rat populations than the specifics of the surrounding vegetation.

African Bush Elephant *Loxodonta africana*

CONSERVATION STATUS: Vulnerable

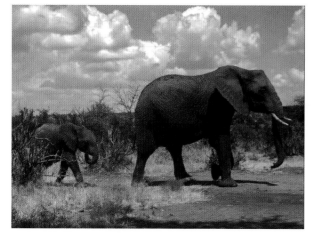

An African bush elephant matriarch leads her young between feeding grounds and water sources. Elephants have excellent memories, and the older animals are trusted to lead the herd based on their past experiences.

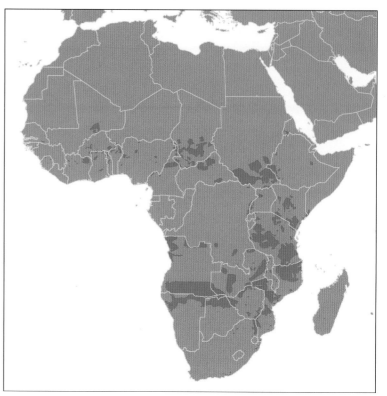

African bush elephants are the world's largest land animals, and they leave a big wake through their grassland, bushland, and woodland habitats. Each adult eats somewhere between 220 and 440 lb (100 to 200 kg) of food per day, and plant communities bear the scars of this grass grazing and leaf browsing. Like an animal bulldozer, a herd of elephants can also transform an area by trampling paths through thick vegetation, pushing over trees, and even digging water holes in dry streambeds.

The degree to which elephants modify an ecosystem is tied to their local abundance. The disturbances caused by a moderate-sized elephant herd can be beneficial to the ecology of a region, but too many elephants can turn a once-lush area into a wasteland. One study of fenced game preserves in South Africa found that overabundant elephants reduced the thorn thickets that smaller species used to hide from predators. These smaller herbivores were eventually lost from fenced preserves with no bushy hiding places. Having too many elephants is rarely a problem today, given the modern poaching plague afflicting much of Africa.

The tusks of elephants can sell for big money in some Asian countries, which has led to an elephant-poaching epidemic that is wiping out animals across the continent. Camera traps are a useful

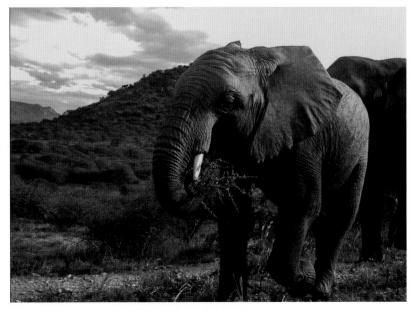

This elephant takes a bush along for a walk, chewing the sticks and leaves as it goes on to the next tough meal.

A camera trap takes a photo of an elephant's foot after the animal wrecked the tree to which the camera was attached. The massively strong and heavy elephants can modify environments just by walking through an area.

tool in fighting this illegal hunting and help wildlife managers target their patrols by determining where both animals and hunters are moving. Scientists also use camera traps to see how humans and elephants can coexist on a daily basis. For example, one study found that elephants and cattle can feed together in African brushlands, but that elephants avoided areas with free-ranging dogs.

Another conservation story comes from the establishment of an animal movement corridor connecting Mount Kenya National Park with a nearby nature preserve, including a new underpass under the Nanyuki-Meru highway. Maurice Nyaligu set camera traps to see whether this narrow strip of natural land that runs through farmland would actually be used by wildlife. Before long, Nyaligu was pleased to see an elephant walk along the entire strip. He named this male Tony, and the elephant was later joined by others in the herd. In fact, the camera recorded 123 elephants using the underpass in just two months, with as many as 26 in a single day.

African Forest Elephant *Loxodonta cyclotis*

CONSERVATION STATUS: Endangered

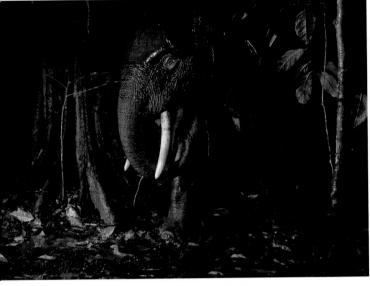

An elephant emerges from the dark forest.

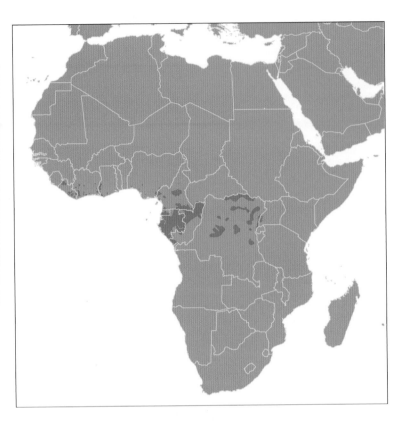

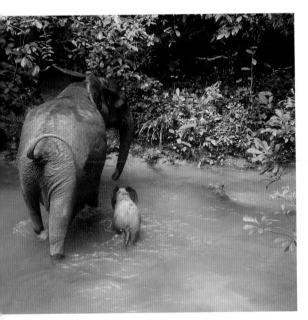

A cow elephant walks cautiously across a swollen forest river with its small calf.

For being the second-largest land animal, African forest elephants keep a surprisingly low profile. They are skilled at disappearing into the rainforest of central Africa. They weren't even recognized as a separate species until genetic results confirmed the suspicions of naturalists, who also noticed physical differences. Forest elephants have the straighter tusks, with a tinge of pink color to their ivory, and have one more toenail on each foot (five on forefeet and four on hindfeet).

Camera traps have been more important for studying forest elephants than bush elephants because they are harder to find and watch in person. Whereas African bush elephants can be studied from a vehicle, trailing behind in the open country, forest elephants can only be seen reliably in forest clearings known as "bais." Camera traps are even useful in bais because, as one camera-based study noted, elephants mostly visit them at night, peaking their activity at 11 p.m.

Each elephant has a unique appearance, based on size, ear shape, and scarring patterns. By placing camera traps in a regular grid across the forests of Loango National Park, Gabon, Josephine Head and colleagues were able to photograph and identify 139 unique individuals, estimating a density of 0.54 animals/mi^2 (1.4 animals/km^2). By noting who was hanging out with whom, Head recognized 18

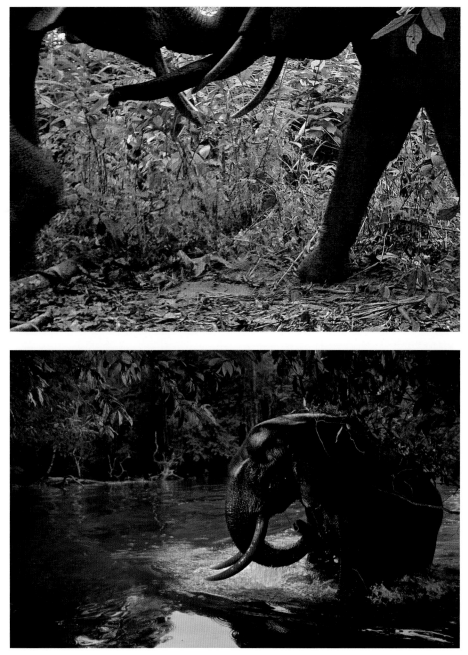

Two tuskers fight in front of a camera trap. The social structure of forest elephants includes smaller social groups than that of bush elephants, to which these males are presumably fighting for access.

different social groups, averaging just seven animals in each group. This is a much smaller group size than found in bush elephants, which may help keep them hidden from people in the African forests.

FOREST GARDENERS

Elephants in forests eat more fruit than those in Africa's savannas. Most of these fruits include seeds that elephants end up dispersing in piles of dung left behind as they move along their trails. Each forest elephant defecation is a chance at new life for a young tree seedling. Many plants have come to depend on this megafaunal dispersal, evolving extra large fruits and seeds to attract hungry elephants. In some cases, these seeds are now too large for most other mammals to eat, or cannot germinate without having passed through an elephant's digestive system. As elephants get hunted out of certain forests, we gain an unfortunate understanding of the importance of their seed dispersal to forest health. For example, one of the elephants' favorite big fruits, which is dispersed by no other animal, sprouts seedlings only immediately under seed trees in forests with no elephants. In more natural forests, with plenty of elephants eating, moving, and pooping, seedlings of this tree can be found scattered throughout the area, spread in the dung of this gardener of the forest.

An older adult male elephant comes up from a swim in the Echira River of Loango National Park, Gabon.

African forest elephants eat a combination of leaves and fruits. They help plants by dispersing their seeds long distances, but they also devour some plants' leaves.

THE CRITTERS **99**

Asian Elephant *Elephas maximus*

CONSERVATION STATUS: Endangered

The Asian elephant has a much different profile than African elephants, with a dome-shaped head and a sloping back.

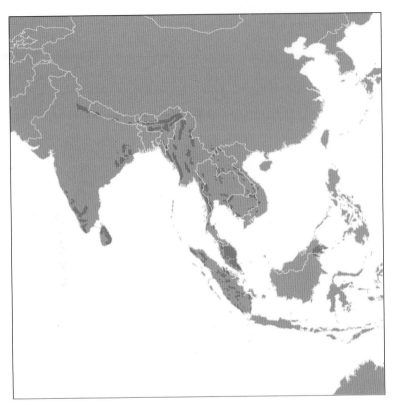

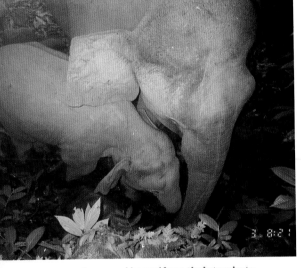

A cow and her calf use their trunks to consume the dirt at a mineral lick. Elephants eat a wide variety of plants, many of which contain complex chemical compounds as defenses against herbivores. The minerals embedded in this rich clay help elephants ward off the negative effects of these poisonous compounds.

The Asian elephant ranges over forests, savannas, and brushy areas, using almost any natural habitat that meets their one requirement—few people. Elephants eat a wide variety of plants and can be troublesome crop raiders. As the great forests of Asia are cut down and replaced with agriculture, the elephants get squeezed into smaller and smaller remnant natural areas. Poaching is also a problem, fueled by the illegal trade in ivory; corrupt gangs hunt elephants, or pay locals to sneak into parks and do their dirty work.

Most Asian elephants are shy, trained by generations of this conflict to fear people, and they are difficult to study through observation. Camera traps have proven a useful alternative, although special precautions are needed to protect the electronics from these giant ornery beasts. Some elephants have been known to destroy these man-made intrusions. Researchers have developed an armor to protect the cameras. Although it doubles the weight field biologists need to carry in their backpacks, this armor lets the elephants take their aggression out on the camera without wrecking the electronics.

These studies have helped map where elephants survive in Asia and determine what factors affect their distribution. For example, scientists led by Thomas Gray found a population of elephants in Phnom Prich Wildlife Sanctuary, Cambodia, but discovered that they

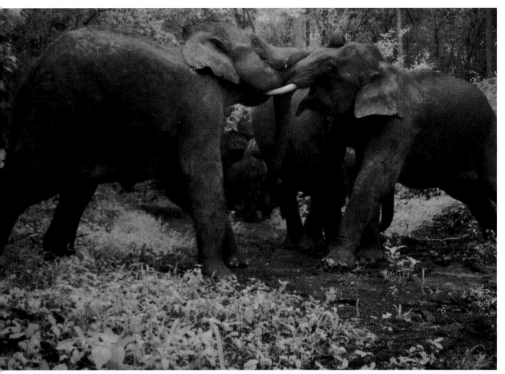

Male elephants sparring for access to females for breeding. These fights rarely escalate to the point where either animal gets hurt, but smaller calves better keep their distance to avoid getting caught underfoot.

A herd of elephants crowd around a camera trap in Borneo.

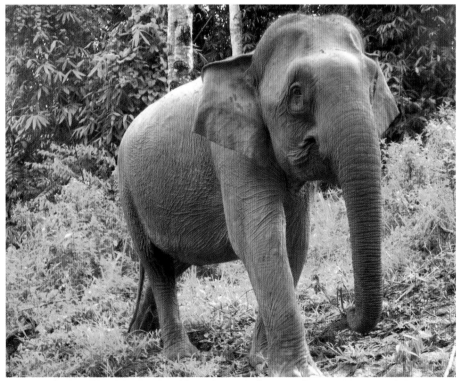

Female Asian elephants do not grow big tusks; sometimes smaller overgrown teeth, known as thrushes, can be seen protruding from their lips. Male elephants of Borneo and Sumatra grow straight tusks, smaller than those of other elephants.

avoided nearby villages. Cameras showed that there were more than twice as many elephants in parts of the park that were more than one day's walk from a village.

Each elephant has a unique appearance, allowing them to be recognized in photographs. One study in India found that about one-fourth of elephant photographs had suitable views of the animal to identify, age, and sex it. They showed that their study area had 44 individuals, including 17 adult females, only 2 adult males, and 6 calves, with the rest being sub-adults and juveniles. Documenting this population structure helps evaluate the health of the local herd and determine their success in providing new generations of elephants that can learn to survive in a human-dominated landscape.

PYGMY ELEPHANTS?

Hardly small compared to other mammals, the elephants of Borneo and Sumatra are about one-fifth smaller than their relatives in India and sometimes are referred to as pygmy elephants. In fact, Sumatran elephants are about the same size

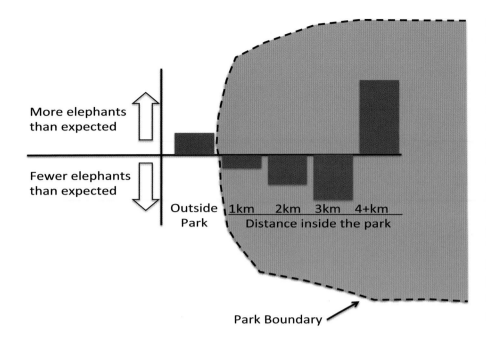

More elephants than expected

Fewer elephants than expected

Outside Park

1km 2km 3km 4+km
Distance inside the park

Park Boundary

Camera trap surveys of Bukit Barisan Selatan National Park and surrounding areas in Sumatra found that elephants were common in the core of the park but avoided the boundary zone. The edge of the park was rapidly being deforested, as agriculturalists pushed farther and farther into the park, such that even areas 1.8 mi (3 km) inside the official park boundary had few elephants. Most elephant activity was concentrated within the core of the park, more than 4 km from the edge. The corrosion of suitable elephant habitat around parks, as well as rapid loss of habitat outside of parks, is the top conservation problem for Asian elephants.

as their nearest Asian elephant relatives in Peninsular Malaysia, making the "pygmy" name inappropriate. These elephants are unique in other ways, including an extra pair of ribs, lighter coloration, and reduced tusks, which are sometimes barely visible in females. Genetic analysis confirms that these elephants have been evolving apart from other Asian elephants since the Pleistocene; thus, they are now recognized as a unique subspecies.

Sumatran elephants have earned another unique distinction, one they would rather not have, as the most endangered subspecies of Asian elephants. Their population

has declined by at least 80% over the past three generations, earning them the designation of "critically endangered." Habitat loss is the root of this problem, followed by retribution killing by farmers after hungry elephants raid the crops planted after the forest is cut down. The proliferation of oil palm plantations has also been bad for Sumatran elephants, as these forests offer nothing for these herbivores to eat. Conservationists are now trying to rally support to better protect existing parks and prevent the destruction of the other forests that offer a last stand for this not-so-small island elephant.

Black Rhino *Diceros bicornis*

CONSERVATION STATUS: Critically Endangered

A black rhino cruises the Kenyan bushland with a pair of oxpeckers on its back.

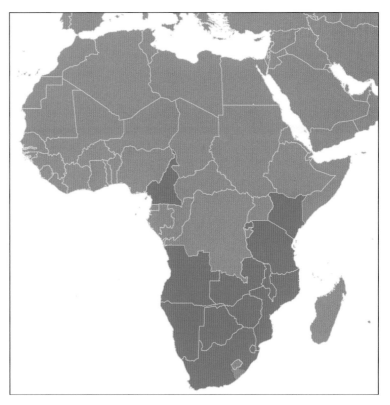

In the absence of hunting by humans, black rhinos would be common throughout Africa. They browse on just about any leaf or twig they can find, meaning they have a virtually endless food supply. Although younger animals have to watch out for lions, the large body size and big horns of adults protect them from all four-legged predators. Indeed, early explorers of the African wilderness reported rhinos to be "boiling out of the bushes," a common and dangerous animal.

The same horn that protects this species from lions could cause its extinction at the hand of man. The poaching of rhinos for their horns is causing the decline of African rhinos across the continent. Horns have no true medicinal value but are still prized on Asian black markets as a cure-all. As the prices go up, poaching pressure increases; conservationists are scrambling to save the rhinoceros.

In these desperate conditions, camera traps become part of the security system for park managers. Cameras set at water holes help keep track of the assets, individual rhinos identifiable by their unique scars and horns. Cameras hidden in the bush record poachers trying to sneak into a preserve to kill a rhino, helping rangers determine where to target their patrols. Where phone networks are available, special camera traps can

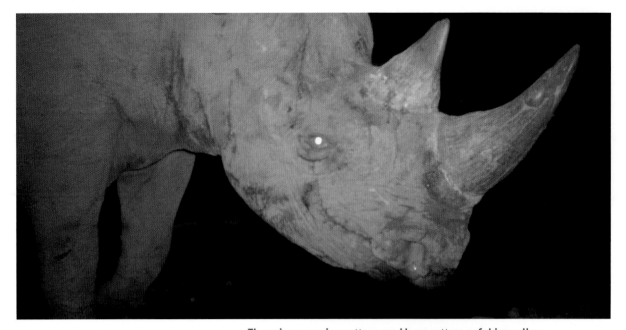

The unique scarring patterns and horn patterns of rhinos allow scientists to identify individuals from photographs, giving more accurate counts of how many animals are in an area.

be set to send live images to park rangers, helping them fight poachers in real time.

The recent increase in intensity of poaching comes after a reprieve for a decade in the late 1990s and early 2000s, when rhino populations actually increased for the first time ever. That brief recovery gives hope that the battle against poaching can be won again and that rhinos can reclaim their place on the African continent.

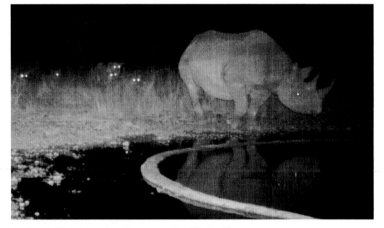

A pride of lions cautiously approach a black rhino at a water hole in Namibia. Rhino horns are effective lion deterrents, and even a full pride of lions won't risk an attack on an adult rhino.

Javan Rhino _Rhinoceros sondaicus_

CONSERVATION STATUS: Critically Endangered

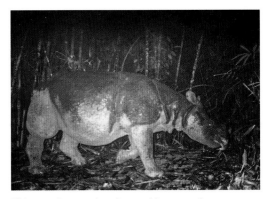

This was the very last Javan rhinoceros from Vietnam. This animal was poached in 2010, shortly after this photograph was taken.

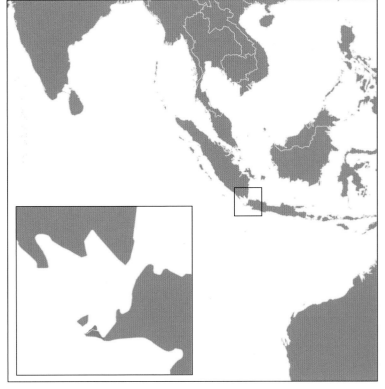

The Javan rhino is probably the most endangered species of mammal on earth, with fewer than 50 animals surviving in only one population. The cause of their dramatic decline is obvious—overhunting for their horns to use in "medicinal products." A rhino horn is basically an overgrown fingernail, made of keratin, and has been shown to have no medicinal value. Unfortunately, the rarer rhinos get, the more people seem to value their horns, raising great concerns about the future of this rarest rhino.

Rhinos love to use mud wallows to cool off, giving hunters an easy place to sit and wait with their guns. Camera trappers also targeted these water holes as they race against poachers to find and try to save the last rhinos. Conservationists lost this race in Vietnam, were the last Javan rhino was poached in 2010. Researchers knew about this last Vietnamese rhino, hiding in Cat Tien National Park, from their camera trap photos. Unfortunately, weak law enforcement and high prices for rhino horn resulted in a sad ending for this second-to-last Javan rhino population.

The very last Javan rhino population still survives in Ujung Kulon National Park in Indonesia. This park is isolated at the western tip of Java and has beefed up anti-poaching patrols that have, so far, protected the rhinos. Adhi Hariyadi worked with park managers to

set an array of camera traps near mud wallows to monitor the population. In 2009 they identified 27 unique individuals and estimated that the total population size was 32. Although all rhinos are slow breeders, this population is making babies, and about one-fifth of the animals photographed were calves. Managers have been tracking this population over the past 10 years, documenting 14 births and 9 deaths, resulting in a population growth rate of 1% per year. This is less than the managers' goal of 3% growth, but it is better than a decline, and perhaps the first bit of good news in the sad history of the Javan rhinoceros.

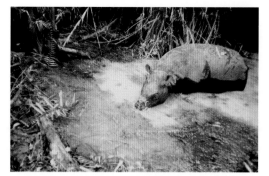

Mud wallows are important for keeping rhinos cool and to combat biting insects. They also provide predictable places for camera trappers, or poachers, to look for rhinos.

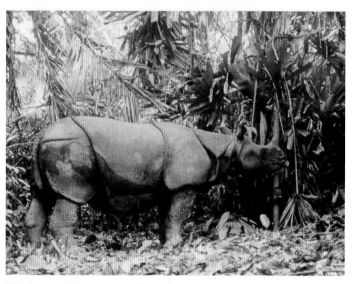

This is one of the 32 Javan rhinos that survive in Ujung Kulon National Park, Indonesia. Managers use camera traps to monitor the population by counting individuals and noting births and deaths.

Brazilian Tapir *Tapirus terrestris*

CONSERVATION STATUS: Vulnerable

A tapir walks down a dry trail in the Brazilian Pantanal.

The Brazilian tapir is South America's largest land animal and one of three tapir species in the New World. Despite their size, tapirs can be amazingly stealthy as they move through the forest. This means that true observational studies are impossible, and even casual sightings are rare and sometimes misleading. In fact, data from camera traps show that prevailing knowledge from anecdotal observations is not always accurate. For example, although tapirs are frequently sighted using river beaches, cameras show that they use the forest interior just as much. Another study found a surprisingly high density of tapirs living in dry forests, despite their assumed preferences for swampy areas.

Given the big meal they can provide, tapirs are sought-after prey of human hunters, legal and illegal. Overhunting can drive animals out of an area, or concentrate them in the most remote corners of a park, farthest from the nearest hunter trailhead. An assessment of tapir densities and human hunting levels at 11 sites in French Guiana, led by Mathias Tobler, found that hunting levels were unsustainable in at least seven villages. However, because of the remoteness of their habitat in much of French Guiana, tapirs were not considered immediately threatened in the country as a whole.

Given protection from hunting, tapir populations can recover. For example, after the creation of the

Madidi National Park in Bolivia, the region saw a slow but steady increase in the tapir populations. Now camera trap studies suggest that there are approximately 20,000 animals roaming the transboundary forests connecting Bolivia and Peru. The abundant wildlife in the region help attract more ecotourism, which helps fund additional park patrols, in addition to giving economic opportunities to local communities. When not overhunted, tapirs can be good for business.

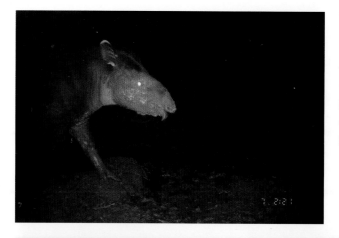

This tapir has a face full of mud after feeding at a natural salt lick. The clay in the salt lick provides minerals that help counter poisonous secondary compounds found in the plants eaten by tapirs.

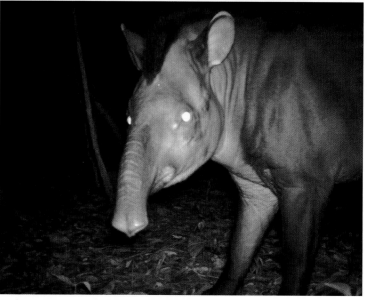

Tapirs have a long, fleshy prehensile nose that works similarly to an elephant's trunk. It can be used to grab leaves, as a snorkel while swimming, and, of course, to smell for food or predators. This long-nosed tapir was photographed in Suriname as part of a global camera trap mammal study.

Malayan Tapir *Tapirus indicus*

CONSERVATION STATUS: Endangered

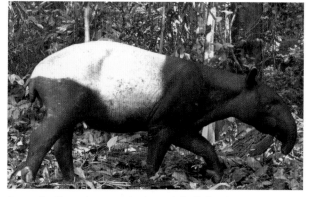

A rare daytime photograph of a tapir in Malaysia.

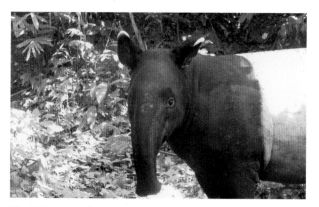

The Malayan tapir has the longest snout of the five tapir species.

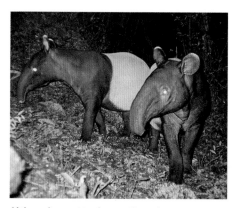

Although most tapirs are thought to be solitary, Malayan tapirs are often photographed in pairs. In Kerinci Seblat National Park, Sumatra, the same pairs were photographed together many times, leading to new questions about their sociality.

The Malayan tapir is Southeast Asia's least known species of megafauna. They are generalist herbivores, eating fruits and leaves, a diet similar to their larger competitors the Asian elephants, with which they often coexist. To learn more about where tapirs survive and what types of habitat they thrive in, 37 biologists joined forces by combining their images and data. This joint effort represented 52,904 camera trap days of effort across 1,128 locations in 19 nature preserves. By comparing locations where camera traps did and did not detect tapirs, researchers found that the animals preferred the wettest evergreen forests and that they will use forests that have been lightly logged.

Malayan tapirs are strongly nocturnal, a behavior that helps them avoid human hunters better than some other wildlife in the area. Compared to other large species in Southeast Asia, tapirs are also not typically targeted as intensely by poachers. Thus, they are more threatened by habitat loss than by market hunting. Nonetheless, they are shy species, avoiding people and development. Hopefully, these traits will help them survive as their habitat continues to dwindle.

Bearded Pig *Sus barbatus*

CONSERVATION STATUS: Vulnerable

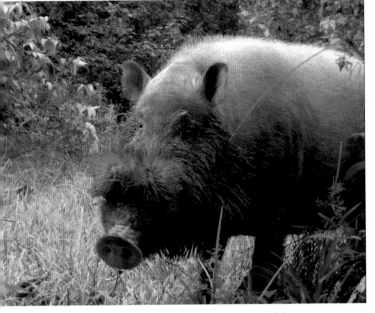

Large male bearded pigs have the most facial hair, which is thought to attract females and may also help spread the smell of scent glands hidden beneath the hair.

Bearded pigs are social animals that roam over large areas looking for fruit. Many of the fruit trees they rely on have a synchronized boom-bust cycle, providing an overabundance of fruit in some years and then offering next to nothing in other years. The nomadic movements of bearded pigs help them adapt to this cycle but are not enough to completely escape the fruit famines. Camera trap photos from Sabah, Malaysia, in famine years show bearded pigs at various stages of emaciation and starvation.

From the tree's point of view, this is exactly the point. Regular yearly fruit production would allow pigs and other seed predators to main-tain stable populations, destroying the seed crop each year. By starving out their predators one year and overfeeding them the next, the trees are ensured that some seeds have a chance to germinate and grow. The ability of pigs to store fat in abundant-fruit years helps at least some of them survive and maintain their part of this vicious cycle.

When the pigs do find a fruiting tree, being in a large group is problematic because the available food has to be split between many animals. For bearded pigs, the added protection against predators offered by large groups appears to outweigh the increased competition for food. Furthermore, these pigs are able to make fine adjustments to their group size based on the local level of predation risk. In Borneo, where the Sunda clouded leopard is the top predator, and a pig's worst nightmare, photographs showed pigs foraging in larger groups in areas with a higher density of clouded leopards.

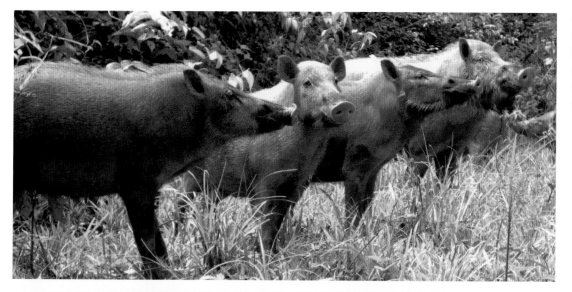

Camera trap photos like this provide evidence that bearded pigs form larger groups in areas where they face more predation risk from big cats.

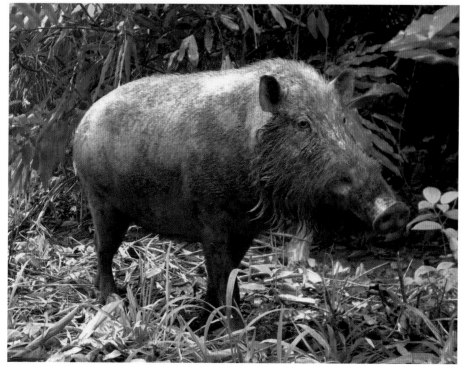

In addition to the showy beard, this species also has a very elongated snout, which the pigs use to root through the leaf litter.

Pygmy Hippopotamus *Choeropsis liberiensis*

CONSERVATION STATUS: Endangered

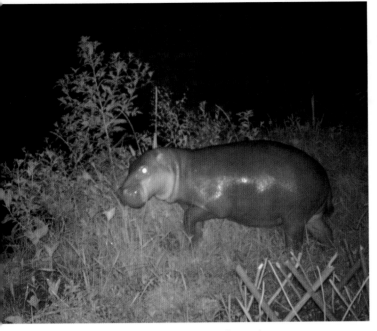

A pygmy hippo walks past a garden and toward a river in Sierra Leone. The wooden stakes in the foreground were set up to protect the garden from hippo browsing.

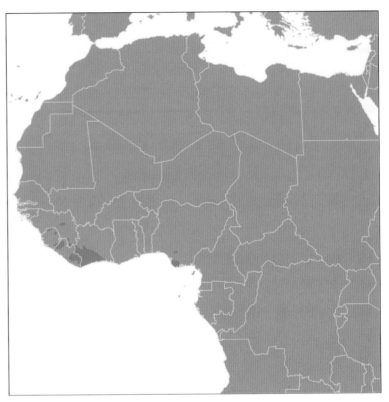

It's not easy being a big mammal in West Africa. Hardly any forest remains, and even the protected areas are under siege, as swelling human populations in surrounding areas push into parks to cut trees or hunt wildlife. Weighing 350 to 600 lb (160 to 270 kg), pygmy hippos are closer in size to a big pig than their larger (1+ ton) hippo cousins, but they are still targeted by poachers hunting for anything to sell at local bushmeat markets.

Like larger hippos, the pygmy species spends most of its time in rivers, coming out to dry land at night to feed on plants. Pygmy hippos are less social than the hippopotamus and so can more easily hide from hunters in swamps, wal-lows, or hollows under the stream banks. However, their nocturnal foraging trips create tunnel-like paths through the vegetation that are easy for hunters to discover and stake out.

Conservationists are scrambling to discover and protect the last remaining pygmy hippo populations. Camera traps are important tools in this effort; they can be set along potential hippo paths to verify their presence and also to detect poachers. There is still much to do for this dwindling species, as best initial estimates suggest that a few thousand individuals remain, scattered across fragmented populations in four countries.

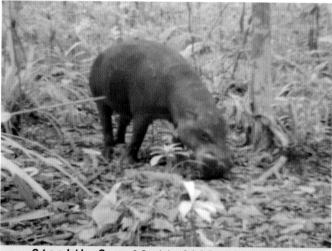

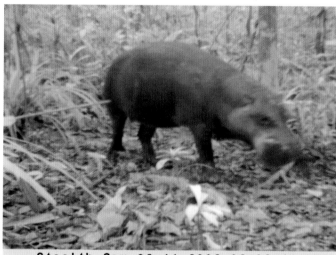

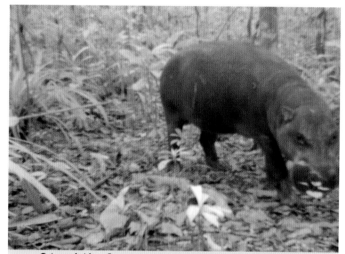

A pygmy hippo takes a morning stroll past a camera trap.

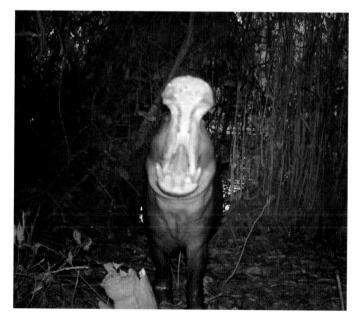

A pygmy hippo yawns in front of a camera trap in Sierra Leone.

Giant Sable Antelope *Hipotrachus niger variani*

CONSERVATION STATUS: Critically Endangered

(*above*) The main bull, nicknamed Ivan the Terrible, of the endangered giant sable antelope herd surveys his domain. He was once captured and given a tracking collar, which can still be seen around his neck in this photo.

(*right*) The endangered *variani* subspecies of the sable antelope (blue in map; green shows other subspecies) lives only between the Cuango and Luando Rivers in Angola.

A female passes close to the camera as her herd mates kneel down to eat clay from a salt lick in Cangandala National Park.

The giant sable is an endangered subspecies of antelope which nearly went extinct during the Angolan Civil War. After the war, a camera trap survey confirmed that the species still survived, but it also showed that they were still highly endangered by the dual threats of poachers and hybridization with another antelope species.

Antelope in Cangandala National Park use salt licks, which become a center of activity for the herd. Scientists led by Pedro VazPinto take advantage of this and mount their cameras nearby to keep tabs on the herd. Unfortunately, poachers have also discovered these animal hot spots and are often caught on camera as they patrol by. They have seen and destroyed enough camera traps at this site that scientists now have to climb trees and mount them out of sight.

A second threat to the herd became obvious in the color photos of some young antelope—they were hybrids. The population size of giant sables had become so low that the females started breeding with a related species, roan antelope, which are more common. These hybrids are lighter in color than the giant sable and thus easy to pick out in photographs. Conservationists have sterilized some hybrids to try to stop the dilution of the last pure giant sable antelope.

A herd of females congregate around a salt lick. Female sable antelope also have horns, although they are not as long or curved as the males.

2012-07-30 3:59:49 AM M 1/5 13°C

A poacher caught hunting at a salt lick at 4 a.m. Hunting is a major threat to the giant sable antelope today.

Tamaraw *Bubalus mindorensis*

CONSERVATION STATUS: Critically Endangered

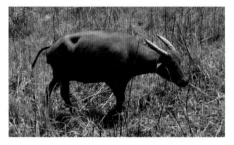

A tamaraw crosses a grassy glade in Mindanao, the only place in the world where they live.

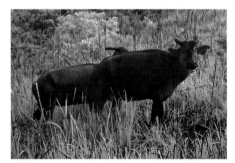

Tamaraw are less social than other buffalo species, usually moving alone or in small family groups. They are easiest to see and count when they graze in the open grassy glades, but they also spend time in the thick rainforests of Mindanao.

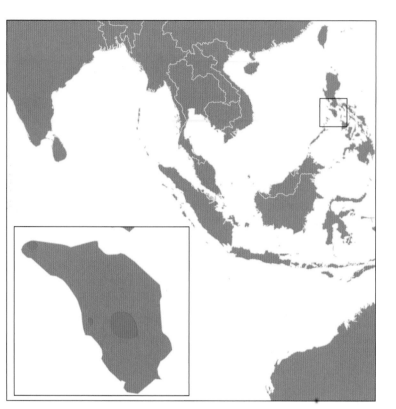

The Philippines are a series of small islands with over 90 million people, leaving little room for wildlife. The tamaraw, a type of small buffalo, is the largest native species in the country, but it has been pushed to the edge of extinction by the growing human population. This 400 to 660 lb (180 to 300 kg) species of buffalo probably once roamed over much of the Philippines, but it was already restricted to the island of Mindanao by the 1800s. As Mindanao was settled in the early 1900s, the tamaraw population crashed from around 10,000 to just 1,000 animals by 1950. The downward trend continued, with 250 animals counted in 1953 and just 100 in 1969.

The tamaraw prefers tropical highland forest areas, moving between thick bush, where it can hide, and open glades, where it can graze on grasses. Unlike larger species of buffalo, the tamaraw does not form large herds. They are often seen alone, or in small family groups, although larger packs of teenagers will sometimes band together. Interactions with people are rare, but the tamaraw has a reputation of being fierce and is admired by Filipinos for being compact (for a buffalo) and tough.

The plucky personality of the tamaraw might actually help save it from extinction. The species has become a source of national pride, and a number of laws have been passed to protect it. It has been featured on coins, has had a car named after it, and is the mascot for a number of local sports teams. There is now a cooperative conservation action plan to protect the animals and their habitat, and it seems to be working. For the first time in over a century, tamaraw populations are increasing. Recent surveys with observers and camera traps counted 345 heads in 2013. This is still a small number of animals, living in a restricted range, on a little island full of people. But the species is now more valued. Hopefully, people will continue to make room for this unique Filipino buffalo.

Asiatic Wild Water Buffalo *Bubalus arnee*

CONSERVATION STATUS: Endangered

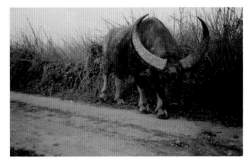

An Asiatic wild water buffalo walks down a road in India. These were the ancestor of domestic buffalo and are threatened by hybridization with their much more common cousins.

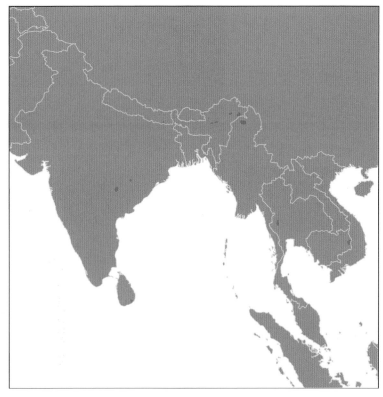

Water buffalo are one of the most important domestic animals in the world, with over 170 million animals, mostly in Asia. These farm animals have flourished over the past century, helping people plow rainforests into rice fields. Wild water buffalo, the ancestor of the domestic buffalo, still stalk the few remaining wild parts of Asia, but their populations are sharply declining as more forests fall and as poachers pick off the remaining wild herds.

Wild water buffalo weigh from 1,500 to 2,600 lb (700 to 1,200 kg), making them one of the heaviest living wild bovid species, along with the similarly sized gaur. True to their name, wild water buffalo prefer wet habitats, especially swampy grasslands or forests along river courses. Buffalo are grass grazers, but they will also eat herbs and fruit and occasionally browse on trees and shrubs that are in reach. They sometimes break into farmers' fields to feed on crops, where they can cause considerable damage. Buffalo are social animals, with female-led clans of one to two dozen animals making up smaller subunits of bigger herds that can reach 500 animals. These clans spread out while feeding and reunite at resting areas.

Like most Asian mammals, the wild water buffalo is threated by habitat destruction, but for this big game species, hunting is an even

bigger problem. There are numerous parks with good habitat but no buffalo because they were hunted out. They have been extirpated from Pakistan, Bangladesh, Laos, and Vietnam, with less than 4,000 animals now left, 90% of those in eastern India. Camera trapping is an important tool for park managers and conservationists to map out where herds of these giant endangered wild cattle still survive, aiding the attempt to put new protections in place to halt their slide to extinction.

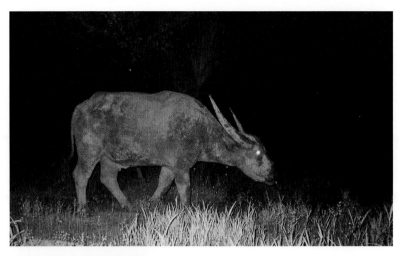

(*above*) Wild buffalo have the broadest horns of any living bovid, and this trait can help distinguish them from domestic animals.

(*left*) These wild water buffalo caught by a camera trap in Mondulkiri Protected Forest are part of the last herd known to survive in Cambodia. Cameras at this special place also recorded two other large bovids, banteng and gaur, making this one of two sites in the world to have all three of these massive wild cattle species still living together.

Alpine Ibex *Capra ibex*

CONSERVATION STATUS: Least Concern

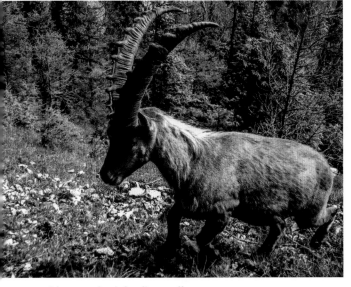

A large male alpine ibex walks up a mountain meadow in Austria.

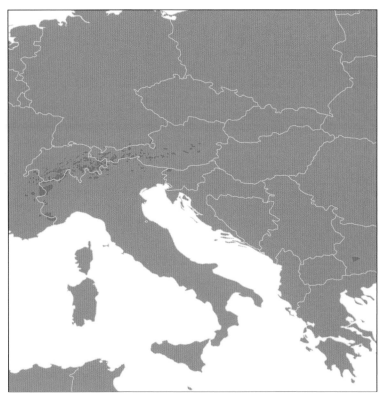

The Alpine ibex is an amazing species of goat with enormous, arching horns. The species is now widely distributed above the tree line in the Alps of Europe, but its future was in question a century ago. The incredible horns of this species made it highly prized by hunters, and its mountaintop habitat made it relatively easy to find and shoot. By the beginning of the nineteenth century they had been completely wiped out from every mountain range except one—the Gran Paradiso massif in Italy. Ironically, this population was protected as the private hunting ground to the Italian king.

Fortunately, the slaughter of ibex was halted at the last second, and the species was saved. The hunters got organized, stopped unregulated harvest, and initiated a reintroduction program. The species took well to reintroductions, and Alpine ibex from Italy were eventually transferred all around Europe. Most of these flourished, and there is now also some natural migration between areas. Today there are some 40,000 ibex in Europe, and carefully regulated hunting is allowed in some countries.

Wildlife biologists charged with maintaining these healthy ibex populations recently started using camera traps to help monitor the herds. Ibex typically use open rocky habitats but also increasingly use the woodlands below the tree

line, where they can be harder to count. In clear images, individual animals can be identified based on unique patterns in their horns and faces, making it easier to estimate densities with "capture-recapture" methods. Annual monitoring lets managers know how to modify the number of animals that can be harvested each year, continuing the European hunting tradition, but in a sustainable way.

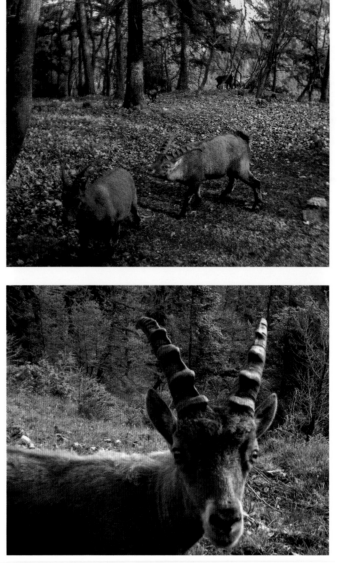

(*top*) Here a young male courts a female, pursuing her from behind to get a good whiff and discern her reproductive status. Two chamois, another Alpine ungulate, can be seen in the background.

(*bottom*) Females and young males (like the one shown here) carry smaller horns than males, and the variety in sizes is useful for researchers trying to age, sex, and identify individuals. Scientists found that each ibex has a unique pattern on their horns, allowing more accurate estimates of population size from camera trap photographs.

Southern Pudú *Pudu puda*

CONSERVATION STATUS: Vulnerable

Pudú are the world's smallest deer. The southern pudú, shown here, is about twice the size of the northern pudú.

The South American pudú is the world's smallest deer, with the southern species weighing 14 to 30 lb (6 to 13 kg) and the northern pudú (*Pudu mephistophiles*) just 7 to 13 lb (3 to 6 kg). Pudú live in temperate rainforests along the Andes mountain chain and eat a variety of plants. Being short, they sometimes stand on their hind legs or use their hooves to bend branches down to get a bite of leaves. Males are larger than females and have short spiky antlers. Pudú are preyed on by a variety of native predators, especially cats like the guigna and puma. To avoid becoming cat food, pudú are very wary as they move slowly through the cool rainforests, stopping often to scan for danger. If a predator is detected, the deer give a short bark of fear and run off in a zigzag path.

Populations of pudú are declining across their range, in part because their rainforest habitats are being converted to agriculture. However, there is also concern about their survival within forested habitat, and competition for food from introduced red deer might also be contributing to their troubles. A recent camera trap study led by Eduardo Silva-Rodríguez surveyed 254 locations in evergreen Valdivian forests and eucalyptus plantations in Chile to determine what affects pudú distribution there. Their cameras detected pudú 99 times but also recorded a lot of

domestic dogs roaming the forests. In fact, domestic dogs were the most commonly detected predators in their cameras, more than the local wild cat species. Locals reported that their dogs often chased pudú, and the scientists analyzed their data to see whether the dogs were affecting pudú distribution. They were—the strongest relationship they found was that very few pudú were photographed by cameras that did detect dogs, which were most common in forests closer to houses.

The little pudú have plenty to worry about in their forests with the native predators, and packs of feral dogs seem to be enough to drive them out of an area. Conservationists are now encouraging people to keep their dogs closer to home and get them neutered to reduce the impact of man's best friend on the world's smallest deer.

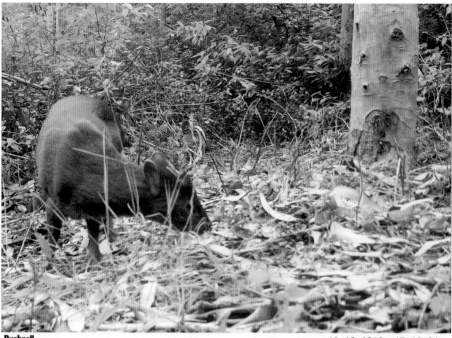

This pair of images shows a pudú and a pack of dogs photographed by the same camera trap five hours apart in Chile. Their small size makes pudú potential prey for a wide variety of predators, so the small deer are nervous and avoid dangerous areas. Free-ranging dogs chase and kill pudú, and research has shown that when dogs use native forest, they push pudú out of the area.

White-tailed Deer *Odocoileus virginianus*

CONSERVATION STATUS: Least Concern

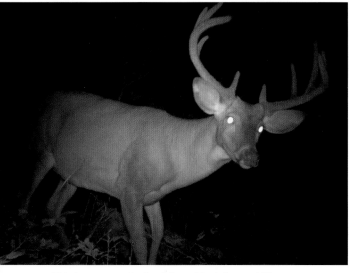

This large 10-point buck from Virginia would be a sought-after trophy for any hunter.

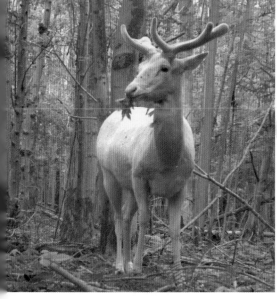

The antlers on this albino deer are still growing, covered by a "velvet" of skin. Unusually colored animals, or those with odd antlers, are also valued by hunters as trophies.

Scientists owe a debt of gratitude to the white-tailed deer for the development of camera traps. The majority of camera traps in the world are purchased and set not by scientists searching for endangered species but by hunters searching for the buck with the biggest set of antlers. Before deer season begins, hunters will post their cameras throughout the land they intend to hunt, trying to map out the movement patterns of the largest male deer. In some states, where baiting deer is legal, they might set cameras over piles of corn or apples. Although some hunters shoot to put meat on the table, a number of them are specifically gunning for the largest trophy buck.

Male deer grow antlers every year and use them to battle each other for access to females during the breeding season. Antlers are made of bone, grow over the summer, and are shed midwinter, after the rut is over. For young deer, antlers grow larger each year, but after the age of three or four years the size of the antlers will depend on the deer's overall condition and nutrition. Antler size is thus a sign of a buck's health, as well as a weapon used to fight other males. Large racks have always been coveted as trophies by hunters, and camera traps are an increasingly popular tool to help hunters discover the largest possible trophy animal in their local population.

The best hunters use these cameras to study deer behavior, trying

(*top*) A trophy buck shows off its antlers to the camera trap as it feeds on ground cover.

(*middle*) Two big-eyed fawns frolic in front of a camera trap. Twin fawns are not uncommon, but they are much more work, costing the mother twice as much milk as singletons. New mothers are more likely to have smaller litters, while older females are better prepared to raise two, or even three, fawns at a time.

(*bottom*) This deer was startled while feeding on apples, either by the flash of the camera trap or by the flying squirrel behind it.

to learn their motivations in order to predict how the animals will move through the landscape, so they can be at the right place at the right time to bag their game. The pursuit of big bucks has greatly benefited science past this narrow field of deer behavior. The use of camera traps by millions of hunters has led to steady improvements in this technology and a drop in their prices by companies competing for the business of recreational hunters.

WHITE-TAILED SCIENCE

Researchers studying white-tailed deer have also used camera traps to collect data and address scientific or management questions. Knowing how many deer are in an area is often the goal of this research, and the unique branching patterns of males allow their density to be estimated with accuracy using mark-recapture analyses. White-tailed deer also show up in mammal community studies, as they are usually the most commonly photographed species across most of North America. Comparing the detection of deer across multi-

ple sites can also show what habitat features are important for them. For example, one suburban study found deer to be most common in areas with high tree canopy cover, near water, and farther from areas with many houses, people, or dogs.

Deer typically eat plants growing at ground level, but feeding with their head down is risky because they can't be on the lookout for predators. Nervous deer keep their heads up, looking, listening, and smelling for wolves, cougars, coyotes, people, or other predators that might be trying to sneak up on them. The position of a deer's head, and thus their judgment of the security of the situation, can easily be evaluated from a camera trap photo. A study by Marcus Lashley found that deer in groups are less vigilant than solitary animals, showing the safety in numbers, and that females are 50% more vigilant when they have fawns with them. Light level also affects deer behavior: deer increase their vigilance on nights with bright moonlight, probably because they can see better and thus have a better chance of spotting an advancing predator.

Chimpanzee *Pan troglodytes*

CONSERVATION STATUS: Endangered

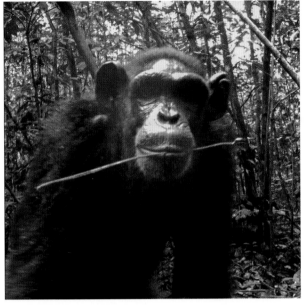

This chimpanzee was caught on camera carrying its favorite termite tool. Chimps modify sticks to make them effective for pulling termites from their mounds, sometimes carrying them as they move on to look for new feeding sites.

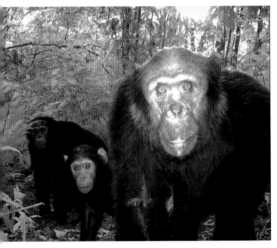

A family of chimpanzees investigates a camera. Chimps typically notice the camera traps placed in their range, and often investigate, but quickly realize that the camera is not harmful, making it an object of curiosity rather than fear.

For years, everything we knew about wild chimpanzees came from careful observation of a few groups that had been habituated. Countless hours of watching how they find food and interact with each other have revealed complex cultures and behaviors, many of which parallel our own. Repeating this intensive fieldwork over large areas to evaluate larger-scale ecological patterns is not practical. Furthermore, having humans on the ground all the time could impact the chimps' behaviors or frighten away other species they interact with that are not habituated to our presence. Camera traps have recently been applied to the question of chimpanzee ecology, allowing data to be collected on chimps and competing species over larger areas, giving a new picture of our closest primate cousins.

APE COMPETITION

The conversion of African forests to farmland has likely decreased the area available to chimpanzees, but exactly where and how much was unknown. A recent continent-wide study combined camera trap and visual observations to evaluate the habitat requirements of apes. They found that chimpanzees had lost about 15% of their possible habitat in just 15 years, while bonobos, a cousin to the chimp, had lost nearly one-third of their potential habitat, and gorillas had lost more than 50%.

Camera traps have also been

used to collect detailed data on local chimpanzee populations by identifying individuals based on their unique faces. In Loango National Park, Gabon, scientists used cameras to count all the individuals in four groups of chimpanzees, estimating a density of 0.66 animals/ mi² (1.72 animals/km²). Gorillas and elephants were also detected by their cameras and could also be identified based on unique natural markings, revealing similar densities (0.46 and 0.53 animals/ mi² [1.2 and 1.37 animals/km²], respectively). These three species all compete for fruiting trees, and comparison of their abundances over time showed that the elephants actually excluded the chimpanzees from certain habitats during the fruit-scarcity season.

Within forests, chimpanzees have the skills to avoid elephants and compete with gorillas for food, but they cannot stop us from cutting down the trees. The larger question for the long-term survival of African apes is whether the most intelligent primate, humans, can find a way to set some land aside for their jungle-loving cousins.

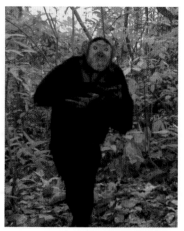

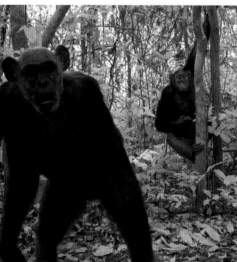

Much like humans, chimpanzees have unique faces and can easily be recognized from clear camera trap photos. This allows individuals to be identified and counted, helping conservation groups to monitor chimpanzee populations more accurately. Computerized image analysis is now quite accurate at recognizing people and has recently been applied to chimpanzees. Initial research found that this software performs quite well on high-quality images but is challenged by the lower-quality images typical from camera traps. Hopefully, this will improve with better algorithms and improved camera technology, to enable larger-scale chimpanzee surveys.

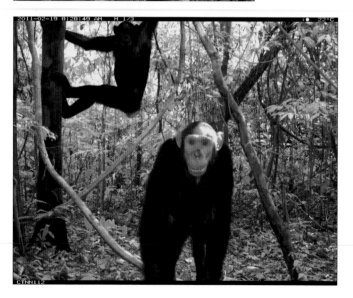

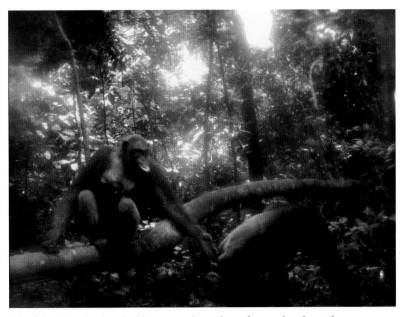

A female chimp looks mischievous as she makes a face and grabs at the rear of a male passing by. However, this "pout" face is actually a sign of being submissive, and she was probably even whimpering, trying hard not to cause trouble with the male. Males are dominant over females and can sometimes physically abuse them, so females try to stay on their good side.

This video camera trap recorded a chimpanzee hauling an armful of corn back into the forest from adjacent croplands. Chimps were known to occasionally raid crops, but this study by Sabrina Krief in the fields bordering Kibale National Park, Uganda, found that it was more than just a few rogue individuals. Her cameras recorded large parties feeding on the crops, including vulnerable females with clinging infants. Krief suggested that the destruction of habitat in other parts of their range has forced this troop to raid crops. Farmers are not likely to tolerate extensive crop damage, so finding ways to reduce this conflict is important for the survival of Kibale's chimpanzees.

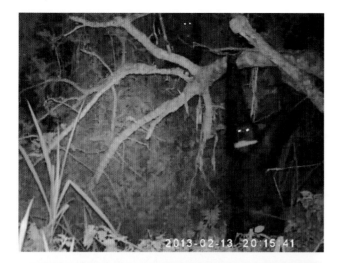

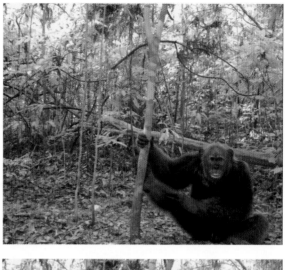

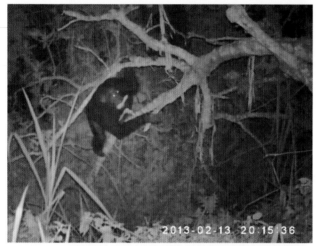

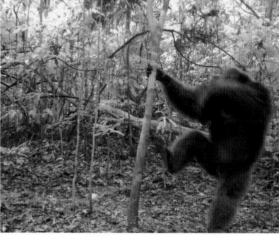

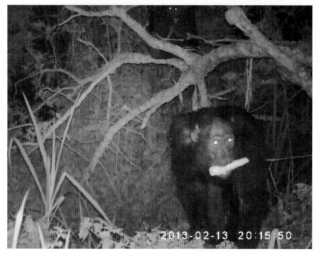

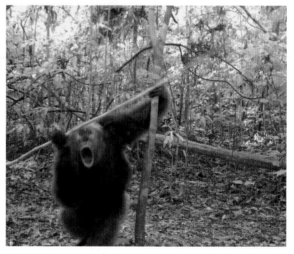

A pair of chimpanzees is caught on film using a fallen tree to cross a creek after raiding a farmer's corn crop. The nighttime activity was surprising; this was the first report of regular nocturnal behavior by any chimpanzees. The cover of darkness seemed to give the animals a sense of security, as they stayed longer in the corn field and were less vigilant at night.

A male chimpanzee puts on an aggressive display after spotting the camera trap. This type of aggression is usually accompanied with a roar or "wraa-bark" and is given when they are startled or see something unusual. Presumably, this animal had just noticed the camera for the first time. Chimps quickly habituate to camera traps once they realize they are not a threat.

Western Gorilla *Gorilla gorilla*

CONSERVATION STATUS: Critically Endangered

A silverback male from Gabon. These are the world's largest primates, weighing up to 600 lb (275 kg).

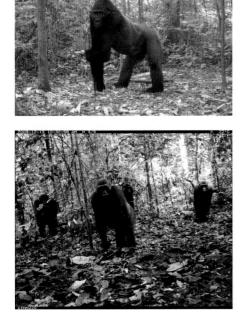

(*top*) A male gorilla from Nouabalé-Ndoki National Park, Republic of Congo.

(*bottom*) A group of gorillas approaching a camera trap. Gorillas live in groups with one dominant male and multiple females. These groups grow slowly over time as more young are born into the unit. Western gorillas have smaller groups than the mountain gorilla, typically with only four to eight animals.

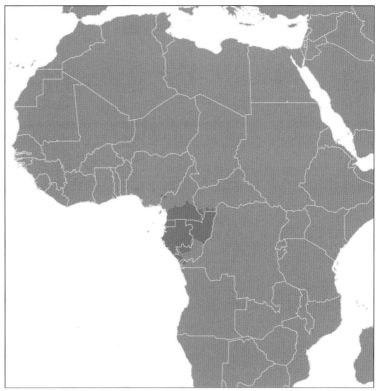

The western gorilla uses a broad swath of lowland rainforest across central Africa—or at least it did use this area, until recently, when out-of-control bushmeat hunting and epidemics of Ebola swept across the region, eliminating this great ape from many forests. The bushmeat hunting has intensified since logging roads opened up previously inaccessible areas to hunters. The Ebola epidemic surprised conservationists and disease ecologists alike, and where it originated remains unknown. What is clear, however, is that Ebola can have decimating effects on infected gorilla populations, reducing them by 95%, or eliminating them completely.

What is concerning about these problems for gorillas is that both affect them within otherwise pristine habitat, even in the most remote areas. A number of the Ebola outbreaks were not initially noticed, but only deduced later when scientists surveyed remote areas and found no gorillas where there previously had been many. Although gorilla reproduction rates are slow, there are some signs that their populations can recover after crashes due to hunting or disease. Tracking the declines and recoveries of gorilla numbers over these remote areas is challenging, and many traditional methods have since been found to be unreliable, or too difficult to scale up. A few recent studies with camera traps suggest that they could be a useful

tool to help count and protect gorillas.

Gorillas have unique faces and can often be identified from photos. One study lead by Josephine Head in Loango National Park, Gabon, was able to count 52 individual gorillas living in eight social groups, with an overall density of 0.46 animals/mi² (1.2 animals/km²). Repeated monitoring across their range could help the conservation community protect the few remaining gorilla strongholds and encourage the recovery of other populations.

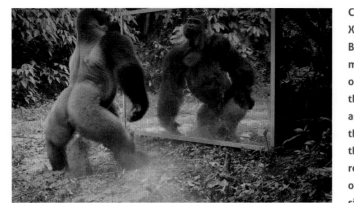

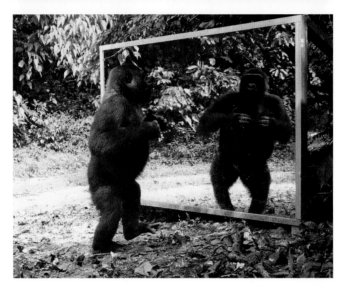

Camera trapper Xavier Hubert-Brierre put this large mirror on the side of a road through the jungle in Gabon and left a camera there to record how the animals would respond to their own reflections. A silverback gorilla saw another silverback in its own reflection and responded with aggression, trying to scare off a potential challenger. However, his younger son sees a playmate in his own reflection and walks up to kiss the mirror.

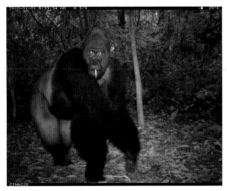

Gorillas eat mostly leafy vegetation but supplement this with fruit when they can. One camera trapping study found evidence that elephants might compete with gorillas for fruit and exclude them from the most productive areas during some seasons.

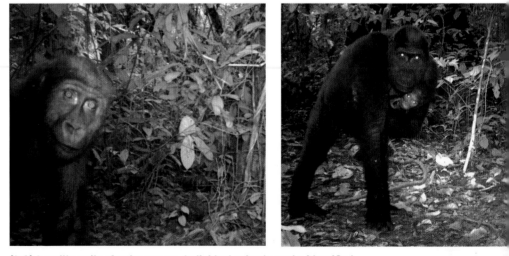

(*left*) A gorilla smiles for the camera. Individual animals can be identified and counted from photos like this based on their unique faces.

(*right*) A new mother carries her baby with one arm while walking through the Congo rainforest.

Bornean Orangutan *Pongo pygmaeus*

CONSERVATION STATUS: Endangered

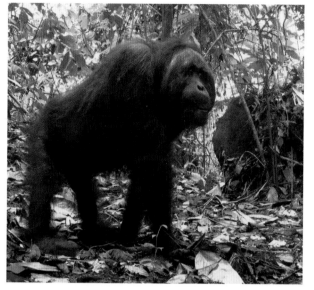

A large male orangutan walks across the forest floor in Borneo.

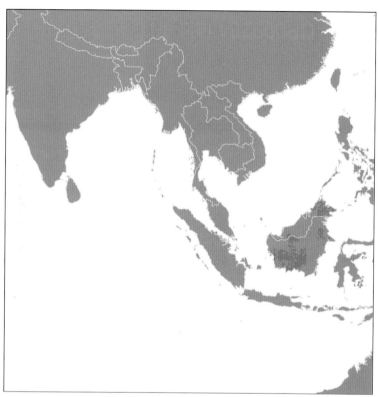

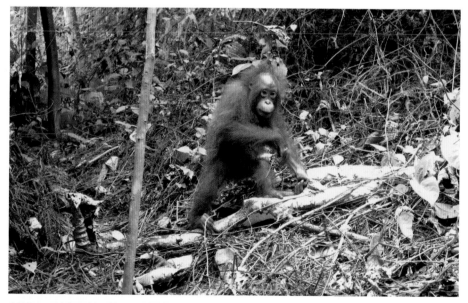

A baby orangutan crosses a gap in the forest to catch up with its mother.

Orangutans are the only great ape species in Asia, and the most arboreal. Their long arms, dexterous feet, and legendary strength help them climb through the trees. Orangutan males can weigh up to 260 lb (118 kg), making them the largest arboreal species in the world. Climbing from tree to tree is dangerous for such a large species, as they are more likely to break branches and to injure themselves from a fall; presumably, the benefits of finding fruit and avoiding terrestrial predators are worth it for orangutans.

Like much of Asian forest wildlife, orangutans are losing their habitat as logging and development push into the last strongholds

of the species. This not only destroys some habitat completely but also degrades and fragments continuous-canopy forests, making it more difficult to get around by moving from tree to tree. Some conservationists have suggested that this degradation forces orangutans to come to the ground more often than they would like to, making them more vulnerable to predators. Testing this idea by observing orangutans in person is biased because the animals might climb trees to avoid the ground-based human observer. Camera traps provide a less biased view on orangutan behavior, and two studies from intact forests confirmed that all age-sex classes use the ground, even when continuous tree canopies are above them. This shows that terrestrial movement is more a part of the orangutan's natural behavior than previously thought. This behavior could actually help them deal with degraded forests, where more dedicated tree climbers would find themselves isolated on small "islands" of tall trees.

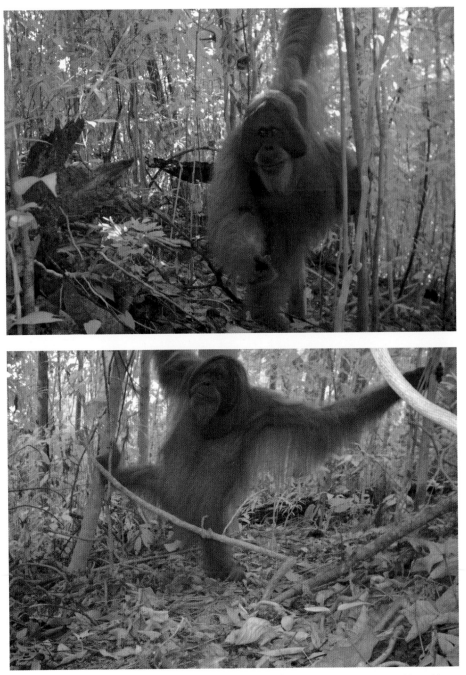

A flanged male uses trees to keep himself upright as he walks through the forest. Males grow flanges, distinctive cheek pads and throat pouches, when they are 15 to 20 years old. Flanged males are larger than unflanged males and preferred by most females. Camera traps record flanged males on the ground more often than unflanged males, probably reflecting the relative danger of such a large animal moving through the canopy, where they would be more likely to break a branch and fall.

Golden Snub-nosed Monkey *Rhinopithecus roxellana*

CONSERVATION STATUS: Endangered

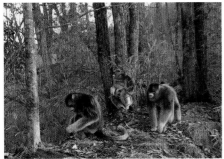

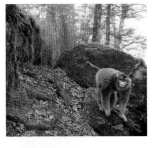

A group of golden snub-nosed monkeys walk along a ridge in their deciduous forest habitat.

Snub-nosed monkeys have blue skin on their faces and penises.

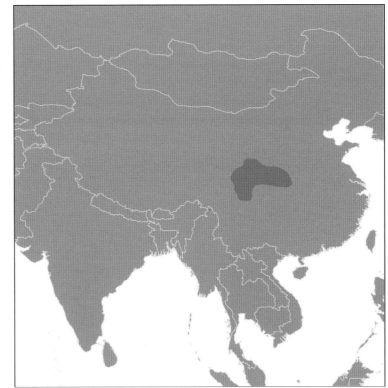

Young snub-nosed monkeys have very long fur to help keep them warm.

When you think of monkey habitat, you generally picture a lush tropical forest, or maybe a hot African savanna. The golden snub-nosed monkey breaks these stereotypes by living in montane deciduous forests that can have snow on the ground for half the year. Found only in China, these unique primates eat leaves and fruit during the summer. Unable to hibernate or migrate, their secret for making it through the winter is to feed on lichens. Lichens are low in nutrition but can be found year-round, especially growing on dead trees.

Another problem faced by monkeys in the winter is staying warm. The golden snub-nosed monkey has longer fur than most primates,

giving them extra insulation. These social animals also huddle together in clusters to sleep for the night, or when taking a midday break. The monkeys climb into the trees for these snuggle fests to stay out of the way of predators such as leopards or dholes, but they only climb into the midcanopy, avoiding the cold winds at the tops of trees.

The species has large social groups, ranging from 40 to 60 in the winter up to 600 in the summer. Various groups splinter off or merge back together through a "fission-fusion" process. Within these groups there are also smaller subgroups of a few females and their young, attended by one male, which function as a type of

harem. In addition to providing warm places to sleep together, the groups help defend against predators; monkeys place their young in the center, and the stronger adult males rush to the scene of the alarm.

The species is threatened by habitat destruction and by selective logging. Locals sometimes cut down the dead trees to use as wood, removing the best places to find lichens in the winter. Camera trap surveys can map where these monkeys still roam, helping to target conservation efforts.

A monkey hides behind a rock after noticing the cameras.

Pig-tailed Macaque *Macaca nemestrina*

CONSERVATION STATUS: Vulnerable

Pig-tailed macaques are predominantly terrestrial animals and are regularly photographed by camera trap surveys.

Macaques are strongly diurnal, with only 3% of photographs taken at night. They have a peak of activity in the morning and are about half as active in the afternoon.

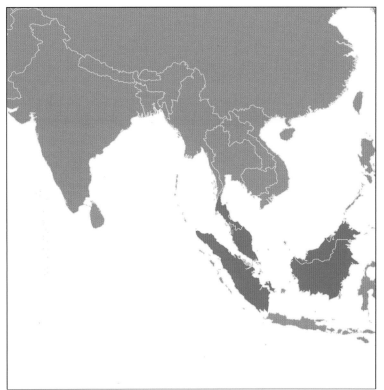

Activity Level

0:00 6:00 12:00 18:00 24:00

Most camera trap surveys in Southeast Asia are not designed specifically to study macaques, but all of them still get a lot of photos of this terrestrial monkey. The pig-tailed macaque is one of the most common mammals in much of its range, using primary and secondary forest, including swampy and montane areas. They can survive in agricultural landscapes, but they do best in dense rainforest. One study in Bukit Barisan Selatan National Park in Sumatra, Indonesia, found them to be twice as abundant in areas with lower human density. Another study in Borneo found them to be less common in areas that had recently been logged.

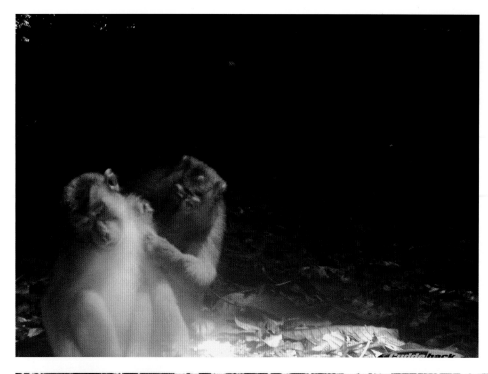

(*left*) Two macaques take a grooming break in a sunbeam. These monkeys live in social groups of 15 to 40 animals. Within these groups there is a strong social hierarchy, and grooming behavior like this helps maintain social bonds and form alliances that allow animals to improve their social ranking.

(*below*) A young macaque sits on a log considering the camera trap.

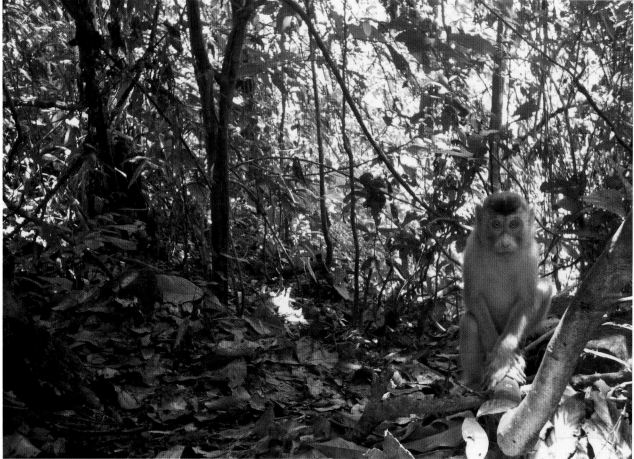

Aardvark *Orycteropus afer*

CONSERVATION STATUS: Least Concern

The long ears of this aardvark probably help keep it cool in the dry savannas of Kenya.

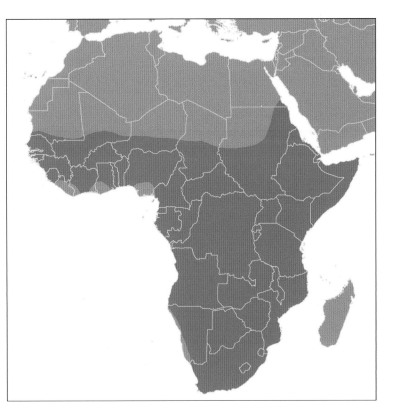

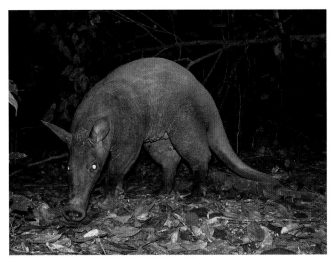

This forest aardvark from Gabon has much smaller ears and darker color than the savanna form. Currently they are classified as distinct subspecies, but their taxonomy has not been studied recently.

Considering that the aardvark starts every alphabetized list of animals and is the only species in their taxonomic order (Tubulidentata), we know surprisingly little about them. They are hard to observe in person because they are strictly nocturnal, spending the daytime in holes dug into ant and termite mounds. Camera traps show that they are not as rare as they appear based on scant visual sightings, as most camera surveys in appropriate habitat will detect them.

The mouth of an aardvark looks like a vacuum, but they do not suck termites out of their mounds. Instead, they have a long sticky tongue that they flick in and out of their extended snout. Ants and ter-

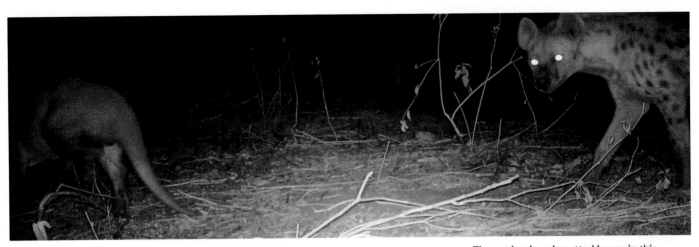

mites live throughout Africa, and aardvarks can be found in almost any habitat with big insect populations, including savannas and forests. Studies at cattle ranches suggest that aardvarks can even coexist with moderate levels of livestock.

Although currently considered only separate subspecies, the big differences in appearance between aardvarks photographed by camera traps in dry savanna and those in wet rainforests suggest that there may actually be more than one species represented in this unique mammalian order. The tidbits of new biology offered by these few photos suggest that there is still a lot more to learn about the aardvark.

The aardvark and spotted hyena in this photo look rather nonchalant, suggesting that this moment wasn't on the verge of becoming a predation event. Hyenas can kill big prey, but the aardvark's sharp claws might be enough to dissuade them. Hyenas are known to use aardvark holes as their own den sites, so maybe this hyena is just hoping the aardvark will lead it to a good place to raise its next litter.

Giant Armadillo *Priodontes maximus*

CONSERVATION STATUS: Vulnerable

A giant armadillo rears up at the entrance to its burrow, revealing its huge sickle-shaped third claw, used for digging.

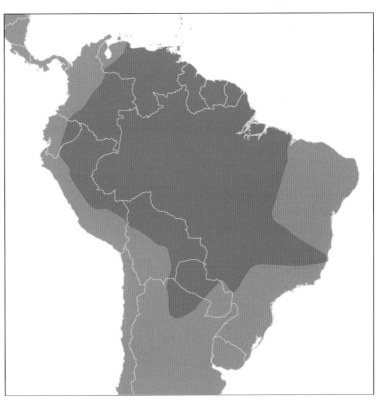

The world's largest armadillo feeds on some of the smallest prey—termites and ants. Despite their large size (up to 119 lb [54 kg]), they are very rarely seen and remain one of the most mysterious animals in South America.

Camera trap records of giant armadillos are almost always at night, peaking at 2 a.m., which might partly explain why they are so rarely spotted by people. They spend their days sleeping in holes, which they don't fill in when they leave, making the holes much easier to find than the animals themselves. Armadillos prefer a freshly dug hole and create a new burrow every few days. Typically, these are in loose soil, but some are at the base of a termite mound, providing a bed-and-breakfast for the insectivorous resident.

Other animals like the armadillo holes too, and camera traps at their entrances have detected 24 species of vertebrates using the structures. Peccaries actually use the mound of sand in front of the burrow as a dust bath, while coatis and foxes have been recorded digging through the dirt pile searching for grubs or worms. Sixteen animal species actually went down into the hole, searching for their own resting spot. The incredible activity around these burrows shows how important giant armadillos are to the animal communities in South America, suggesting that they may be functioning as a sort of "ecosystem engineer."

Although their holes can be common, the giant armadillos themselves seem to be rare everywhere. Only one study, led by Andrew Noss, has collected enough data to estimate their density, finding about five animals per 40 mi² (100 km²) in dry forests of Bolivia. Other studies get fewer photos, suggesting even lower densities. However, they have been found in a variety of habitat types across South America, including rainforest, scrubland, and natural grasslands, so they do not seem to be habitat specialists. They are moderately sensitive to deforestation but are surviving in some developed areas, such as the Atlantic Forest of Brazil, and thus might be able to coexist with people if some habitat is set aside for them. As scientists run more camera traps in these areas, we'll get a better count of these mysterious mammals and a better indication of how we can maintain these giant diggers, so important to all the other hole-loving species of South America.

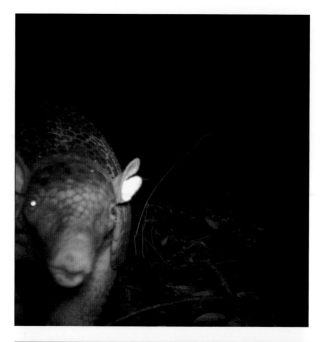

A giant armadillo inspects the camera trap.

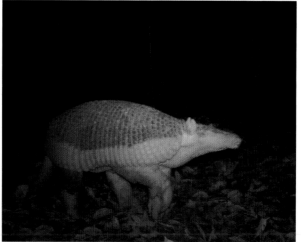

Giant armadillos can be individually identified by good photographs based on the position of the lateral line separating their darker back from their paler underside.

Giant Anteater *Myrmecophaga tridactyla*

CONSERVATION STATUS: Vulnerable

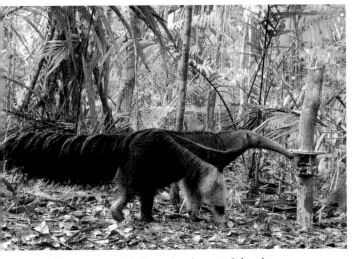

Giant anteaters' tails can be almost 3 ft (1 m) long and are used as a blanket to keep the animal warm when sleeping.

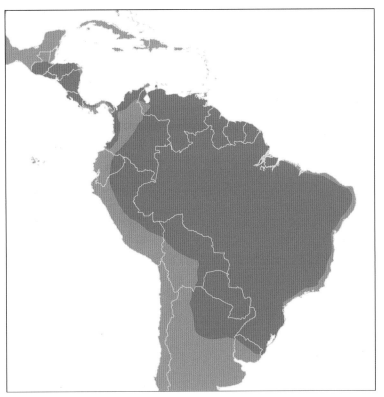

Giant anteaters are conspicuous residents of the open habitats of South America, where they can be seen running through the grass or shrubland during the day, moving between termite or ant mounds. In the Cerrado grasslands of Brazil camera traps show that they actually are more (60%) active at night, and ecotourism groups sometimes find them sleeping in the grass during the day. They do not have good eyesight or hearing and can be killed when they cross roads without noticing oncoming cars, or when fields are burned and they fail to escape in time.

Their front feet have five toes, two of which have elongated claws adapted for digging into ant and termite nests. They fold their front fingers under to walk on their knuckles, keeping their claws sharp for digging or fending off predators. Only cougars and jaguars are large enough to risk an attack on a giant anteater, and neither appears to seek them out as easy prey, only hunting them in proportion to their abundance in an area.

Giant anteaters also use forested habitat, but in these areas they are harder to find, and their distribution appears to be quite patchy. They might be the rarest mammal species in Central America, where there are very few records of any kind, despite their conspicuous habits. They appear to be extinct

in Belize and Guatemala and confined to a few highland regions in Costa Rica. A recent survey by David Gonthier along the Sikre River in Honduras captured four photos of giant anteaters, showing that they still survive in this forest. Why some forests are better habitat than others for giant anteaters remains a mystery.

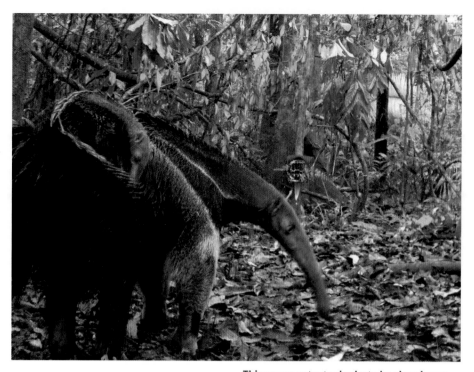

This young anteater looks to be sleeping as it hangs on to its mother's back in a Bolivian rainforest.

This oversized youngster is still riding around on its mother in the Brazilian Pantanal. Females will carry their young for six to nine months, or until they are about half her size.

Giant Pangolin *Smutsia gigantea*

CONSERVATION STATUS: Vulnerable

A giant pangolin rears up, showing its fierce claws. Its heavy tail acts as a counterbalance, allowing the pangolin to run along with very little weight on its front feet, keeping its claws sharp for digging into termite or ant mounds.

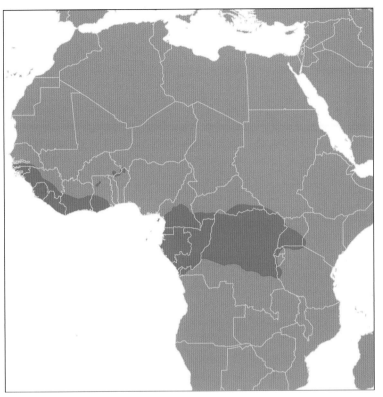

Pangolins are bizarre mammals with scales that protect them from larger predators, as well as the small bites of their ant and termite prey. They are shy, solitary, nocturnal animals that have rarely been studied. Even estimates of population numbers for the giant pangolin, the largest of the eight species worldwide, are lacking. This 70 lb (30 kg) mammal has always been threatened by local bushmeat trade, but conservationists are now worried that its big scales may have attracted an international clientele, which could increase hunting levels above what is sustainable.

The pangolin's scales are made of keratin, the same material that makes up our fingernails. Despite scientific studies showing a lack of any medicinal benefits of keratin, some Asian cultures believe that pangolin scales can cure a variety of maladies. The meat of these animals is also considered a delicacy, fetching high prices in the black markets of China. The illegal trade in pangolins has increased in recent years, being efficiently expanded by crime organizations.

Because we have no estimates of pangolin populations as reference points, it's unclear what effect this illegal-market trade is having on the species. The huge hauls of confiscated dead pangolins at some black markets, combined with the slow reproductive rate of pangolins, have some conservationists

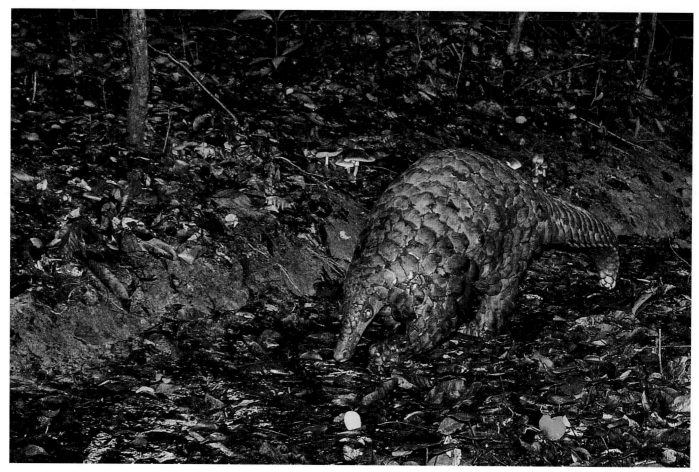

The scales of a pangolin can make up to 25% of their total weight.

worried that pangolins will not be able to sustain the pressures and may soon become extinct. Given the urgency of the situation, conservationists are acting on three fronts simultaneously. In Asia, they are trying to change the culture of eating these strange animals, to reduce the demand. Globally, they are policing the international trade to fight the organized crime rings running illegal cargo of animal parts. Locally, on the ground in African and Asian forests, they are patrolling for poachers and using camera traps to try to determine where the pangolin populations persist.

Pangolins roll into balls when threatened by predators, trusting their thick scales to protect them from talons or teeth. Unfortunately, this strategy doesn't work against human poachers, who are increasingly targeting them to satisfy the high demand for their meat and scales from Chinese markets.

Wombat *Vombatus ursinus*

CONSERVATION STATUS: Least Concern

A common wombat exits a burrow with her young joey. Wombats have just one offspring at a time, which is dependent on its mother for at least 17 months. This slow reproductive rate makes it difficult for their populations to bounce back after declines, increasing their risk of extinction.

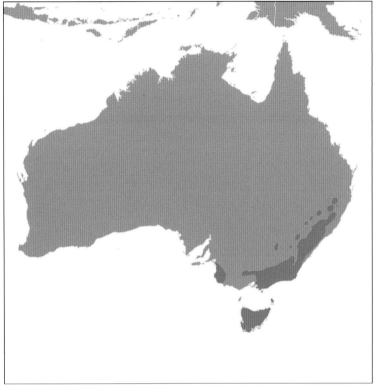

Wombats look like big rodents but are actually marsupials, living only in Australia. Like many rodents, wombats live in extensive burrow systems and come above ground to graze on grasses. Despite their woodchuck-like appearance and habits, their marsupial ancestry is clear from the pouch they use to keep their young safe. The wombat's pouch is unique in facing backward, which prevents it from collecting dirt as they dig new burrows. The northern and southern hairy-nosed wombats are endangered as a result of competition for grazing land from livestock. The common wombat is the most common of the three wombat species, although they are not common everywhere. In some places they are so abundant they are considered a pest, whereas in other parts of their former range they have disappeared completely.

In areas where their populations are doing well, wombats can be the animal most frequently photographed with camera traps. For example, of the 1,480 images recorded in one survey by Philip Borchard, 80% were of common wombats, with fewer records of swamp wallabies (12%) and invasive red foxes (8%). Some people consider wombats a pest because they burrow under buildings or fences. One study tested the use of floodlights to scare wombats away from buildings, using camera traps

P.A.BORCHARD

A wombat makes its way through the crawl space of a house, where it has made its home. Researchers hoped that floodlights would dissuade the animals from using the area, where they were digging holes into the foundation, but camera traps tallied no difference in wombat activity after the lights were installed.

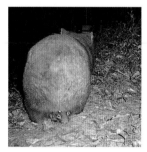

This mother wombat appears to be sitting on its joey, but the youngster is actually peering out from the comfort of its pouch, which faces backward to avoid collecting dirt when the mother digs a new burrow.

to measure animal activity before and after the lights were installed. Unfortunately, they found no effect, concluding that the wombats didn't seem to mind the light.

At the edges of their range common wombats are rarer, and conservationists are working to help the species. For example, managers found that maintaining forest cover near drainage culverts increased the rate at which wombats used these tunnels to cross under a road, thus avoiding becoming roadkill. Managers also found that they can use camera traps to monitor the rate of mange infection in wombats, which is a problem anywhere they come into contact with invasive red foxes, which carry mange. Foxes often use the burrows constructed by wombats, and this is one way that mange is spread. Another camera study led by Borchard found that 45% of wombats

had some mange infection. Infected animals have thinner fur, and Borchard also discovered that these infected animals were more active at day, when temperatures were warmer.

Tasmanian Devil *Sarcophilus harrisii*

CONSERVATION STATUS: Endangered

A Tasmanian devil runs away from a small bird carcass that served as its recent meal. When feeding on larger carcasses, devils can eat up to 40% of their own body weight in one sitting, leaving them heavy, lethargic, and unable to run around.

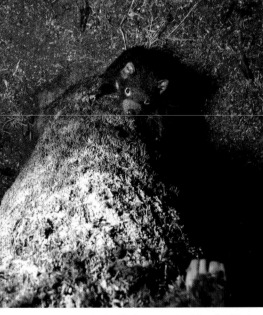

A young devil climbs a tree looking for bird eggs, insects, or possums. Young devils are good climbers and have two times more arboreal prey in their diet than older animals, which are heavier and not as good at scaling trees.

Although the Tasmanian devil is only the size of a small dog, it is the largest surviving predatory marsupial. It now lives only on the island of Tasmania, but fossils show that it previously lived on mainland Australia, becoming extinct there about 3,000 years ago, after the arrival of dingoes and humans. These stocky and muscular animals have oversized forelegs and a large head, which can deliver an exceptionally strong bite for its size. These traits help them hunt prey up to the size of a wombat or wallaby, as well as scavenge on carcasses. Their unique appearance, a loud screech, and ferocity when feeding have made them an iconic symbol of Tasmania.

Devils were historically common across all habitats of the island. They generally tolerated people well, reaching their highest densities in mixed landscapes of grazing land and forests, and they sometimes denned under houses. Their populations were stable. All of this changed in 1996 when a single cell on the face of a single Tasmanian devil on Mount Williams mutated into a unique transmissible cancer that has now spread throughout the island and reduced the species by 80%–90%.

Devil facial tumor disease is one of three transmissible cancers known on earth. Managers have monitored the decline, but with no vaccines available, they have few

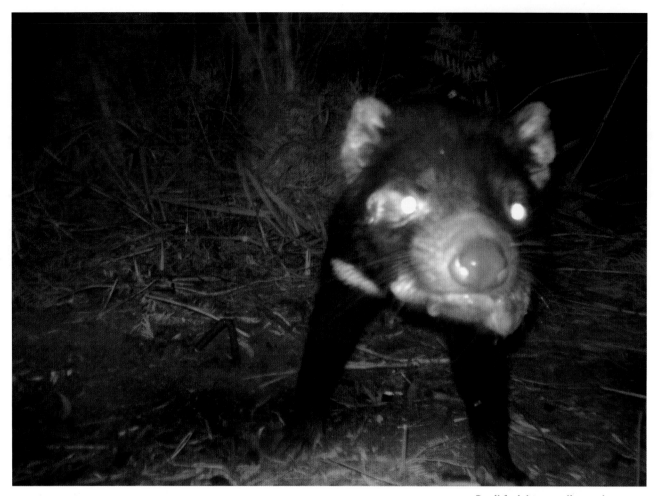

options but to watch as the tumors spread across the island population. Conservationists established an "insurance population" in Maria Island National Park, hoping that this isolated oceanic island would offer a safe haven from disease, should the main population go extinct.

Recent monitoring suggests that the insurance policy may not be needed after all. For example, devils at Freycinet National Park suffered only a small initial population decline when the cancer first arrived, but the population has since bounced back. The tumors can be identified in good camera trap photos, allowing officials to see that it was never common in the park, and that it has declined since 2006, with no incidences in the past two years. Another survey of "ground zero"—the Mount Williams site where the facial cancer first appeared—found devils at 67% of the sites they surveyed, despite model predictions that they should be extinct there by now. The tumor is still a major cause of concern, but these recent survey results offer hope that the species may be evolving a response that will allow it to bounce back and maintain its iconic status in Tasmania.

Devil facial tumor disease is a rare transmissible cancer that originated through mutation in 1996 and has decimated devil populations across much of the island. It is often visible in camera trap photos such as this one, which can be used to determine the infection rate for a population.

Sumatran Striped Rabbit *Nesolagus netscheri*

CONSERVATION STATUS: Vulnerable

The Sumatran striped rabbit is one of two species in the genera Nesolagus, with the closely related Annamite striped rabbit from Indochina being similarly rare and mysterious. The purpose of the stripe, unique in the world of rabbits, is unknown.

The Sumatran striped rabbit is probably the rarest lagomorph in the world. It is known from only seven locations in rich volcanic soils above elevations of 2,000 ft (600 m) in Sumatra. It is one of the few rabbits that choose to live in dense rainforests, and it is one of two striped rabbits in its genus. It apparently comes out only at night, and it is so rare and hard to observe that it is not even known to most local people. There were about a dozen museum specimens collected between 1880 and 1916, which were used to describe the species to science. Many decades passed with no additional sightings, until one striped rabbit was spotted in 1972. But three follow-up expeditions looking for the rabbit could not find them, and the species was feared to be extinct.

Fortunately, the rabbit was still there, hiding in the dark nights of the Sumatran forests, as confirmed by a camera trap photo in 1998 captured by Jennifer McCarthy. Subsequent surveys have shown that the animal still survives in Bukit Barisan Selatan and Kerinci Seblat National Parks. The species seems to be naturally rare, and its small geographic range suggests that it is still in danger of becoming extinct. Both of these parks face human encroachment and deforestation along their borders, which further threaten the habitat of this shy animal.

Although this scattering of camera trap photos over the past few decades has shown that the Sumatran striped rabbit is not extinct, we still know little about its ecology or behavior. How this unique rabbit survives in dense forest, whereas most rabbits prefer edge or open habitats, remains a mystery, as is the function of the racing stripe that gives it its name.

A Sumatran striped rabbit hops through the dark forest of Bukit Barisan Selatan National Park at night.

Thomas's Flying Squirrel *Aeromys thomasi*

CONSERVATION STATUS: Data Deficient

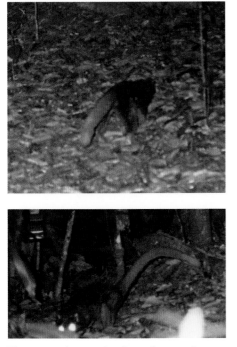

These two photos stirred up a frenzy of attention and controversy when they were published as evidence of a mysterious new species of carnivore from Borneo.

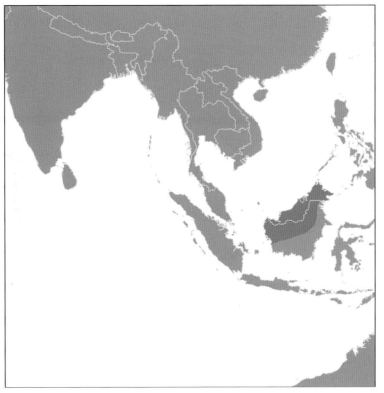

The publication of these two photos of an unknown reddish animal in 2005 stirred up a storm of interest and controversy. The photos were captured two years prior, in Kayan Mentarang National Park, East Kalimantan, Indonesia. The animal wasn't familiar to the scientists or to locals. Some suggested that it was a new species, unknown to science, probably some kind of civet or mongoose. The discovery of new carnivorous species is big news and attracted a lot of positive attention for the national park, but also a lot of scrutiny from biologists. A team set live traps in the forest, hoping to catch the new carnivore, but had no success.

In 2006 three skeptical scientists published a comprehensive evaluation of these two photographs against 17 known species from the region, comparing 13 different morphological characters. They found that the Thomas's flying squirrel was the best match, fitting every character except the way that the tail was held in the air as they walk on the ground, which is actually not known for this species. This little-known flying squirrel spends most of its time in the trees and so is rarely captured by camera traps on the ground. Using museum specimens and other photographs, an artist drew the squirrel in the poses shown by the images, offering a compelling and more likely interpretation. The squirrel

in question is actually quite rare and unknown itself, so these two photos are still important in adding to our knowledge of their habitats.

This case illustrates the importance of vouchers in two ways. First, it shows how vouchered camera trap photographs can be examined by multiple experts to reach a consensus identification—this cannot be done for observations without photo documentation. Second, this shows the importance of having a physical specimen vouchered in a museum before describing a new species, as photographs alone typically do not provide enough evidence to adequately describe a new form of life.

Scientists later concluded that the photos were most likely of a Thomas's flying squirrel, and they commissioned this illustration showing the squirrel in the poses captured by the camera trap.

Common Vampire Bat *Desmodus rotundus*

CONSERVATION STATUS: Least Concern

A vampire bat rides through the forest on the back of a cougar in Peru.

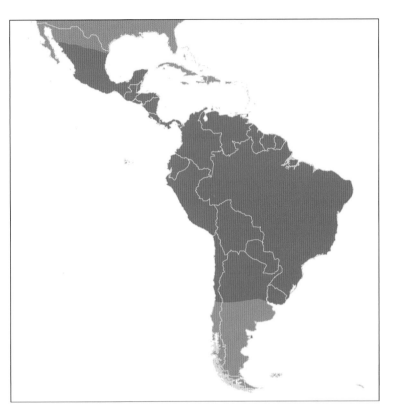

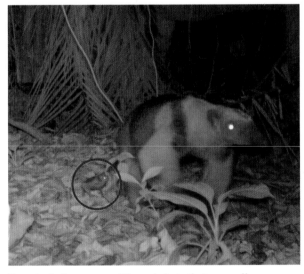

Vampire bats are one of the only bats that can walk on the ground, as shown by this bat sneaking up on a tamandua. Vampire bats have to be very agile to dart in and make a small incision that starts the blood flowing and avoid getting stepped on. They then follow along as their oblivious, bleeding prey walks through the forest, dashing in occasionally to lick the oozing blood from the wound.

The camera trap is not a traditional tool of bat biologists. Camera traps with very fast triggers occasionally photograph bats on the wing, but these swift mammals have usually flown out of view by the time a photograph is taken. However, when a vampire bat is riding on, or walking beside, their larger prey, the camera can return a remarkable snapshot of this bloodsucking parasite at work.

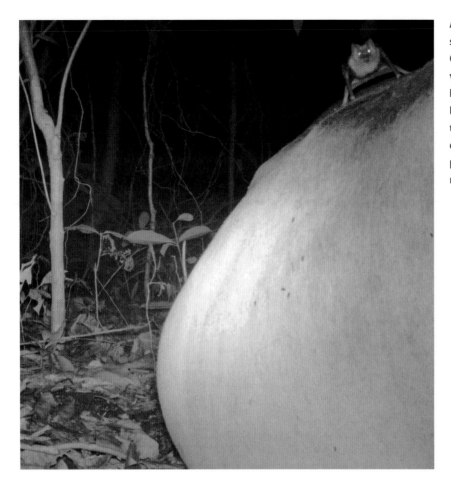

A vampire bat feeds on a cow that is sleeping at the forest edge in Panama. Cattle are now a primary food for vampire bats, and the bats reach their highest densities near cattle ranches. Ranchers hate vampire bats because their feeding slows the weight gain of individual cows, reduces milk production, and could even transmit rabies to the herd.

Sumatran Ground Cuckoo *Carpococcyx viridis*

CONSERVATION STATUS: Critically Endangered

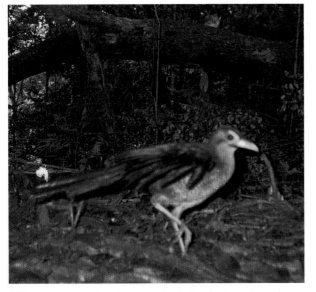

A Sumatran ground cuckoo parades in front of a camera in 2007, registering only the second record of this species since 1916.

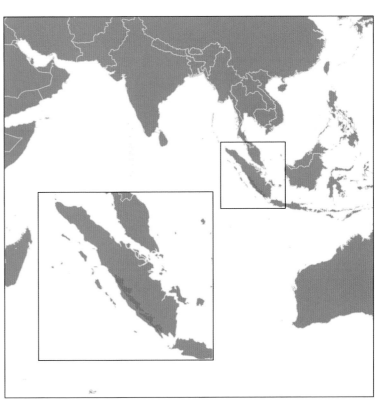

The Sumatran ground cuckoo is a very difficult bird to observe. There were no confirmed accounts of this species between an expedition in 1916 and 1997, when one was accidently caught in a small mammal trap in Bukit Barisan Selatan National Park. Another decade passed without sightings, and the species was again feared to be extinct. Then, in 2007 camera traps placed by tiger biologists photographed a cuckoo walking back and forth in front of a camera. Inspired by this discovery, another biologist dug into his archives of photographs from 2006 and found a photo of a Sumatran ground cuckoo that had been misidentified as a dove.

The case of the Sumatran ground cuckoo illustrates the importance of keeping all the photographs from a camera trap survey in an archive that can be reexamined by different scientists to address research questions that might not have been part of the original motivation. In this case, photos of small birds would have been considered "bycatch" by the tiger biologists, but they were key data for ornithologists. As data and photographs accumulate from camera trap studies around the world, it is paramount to create reliable data archives accessible to future generations of biologists interested in testing their own unique questions, or in comparing the status of animal populations over time.

These two records prove that

The bird in this blurry photograph was originally identified as a dove, but the colorful eyebrow gives it away as a Sumatran ground cuckoo. Camera traps are set to have the distant background in focus, and so any animals too close to the camera are likely to be out of focus.

the Sumatran ground cuckoo is still alive, as well as suggesting a clue about their habitat needs. The 2007 photograph was taken in disturbed forest that had been left to recover near a national park. If the Sumatran ground cuckoo can persist in this type of modified forest, it gives more hope for its future survival.

With its wings out, it looks like this animal might be displaying, perhaps fooled by its own reflection in the lens of the camera trap. Nothing is known about this bird's mating behavior.

Black Cod *Epinephelus daemelii*

CONSERVATION STATUS: Near Threatened

A large adult black cod approaches a baited underwater video station in the rocky reefs of eastern Australia.

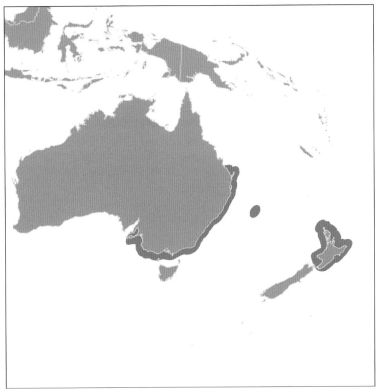

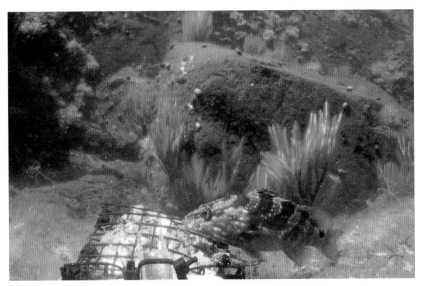

Juvenile black cod are colored to be camouflaged in their rocky pool habitat and can even change their shading to match the lighting conditions.

The black cod is a big beautiful fish that also has the misfortune of being delicious. In the face of heavy line fishing and spearfishing from the 1950s to 1970s, this species suffered a severe population decline. Although protected since 1983, the black cod has failed to regain numbers, in part owing to their slow growth rate and late maturity. Out in the deeper waters around rocky reefs some large adults are now seen by snorkelers and photographed by baited remote underwater video stations (BRUVSs). However, young fish are almost never seen, raising concerns over the next generation of black cod.

Juvenile black cod are variable in color, and a few have been re-

This photo and sketch (*inset*) show the mini-BRUVS used to survey for juvenile cod in small rocky pools. Fish bait is placed in a mesh bag on a pole 12 in (30 cm) from the camera.

ported from near-shore reefs, estuaries, and rock pools, where they are very well camouflaged. To try to learn more about these young fish, David Harasti and his team created a new mini-BRUVS that could fit in small rock pools. They used this system in 412 sites along 500 mi (800 km) of coast off of New South Wales, Australia. The system was effective at documenting the juvenile black cod, and video footage even showed how their coloration would lighten within seconds as they moved from their shadowy hiding places to feed on the bait bag.

Unfortunately, the young cod are as rare as the adults, being found in only 5% of the sites they surveyed. Twelve were found in rock pools and eight in shallow intertidal reefs. Video footage showed their preference for using boulders and rock overhangs, as well as their complete avoidance of areas dominated by algae. These remote cameras proved the importance of near-shore waters as nurseries for the black cod, but the study also raises new concerns over their rarity in Australia.

Animal Neighborhood Watch

Biologists initially used camera traps to try to study a specific target species, such as tigers or jaguars, and were frustrated to be wasting film on "bycatch" photographs of other warm-blooded species walking by. Now that digital cameras have freed us from the limitations of 36 images per roll of film, these nuisance photos have been discovered to be a gold mine of data. Many modern scientists use camera traps to get a view of the entire animal community, not just one species, documenting the natural "neighborhood" of animals.

Sometimes this research creates a starting point for understanding what lives in natural areas, but the real strength of this approach is in making comparisons across areas. Often these studies are designed to understand the impact of human activities on wildlife, with the hope of finding solutions for humans and wildlife to coexist. This section of the book highlights some of the most interesting community studies, graphically summarizing their results with artwork by Eric Knisley, and introducing the animal characters with photographs from the original research.

The first three studies show how camera traps can be used to document the most basic patterns of animals on the landscape. Research from China shows how leopards are replaced with snow leopards, and giant pandas with red pandas, as you move up the Himalayas. Studies in a variety of large and small islands in the Panama Canal allowed scientists to discover that larger species disappear from communities as the size of a natural area decreases. Remote cameras are also useful underwater; they are being used in Australia to help figure out where marine nature preserves should be placed to protect the maximum diversity of fish. The fourth example in this section discovered a remarkable difference in animal communities

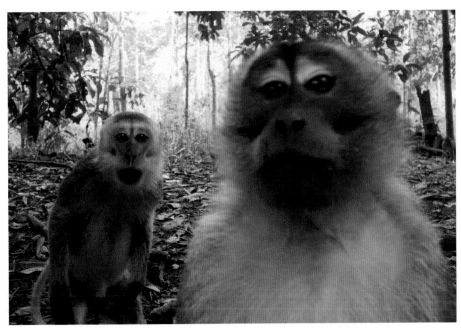

Long-tailed macaques are a common species in Southeast Asia and live a bold and curious lifestyle. Although about half of their diet is fruit, they are always on the lookout for a small insect or lizard to pounce on. They also beg for handouts from tourists, congregating in huge groups at temple sites.

Chaos breaks out at a water hole in Namibia as lions harass a black rhino. With their thick hide and dangerous horns, healthy adult rhinos are generally safe from lion attacks, but prides will pester the big animals to probe for weaknesses.

Birds are not usually the target of camera trap studies, but they are an important part of the animal community. Any large species that walks along the ground is likely to be picked up by camera traps. This photograph captures a jabiru stork fishing a Synbranchus swamp eel out of a marsh in the Pantanal of Brazil.

Across their range, northern raccoons are typically one of the most common mammals, especially in areas that have water or human development nearby, supplying streams or rubbish for them to forage through. This animal from the Florida Keys has plenty of people and water around to live a prosperous raccoon lifestyle.

A pair of golden jackals are focused on something happening down in the valley of these Pakistani mountains. As a mesopredator, jackals can have strong influences on smaller prey species, but they also have to look out for larger predators, such as wolves.

over the course of a day, but in the same space, finding over 8 times more animal activity climbing through the tropical trees at night than during the day.

The rest of this section gives examples of applied research addressing the conservation challenges associated with trying to find ways in which humans and wildlife can share the planet. Studies in the giant cities of Japan and the United States show how wildlife varies along urban-rural gradients, discovering that some species are quite good at adapting to thrive in developed areas, while others need wilderness. Research examples from Yemen and Kenya show how livestock grazing affects wildlife communities, documenting which animal species are the most sensitive to this type of disturbance and which can coexist with moderate levels of stocking. Some protected areas in Canada and the United States are used intensively for recreation, including hunters and hikers, and camera traps are helping us learn how animals react to this use, finding that some prey

species even take advantage of humans as a shield of protection against their predators. The final two studies look at two intense ways that humans use the landscape, logging and palm plantations, to see how wildlife responds, as well as how management might change their practices to help the native species survive while still allowing people to commercially use the forest.

From treetop to ocean bottom, rainforest to desert, these examples show the diversity of places in which scientists are using camera traps to study animal communities. The results are interesting, sometimes surprising, and hopefully useful to conserving the planet's biodiversity. The photos are also amazing, doing their own part to introduce the animal characters in these conservation dramas and help people realize the importance of saving some of our planet for the animals.

CHINESE MOUNTAINS

Famous for their giant pandas, the mountains of China have an amazing diversity of other species, including hog badgers, porcupines, weasels, monkeys, and an array of colorful pheasants. Vegetation changes as you move

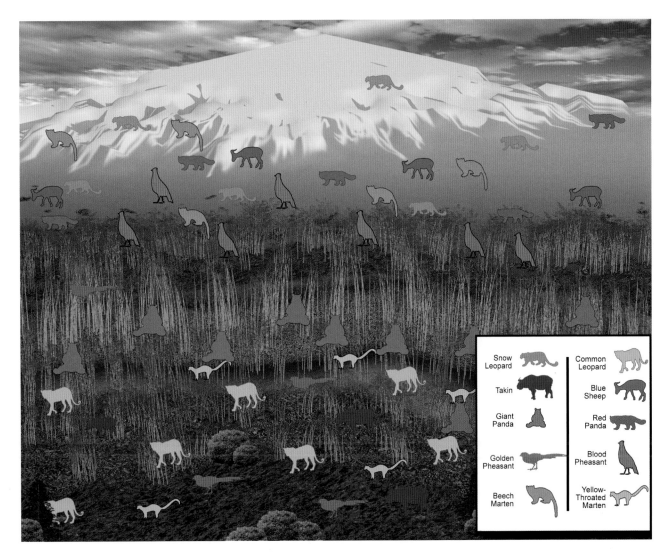

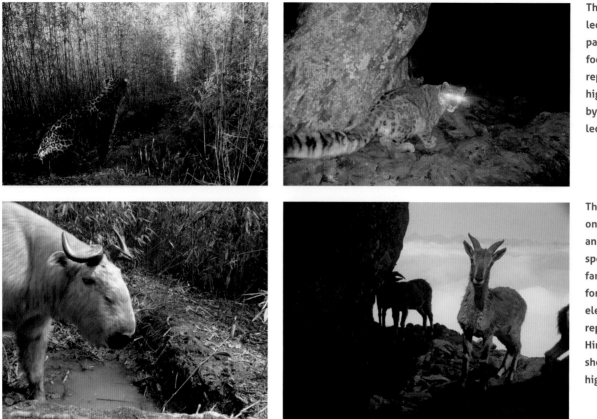

The common leopard (*left*) patrolling the foothills is replaced at higher elevations by the snow leopard (*right*).

The takin (*left*) is one of the largest and stockiest species of the goat family and roams forests in the lower elevations, being replaced by the Himalayan blue sheep (*right*) at higher elevations.

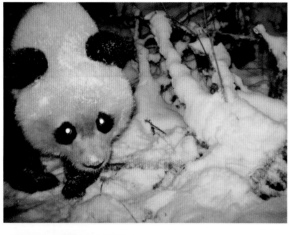

The famous giant panda (*top*) eats bamboo in the Chinese mountains but overlaps little with the red panda (*bottom*), which uses higher-elevation forests and climbs to reach the newest shoots of bamboo plants.

The remarkable golden pheasant (*left*) hunts insects and seeds in the understory of mountainous forests but doesn't go above the snowline, whereas its high-elevation relative the blood pheasant (*right*) shows a more subdued beauty.

The beautiful Temminck's tragopan (*left*) and the Chinese serow (*right*) migrate upslope during the summer but retreat to lower elevations when the weather gets too cold and snowy.

upslope from bamboo forests to mountaintop tundra—and so do types of animals. Snapshots of these high- and low-elevation animal communities were captured by camera traps run by Sheng Li and his research team.

There may be no place on earth with more colorful and diverse populations of pheasants. The brightly colored male golden pheasant is shy and surprisingly hard to observe in person, making camera trap data crucial to understanding its ecology. They are most common in the lower areas, while the blood pheasant and snow partridge predominate in the high mountains. Temminck's tragopans live at all elevations, and males have blue facial horns that can inflate to impress any passing female. The koklass pheasant ranges widely across Asian mountains but seems rare everywhere. All these birds eat grain, leaves, and insects pecked from the ground.

On the mammal side, these mountains are rich with leaf-eating ungulates. Members of the goat family predominate, with the stocky takin and its smaller cousin the goral being the most abundant species in the forest. Higher up, blue sheep pick their way through rocky landscapes. Another goat, the gorgeous Chinese serow, migrates down to lower elevations in the summer and then back up into the mountains in the winter.

Tigers used to be the top predator of the region, but they have not been seen in over half a century. Wolves and dholes were also not recorded by the cameras of this study and haven't been seen for over 20 years. The elusive leopard is better at avoiding humans, and for the few remaining in China, these forests provide a cornucopia of dinner options. Snow leopards hunt the higher elevations, while common leopards patrol the lowlands.

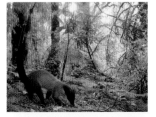

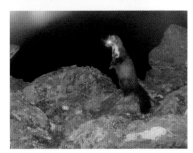

The yellow-throated marten (*top*) is more of a tropical species and uses lower-elevation forests in China than the beech marten (*bottom*), which is better adapted to forests in colder climates.

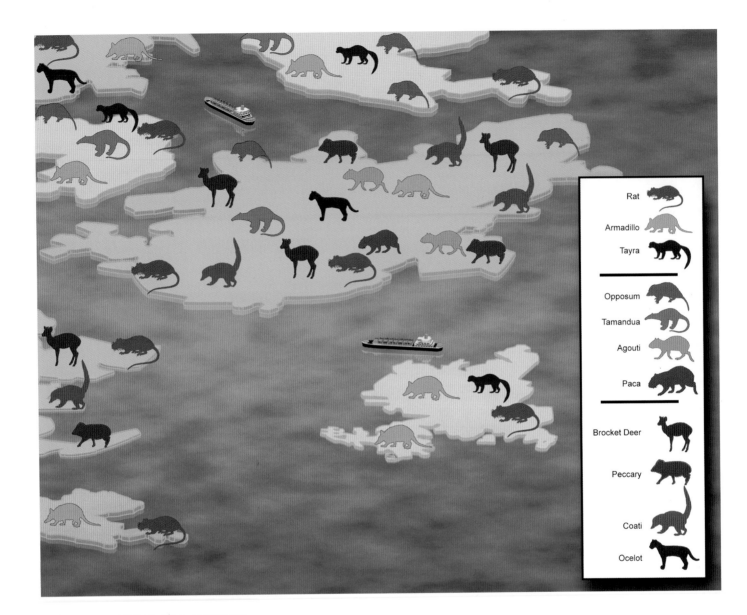

Rat	
Armadillo	
Tayra	
Opposum	
Tamandua	
Agouti	
Paca	
Brocket Deer	
Peccary	
Coati	
Ocelot	

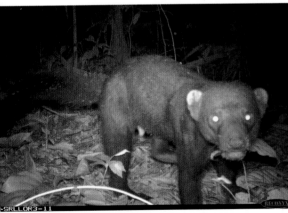

The weasel-like tayra was a surprise visitor to some very small islands, apparently swimming from the mainland to hunt the abundant rats.

PANAMA CANAL ISLANDS
Islands as Natural Experiments

Islands are like test tubes for ecologists: they offer a carefully controlled experiment to test the effects of declining habitat on animal communities. Scientists led by Helen Esser used camera traps on a series of islands and peninsulas in Lake Gatun, part of the Panama Canal, to see how much rainforest habitat each mammal species required. They additionally tested how changes in the mammals affect other species by also sampling ticks at the exact same places.

In total Esser sampled 12 forests that ranged 1,000-fold in size, from 5 to 7,000 acres (2 to 2,800 ha). Her cameras captured about 4,000 animal photos from 21 different species. As predicted, the diversity of terrestrial mammals decreased as islands got smaller, from 11 species at most mainland plots to just 2 species surviving on the smallest island. The largest

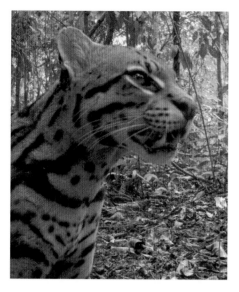

(*left*) Ocelots were the most common predator in larger forests, where they hunt small and medium-sized prey, and are active mostly at night.

(*right*) The collared peccary lives in groups, which swell to be larger in the wet season and fission off into smaller groups in the dry season.

The red brocket deer was very common on Barro Colorado Island, in the Panama Canal, but photographed less on the mainland, where it had to compete with more white-tailed deer.

mammals, such as deer, peccaries, and ocelots, were only found in the largest forests. Most medium-sized mammals were in large and medium-sized islands, but they disappeared in the smallest islands, where only spiny rats and armadillos could survive.

Tick diversity declined on smaller islands at the same rate as the mammals. Specialist ticks, those that feed on only one species of mammal, disappeared from places where their host could not survive, leaving gener-

The insect- and fruit-eating coati is a cousin of the raccoon, with a unique social structure. Females and their young form bands of a few dozen animals, while the larger males are mostly solitary. Living in groups might make the coati more sensitive to forest fragmentation, since groups have larger food requirements.

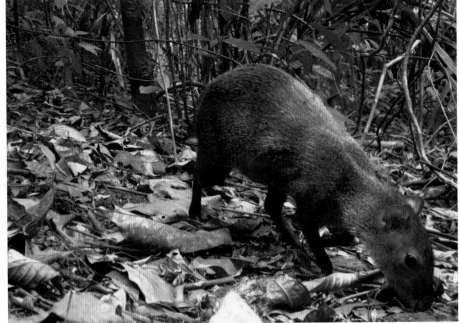

The agouti is a medium-sized rodent and was the most common mammal in the survey of Panamanian forest islands. They were present in all but the very smallest island, making up 38% of the total photos in this study.

The common opossum is a generalist species that feeds on a variety of food and is able to survive on large and medium-sized islands but not on the very smallest ones. This mother opossum is seen carrying her young on her back, now that they have grown too large for her pouch.

alist ticks more abundant. These generalists ticks that feed on a variety of animals are more likely to spread diseases from one species to another. These generalists also bite people and thus could spread new diseases to humans.

This result suggests that biodiversity, of both mammals and ticks, is critical to a healthy environment. In many ways, remnant natural areas within our cities are like these islands, isolated patches of wildlife habitat surrounded by inhospitable "oceans" of roads and buildings. Maintaining diversity in fragments of forests in urban areas may require management to make them less "island-like." For example, corridors of habitat connecting fragments, or wildlife passageways under busy roads, could help more species move between the remaining forests.

Larger Animals Need Larger Forests

The biggest animals in the study of islands in the Panama Canal survive only in the larger forests. This was not a surprise, as they have higher energy needs and must cover larger areas to find enough food. Some of these species are also social, which further amplifies the amount of food needed to sustain them in an isolated forest. Predators, such as the ocelot, are often the first to disappear from an area, since they require very large hunting grounds, compared with herbivores. Indeed, the largest cats of the region, cougars and jaguars, are now rare in the forests of the Panama Canal watershed because human development has reduced the rainforest into virtual islands, surrounded by farms and cities. Although a few of these large cats are still known to use the area, none were photographed by this study.

The fruit-eating paca was the third most common species in this study and was also found in all but the smallest islands.

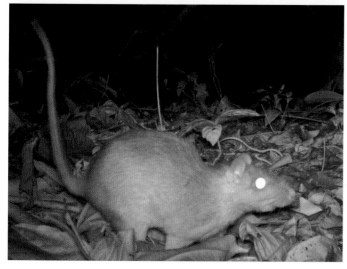

(*left*) The spiny rat was found everywhere, even on the smallest island, where it probably benefited from a lack of competitors and predators.

(*right*) The nine-banded armadillo is a good swimmer and feeds on insects, which probably helped it survive in even the smallest islands in the Panama Canal.

Tamanduas eat ants and termites, often by climbing into the trees. This study only set cameras on the ground, obtaining 13 photos of these anteaters, but only in two islands, one of which was rather small.

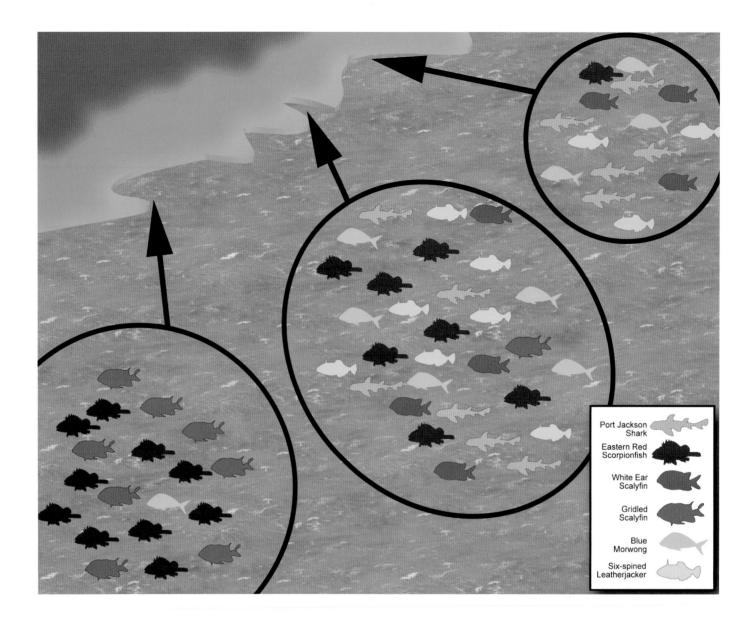

Port Jackson Shark

Eastern Red Scorpionfish

White Ear Scalyfin

Gridled Scalyfin

Blue Morwong

Six-spined Leatherjacker

AUSTRALIAN ROCKY REEF FISH

How many protected areas are needed to guard the full diversity of species? This is one of the core questions of conservation biology, and answering this requires data on which species live where. If the diversity of animals varies greatly as you move to different places, then more protected areas will be needed to have a comprehensive plan. An underwater camera trap has been important for documenting the diversity of fish on the coast of Australia, helping to advise the establishment of new marine protected areas.

To see what fish were in a given area, scientist Hamish Malcom created a baited remote underwater video station (BRUVS). The basic concept was simple: aim an underwater video camera at a plastic mesh bait bag attached to the end of a pole, and film for 30 minutes to count what fish swim by. This method turns out to be quite effective and is better at detecting shy species than visual surveys by scuba divers. The cameras recorded a variety of fish types, including plankton eaters and herbivores, showing

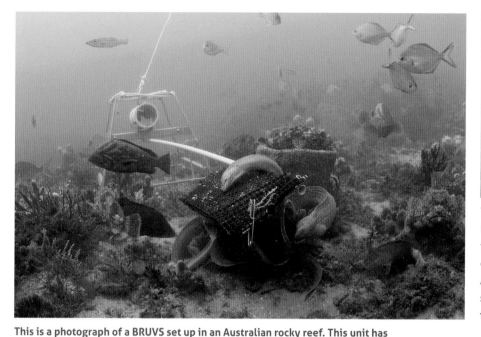

This BRUVS, set at a depth of 230 ft (70 m), has attracted four different species at once, including the Australasian snapper, which are one of the most fished species in this area. Also seen are a pigfish, a yellow-and-black-striped mado, and a blue morwong that is feeding on the bait bag.

This is a photograph of a BRUVS set up in an Australian rocky reef. This unit has attracted green moray eels, which are frequently detected with this method but rarely seen in visual censuses.

The BRUVSs were particularly effective for detecting cryptic predators like this ornate wobbegong, a type of carpet shark. This bottom-dwelling, bait-loving fish was detected consistently at most sites during a five-year survey of the Solitary Islands Marine Park. The striped mado is a plankton-eating fish and was the most common species in the survey.

that they were useful for documenting more than just those carnivorous species attracted to the bait.

For this test of how fish diversity changes throughout a region Malcom and his team deployed BRUVSs at three different marine parks in New South Wales, Australia. In total they recorded 5,874 fish from 101 species, and they suggested that more effort would record still more new species. The fish communities they discovered in the three sites were surprisingly different from each other, in both species diversity and their abundance. Schooling fish such as the Australian mado and silver sweep were the most common species, although there were big differences between sites in how common they were. With 10 species of sharks and rays, one site had twice as much diversity of this group as was recorded in either of the other two sites.

A small school of Australasian snapper join a fish called the striped mado at this bait bag. Actually related to porgies, not the traditional snapper family, this is a highly prized fish for eating and is targeted by commercial and recreational fisherman.

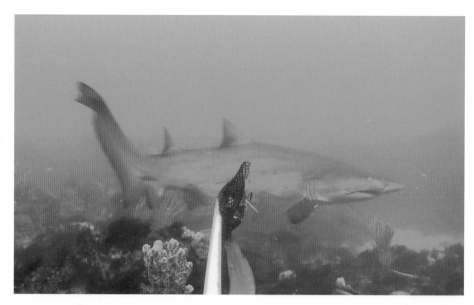

The Port Jackson shark is a specialist feeder on hard-shelled clams and crustaceans, but this one was also attracted to the fish bait used by this study. This broad-headed shark was variable across this study, being common at one site, absent from another, and rare in the third.

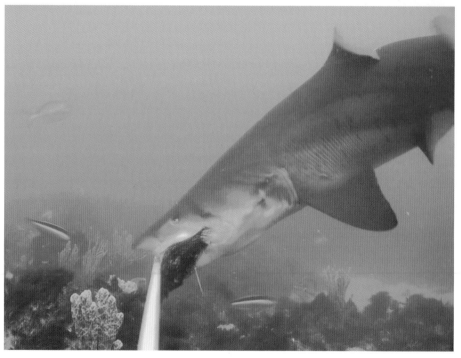

A gray nurse shark passes by to inspect the bait (*top*) and then returns to bite it (*bottom*).

At one of the protected areas, scientists kept the BRUVS running for five years to look at temporal changes. This effort recorded 88 species total, documenting a relatively stable community of about 30 species at each camera, with the other 58 species being rarely detected. Thus, there was much more variation in fish diversity over space (comparing the three sites) than over time (five years at one site). This suggests that even within the New South Wales regions there are different bioregions of fish, and a network of multiple marine parks will be needed to protect the full variation in reef fish.

Capuchin Monkey		Night Monkey	
Tamarin		Kinkajou	
Toucan		Sloth	

RAINFOREST CANOPIES

Tree canopies remain an unexplored frontier, with countless secrets yet to be discovered. Camera trappers have just started to climb into the trees and survey the arboreal animals. Setting cameras in trees is a challenge, not only because of the rigors of tree climbing but also because blowing branches often trigger the cameras, filling the memory card with thousands of photos of moving leaves. The largest camera trap study to date, by Tremaine Gregory and colleagues, managed to capture 1,522 records of animals climbing through the trees, but the scientists also had to sort through over 200,000 empty images triggered by the blowing branches.

The animal data were worth the effort, with amazing photographs of 23 bird species, 20 mammal species, and even 4 reptile species. While monkeys and large tropical birds, such as toucans and parrots, are what most of us think of as typical canopy animals, these camera traps showed that this was not the case. Nocturnal mammals dominated the treetops, making up 88% of the photographs.

Night monkeys and kinkajous were the two most common species, together representing about half of the mammal photos. It is amazing to think about these animals jumping from branch to branch in the complete darkness of the Peruvian rainforest. The camera traps also recorded a few very small mammals, including a mouse opossum and a tree-climbing rat, as well as two different species of nocturnal porcupines.

Toucans are some of the most conspicuous birds in neotropical forests, but they were only caught a few times by this study with treetop camera traps. This channel-billed toucan was photographed once, and two smaller species, known as aracaris, were represented in seven photos.

Small brown-mantled tamarin monkeys were photographed four times using these bridge trees to cross over a gap in the forest below.

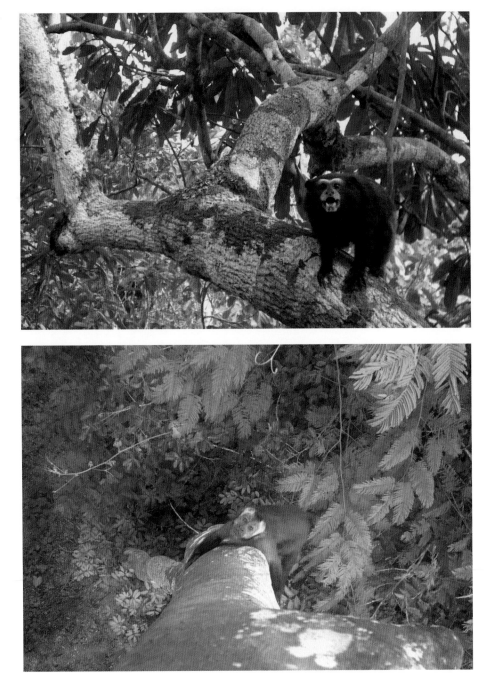

A brown capuchin monkey scales a tree trunk on its way up into the rainforest canopy. This was the only monkey species photographed by camera traps both on the ground and in the trees, and one of only three arboreal mammals to risk a walk on the forest floor, where at least three species of predatory cats patrol.

Gregory set these camera traps on branches that bridged over a gap in the forest. Her comparisons with cameras on the ground showed that all arboreal animals would rather cross the gap along these narrow "bridge trees" than climb to the ground. These terrestrial cameras photographed a number of predators patrolling just under these trees, including jaguars, cougars, and ocelots. No mammalian predators were photographed climbing up into the trees, making treetops a safer place for nocturnal mammals, as long as they can navigate the high-wire world of the tree canopy in complete darkness.

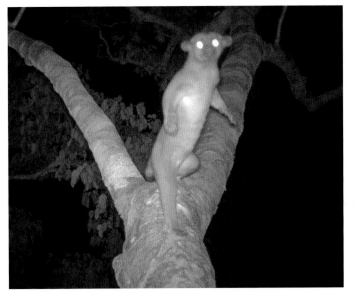

(*left*) Kinkajous were one of the most common animals photographed by treetop camera traps in Peru, representing about one-quarter of all photos. These raccoon relatives are very specialized for their nocturnal arboreal life. They have big eyes for better night vision and a prehensile tail that they use like an anchored safety line in case a branch breaks in front of them. Although they typically climb through the forest on all four limbs, this animal has risen up on its hind legs to get a better look at the camera trap, using its tail as a third point of support.

(*right*) This Hoffman's two-toed sloth triggered the camera as it climbed below the branch, its typical style of travel. A sloth moth can be seen in this photograph, drinking from the left eye of the sloth. This is a specialized moth species known only from sloths, which may be involved in a three-way mutualism between sloths, moths, and a unique algae that also lives on sloth fur.

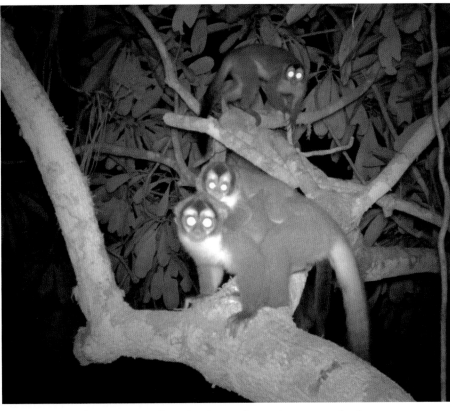

Night monkeys, also known as owl monkeys, were the most common animal in this canopy study. They live in small family groups in which the male is the primary caregiver. In this family portrait the father can be seen carrying the baby monkey through the trees, while the mother hangs out in the background. By taking on the burden of child care, the male reduces the metabolic costs of the female, which are already high owing to lactation.

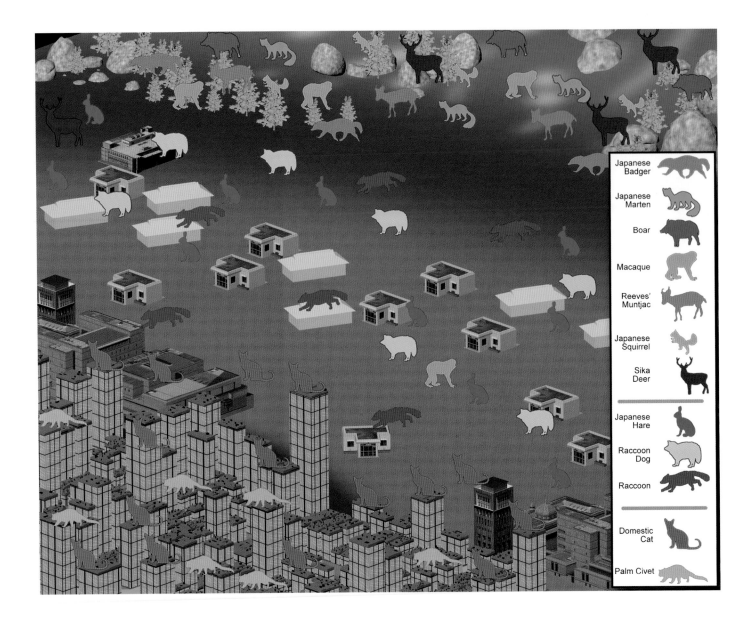

Japanese Badger
Japanese Marten
Boar
Macaque
Reeves' Muntjac
Japanese Squirrel
Sika Deer

Japanese Hare
Raccoon Dog
Raccoon

Domestic Cat
Palm Civet

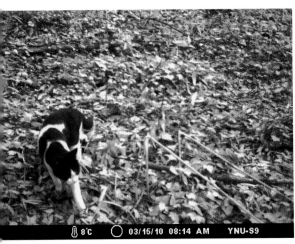

8°C 03/15/10 08:14 AM YNU-S9

Domestic cats, including pets and ferals, were common in urban Tokyo but not in the suburban or rural areas.

THE WILDLIFE OF TOKYO

A camera trap study of Tokyo by Masayuki Saito found that the city has already been invaded by wild creatures. Two nonnative species, domestic cats and masked palm civets, are essentially the only wildlife using urban Tokyo. There is more to this story as you get out of town, however, as Saito discovered by extending a line of camera traps along transects stretching into suburbs, through the rural zone, and into the remnant forests outside of Tokyo. Ignoring the photos of pet dogs and various smaller rats and mice, they obtained 1,329 records of 12 different species of large and medium-sized wildlife.

Wildlife abundance generally increased as you got farther from the center of town, especially for the larger species, which were only found in the wilder areas. In fact, the two largest species Saito was hoping to detect, Asiatic black bears and Japanese serow, were never photographed. They were apparently too sensitive to human development, only surviving in the remotest parts of Japan. The suburban areas were dominated by rac-

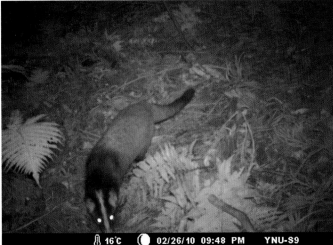
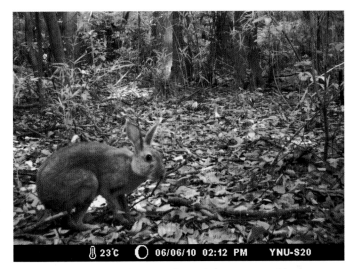

16°C ◐ 02/26/10 09:48 PM YNU-S9

23°C ◐ 06/06/10 02:12 PM YNU-S20

(*left*) The masked palm civet is native to Asia; some consider it a native species in Japan, while others think that it was introduced hundreds of years ago, possibly multiple times. It does well in urban areas of Tokyo, and many people don't notice its nocturnal activity in their neighborhoods. It was also found in the rural forests, but curiously not in suburbia.

(*right*) The Japanese hare is most common in suburban areas, where some consider it a nuisance.

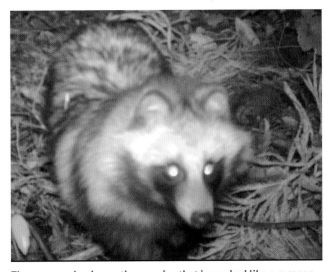

The raccoon dog is a native species that is masked like a raccoon but related to canids; they are common in suburban Japan, where they use remaining forest fragments. Camera trap photos show that they need larger forests for breeding, as these are the only places in which raccoon dog puppies were photographed. Adults also forage in smaller forest fragments but apparently find them unsuitable for raising young.

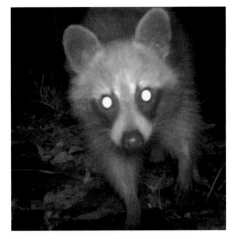

The northern raccoon is a North American species that reaches some of its highest densities in American towns. They were brought into Japan in the 1970s as pets. Not surprisingly, some escaped and found suburban Japan to be suitable habitat. They presumably compete with raccoon dogs for food and living space.

coons, raccoon dogs, and Japanese hares. The less developed an area was, the more species of wildlife were detected, with a great diversity found in the natural areas farthest from town, including species such as deer, boar, marten, badger, and even a native primate, the Japanese macaque.

In addition to the two urban invaders, cats and civets, Saito found two other invasive species to be more common farther from town: the northern raccoon and Reeves's muntjac. Both of these species were introduced by humans and now have breeding populations that compete with native species. Across the study, these four nonnative species were detected about half as often as native species, showing that they are a minority, but making up a significant portion of the wildlife community of greater Tokyo.

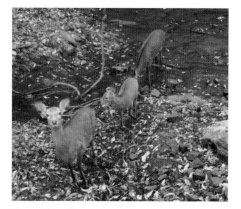

The native sika deer were the predominant species in larger forested landscapes of this study.

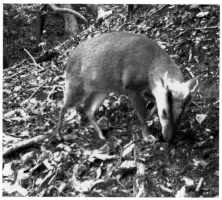

The Reeves's muntjac is a small deer species native to China. It escaped from a zoo south of Tokyo in the 1960s and has established breeding populations in the area that compete for food with native deer.

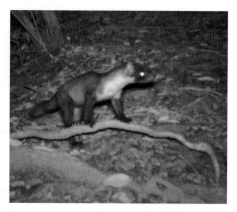

Japanese martens were found only in the wilder parts of this study area.

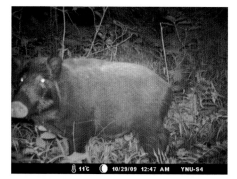

The native wild boar was the most common large mammal in agricultural landscapes.

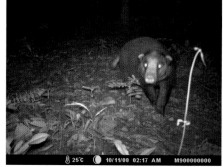

The Japanese badger was common in wooded areas far from the city of Tokyo.

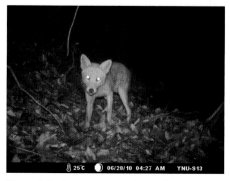

The red fox is a common urban animal in many parts of the world, but it was surprisingly rare in this study of Tokyo, with only two photographs recorded, both in remote forests.

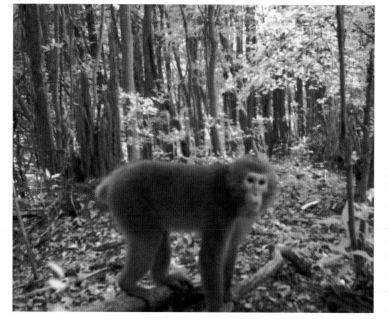

Japanese macaques are the northernmost-living primate in the world, other than humans. In some snowy parts of Japan, these monkeys are famous for using hot springs. Around Tokyo, macaques are most common in the wilder areas, but the species is slowly losing their fear of humans and increasing in number in rural and urban areas. One famous wild macaque even survived in central Tokyo for several months.

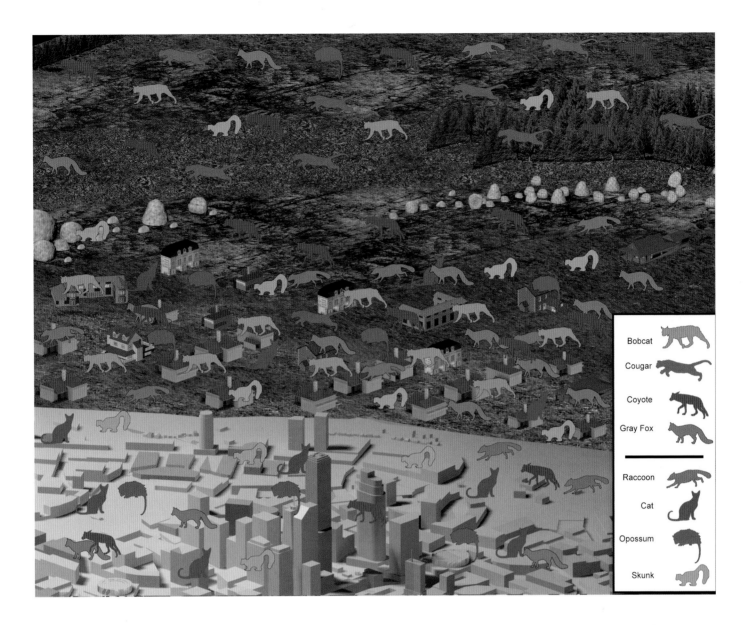

Bobcat

Cougar

Coyote

Gray Fox

Raccoon

Cat

Opossum

Skunk

AMERICA'S URBAN PREDATORS

Whereas some urban streets are dangerous for humans, the wooded areas outside of town can be just as risky for smaller wildlife species. When night falls, predators of all sizes hit the trail and patrol nature parks, power-line rights-of-way, and whatever scraps of nature are left between the sprawling developments of American cities. Most people sleep through this excitement, but camera traps run by urban ecologists record the drama.

The most obvious pattern discovered is that the largest wildlife species decline as you work your way closer to downtown. There are no elk feeding on the lawn at town hall, and no packs of wolves hunting Central Park. However, many smaller species have found their way into our cities, and they are quite happy that larger predators are more afraid of humans than they are. Squirrels and rabbits are famously abundant in many suburban areas, and some small predators are willing to risk living close to people to have a home with abundant prey and no larger predators to harass them. In many developed areas these medium-sized predators (aka mesopred-

A cougar carries a raccoon it has killed along a trail outside of Boulder, Colorado. Cougars have moved close to people in a number of western cities, where they help restore a balance of nature by hunting overabundant prey, but they also make people nervous. Cougar attacks on people are rare, but they have killed about 20 people in the past century (making them much less of a risk than dog attacks or lightning strikes). People living in cougar country should take care to hike in groups and not let kids play alone in big cat habitat.

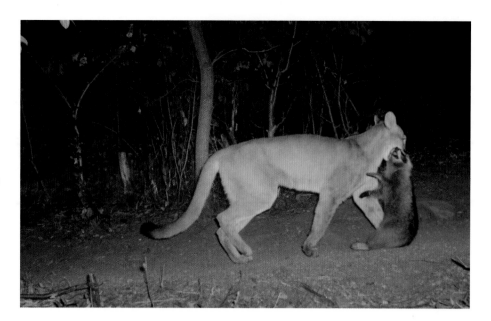

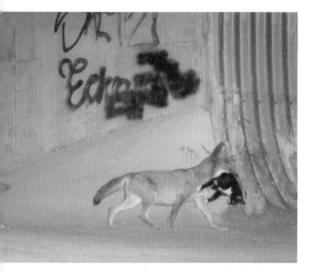

A coyote carries a domestic cat it has killed to a highway underpass in Southern California. Coyotes help control populations of feral cats in urban areas, which can otherwise overpopulate and damage bird populations.

ators) can be abundant, benefiting from a phenomenon known as "mesopredator release," resulting from a lack of pressure from larger carnivores. Feral cats and raccoons are examples of mesopredators that can reach very high densities in developed areas.

However, the imaginary lines marking how far a predator will move into a town are slowly shifting inward. For example, biologist Miguel Ordeñana compiled data from cameras run at 217 natural sites in San Diego and Los Angeles and found that coyotes and bobcats were the most widespread carnivore species, present at 86% and 74% of the sites, respectfully. Coyotes are known to feed on domestic cats and smaller fox species, meaning that there are now fewer predator-free urban havens for those smaller carnivores. The largest predators are also returning to some cities, which will make even the coyotes nervous. In Ordeñana's study, cougars were captured by 18% of the cameras, primarily in remoter sites.

Which predators are adapted to use cities, as well as exactly how close they will come to people, remains hard to predict. For example, in the eastern United States coyotes use suburban areas but are not common there, and bobcats are completely absent from most cities, much different than in the West. However, gray foxes avoid the urban edge in California but are common backyard animals in North Carolina. Meanwhile, fishers, found only in wilderness areas of the West, have recently colonized suburban areas in the Northeast, apparently feasting on gray squirrels.

These animals are evolving, becoming better adapted at living in our midst, and will likely continue to do so. The consequences of these evolutionary changes to our urban ecology and human-wildlife interactions in the future will be fascinating to watch, through the lenses of our camera traps.

A gray fox watches for larger predators from his hideout under a bridge of the I-405 freeway in California.

A striped skunk begins its hunt for grubs as the sun sets over suburban Santa Cruz, California.

This fisher is walking along a narrow strip of woods between a church and an apartment complex in Albany, New York. This large weasel relative has recently colonized the suburban areas of many northeastern cities and was even sighted once in the Bronx. Fishers are good at climbing trees and running through tunnels, making them effective predators of the most common suburban herbivores: squirrels and rabbits.

The Virginia opossum is a common backyard animal in much of North America. By sleeping under sheds and back porches, this species has been able to extend its range northward, into colder climates than it would otherwise be able to tolerate.

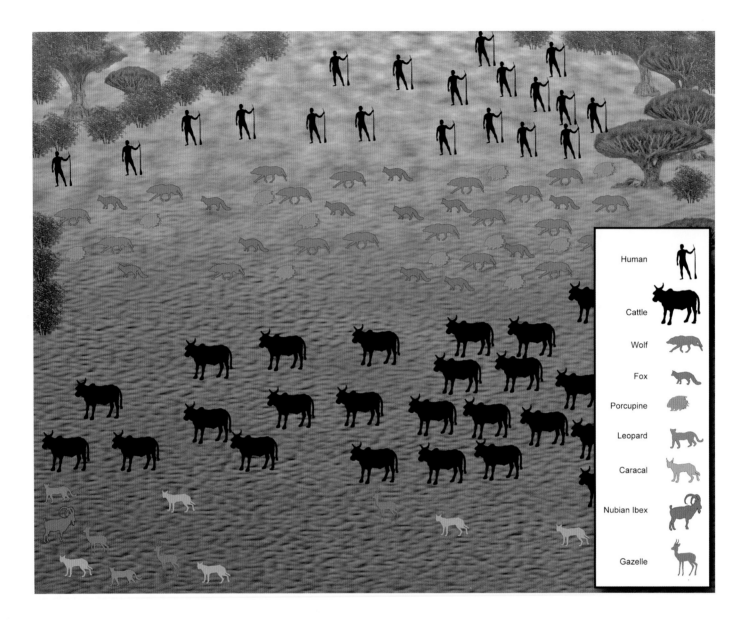

Human	
Cattle	
Wolf	
Fox	
Porcupine	
Leopard	
Caracal	
Nubian Ibex	
Gazelle	

THE FOGGY, FORESTED HILLS OF YEMEN

The Hawf region of Yemen is a special place—dry, but not as dry as other parts of the Arabian Peninsula owing to a regular fog that rolls in from the ocean; used by people, but not so overrun by agriculture and pastoralists that the fragile vegetation is destroyed. Hawf contains some of the largest forests in Yemen and precious wildlife.

Curious to examine this balance of people and animals, Igor Khorozyan and colleagues conducted a survey of the region, recording 14 mammal species. They found people throughout the landscape and captured about the same number of photographs of wildlife as they did of people on their camera traps. Surprisingly, the people and animals were positively correlated, up to a point. At low and moderate levels of human use (less than 100 photos per site) the local abundance and diversity of mammals increased as human use increased. Above that threshold of human use, most mammals declined, excepting three species: wolf, red fox, and Indian crested porcupine. These three have locally adapted to living with people

This was the only Nubian ibex photographed by the three-year camera trap survey in Hawf. This species is found in scattered populations across the Arabian Peninsula and along the Red Sea in Africa. It is challenged throughout by competition from livestock and in some places also by hunting.

The wolf was widespread in Hawf (photographed at 43% of sites), especially in areas with higher human use. Wolves do hunt livestock in the area, and public complaints about wolf attacks on domestic animals are quite frequent. Fortunately, this has not led to retaliatory, large-scale, and indiscriminate shooting of wolves, or other predators, as is more typical of wolf-human relations in other areas. Wolves appear to be expanding in this area, and this situation should be monitored to maintain a balance between wildlife and human interests in the Hawf region.

on the landscape and dominate the animal community in areas of higher human use.

The pastoralists that live in much of this landscape actually help wild animals by maintaining watering points for their livestock, which are also used by wildlife. Livestock were responsible for most photographs of this study, including 3,127 photos of cattle, 1,823 of sheep and goats, 618 of donkeys, and 2,646 of camels. In total, there were eight times more images of livestock than native wildlife. Wolves and hyenas also hunt some livestock, which has the potential to cause conflict between wildlife and local communities, but it seems to help these predators survive in these areas where little native prey are available.

Unfortunately, Khorozyan found that populations of native ungulates such as the Nubian ibex and mountain gazelle were severely depleted, probably owing to competition from the abundant livestock. Likewise, the Arabian leopard, a subspecies of the common leopard, is very rare in the Hawf region. Leopards have a local reputation as livestock raiders, but studies show that they actually rely on wild prey and find sparse hunting in the dry, foggy, livestock-rich hills of Yemen.

The striped hyena was the most common animal in the region, in terms of the number of photographs taken by camera traps (0.09 per day) and the proportion of sites in which it was detected at least once (57%). This scavenger probably takes advantage of garbage and food leftovers from humans, including livestock that don't survive in this dry climate.

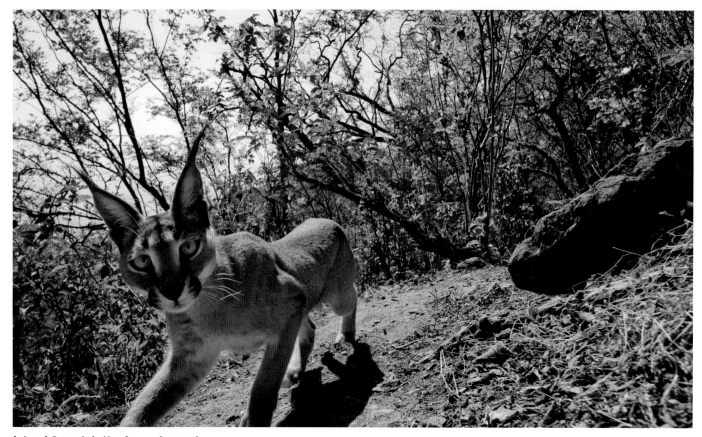

(*above*) Caracals in Hawf were detected nearly equally during the day and at night. These medium-sized cats are not a risk to livestock and appear to tolerate humans well as they pursue their rodent and bird prey. The oversized ears presumably help it hear scurrying prey, while the function of the tassels on the top of the ears remains unknown.

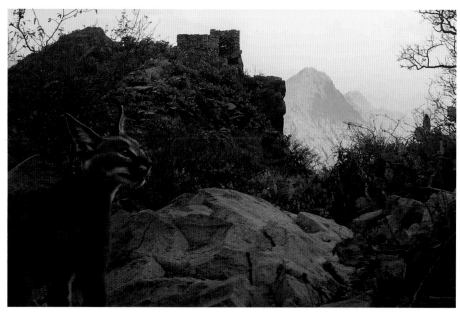

A caracal overlooks the arid and hilly landscape that it has shared with humans for hundreds of years.

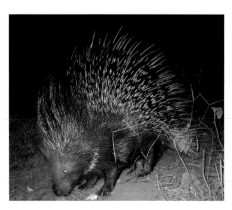

The Indian crested porcupine was found more in the foothills than on the higher slopes, but it was widespread and common everywhere, even in areas with lots of human activity.

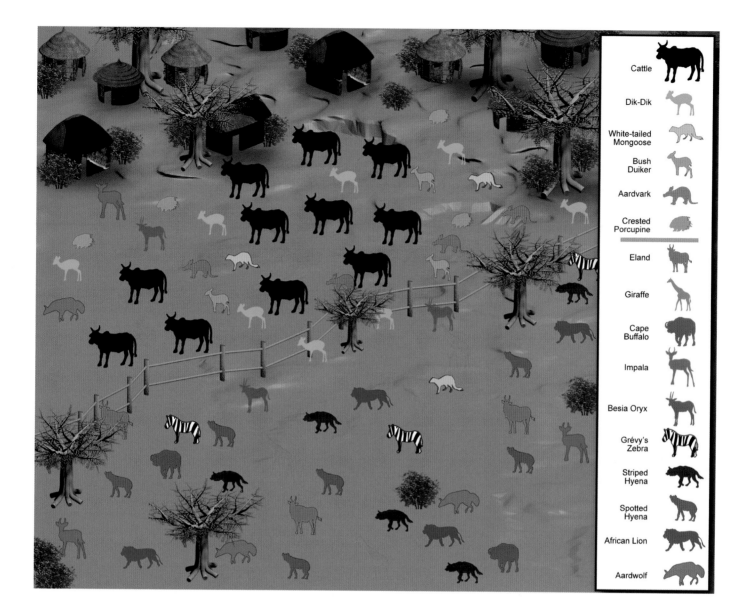

Cattle
Dik-Dik
White-tailed Mongoose
Bush Duiker
Aardvark
Crested Porcupine

Eland
Giraffe
Cape Buffalo
Impala
Besia Oryx
Grévy's Zebra
Striped Hyena
Spotted Hyena
African Lion
Aardwolf

CATTLE AND WILDLIFE IN AFRICA

Africa is famous for its wildlife, with hundreds of species of herbivores and the big predators that stalk them. Into this age-old drama humans have brought the cow, the sheep, and the goat; millions of livestock now graze the continent. Over the millennia, an incredible diversity of native herbivores have evolved mechanisms to all coexist together with minimal competition. Different species feed on different plants, or different parts of the same plants. Some have an annual cycle of migration, following local rainfall to keep them in a constant growing season. But what happens when you add cattle, sheep, and goats to this equation—can the system handle three more herbivores?

This is the question Margaret Kinnaird and Tim O'Brien recently asked in Kenya. By setting up arrays of camera traps in areas with different amounts of livestock, they could evaluate the response of wildlife. After

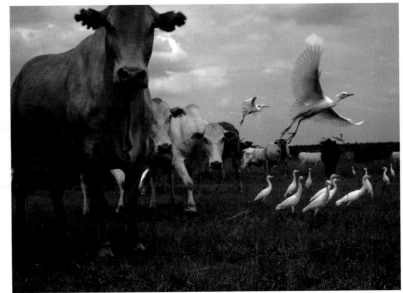

(*right*) A herd of cattle and their accompanying egrets graze a semiwild landscape in Laikipia, Kenya.

The crested porcupine was found at about the same levels across the study area, regardless of cattle stocking levels.

Although dik-diks were negatively affected by cattle, this littlest antelope was still the most common wild animal on most ranches.

Why the nocturnal aardvark was so much more common on ranches than areas with no cattle remains unknown.

running cameras in 522 locations and recording 28,586 photos of 50 mammal species, they were able to show some strong effects of competition with domestic stock.

Although livestock and wildlife did coexist, Kinnaird and O'Brien found that areas with more domestics had fewer wild animals. The sanctuaries with no livestock had five times more wildlife activity than the ranches with the highest stocking levels, while the areas managed with moderate herds had two times more wildlife. Larger species, such as giraffe, buffalo, and eland, were more sensitive to the intrusion of domestic animals than were the smaller herbivores. Predators were also rare on the lands with high stocking levels. Ranchers typically have little tolerance for lions and hyenas and are known to use poisons, shooting, and snares to try to eliminate them, which probably explains their rarity.

Kinnaird and O'Brien's discovery that most wildlife will tolerate intermediate levels of cattle is a promising result. Conservationists are working with ranches to find sustainable solutions that encourage low-intensity ranching, including supplemental income from ecotourism. There is also potential for cattle and predators to coexist. In areas with sufficient native prey available, conservation biologists have been trying to find ways to make livestock harder to hunt, especially at night, when most predators are active and the stock are sleeping. More robust bomas, thorn fences used to corral cows at night, show promise in keeping the lions out of the livestock herd, giving them a better chance to survive on a ranch landscape.

Cattle Commensals

Some smaller wildlife species are actually more abundant on ranchlands with high stocking levels. For example, bush duikers, bushbuck, and bush pigs were most frequently photographed in the most intensely ranched areas. These species may benefit from the reduced competition, or reduced predation, from larger species that are excluded by the cattle. Many of

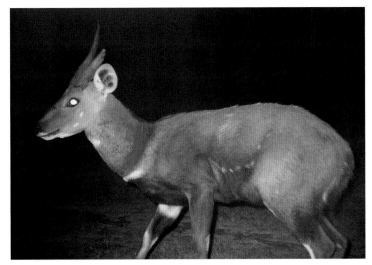

The bushbuck was rare in the study, found only on fenced ranches.

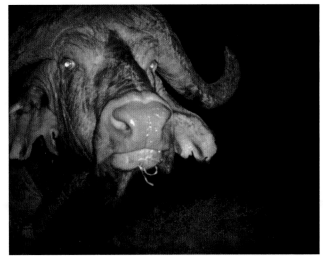

Cape buffalo have the most similar ecology to cattle and were reduced by a factor of 10 in the highest stocking areas.

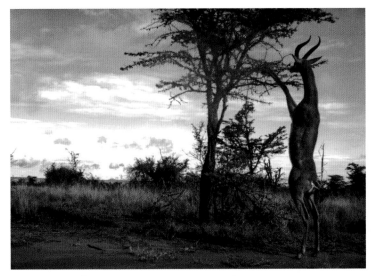

The long necks of gerenuk help them browse higher bushes than most livestock, but their numbers still declined on ranches, possibly because they are shy around people.

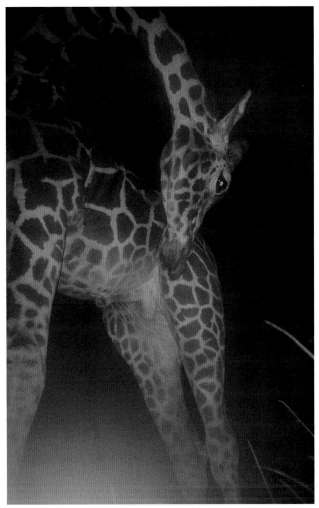

Giraffes were common in areas with few or no cattle but rare on or absent from ranches with high stocking levels.

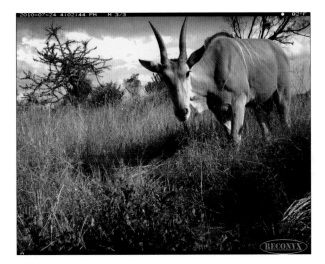

The very large eland was very sensitive to cattle.

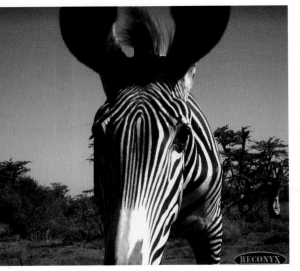

The endangered Grévy's zebra was absent from heavily stocked ranches.

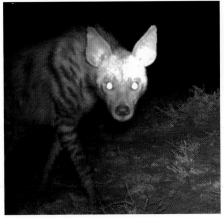

The striped hyena is a more dedicated scavenger than its spotted cousin, and not a direct threat to goat or cattle ranchers. However, they are just as likely to feed on a poisoned carcass, or get trapped in a snare left for a lion, and thus are reduced in number where ranchers persecute predators.

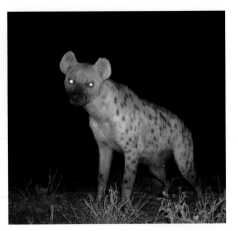

The spotted hyena is not only the largest scavenger in the world but also a capable predator. They are also one of the most social carnivores, living in clans of many dozens of animals. However, they usually spread out in their nightly rounds, using a haunting "whoop" to maintain contact, and reunite around a large meal. This camera trap study found them at similar levels in areas with few and no livestock but at much reduced levels in the heavily stocked ranches.

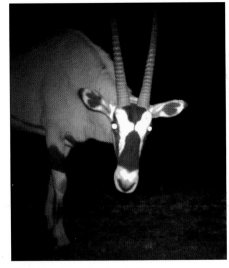

The beisa oryx steadily declined as livestock grazing levels increased.

Although related to hyenas, the aardwolf eats primarily termites. Why they decrease as livestock use increases remains a bit of a mystery, especially since the aardvark, another termite specialist, shows the opposite trend.

these species that do well in cattle lands are also nocturnal, which further reduces conflict with the diurnal cattle and cattlemen.

Larger Herbivores Can't Compete

The larger species of ungulates in Africa lose out to cattle in areas with very high stocking levels. This is probably due to competition for food but may also reflect their fear of the humans that accompany the herds of livestock.

Can Predators and Livestock Coexist?

The predators of Africa like to eat beef and goat meat just as much as we do, making them our direct competitor. Some ranchers choose to fight this battle with snares and poisons. These are easy to deploy but kill animals indiscriminately, wiping out a wide swath of predators and scavengers. Nonlethal solutions are showing promise, especially new fence designs to keep the mostly nocturnal predators away from livestock at night.

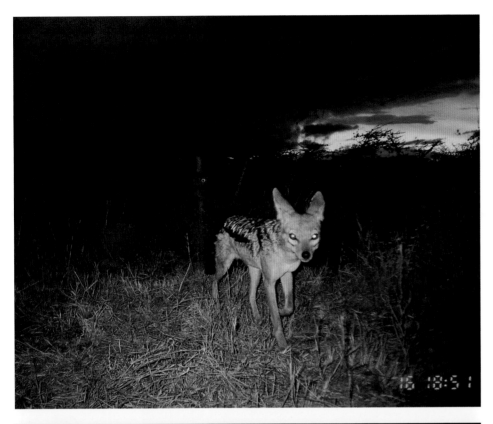

Surprisingly, the little black-backed jackal was completely absent from the most heavily stocked ranches. These small, quick canids are famous for stealing bits of carcasses away from larger predators. Thus, if ranchers poison carcasses targeting lions, the jackal would also suffer.

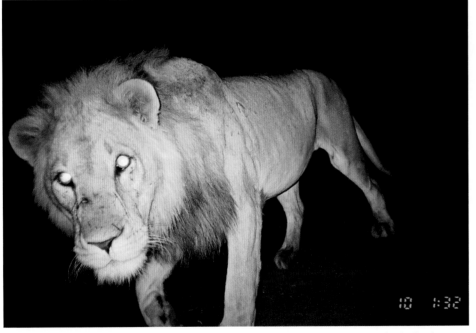

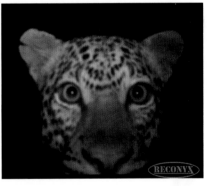

Although leopards rarely attack cattle, they will grab goats and sheep away from their flocks, raising the ire of herdsmen. As with lions, leopards were absent from the most heavily stocked ranches and increased in abundance as cattle levels decreased.

The African lion specializes in hunting large herbivores, making a cow left alone in the bush hard for them to resist. Finding ways for ranchers and lions to coexist is one of the greatest conservation challenges in Africa. In Laikipia, Kenya, camera traps show the magnitude of this problem. Lions were completely absent from the most heavily stocked ranches and rare in others. However, lions did coexist with moderate levels of livestock grazing, as long as there weren't retribution killings through poisons or snares. Private lands are important lion habitat in Africa, and maintaining lions on these landscapes will require additional work to minimize the conflict between lions and livestock.

Hiker	
Cougar	
Wolf	
Mule Deer	
Moose	
Elk	

ROCKY MOUNTAIN TRAILS

The Rocky Mountains of Canada are a hiker's paradise, and that's ok with the resident ungulates such as elk and moose. These herbivores have bigger things to worry about than some backpackers out for some fresh air—the mountains have abundant bears, cougars, and wolves that thrive on killing large ungulates. These predators are afraid of people, more so than their prey are, a difference prey take advantage of wherever hikers are common.

Predators and prey are locked in a never-ending "space race," where prey try to minimize, and predators maximize, their spatial overlap. Tyler Muhly and colleagues deployed 43 camera traps on roads and trails in southwest Alberta, Canada, to test whether the presence of humans was scaring predators away from certain areas, thus creating safe havens for prey along the busiest hiking trails.

Their cameras picked up nine large mammal species, including five

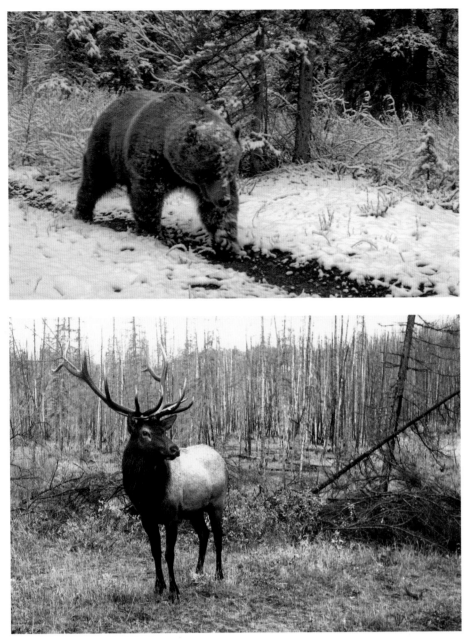

A large brown bear is caught in a late May snowstorm as he walks down a hiking trail in Banff National Park. Predators, like this bear, generally avoided trails that had more than 18 hikers per day.

This bull elk has a giant rack of antlers that will help him battle other males for access to females and might also help defend himself against predators.

A wolf hunts a mountaintop far from hiking trails in Banff National Park.

predators and four prey species, as well as cattle and humans. They confirmed that predators were leery of using trails with high levels of human traffic, generally avoiding trails used by more than 18 people per day. Prey species, meanwhile, were three times more abundant on roads and trails with high human use (>32 humans per day).

Although Muhly expected to find mixed communities of particular combinations of predator and prey species, he instead found that all predators clustered together in remoter areas, and all prey species formed herbivore-rich communities closer to people. Muhly concluded that there was quite a bit of spatial separation between predator and prey, suggesting that humans are helping prey win the predator-prey "space race."

This pack of Canadian wolves go out of their way to avoid parts of the national park with high human use.

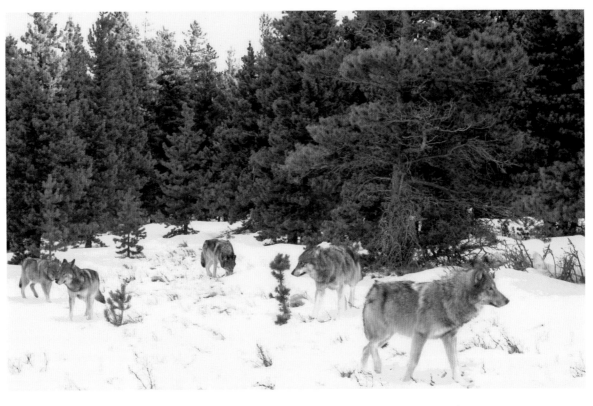

(*above*) A cougar trudges through deep snow.

(*right*) Herds of elk habituate to humans and, after a while, come to prefer living in areas with high human hiker traffic because they contain fewer predators.

This separation is not complete: predators still overlap with, kill, and eat prey. Those predators who feed and survive best will pass their genes and behaviors on to the next generation. If avoiding humans is the best strategy, herbivores are likely to continue to use humans as shields against predators. However, if predators lose their fear of hikers and tolerate closer human presence to find better hunting, they could regain the advantage in the race for space in the Canadian Rockies.

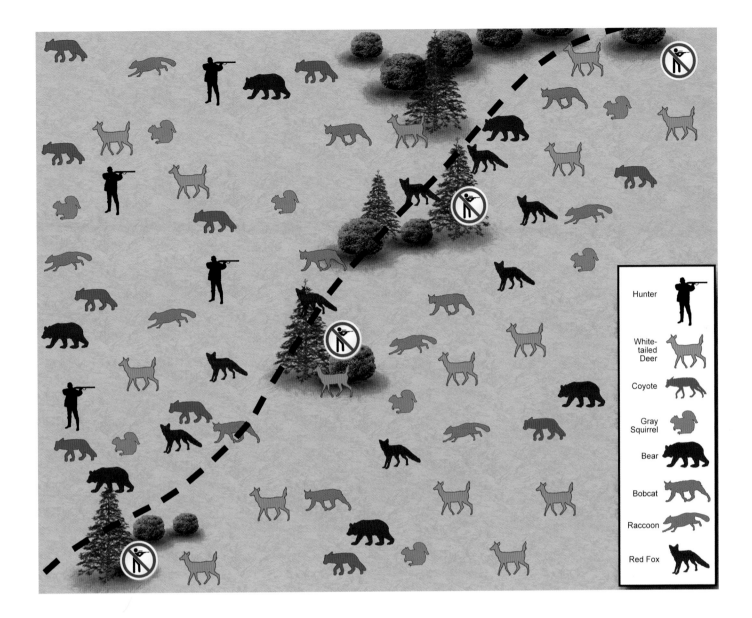

AMERICA'S HUNTING GROUNDS

Over 1 billion acres of land in the United States are in some form of protected area, across almost 100,000 different parks, preserves, or game lands. New development is restricted in these areas, making them a beacon for recreation and a critical place for our society to go to reconnect with nature. Wildlife is an important component of these parks and a big motivation for visitors who want to watch, or hunt, these species. However, most wildlife species try to avoid humans, especially those with guns. What is the effect of these types of recreation on the wildlife of a park? Do hikers scare wildlife away from trail networks? Does recreational hunting have impacts on the composition and behavior of all local mammals?

A large camera trap survey recently set out to address these questions by surveying 32 protected areas across six states, from South Carolina to Maryland. Parks where hunting was allowed were compared with nearby unhunted preserves, and cameras were equally partitioned among being

White-tailed deer were the most common animal in this survey, being detected at 88% of the camera traps at an average rate of about one deer photo every other day. They were most common in parks that were surrounded by development, where they walked past cameras as often as five times per day, and were scarcer in wilderness areas. Parks that allowed hunting had fewer deer, and those deer tended to avoid people more than deer living in parks that did not allow hunting.

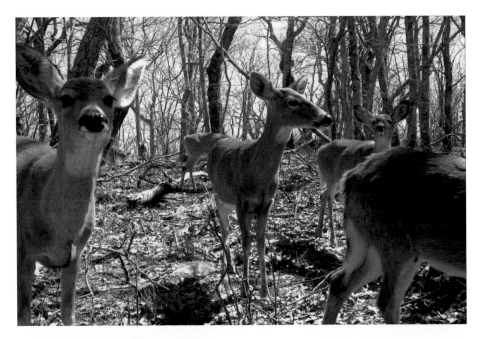

A pack of coyotes hunt in the Sandhills of South Carolina. This is an unusual photo, as most coyotes are photographed alone or in pairs. Eastern coyotes can kill deer, especially fawns, but don't seem to be reducing the deer population; deer herds have only grown in size since coyotes colonized eastern forests in the latter half of the twentieth century.

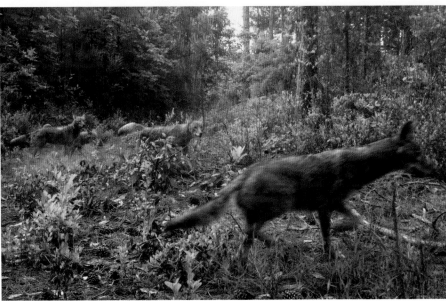

A gray squirrel carries a nut on a foggy morning. These rodents were the second most commonly detected species in the region, after white-tailed deer.

placed on hiking trails, near (164 ft [50 m]) trails, and far (656 ft [200 m]) from trails. This project worked with citizen scientists, local volunteers interested in running cameras to learn about wildlife, to get camera traps to more than 2,000 locations within these parks. After being trained in how to run a camera, these volunteers hiked out into the parks to set cameras and then returned later to collect the memory cards and see what animals had passed by in the past few weeks. Volunteers examined the photos, identified the species captured, and uploaded everything to the scientists as part of the "eMammal project." After confirming the species in the images, scientists compared the variety and abundance of animals to local hunting and hiking levels.

The cameras showed that hunted parks had fewer deer, which was not surprising, but that they also had more coyotes, which was a bit of a shock.

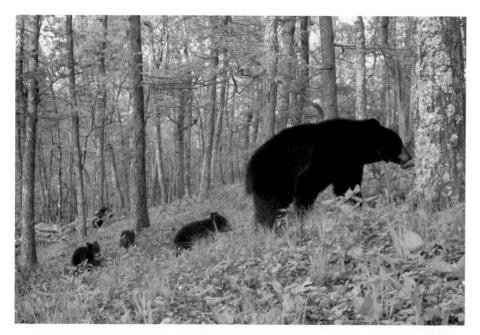

Black bears were found in the wilder parks of the region, where they were usually a relatively uncommon species. The exception was Shenandoah National Park, where bear photographs were nearly as common as those of white-tailed deer. At all sites, bears avoided trails with the most human traffic, especially in hunted areas.

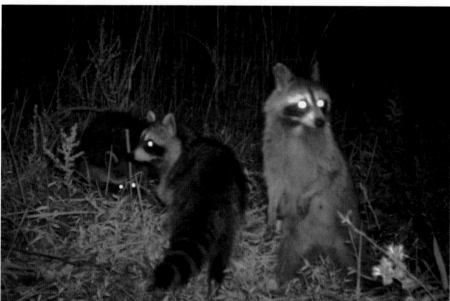

Raccoons were the third most common animal in this survey and were found at each park. Most (85%) photos were of solitary animals, but pairs or trios of animals were seen together in 15% of images, typically females with young or small coalitions of males.

Bobcats were frequently photographed on trails, like this animal, but avoided trails with lots of human traffic in parks that allowed hunting. They were found in many parks (25/32) but were never common. These eastern bobcats were absent from the most urban parks, in contrast to West Coast bobcats, which are present in developed areas.

Scientists speculate that the disruption of the social system of coyotes might lead to less stable coyote territories and more immigration. Hunting didn't impact most other species, and, in general, the habitat types of a park had much more impact on the mammal communities. Most animals also seemed not to mind an occasional hiker, and most species did not avoid the hiking trails. In fact, the predators (foxes, bobcats, and coyotes) all preferred running on the trail to off, although mostly at night, when no people were around.

The bottom line was that nature preserves in eastern North America are teeming with wildlife, and our use of these areas, through hiking or regulated hunting, seems to have only small impacts on the animal populations. This is good news for the animals, as well as the animal lovers, who don't want their own recreation to drive animals out of nature parks.

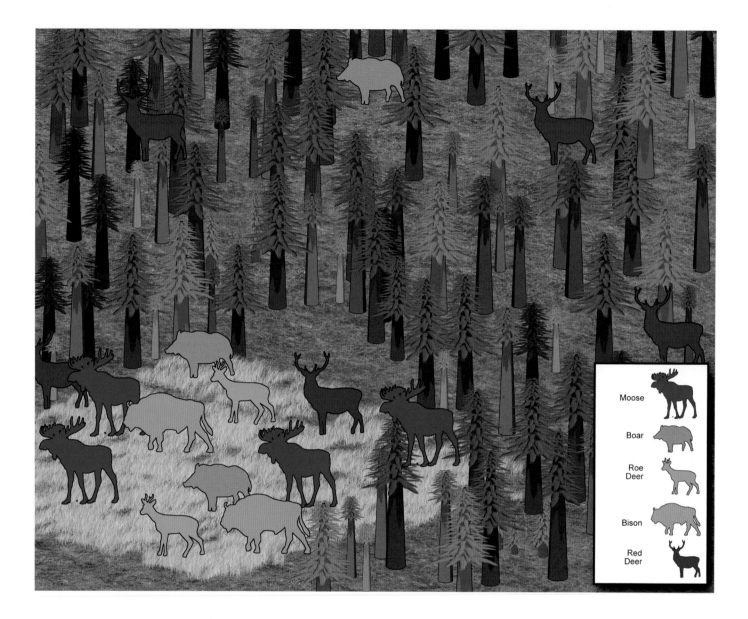

Moose
Boar
Roe
Deer
Bison
Red
Deer

GAPS IN THE POLISH WOODS

Deep, dark forests are not always the best habitat for big terrestrial herbivores such as moose and deer. If the tall tree canopies capture all the sunlight up high, it is difficult for any plants to grow down low in the understory, where big mammals can reach them. Anywhere sunlight can reach the ground, however, new vegetation can grow rapidly, providing ample forage for hungry herbivores. Sunlight can hit the ground along the edges of forests, or when storms or other disturbances cause trees to fall, creating a gap.

In modern managed forests, the main reason that trees fall is because loggers cut them for wood. Scientist Dries Kuijper wondered whether these man-made gaps were attractive to the forest ungulates, and whether their browsing could actually slow the regeneration of forests within these gaps. To test this idea, Kuijper and his team worked in the Białowieża Primeval Forest in Poland running camera traps to compare the activity of

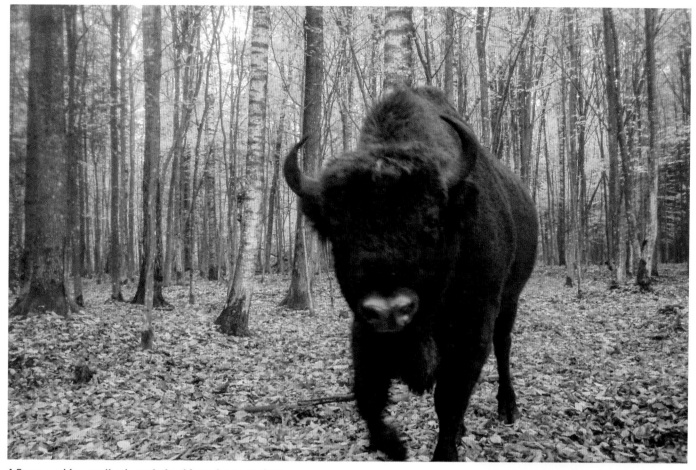

A European bison walks through the thin understory of the Białowieża Primeval Forest, where few green plants can grow owing to limited sunlight. Białowieża is unique as one of the very few areas in Europe where the complete native assemblage of five species of ungulates still occurs in the wild. The bison is the rarest of these, and Białowieża is its stronghold.

five species of large herbivores inside and outside of six clear-cuts within the forest.

They found dramatic differences, with total activity of all ungulates combined almost twice as high inside forest gaps as in closed forest. European bison were the most strongly affected, being the rarest species in the forest but the most common inside the gaps. Videos from the camera traps showed that three most common ungulates partitioned the available food, with the bison grazing on the grass, the red deer browsing on the leaves, and the wild boar rooting around at ground level.

A moose enjoys its rich buffet of green leaves available in a gap created by loggers in the forest.

All these large plant-eating animals had a big effect on the vegetation, with plants inside the gaps having a 1.5 times greater chance of being eaten than those in the forest. To reduce this pressure on regrowing trees, Kuijper recommends a different pattern of tree cutting that spreads out smaller holes in the forest, rather than creating one large clear-cut, which results in an irresistible salad bar to the resident plant eaters.

A group of wild boar walk a line through the snow in Białowieża Primeval Forest. These animals prefer to feed in the productive forest gaps, and camera trap videos show that they actively root around in the soil for food, spending 88% of their time in gaps with their nose to the ground.

Red deer caught by a camera trap while feeding in an old forest gap. This species was the most common ungulate in Białowieża Primeval Forest and showed a strong preference for feeding within gaps. They were also more leisurely about feeding than other species, spending the longest time within the gaps for each time they visited.

Tapir	
Tiger	
Clouded Leopard	
Macaque	
Sun Bear	
Bearded Pig	
Wild Boar	
Leopard Cat	
Domestic Cat	
Common Palm Civet	

OIL PALM PLANTATIONS

In Southeast Asia one type of forest is on the increase—oil palm. This palm tree, native to West Africa, produces a fruit so rich in oil that it can be extracted and used commercially. Historically, most of this oil was used for human foods, with small amounts used for cosmetics or pharmaceuticals. However, new interests in biofuel have driven up demand, most of which is being met by new plantations in Malaysia and Indonesia. These are essentially tree farms, with palms planted exactly 30 ft (9 m) apart. Almost no other plants can grow in these forests, other than some low, leguminous ground cover and the occasional fern.

With these monoculture plantations replacing diverse rainforests, it is important to know the impacts on native wildlife. Scientists set up a simple camera trap study on the island of Sumatra, Indonesia, to compare the animals using the oil palm plantations with those in the nearby rainforests. The results were depressing, although hardly surprising. They found that the oil palm crop is a very poor habitat for most mammals: 95% of species

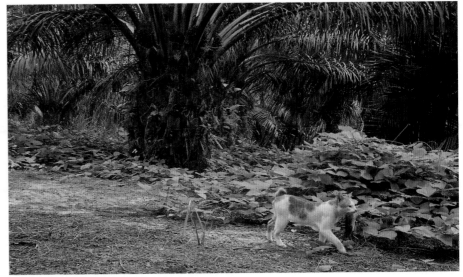

A feral cat with a bobbed tail walks through an oil palm plantation with a rat in its mouth.

The leopard cat is one of the few native predators able to take advantage of the abundant rats in oil palm plantations.

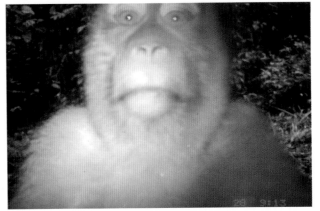

The southern pig-tailed macaque is a rainforest species known to occasionally venture into plantations and gardens in search of food.

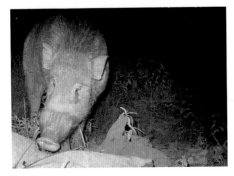

This wild boar can eat the oil palm nuts and thrives by eating excess fruits and rooting in the low herbaceous growth. This was the most frequently photographed species inside the plantations.

preferred the natural forest habitats, 55% were never recorded in oil palm, and only 10% showed any ability to survive within the oil palm crop on a long-term basis.

A few species that can eat the palm fruit, such as pigs, palm civets, and small rodents, were abundant in the plantations. Likewise, two small predators were able to live off the abundant rats within the plantation: the leopard cat and domestic cat (an invasive species). Although dholes, clouded leopards, and tigers are fond of pigs, they were never recorded entering the plantations to hunt them. The lack of diversity in the structure of the plants provides no cover for hunting, thus making this poor habitat for larger predators, even if prey are available. A few species used the plantations on occasion, before returning to the nearby rainforests, including East Asian porcupine, pig-tailed macaque, sun bear, and pangolin.

One surprise from this study was that the degraded habitats often found in association with oil palm plantations can actually be very useful to wildlife. If protected from development and hunting, these shrubby areas of secondary growth along the margins of plantations could help mitigate the fact that the heart of oil palm plantations are essentially a wildlife desert.

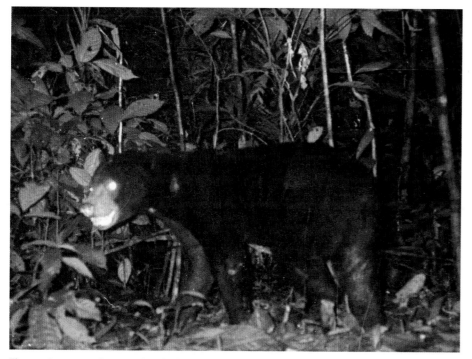

The sun bear was photographed inside plantations 21 times, foraging for insects and fruit before heading back to the rainforest.

Packs of dholes hunt large prey and were never found within the plantations, although they were photographed within the degraded forest along the periphery.

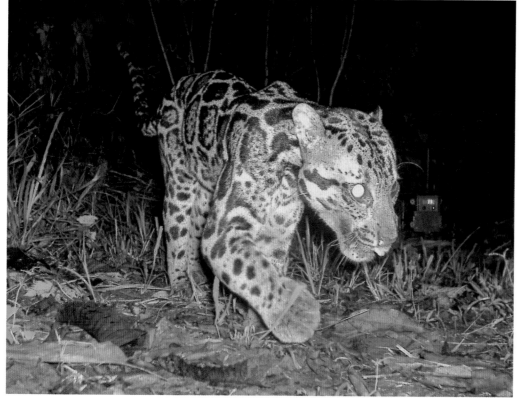

The clouded leopard was rare in this study, captured by camera traps only three times, always in rainforests.

The small Indian muntjac was common in natural forests but absent from the oil palm plantations.

Tigers were photographed 115 times within primary and secondary forests, but never within the oil palm plantations.

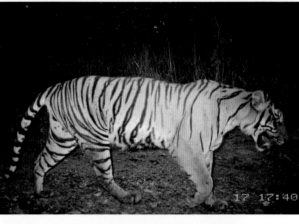

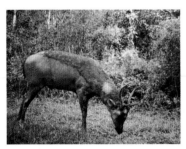

Within the natural forests the big sambar was photographed 41 times by camera traps, and even sighted 10 times by the field crew, who found no evidence for this species within the palm plantations.

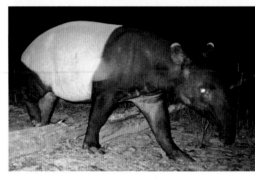

The Malayan tapir was never recorded entering the oil palm plantation, seeming to prefer the shrubby secondary forest nearby.

Caught in the Act

Camera traps are the naturalist's surveillance robot. Silent, tireless, and unblinking, a motion-sensitive camera is the perfect tool for a stakeout in nature. The questions being asked are usually simple, but the results can be surprising and important. For example, setting cameras to record what animals used a hole in the ground ended up showing the greater risks faced by prey animals that have to stay up too late to scrounge for food, thus being more likely to run into a predatory cat. Cameras left on frozen deer carcasses to see what would show up turned into a new survey method for eagles, documenting their wintering grounds better than bird-watchers. Simply monitoring a bush in the African savanna led to surprising insight about the intense browsing pressures these plants face from herds of elephants and armies of smaller dik-diks. Sitting around and watching a bush all day to record the one moment an antelope walks up to take a bite isn't the most stimulating activity, but the mechanical determination of a camera trap makes it easy to catch animals in the act.

Our knowledge of road ecology has benefited immensely from camera trap research. The main goal of this field is to minimize the effects of roads on animals by helping them cross the road without getting hit by a car. A variety of structures have been proposed to help different kinds of animals get safely across the street, and camera traps are the primary method for assessing their success. Some animals need wide-open spaces and won't go into a tunnel under a road, while others prefer the cover offered by a narrow culvert. Many tree-climbing species won't even go to the ground to look at an underpass, but they might climb a rope strung over the road. Catching animals on film as they use these crossing structures helps engineers and biologists tweak their designs and give animals a safer alternative to simply dashing through traffic.

Camera traps have also helped us learn a lot about the perils faced by nesting species, by catching nest predators in the act. Surviving the nesting period is typically the most dangerous part of a bird's life, so figuring out exactly what is raiding nests could lead to management plans to help endangered species.

A few biologists have recently extended this surveillance approach to conduct predation experiments in nature. By placing animal models in front of camera traps, they can record the reaction of other species to them. In some cases this is simply to see what predators might attack a species of interest, while other experiments have varied the color of their prey models to test the preferences of predators in something known as a "cafeteria experiment."

Most of the stories in this section of the book come from a curious naturalist or scientist identifying an area of interest (e.g., nest, culvert, hole, carcass) and staking it out with a camera trap to find out what's using the spot. However, if you run enough cameras in random locations, you also catch animals in the act of doing interesting things, sometimes in flagrante delicto with a member of the opposite sex, or even with a prey species.

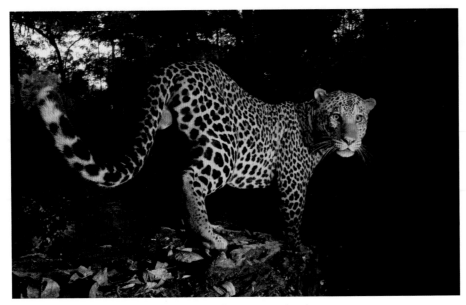

Scientists put a camera trap at this salt lick in Brazil to see what types of animals came to eat the rich clay, but they ended up also recording the attendees at a carcass after a collared peccary died at the site. Here king and black vultures pick at the putrefied peccary.

A male leopard is caught by a camera trap as he crosses a river by walking along a large fallen log in Lope National Park, Gabon.

A camera trap caught this black bear in the act, answering the age-old question about ursine toilet behavior.

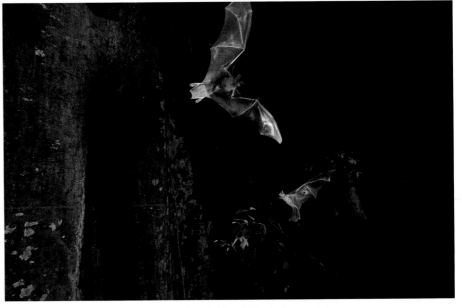

A camera trap with remote flashes catches fishing bulldog bats as they fly out of a roost in a hole in a tree trunk near the Panama Canal.

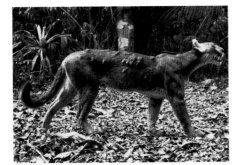

This cougar from Belize is badly infested with botflies. This parasitic fly lays its eggs on mosquitoes, which then pass them to mammals when they bite them for a blood meal. The fly's larvae develop under the skin for about six weeks, creating the welts seen on this animal.

HOLES IN THE GROUND
What Lives in That Hole?

Have you ever walked by a hole in the ground and wondered what lives in there? Camera traps are a great way to find out. In fact, some of the very first camera traps created in the early 1900s were set over holes, and hobbyists and scientists alike have learned a lot about this basic, fun question. Almost all small or medium-sized mammals use a hole at some point in the day, either underground or in a tree. These holes provide a refuge where smaller animals can rest

without worrying about predators. Sometimes these cozy hideouts also provide a base for animals to have a litter and raise a family.

Agoutis Sleep In If They Can Afford It

In Panamanian rainforests the rabbit-sized rodents known as agoutis spend their days running around eating nuts and their nights hiding from predators in hollow logs or holes in the ground. Nocturnal ocelots are their main foe, and camera traps have recorded this cat trying to get into agouti refuges. The two are most likely to run into

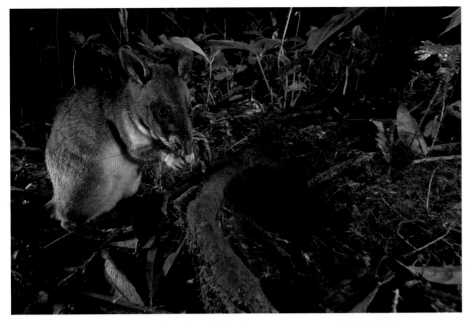

A Gambian pouched rat grooms itself outside its burrow entrance on Bioko Island.

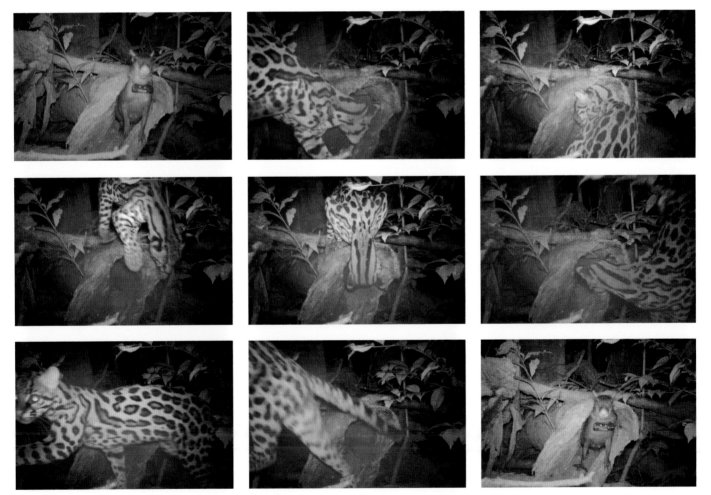

A camera trap records an agouti on its way to bed in a hollow log at dusk. Later that same night an ocelot visits the den and tries to get the agouti. A photo the next morning confirms that the agouti survived the night.

Agouti Bedtime

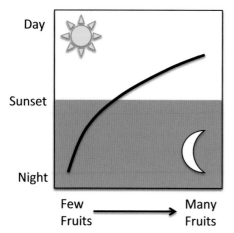

Day

Sunset

Night

Few Fruits → Many Fruits

This graph shows what time agoutis go to bed in relation to how much food is available in their home range. Hungry animals stay up later, when they have a greater risk of running into a predator.

each other on the forest floor at dusk or dawn, as one is waking up while the other is heading to bed. So why don't agoutis just go to bed earlier and sleep in later to avoid the ocelots? Willem-Jan Emsens led a study that used camera traps to record the exact time agoutis entered and exited their sleeping spots. He found that agouti bedtime was related to how much food was available in a particular home range. Animals living in areas with lots of fruit trees were able to leave their sleeping sites after sunrise and go to bed well before sunset, thereby reducing their chances of encountering an ocelot outside their hole. Animals in neighborhoods with poorer fruit production had to work harder for their meals, sleep less, and take more risks in the dark.

WATER HOLES
Supplemental Water

Although desert wildlife are adapted to go without water, game managers often maintain artificial water holes in arid areas to help animals survive the dry season or occasional droughts. In the southwestern United States there was concern that this water in the desert would help generalist species, like the coyote, colonize the area and drive out specialist species, like the kit fox. Using camera traps, wildlife biologist Lucas Hall found that coyotes did use the water holes, but that the kit foxes used them even more. Hall found no indication that water sources increased the coyote population, and no temporal avoidance between the two species. In the case of the kit foxes, the supplemental water seems to be helping them directly by giving them something to drink, and not hurting them indirectly by increasing coyote populations.

Dangerous Drinks

Water holes create a focal point for predator-prey interactions in Africa. Predators know that herbivores will come for a drink at some point, and they often rest in the bushes nearby, waiting for dinner to come to them. Prey animals know the dangers and approach water sources in large groups to reduce the risk.

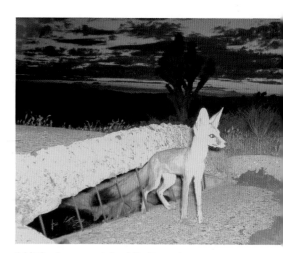

A kit fox keeps watch while its partner goes down for an evening drink in the Mojave Desert. These concrete "guzzlers" were built to help Gambel's quail populations nearly 50 years ago, with metal bars to keep larger animals out.

A pair of bighorn sheep eye the camera trap as they approach a supplemental water hole. Water sources are often created throughout natural areas to help sheep populations.

Zebras create a ruckus as they dash away from a water hole in alarm after detecting a predator.

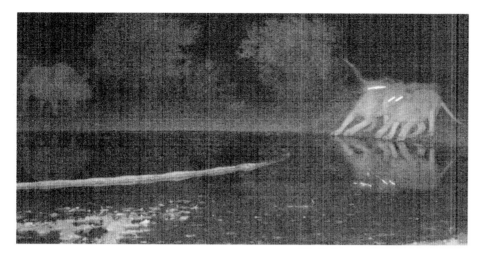

A rhino chases a pride of lions from their midnight drink at the water hole.

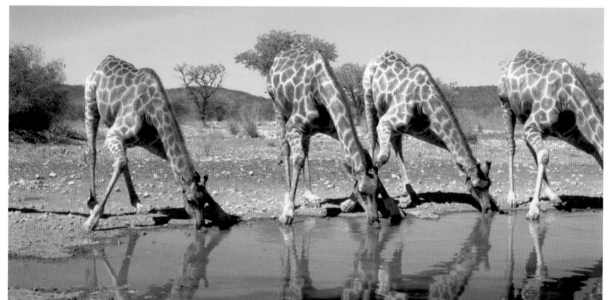

A herd of giraffes splay their legs to reach a drink of water at Ongava Game Reserve, Namibia.

This spotted hyena isn't hiding from anyone as it enjoys a bath in a water hole.

MOVEMENT CORRIDORS

Animal Movement Corridors

Corridors of habitat have long been a conservationist's tool for helping animals get through hostile habitats, from one natural area to another. However, figuring out what makes a good corridor, and even confirming that animals use them at all, remains an active area of research. Scientists led by Scott LaPoint in Albany, New York, were surprised to find fishers living in small forest fragments surrounded by urban development, with busy roads all around. They used a combination of GPS tracking collars

A fisher enjoying easy traveling over a crust-covered snowpack in a small suburban Albany forest in Upstate New York.

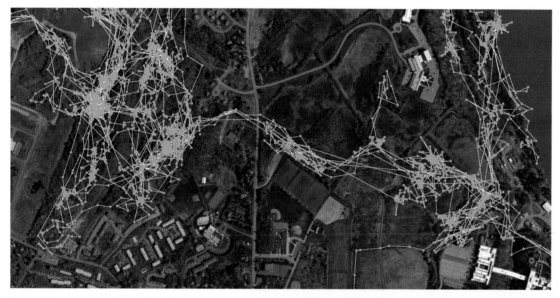

(*above*) This map of GPS tracking data shows how one fisher named Leroy moved back and forth between two forests along the same movement corridor over one month. Each orange dot represents one GPS location separated by 5 to 15 minutes. Scientists wondered why Leroy went back to exactly the same place to cross the road. Inspecting the area themselves, they spotted a small drainage culvert. They left a camera trap at the site, which recorded Leroy using the culvert tube to cross under the road, rather than face the busy traffic overhead (*right*).

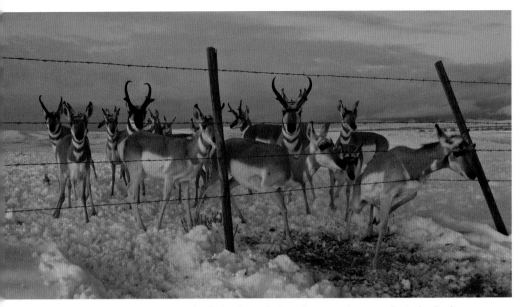

The new wildlife-crossing overpass at Trappers Point, Wyoming, is crossed tens of thousands of times a year by a variety of wildlife, including the migratory pronghorn, as well as resident deer and elk.

This camera trap photograph of a logjam of migrating pronghorn stuck at a barbed wire fence helped motivate the creation of a better highway-crossing structure.

and camera traps to see how these big weasels had colonized suburbia.

The tracking collars showed that most small fragments of forests in Albany were not large enough to provide sufficient hunting grounds for one fisher, especially the larger males. Each animal had to move between a network of small nature preserves and undeveloped land and managed to find small strips of forest to make most of these connections. To test whether other forest animals used these same strips of land, LaPoint placed camera traps horizontal to the line of travel and then also set cameras in the larger "core areas" of forest to get a baseline value for comparison. Analyzing the photos confirmed that all fishers, not just the radio-collared ones, frequently used these corridors for movement, as did deer, coyotes, and foxes. This confirms the value of corridors for helping wildlife survive in developed areas and also shows that a

good strip of forest will be used as a movement highway by a variety of species.

Pronghorn Migration Corridors

Pronghorn are the only antelope in the Americas. They are fast, efficient travelers, and many populations follow ancient migration routes. A herd of about 400 pronghorn that breed in the fertile Grand Teton National Park have to migrate south 170 mi (274 km) to the Green River Valley to find a wintering ground with less snow cover. This is not an easy trek: the animals have to cross a high mountain pass and swim through four major rivers. However, none of these obstacles were as daunting to the animals as the barbed wire and traffic of highway 191 at Trappers Point, Wyoming. This was a natural bottleneck for the migration, as two rivers come close to each other, but has since been narrowed even more by subdivisions and roads.

A highway underpass had al-

ready been built at this site, including barbed wire fences designed to funnel wildlife down and under the highway. Although deer and smaller game used these culverts, the nervous pronghorn, comfortable in the open plains, would not go through the tunnel. Instead, they would try to slip through the fence and cross over the road. Some animals got tangled in the wire; others were hit by cars. Camera trapper Joe Riis caught an amazing photo of the migrating pronghorn jammed up at this deadly constriction point, which was shared widely and helped motivate the creation of a new wildlife crossing solution—a natural highway overpass. In 2012 the state built two of these structures, which were immediately used by pronghorn and other wildlife, with camera traps detecting many thousands of crossings every year since.

This Hoffman's two-toed sloth makes its way along a long branch of a tree that extends out as an effective bridge to the next canopy tree.

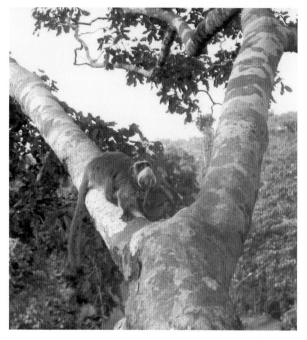

Small monkeys such as this emperor's tamarin are less likely to break branches than larger species, allowing them to climb out to the very tips of thin tree branches before jumping a gap.

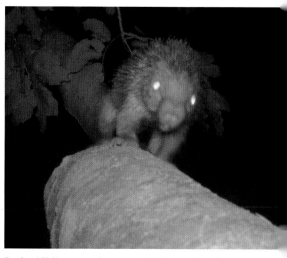

Rothschild's porcupines are strictly nocturnal and so must navigate the high canopy in complete darkness or, at best, with some moonlight. They have a prehensile tail that can act like a safety line as they reach their forepaws forward into the dark for the next branch in their high-wire travels.

TREETOP CORRIDORS

Although it might look like rainforest trees are all connected in a continuous canopy, there are often large gaps between trees, making it difficult for arboreal animals to move through their environment. Going to the ground to cross a gap would expose them to predators like big cats, while attempting to jump a big gap could result in a deadly fall if a branch breaks or the distance proves too far. Gaps between trees are an even bigger concern for nocturnal animals, which have to navigate this high-wire act in complete darkness.

Not surprisingly, canopy animals remember the best routes through the trees. These canopy movement highways can be quite twisted as the animals zig and zag to find the best branches or vines bridging from one tree to another. Species with more specialized locomotor strategies, such as the semibra-

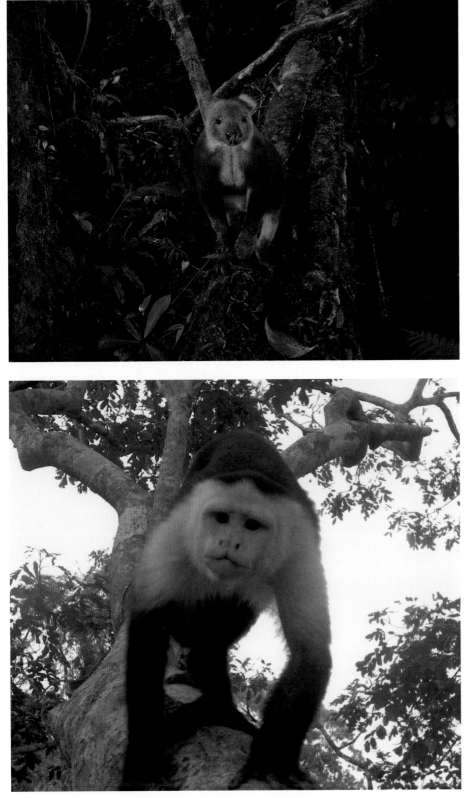

The Goodfellow's tree kangaroo has a unique tree-climbing technique that involves wrapping its forelimbs around the trunk and then using its strong hind legs to hop upward, while sliding its hands along the branches. Although clumsy on the ground, it is bold and quick in the trees. This beautiful species lives only in New Zealand, where it is endangered by hunting and habitat destruction.

chiating spider monkeys, are more selective in their route choice than more generalist climbers, such as capuchin monkeys. All species prefer moving through a thick crown layer with dense vegetation to open forests with scattered trees or dense understory.

One study tested the effectiveness of leaving a few key trees as canopy bridges over a newly constructed oil pipeline in the Peruvian forest. Workers cleared a long thin strip of trees to protect the pipeline and give them easier access, but conservationists worried that the primates on either side of the pipeline would become isolated. Camera traps on the bridge trees confirmed that dozens of arboreal species used the branches to cross the pipeline. This showed the importance of maintaining canopy connectivity for the 75% of tropical vertebrates that spend part or all of their time in the trees.

Compared to other New World monkeys, white-faced capuchins are more likely to descend to the ground to avoid a difficult canopy gap crossing, especially to cross roads or pastures. Their large group size helps them scan for predators before they make the dash across the dangerous forest floor.

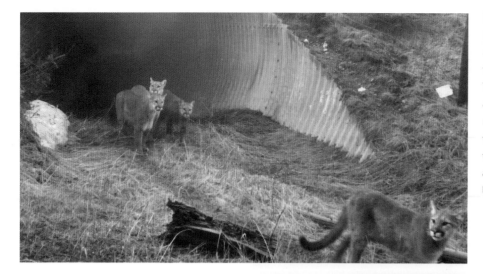

Wildlife underpasses not only reduce the number of animals being hit by cars but also preserve movement and gene flow for the animals on both sides of the road. The movement of genes occurs when an animal born on one side crosses the road and breeds on the other side. The three young cougars being led through this culvert by their mother will be accustomed to using it and are likely to look for mates on either side.

ROAD UNDERPASSES
Helping Animals Go under the Road

Highways through natural areas are a concern for those working to preserve wildlife populations. The most obvious problem, visible to any motorist who scans the roadside, is the mortality of animals that get hit by a car while trying to cross the road. However, over the long run, the animals that don't cross the road could pose an even bigger problem. If highways totally prevented animal movement, wildlife on either side of the road would be fragmented into isolated populations and therefore be more at risk to inbreeding and extinction. Engineers and conservation biologists work together to find solutions to help animals continue moving from one side of the road to the other without risking a car collision, using camera traps as a primary tool to monitor their effectiveness.

Underpasses are the most common solution, allowing animals to cross under the road to avoid traffic. Drainage culverts for creeks are already built into highway designs,

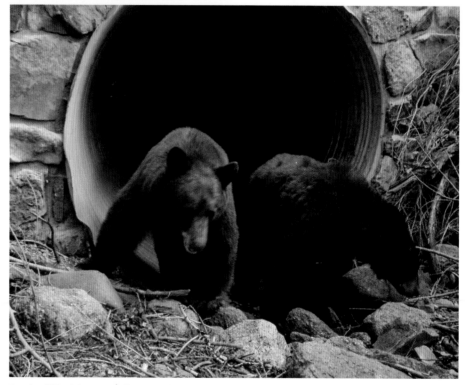

A pair of black bears tumble out of a narrow culvert under a road in Boulder, Colorado. Surprisingly, black bears prefer the tighter quarters of narrow culverts.

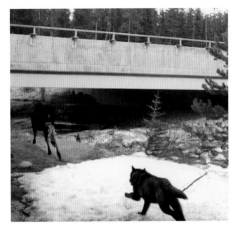

This camera trap caught this wolf in hot pursuit of a moose through a wildlife underpass in Banff, Alberta. This was a rare event at underpasses, probably the result of infrequent opportunism by the wolf rather than the result of predators using underpasses as a favorite hunting ground.

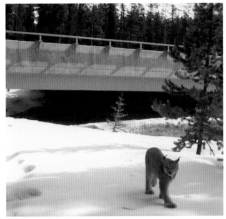

A Canadian lynx takes a rare walk through a wildlife underpass built alongside a river that flows under a highway in Canada. All animals take time to find and start using a new underpass; lynx and wolverines seem to be the most reluctant to try a new route across the road.

A long-tailed weasel checks to see whether the coast is clear before using an underpass to get across a road. This weasel is in the middle of its fall molt, with one stripe of its brown summer coat left to change to its winter white. However, since the snow hasn't fallen yet, it is mismatched against the brown background and would be easy to spot by predators.

and many smaller animals make use of these even if they weren't originally designed for animals. Smaller species, especially tunnel-loving rodents or weasels, are most likely to use these smaller culverts. However, convincing larger species to walk into an enclosed space can be more difficult and may require wildlife-specific designs. Running camera traps on the underpass is a simple way to monitor which species use which underpass and to assess which design features are best for wildlife.

Some studies have also added a genetic component to their road ecology studies. This lets biologists check whether the animals that use the underpass are successful at breeding once they cross, with animals on both sides of the road effectively mixing genes like one continuous population instead of two separate ones. One study of bobcats in Southern California found a surprising level of genetic isolation caused by a major highway, despite occasional photos on their cameras of animals using underpasses, suggesting that the movement they observed was not sufficient to create gene flow. However, another study in Banff National Park, in the Canadian Rockies, found that bears using the underpasses did contribute to the gene flow, thus maintaining genetic connectivity on both sides of the road. They found that 47% of black bears and 27% of brown bears that used the highway crossings successfully bred, including multiple males and females of both species. Banff had many more, and much larger, underpasses than the highway in Southern California, showing that a properly designed system of wildlife crossings can allow sufficient gene flow to prevent genetic isolation, even for big animals.

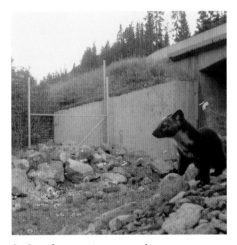

An American marten pauses by a fenced culvert next to a highway.

A cougar uses a long, narrow underpass in Jalisco, Mexico. Cougars are comfortable in confined spaces, which they often use as cover to hunt prey, and are more likely than other species to use narrow tunnels under roads.

A late March snowstorm forces a grizzly bear to push through snow drifts on its way through an underpass in the Canadian Rockies. This subspecies of brown bear avoids most of the year's snow by hibernating during the winter.

Are Underpasses Ecological Traps?

Some worry that predators might recognize road underpasses as ideal hunting grounds—a funnel for wildlife activity with good ambush sites. In this scenario, underpasses could be a type of ecological trap, where ideal conditions for one aspect of survival (avoiding roads) lead to high risk for another (predators). Although predation events are sometimes recorded at underpasses, they are not common. Furthermore, other studies have shown that predators tend to use different types of underpasses than their prey. Prey might appear nervous when using road underpasses, but camera trap studies show that these are not high-risk sites for them.

What Makes a Good Underpass?

Animals will not use underpasses to get across a roadway if they seem like dangerous places. Scientists using camera traps to monitor the use of these structures have learned a lot about what makes animals nervous. The most important factor, discovered by Tony Clevenger and his research team, is high use by people—if underpasses have a lot of human traffic, animals are not likely to use them. If there are few people using the structure, animal travel through an underpass depends primarily on how the structure is made and secondarily on what the surrounding landscape is like. Underpass use also varies with species, since narrow spaces make some animals feel nervous (especially prey) and others more comfortable (especially predators). For example, in the Rocky Mountains of Canada, Clevenger's cameras showed that crossing structures that were high and wide but

(*left*) Although elk will use underpasses if they are large enough, they prefer using one of the six natural-cover bridges built over the highway in Banff National Park. A camera trap comparison of nearby over- and underpasses recorded elk using two underpasses 418 times and two overpasses 1,388 times, showing their clear preference for the less constricted route across the road.

(*right*) The Trans-Canada Highway cut a gash through Banff National Park, which threatened to isolate animals on either side of the road. Six natural-cover overpasses help animals cross the road, maintaining genetic connectivity for populations on either side and reducing roadkill.

short in length were more likely to be used by brown bears, wolves, elk, and deer. More constricted culverts were favored by black bears and cougar. Cougars were also more likely to use an underpass that had thick vegetation near its entrance, while bears, elk, and deer all preferred passages with lots of open space at their entrance. Although animals have their preferences, any underpass is better than no underpass, as long as humans aren't using the structure. Their effectiveness can be seen not only in the camera trap images but also in the reduction of animal mortality on roads near these underpasses.

Helping Wildlife over the Road
Although most species prefer larger underpasses to smaller ones, they may not offer a complete solution, especially for larger herds of ungulates. Tree-covered overpasses provide the most natural passageway to get across the road without getting hit by a car, and research shows that most animals

appreciate the extra effort and cost (overpasses are more expensive to build than underpasses). Clevenger's team also used camera traps to monitor the use of two overpasses installed over the newly expanded Trans-Canada Highway from 1997 to 2009. Each was paired with a large underpass, which was also monitored with camera traps, so they could directly compare how animals used their over/under options. The overpasses were the clear favorite, especially for ungulates, with deer crossing over the road 10,377 times but using the underpass only 636 times. The iconic elk herds of Banff used the overpass three times more than they used the nearby underpasses, and only one moose braved the underpasses, while cameras recorded 84 overpass crossings by moose. Grizzly bears and wolves also used the overpass more, while cougars seemed to prefer the privacy of the culverts to the exposed nature of the overpass.

A deer family walking along a back road is prevented from entering a fenced-in highway by a charged electromat.

A gray fox slowly walks across an electromat for the first time and then jumps as its feet cross two wires, triggering a surprising shock. This charge is harmless to the animals and works to prevent them from walking along an access road onto a busy fenced-in highway.

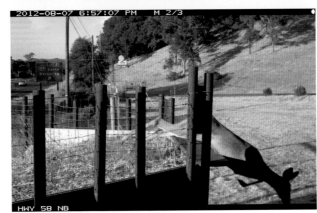

A doe black-tailed deer uses a jump-out to leave a fenced-in highway corridor where she had been stuck after accidently entering along a roadway.

ELECTROMATS

Fences along highways keep wildlife from crossing over the road and getting hit by a vehicle, and they can help to direct them to underpasses, where they can safely cross under the road. However, highways frequently have access roads that cannot easily be fenced or gated owing to the amount of traffic, and these gaps in the fence could allow wildlife to enter as well. Like the metal bars long used as cattle guards at fence openings, electromats have been proposed as a way to prevent wildlife from entering the highway by running across the access road. But instead of metal bars (which many wild animals can easily cross), the mats contain thin electrified metal strips. In theory, any animal that tries to cross the mat will get a shock that sends it back the way it came,

hopefully serving as an incentive in the future to stay away from the crossing.

Biologist John Perrine used camera traps to determine whether electromats successfully prevented wildlife from entering a fenced-in section of highway in central California. He found that the mats did keep many animals out of the highway, but they were not perfect. Animals with small feet could still step between the electrodes to avoid getting shocked. The cameras also showed that snakes were occasionally electrocuted by the mats and then were carried away by vultures or other scavengers before road crews noticed them. These observations are helping to refine the design of electromats, so they can be a more consistent and safer barrier to keep wildlife off the highway.

A black-tailed deer weighs the jump in front of him against the risk of traffic on the road behind. Subsequent camera trap images showed that he jumped out to safety.

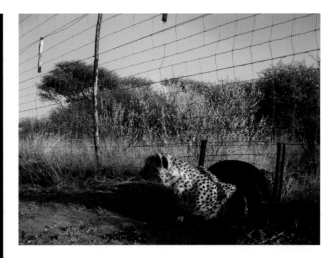

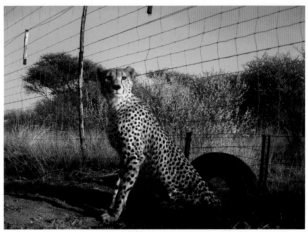

The common eland is the second-largest antelope species; reaching 2,000 pounds (940 kg), they can be a great hazard to speeding cars. This fence helps keep them off the roadway, protecting the animals and local drivers.

Ecologists used discarded tires to create these wildlife underpasses along the border of a Namibian wildlife farm to reduce damage by warthogs and facilitate movement of smaller species. Their camera trap recorded 11 species using the tires, including seven different individual cheetahs (recognizable by their unique spot patterns).

FENCE ESCAPE ROUTES

Fencing a highway is an effective way to reduce roadkill but can also cause new problems. For example, if an animal does make it into a fenced-in highway corridor, it would then be trapped, with no easy escape from the traffic. Engineers in California built a sort of escape ramp for animals which allows them to jump out of the highway corridor, but not back in.

They had no idea whether animals would actually take the plunge until they got these camera trap photos.

Fences are widespread in Africa to protect herds of wildlife and also keep them off the road. However, many smaller species are more careful about crossing the road, and fences only serve to unnecessarily isolate their populations. Even worse, some, like wart-

hogs, will damage the fence to get through. Ecologist Florian Weise found an inexpensive solution, burying a used tire to allow smaller animals to pass under the fence without damaging the structure. Camera traps showed that their efforts were appreciated, being used by numerous smaller animals, while still keeping the larger ungulates off the road.

(*top*) A squirrel glider crawls through a rope bridge strung over a road in Australia.

(*bottom*) A camera trap records a common brushtail possum using a rope bridge to cross a road in New South Wales, Australia.

(*right*) A brown howler monkey crosses a rope ladder bridging a road in Porto Alegre, southern Brazil.

This highway overpass in New South Wales, Australia, includes natural cover to encourage terrestrial animals and a rope bridge strung along poles for arboreal species.

HIGHWAY ROPE BRIDGES

Arboreal animals have a real problem crossing the road. Their tree-living habits make them adverse to entering tunnels, so they will not use the traditional wildlife underpasses designed to help animals. They are even reluctant to walk on the ground across the more natural overpasses built in some areas. Climbing animals are not as picky about the types of things they will climb on, which can be deadly if they climb on certain power lines along roads. As an alternative, conservationists and road engineers have collaborated to string ropes across highways to give climbing animals a safe road crossing.

A variety of canopy bridges have been use to help wildlife, and camera traps are crucial tools to document their success. In Brazil, chain-link and rope-ladder constructions have been used by a variety of species, including brown howler monkeys, white-eared opossums, and orange-spined hairy dwarf porcupines. Simple thick ropes strung between poles, as well as more complicated rope boxes, have been successfully deployed in Australia for their unique tree-loving marsupials. These wildlife-friendly high wires not only help animals avoid becoming roadkill but also maintain gene flow between forest fragments that would otherwise be isolated by broad roads and bustling highway traffic.

A northern flying squirrel surveys the road below and then launches off a pole erected to help it glide over a two-lane road in North Carolina.

A squirrel glider climbs up a roadside pole to get a good launch point over the traffic. Baffles were set at the bottom of the pole to ensure that climbing animals went up the side of the pole with the camera trap on it.

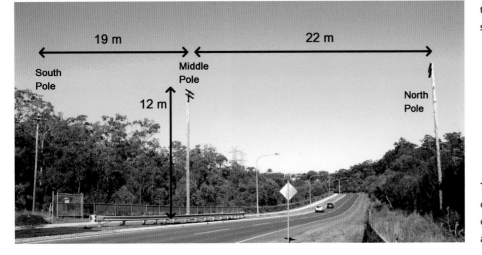

This photograph shows the height and distance (in meters) of a set of three poles erected to help squirrel gliders glide across a busy road in Queensland, Australia.

GLIDE POLES

Bats are the only truly flying mammals and easily soar over roads. However, around the world there are a variety of gliding animals that have more trouble. Many of these gliders are more comfortable gliding or scampering through the trees than they are on the ground, where they are inefficient runners and vulnerable to predation. This makes them unlikely to cross over roads. Indeed, in North Carolina, a new two-lane scenic road through the Unicoi Mountains was enough to divide one population of endangered northern flying squirrels into two smaller ones. The gap was too great for them to glide across, and these animals would not run across the road. There was fear that this isolation could lead to inbreeding and local extinctions, so conservationists tried out the inexpensive option of erecting glide poles.

By erecting a tall pole with a horizontal launch arm on both sides of the road, wildlife managers, led by Christine Kelly, hoped that the flying squirrels would be able to glide over the road, avoiding cars and reconnecting the two populations. Camera traps showed that squirrels were using the poles as launching pads to glide across the road. Kelly's radio tracking and monitoring of nest boxes confirmed that animals were regularly moving back and forth over the road and breeding on both sides.

Concern for sugar gliders in Australia has led to the development of two-stage road crossings over busy highways, with a pole in the middle serving as both a landing place and a takeoff pad. Camera traps confirmed that animals use this pole network to safely cross over roads and maintain connections between the forests on either side.

There are only a few thousand swift parrots left in the world. They nest in tree cavities while breeding in Tasmania, and then they migrate north to Australia for the rest of the year.

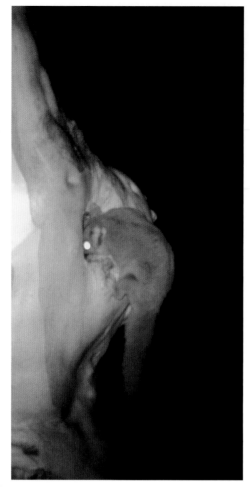

Sugar gliders are not native to Tasmania but have flourished there after being introduced, causing major problems for nesting birds. Here a sugar glider enters an active swift parrot nest, where it will likely kill and consume the incubating female, as well as eat her eggs.

NEST PREDATORS
Security Cameras for Nests

Nesting season is the most dangerous part of the year for all birds. Normally free-flying adults have to stay with the nest to incubate eggs or feed noisy young, while the young themselves are helpless in the face of almost any predator. Remote cameras are a useful tool for studying this critical period, clearly documenting the success or failure of a nest. Like security camera footage, these nest monitors can document the demise of an egg or chick at the hand of a raccoon, beak of a blue jay, or mouth of a snake. This footage has revealed some surprising nest predators as well, including mice, flying squir-rels, and even daddy longlegs (aka harvestmen). Although predation rates can be high for nests, in healthy ecosystems birds maintain the advantage, fledging enough young to ensure future generations. However, in areas with unbalanced predator populations, either through food supplementation by humans or as a result of invasive predatory species, birds are losing the battle for the nest.

Invasive species are the chief concern in Tasmania, where camera traps run by Dejan Stojanovic have shown that introduced sugar gliders are a major predator for the endangered swift parrot. The parrots nest in small cavities in Tasmania and migrate north to Austra-

lia for the winter. Concerned about the future of this species, which has only a few thousand individuals left, scientists used camera traps to monitor which predators raid their nests. After monitoring 70 sites, Stojanovic recorded 10 different species trying to get into the parrot's nest hole, but the small entrance or deep internal chamber of the cavities foiled all would-be predators except for one—the invasive sugar glider. Even worse, by attacking at night, the sugar gliders not only consumed all the eggs but also usually killed and ate the female parrot, which was trapped in the hole incubating her eggs. One bright spot has been the high success rate of parrots nesting on Tasmania's offshore islands, which have not yet been colonized by sugar gliders. Stojanovic's research emphasizes the importance of keeping this cute but egg-loving mammal out of this last stronghold of the endangered swift parrot.

High-Wire Nesting Act

Unlike secretive shrub nests, raptor nests are often conspicuous collections of sticks built on the highest branches of a tree, protruding above the surrounding forests. Mississippi kites build these kinds of daredevil nests, which were thought to be safe locations that are too high for climbing predators and easily defendable against airborne attacks. However, studies of their nests have found high rates of failure, which raises concern for the conservation of the small population that lives in the Mississippi Valley. To find out exactly what was causing these nest failures, biologist Scott Chiavacci rigged cameras

up to monitor 46 nests in the White River National Wildlife Refuge in Arkansas.

All nests were in the canopies of large, super-emergent trees, and the camera views show the dizzying height these young birds grow up with. Almost all nests had just one egg. Four nests started with two eggs, but in each case the cameras recorded siblicide and cannibalism that left just one nestling. Sixty percent of nests were successful, while 19 nests failed. Two chicks fell out of the nest, and another nest was destroyed by a thunderstorm, showing the risk of having such an exposed nest. Predators caused the failure of 13 nests, including 7 by Texas rat snakes, 5 by barred owls, and 1 by a great-horned owl.

Although rat snakes are known to be good climbers in the understory, Chiavacci was surprised to see them scale all the way up these emergent limbs above the canopy. Kites are known to defend their nests from snakes, but most of these snake predations happened during the night, suggesting that the snakes might wait for nightfall to approach the nest, hoping to avoid the adults. Overall, snake and owl predation was more likely when nests were in more conspicuous locations, higher above the tree canopy, or in more isolated trees farther from the forest edge. For Mississippi kites the perfect nest site seems to be something high enough to keep away most climbing predators, but still hidden enough to avoid the nocturnal attacks of owls and snakes.

(*top*) A male Mississippi kite, recognizable by his white head, incubates eggs in its treetop nest. These graceful fliers select high nest sites that give them a good view of their surroundings and help them fend off would-be nest predators during the day. They are even known to attack people that come too close to their nest. Research with remote cameras shows that these conspicuous nests are still vulnerable to predators at night.

(*middle*) Mississippi kites in this area rarely fledge more than one chick. Remote cameras showed that females sometimes laid and incubated two eggs. However, in each case, the video footage showed the larger chick killing and consuming its nest mate. This type of siblicide is widespread in nesting birds and thought to give them the flexibility to produce more young when food is very abundant, while avoiding starvation when times are tough.

(*bottom*) A Texas rat snake is caught on video consuming a Mississippi kite egg at night. Kites are known to defend their nests from snakes during the day but seem to be defenseless at night, which is when most snake predation was recorded in this study.

Keeping the Tundra Naturally Safe

Millions of birds migrate to the arctic to breed in the summer. This seasonal influx is thought to overwhelm nonmigratory nest predators such as foxes, so that most birds can survive even after the foxes have gotten their fill. Although these predators do get easy food during the nesting season, they are limited by the harsh winters and thus can't build up large population sizes. However, there is some worry that scavenging species might now survive winters better by raiding human garbage. If this helps them reach higher populations, they could inflict more serious damage to bird populations in the spring. This is of particular concern in remote areas with active oil exploration, which provide more winter scavenging opportunities.

To test this idea, biologists led by Joe Liebezeit set camera traps on bird nests near the oil fields of Prudhoe Bay, Alaska, and also in a more remote area with no human development. Arctic foxes were the most common predator at both sites, followed by red foxes, as well as a surprising amount of predation by arctic ground squirrels. Bird predators included parasitic jaegers, ravens, and one snowy owl. The ravens and foxes are opportunistic garbage feeders and were more common nest predators at the oil field than at the remote site. Limiting the access to waste food at oil exploration sites might make the winter a bit harsher for the foxes, but it would be good for the millions of birds making their long migration journeys in hope of a safe nest site.

This grizzly bear stopped by to sniff a nest but didn't eat the contents.

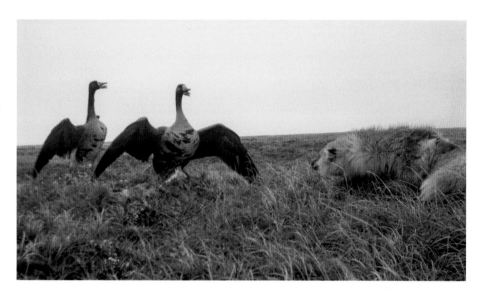

(*top*) A pair of greater white-fronted geese defend their nest from a red fox. The geese were successful, and a few days later the camera trap recorded grown chicks walking away from the nest.

(*bottom*) An arctic fox runs through the tundra with its breakfast, freshly stolen from a nest. With so many nesting birds in the area, foxes find food easily in the spring, but since they can't migrate, they have to endure long, harsh winters.

Although typically vegetarians, the arctic ground squirrel—the third most common nest predator in this study—will take advantage of the protein offered by a songbird nest.

A red fox dines on a savanna sparrow nestling. Red foxes were historically very rare in this area and may be increasing in number owing to a warming trend in the region.

A caribou accidently flushes a nesting semipalmated sandpiper.

A caribou stops to investigate a bird nest as the rest of the herd moves on. Although caribou were abundant at the study site, trampling of nests was not a big problem.

The striped tail of a newly hatched alligator can be seen hanging out of its mother's mouth. This isn't infanticide, but the mother alligator helping the babies get out of the nest and down to the water. This marks the end of her nine-week vigil guarding the nest against would-be nest predators such as raccoons and foxes.

Once the first few eggs hatch, the young gators make faint grunting sounds that let the mom know that it's time to open up the nest. She will also take care of eggs that haven't yet hatched, even delicately cracking the shells to help the hatchling out.

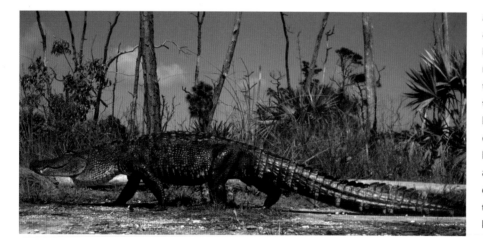

An American alligator strolls across the Florida Keys. Ectothermic (i.e., cold-blooded) reptiles have body temperatures that match the environment and therefore don't usually trip the heat-sensitive motion triggers on camera traps. This animal looks to have just emerged from the water and so might have triggered the camera because it was cooler than the hot Florida sand in the background.

NEST PROTECTORS
Guard Gator

The predatory skills of American alligators serve double duty during nesting season. A mother gator lies in wait near its nest to protect the eggs, and if she's fast enough, she might also catch potential egg predators as a meal for herself. Females lay three to five dozen eggs in a nest of sticks and leaves created in a secluded spot. They lurk around nearby for the nine weeks it takes the eggs to develop, protecting them from would-be nest predators. The vicious tooth-lined mouth of the mother alligator turns into a baby stroller once the eggs begin to hatch. As soon as she hears the characteristic grunts of the first hatchlings, she will dig up the nest and carry the babies and any unhatched eggs down to the water.

Crocodile versus Coati

Like their alligator relatives, American crocodiles also protect their nests from predators and help dig out the babies once they have hatched. Members of the raccoon family (Procyonidae) seem to be the chief threat to crocodile nests, and one study found that 13% of nests in Florida were depredated. Raccoons can smell a single acorn under 2 in (5 cm) of sand, so finding a clutch of ~25 crocodile eggs stashed under a pile of leaves and sticks should be easy for them. Snatching the eggs out from the watch of the mother crocodile, however, is another problem. A video camera trap set by Torrey Rodgers in Panama recorded a

A white-nosed coati beats a hasty retreat from a shoreline area where a crocodile has a nest, barely escaping the lunging reptile protecting her nest.

group of white-nosed coatis trying to steal eggs from the nest of a 12 ft (4 m) long crocodile that lived in the Panama Canal.

Coatis are in the raccoon family and have long snouts that they use to sniff for fruit, insects, or other eatables in the leaf litter of tropical rainforests. This troop of animals was initially attracted to the crocodile's nesting area by an abundance of turtle nests in the sand between the water's edge and this old concrete pad. They returned daily to dig up turtle nests and eventually sniffed out the crocodile eggs. One video sequence records the mother crocodile lunging at a coati as soon as it arrives on the pad. In another sequence a pair of coatis manage to excavate and eat a few eggs before the mother croc shows up. The bold coatis were not put off by the reptilian threat, returning each day for about a week until they had finished off all the crocodile's eggs.

This big crocodile made its nest in the loose dirt next to a decaying concrete pad along the Panama Canal. Camera traps recorded the weeklong battle for the eggs between her and a group of coatis.

Bushnell 03-05-2014 14:47:37

Raptors often spar over deer carcasses, even when there is more than enough for everyone. Here a bald eagle challenges an adult golden eagle's perch atop a large pile of roadkill deer in Upstate New York, while a raven sneaks in to grab a beak-full of venison.

A golden eagle alights on a snow-covered deer carcass at its wintering ground in Tuscarora State Forest, Pennsylvania.

CARCASSES

Mapping Sneaky Eagles with Stinky Carcasses

For such a big bird, golden eagles are surprisingly stealthy when they migrate south. Tracking data from a few birds wearing GPS units, along with occasional sightings by bird-watchers, suggest that some eagles winter in the forests of the eastern United States. However, sightings were so rare that biologists didn't know how important these areas were, or what types of habitats the eagles used in the winter. Eagles are not picky eaters, and biologist Todd Katzner occasionally saw them scavenging on roadkill deer, which are common throughout the region. Katzner started moving these dead deer around, into strategic remote areas up in the mountains, and leaving camera traps out to see what came to eat this offering of venison.

The golden eagles came and fed on the deer, and not just a few times. Golden eagles were present at the baited sites almost one-third of the total days the carcasses were monitored, making them the fourth most common bird species photographed, after crows, ravens, and red-tailed hawks. The night shift brought mammalian scavengers, including coyotes, raccoons, bobcats, and Virginia opossums. Even the eastern spotted skunk, a rare species in the region, has been recorded feeding on the frozen deer.

To expand his survey, Katzner posted his instructions for running camera traps online and asked volunteers to run their own cameras across the area and share their photos. The results have been impressive, with over 250 sites sampled across 16 states, generating many millions of photographs. The

Bald and golden eagles are about the same size and compete for dominance at carcasses. Golden eagles are generally more aggressive and more likely to win in a fight. In this case, however, the camera trap showed that the golden eagle had already been on the carcass for a while and eaten its fill while the bald eagle was perched nearby. The hungry bird's patience finally wore thin, and it swooped in to take its turn, chasing off the satisfied golden eagle in the process.

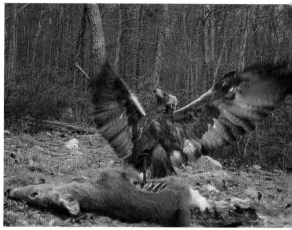

A golden eagle claims its meal in West Virginia.

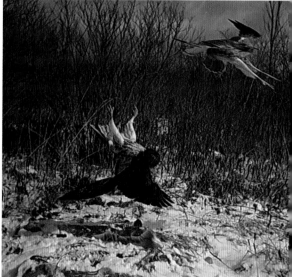

Two red-tailed hawks photographed in a midair battle for deer carcasses. The lower bird briefly flipped itself upside down to aim its talons at its attacker.

new map of golden eagle migration is now much more detailed, showing that they are much more common and more widely distributed than any of the bird-watchers had imagined.

Nonchalant Ravens

Ravens are one of the most common attendants at carcasses across North America, Europe, and Asia. One-on-one, they are no match for the deadly talons of hawks or eagles. But these social birds can call in the reinforcements, and large flocks of ravens sometimes take over a carcass at winter. Many beaks make short work of a dead deer; a flock of ravens can skeletonize a carcass in a week, whereas an eagle would scavenge for at least twice that time. However, hanging around freshly killed carcasses is dangerous business, and ravens have to be careful to avoid the larger predators. Nonchalant ravens face the risk of becoming eagle food themselves, as recorded in some camera traps studying scavenger interactions.

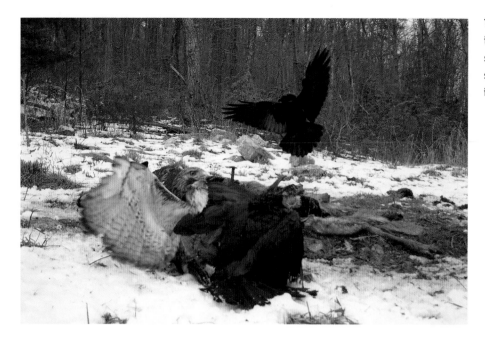

This camera trap caught the moment of impact as a red-tailed hawk attacks a raven, scaring another off in panic. The raven survived this attack but left the hawk to eat in peace.

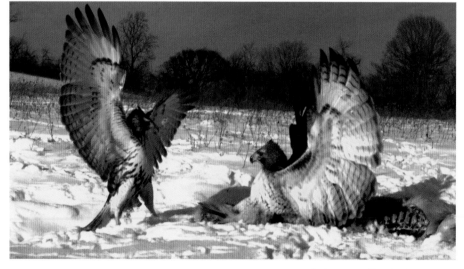

(*left*) Two grounded red-tailed hawks display their size to try to impress the other and win sole possession of a roadkill deer left out to survey raptors in Meadowcroft, Pennsylvania.

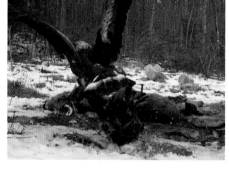

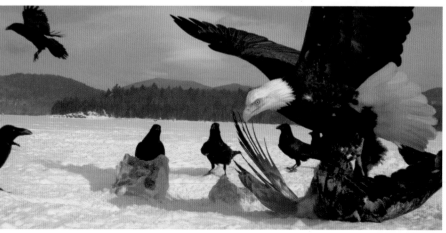

A flock of ravens spectate as two bald eagles spar over a frozen deer at Aziscohos Lake in Maine.

A golden eagle recorded carrying a raven it has just caught (*top*) and then consuming it (*bottom*) next to an old deer carcass.

MINERAL LICKS

Eating Clay

Mineral licks, also known as salt licks or collpas, are hot spots of animal activity. With their rich mineral content, these clay deposits attract animals from miles around, especially herbivores. The exact reasons why these minerals are so important to animals remain unknown. One simple hypothesis is that the plants eaten by the wildlife don't contain enough minerals to sustain the animals, and so they consume dirt as a direct supplement. A second hypothesis is that these clays have a buffering, or absorption, capacity that helps the plant eaters cope with the nasty secondary compounds created by various plants to try to prevent herbivory. Monitoring these licks with camera traps is a great way to see which species use the licks the most, which could eventually help in discovering the true motivation of this natural animal magnet.

Salt Lick Safety

Camera trap studies of mineral licks in the Amazonian rainforests of Ecuador have highlighted the importance of these resources for the local wildlife. One study led by John Blake recorded 8,777 photographs of 23 mammal and 15 bird species. Mineral licks in unhunted parts of the preserve had more animals, with four times more activity than those in hunted areas. As at other mineral licks, herbivores were the most common visitors, with red brocket deer, pacas, collared peccaries, tapirs, and white-bellied spider monkeys being the top dirt eaters.

The local predators and human poachers also recognize these

A flock of red-throated piping guans visit a mineral lick in the Brazilian Pantanal.

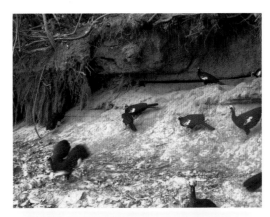

A South American tapir takes a bite of fresh clay from a hillside.

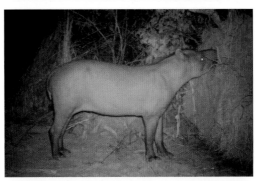

Salty water drips from a tapir's mouth after consuming the soft muddy clay from the wallow.

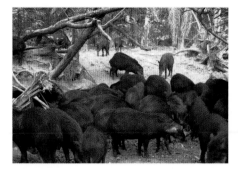

White-lipped peccary herds sometimes number in the hundreds, swarming over salt licks when they visit.

Black howler monkeys are treetop herbivores, but they can't resist the lure of the minerals in this salt lick in Brazil.

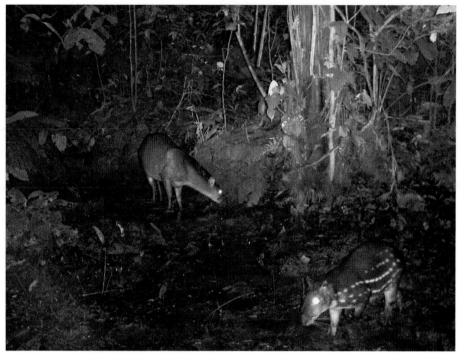

The paca is a big, common nocturnal rainforest rodent that eats mostly fruit. It appears to be waiting its turn in this photo while a deer visits the salt lick.

The red brocket deer was the most common visitor to mineral licks in the Ecuadorian Amazon forest. These herbivores browse on a wide variety of plant species and may need this rich clay to help counteract the toxic chemicals found in some leaves.

A white-bellied spider monkey tries to keep itself clean while drinking and eating clay from a mineral lick.

hot spots of animal activity and are also recorded by the cameras. Thus, visiting a lick is dangerous, especially for the monkeys that are not as quick on the ground as they are up in the trees. A study of white-bellied spider monkeys found that a salt lick was the most intensely used part of their large home range, but that they wouldn't go to eat the clay every day. Spider monkey groups are flexible in size, budding off into smaller groups to reduce competition for food in the smaller fruiting trees, but coming back together when the help of the larger community is needed. In this case, scientists observed a slow fusion of subgroups into one larger monkey group in the two hours preceding a visit to the salt lick. Larger groups mean more watchful eyes and better odds of sounding

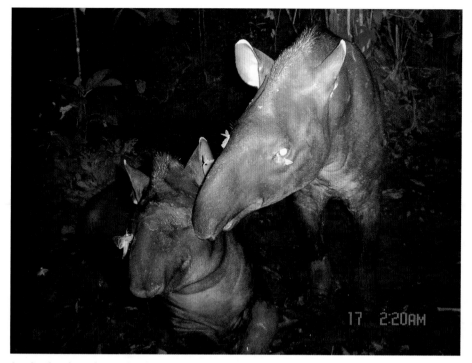

A pair of tapirs enjoy each other's company at a salt lick while lacryphagous moths feed on their salty tears.

(*top*) A tapir looks attentively toward another animal approaching the salt lick, oblivious to the moth feeding at its eye.

(*bottom*) For the nectar-feeding moths, the tears of a tapir have more attractive concentrations of minerals than the salt lick the mammal is feeding on.

the alarm if they discover a big cat lurking in the bushes next to the mineral lick.

Meta-Salt-Lick

Large mammals aren't the only creatures that need salt in their diet. Insects also need this micronutrient for their metabolism and egg production. One study put salty baits out in different parts of South America and found that attraction of ants increased as the experiment was moved farther away from the ocean. Presumably, aerosolized salt near the ocean seeps into coastal environments, meeting the needs of the local animals, while inland creatures are left to search for scattered salty deposits in the soil.

The Amazonian headwaters in Ecuador are about as far away from the ocean as you can get, which may help explain the high animal traffic at salt licks in this area. Tapirs are the largest mammal in the region and one of the most frequent visitors recorded by camera traps at these clay licks. These photographs show that the tapirs themselves were serving as a type of salt lick for insects, with numerous moths swarming around the eyes of the tapirs, drinking their tears. Moths and butterflies that drink eye fluid, known as lacryphagous insects, have been noted in other parts of the world feeding on the eyes of reptiles or sloths. In all these cases the animal serving as a movable salt lick doesn't seem bothered by the insects' lust for salt, although any actual benefit to the host remains unlikely.

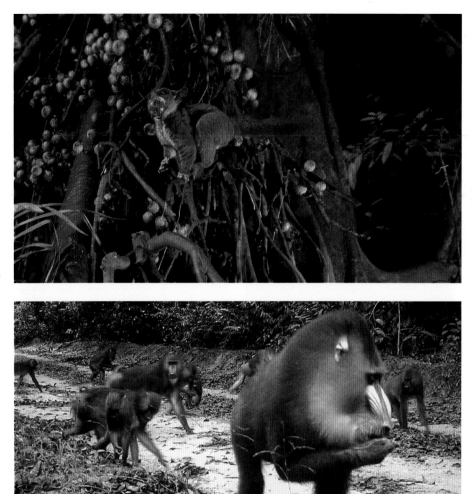

After plucking a ripe fig, this Bioko Allen's galago heads away from the tree, looking for a safe place to eat.

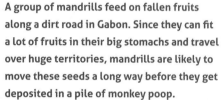

A group of mandrills feed on fallen fruits along a dirt road in Gabon. Since they can fit a lot of fruits in their big stomachs and travel over huge territories, mandrills are likely to move these seeds a long way before they get deposited in a pile of monkey poop.

Scientists put this camera in a tree to see what visited the big clusters of fruits hanging from a black palm in Panama. This photo shows a kinkajou hanging upside down on one cluster, eating the pulp off the seeds one at a time, and then dropping them directly under the tree.

FRUITING TREES
The Fruit Tree's Perspective

The entire purpose of a fruit is to lure animals in to consume the sweet package of pulp and seeds and then move it away from the mother tree. Fruit is payment by a plant for the movement services of animals. Seeds left under the tree are likely to be killed by seed predators or parasites, or simply be shaded out by the foliage above. But all animals are not equal, from the plant's perspective. Some consume the seed in addition to the fruit around it. Others eat the fruit but drop the seed right under the tree. Wide-ranging animals that carry seeds far away and don't hurt the seeds in digestion are the most beneficial for plants. Tree species actually compete for these high-quality dispersers by evolving fruits that are larger or more delicious than those made by other tree species. Camera traps help record which species of fruiting tree has succeeded in attracting which species of frugivore.

This camera trap photo shows a chital eating Indian gooseberries placed out in a careful array by scientists. A series of photographs from this camera prove that the chital actually consumes the fruits. This spotted deer species was one of the most important dispersers of this fruit.

This sloth bear visited gooseberry trees a couple of times during this study and sniffed at the fruits but didn't eat them. Sloth bears prefer termites and ants.

(*top*) This small deer, known as a chevrotain, was one of the most important dispersers for the Indian gooseberry. Camera traps showed that they were the most frequent visitor to the trees, foraging for fallen fruits for three to five minutes before moving on in search of other food.

(*bottom*) The small Indian civet is known to eat some types of fruit, but they did not consume the Indian gooseberry.

Animal Dispersers of the Indian Gooseberry

If fruit trees lose their seed dispersers to poachers, there is fear that the forests will lose their fruit trees. Without animals to move their seeds to suitable locations, other plant species with wind-dispersed seeds are more likely to win the plant battle for space in the forest. Alternatively, animals might survive in one forest but be unable to move across recently developed areas to reach other forests, thus also limiting the spread of plant seeds across the landscape.

Scientists in India led by Soumya Prasad wanted to know what animals were dispersing the Indian gooseberry, or amla fruit, to evaluate the risks it faces in fragmented forests. By aiming camera traps at arrays of fruits on the ground, Prasad was able to distinguish animals that actually ate the fruit from those that happened to wander past the cameras but weren't actually dispersing seeds. Soumya discovered that just six species of mammals were responsible for the dispersal of this plant species, while another six

mammals and one bird were seen walking past the fruits without eating them. Chital and chevrotain were by far the most common fruit eaters, accounting for 95% of the fruit removal. Although frugivores appear abundant within her study site, these two deer species are shy around human settlements and are unlikely to move seeds between different forest fragments. The establishment of animal movement corridors between isolated forests would help not only the animals but also the fruiting trees that depend on them.

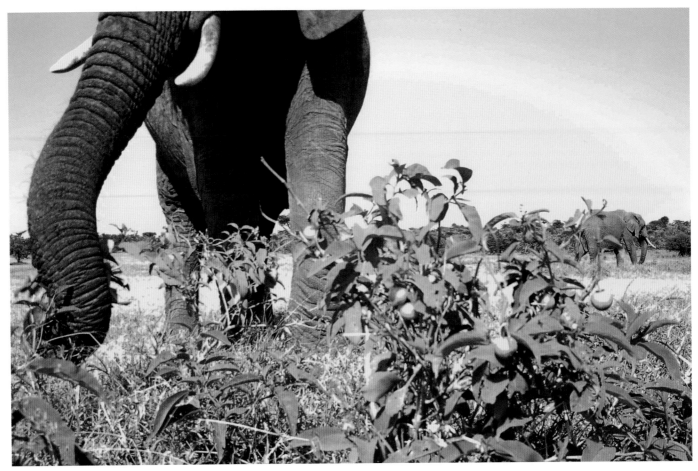

A big elephant can do a lot of damage to a little bush; 16% of the plants monitored with cameras were actually destroyed by these hungry pachyderms.

Impalas not only browsed on shrubs' leaves but also ate their fruit, thus helping disperse the seeds. Impalas were the keenest fruit eaters, taking 75% of the fruit in this experiment within two weeks.

BUSH VERSUS ELEPHANT

The life of a bush on the African savanna is not an easy one—herbivores are everywhere. To see what effect these herds of roving leaf eaters have on the environment, Robert Pringle and colleagues worked in Kenya to erect a series of carefully designed fences that would exclude animals based on size; one treatment kept out only the biggest species (elephants, giraffes), another excluded all herbivores larger than 100 lb (50 kg), and a third kept out all herbivores larger than a mouse. Pringle also used camera traps to see how often the leaves and fruit of the bushes were getting eaten, and by what species.

The cameras showed that, on average, a bush was browsed by a mammal every other day. Almost half of this was by the Guenther's dik-dik, the smallest antelope at the site. Impalas and elephants were the other two common browsers, and together these three ungulates were responsible for 92% of browsing events recorded by the cameras. However, a few nibbles by a dik-dik are not the same as an attack by a hungry elephant, which actually killed 12 of their study plants (16%). The experiment showed that the ultimate effect of these munching mammals was to sharply reduce the abundance of bushes, as the complete mammal exclosures

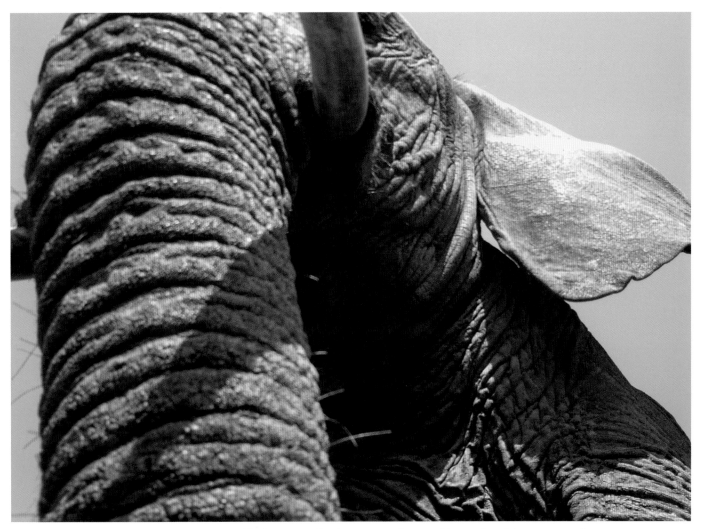

Elephants can also destroy experiments; this one tipped the camera up for a selfie and then moved on, thankfully, without crushing the camera trap.

had about 2.5 times more bushes than the control sites. However, these big mammals also helped the plants by eating their fruits and spreading their seeds. Impalas were the main fruit eater, eating about five fruits per plant each day, and no fruit was eaten from plots where they were excluded. Pringle's study shows that African bushes have evolved a tolerance for constant low levels of browsing by the native mammals and even come to depend on them for seed dispersal services.

The 8 lb (4 kg) Guenther's dik-dik is the smallest antelope in Kenya and the most common browser in this study.

Agoutis are rabbit-sized rodents that serve as important seed dispersers across American rainforests.

Young agoutis practice carrying a large nut.

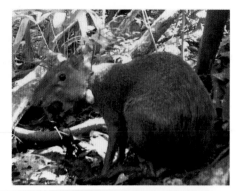

A guilty-looking agouti carries off a seed after stealing it from another animal's cache. Radio collars and other visual marks allowed scientists to recognize individual agoutis in the camera trap footage, from which they discovered that 84% of the retrievals of buried seeds were actually thieveries. Most seeds that are moved are dug up within a week, suggesting that the agoutis might home in on the smell of freshly dug dirt.

This agouti is enjoying fresh fruit under an Astrocaryum tree during the fruiting season. After chewing off the sweet orange pulp, the rodent will bury seeds in scattered underground caches, hoping to retrieve and eat them later. Buried seeds that are forgotten or abandoned have an excellent chance of growing into a new tree.

BURIED SEEDS

Seed-eating mammals have a difficult time finding food year-round if the trees they depend on give fruit only during part of the year. One solution that has evolved in a number of rodent species is to store the seeds in underground caches during the time of plenty and return to them when needed during the hungry season. The two major challenges to this strategy are keeping other animals from finding them and remembering exactly where the scattered seeds are hidden. To see how this worked for agoutis, a rabbit-sized rodent in Panama, scientists led by Patrick Jansen used small radio transmitters to track where seeds were buried. Because all agoutis look alike, the researchers also trapped their study animals to give them unique marks. Finally, they monitored the buried seeds with camera traps to see what happened next.

The cameras showed that most cached seeds were dug up within a week, which was still during the high-fruit season, countering the idea that animals are storing food for the future. However, the majority of these retrieved seeds were not eaten, but moved and reburied. In fact, seeds were repeatedly dug up, moved, and buried: as many as 36 different times. This successional movement resulted in the seed moving farther and farther from its parent tree, which improves the chances that it will be able to establish as a seedling. But why were agoutis moving these seeds around so much? Jansen's camera trap footage showed that 84% of the seed retrievals were by thieving individuals, stealing their neighbor's seed and burying it in their own secret spot for later. The camera footage before a seed was recovered also gave hints as to how these rodents remember so many locations: the cache owner was recorded repeatedly walking past the site to check on it, thus refreshing their memory of the map of their buried treasures.

A great horned owl lands in front of a cat robot and displays, pounces on the cat to sink its talons into the faux fur, and then flies off with its mechanical prey. The cat was found not far away, mostly intact, suggesting that the owl probably discovered the ruse after its first bite.

ANIMAL ROBOTS

Watching how wild creatures interact with animal models is an interesting approach to studying animal behavior. Remote cameras are the best way to monitor these experiments, as having a person watching nearby could affect the animal's behavior. Plus, it could take weeks for the right animal to find the test, especially when considering predator-prey interactions, which are naturally rare.

In this experiment, scientists were wondering which predators would attack a pet cat. Cats themselves can be harmful predators of native small mammals in many parts of the world, but they may also have to look out for larger predators. "Lost Cat" signs attest to the disappearance of pets in many neighborhoods, but it's difficult to know which cat predator was responsible, be they furred, feathered, or the four-wheel variety. Coyotes are well-known cat predators. Smaller species, such as fishers, are rumored to attack cats, but they would seem to be at risk themselves to the claws and teeth of a nasty tomcat.

If there are native predators of cats in a region, it could help maintain a balance of nature through direct and indirect effects. The direct predation of cats, although sad for local pet owners, would work to prevent the overpopulation of

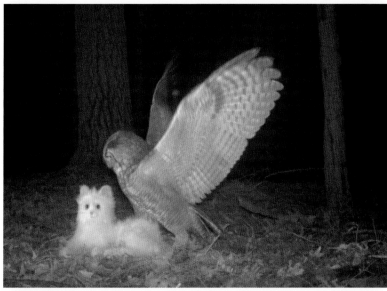

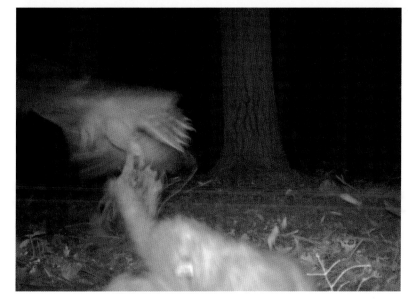

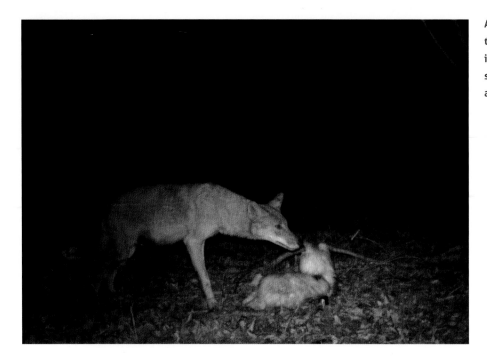

A coyote in North Carolina approaches the cat model for a sniff. Apparently it wasn't fooled by the real cat hair sprinkled around, as it left without attacking.

feral animals. Smart cats would soon realize where the risk was the greatest and change their movement patterns to avoid areas where predators roam. This is an indirect effect of having predators around—creating a landscape of fear which changes the behavior of their prey.

Scientists found their cat model in a toy store. This battery-powered feline robot meowed occasionally and even moved its arms as if it were grooming itself. Scientists also sprinkled some real cat fur around to try to add a bit of genuine scent to the experiment. Left alone in suburban woodlots, a camera trap placed near this cat robot revealed the predators willing to challenge a cat for a meal. Raccoons and foxes passed by without any interest, while a coyote came in for a closer look. A fisher in Vermont went right after the cat, lunging in with a bite to the back of the neck. In suburban New York a great-horned owl literally took the bait, carrying the cat robot out of

view. These images show that a variety of predators make the forests of the eastern United States a dangerous place to be a free-ranging cat, providing further evidence that pet cats are best kept inside.

ANIMAL MODELS

Many brightly colored frogs are poisonous. The problem with this strategy is that these colors also make you conspicuous. Predators can only learn to avoid poisonous frogs after attacking one and tasting the poison—surviving the training period can be difficult. The granular poison frog seems to be trying to play two strategies at once. In southern Costa Rica these frogs are bright red, but northern populations are camouflaged green; both are poisonous. Scientist Beatriz Willink wondered which predators would eat frogs in these different areas, and whether the local frogeaters would learn to avoid the local noxious color morph.

To test these ideas, Willink created clay frogs of different colors and put them out in the forest along a north-south transect in Costa Rica. She had to make a lot of frogs out of clay, as only 3% of their models got attacked. Willink and her team put out 3,600 clay models in total. They rigged up a camera trap to record what happened to the frogs. Early tests showed that lizards and crabs would not trigger the camera because their body temperature was the same as the environment, so they set the camera to record in time-lapse to make sure they didn't miss any cold-blooded frog killers. After biting the clay frog, the predators usually realized quickly that it would not make a good meal and spit it out. The patterns of bite marks on the mangled clay frog were also useful in distinguishing what kind of animal made the attack.

Birds were the most common predators, followed by lizards and crabs. No mammals attacked the

This red clay frog was designed to mimic the red morph of the granular poison frog from Costa Rica. Scientists put out 3,600 clay frogs of various colors to see whether predators noticed and avoided frogs they thought were noxious.

This clay frog was mangled by a motmot, a beautiful bird that is a fierce predator of insects, reptiles, and amphibians.

models, probably because they could smell that the frogs were fake before biting them. As Willink predicted, birds did not typically attack the models colored like the local frogs, avoiding the green morphs in the north and the red morphs in the south. The birds knew and eschewed their local poisonous frogs. Lizards, on the other hand, attacked the conspicuous red frogs more often at all sites. This suggests that they cannot associate warning signals with distastefulness, or that they just don't care. Crabs certainly didn't—they preyed on both color morphs equally at all sites.

Altogether, Willink's frog models colored like the poisonous frogs at that same locality got attacked much less than those with novel coloration. This shows how evolution can select for brightly colored frogs, as well as predators with the color vision and memory needed to avoid them.

This white-nosed coati inspected the model frogs but did not take a bite. Capuchin monkeys and collared peccaries also inspected but did not attack the frogs. Mammals have better senses of smell than other animals and could probably tell with a sniff that the models were made of clay.

This motmot was a major predator of clay frogs but avoided the color most common in their population, suggesting that it already knew this was a potentially poisonous prey.

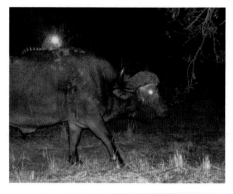

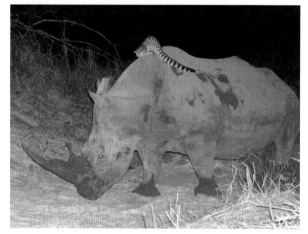

(*left*) A common genet rides on the back of an African buffalo.

The genet might be using this rhino as a movable hunting blind, waiting for mice or insects to run out of the way of the big lumbering beast and then pouncing on them from above.

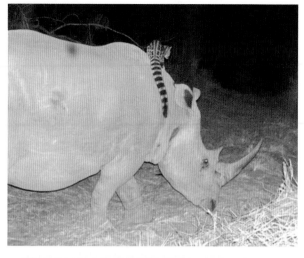

Genets are great jumpers and climbers and presumably would have little problem getting onto the back of a slow-moving rhinoceros. This animal looks like it may have just jumped onto the rhino's back.

This buffalo discovered the genet on its back just as the camera trap triggered, and wheeled around to chase it away.

SURFING GENET

No one had ever heard of any mammal riding around on the back of another mammal before camera trappers in Hluhluwe-iMfolozi Park in South Africa recorded these images of a genet riding a buffalo. They were even more surprised when they got a second photograph of the same genet on another buffalo. This grumpy animal was not amused to serve as a genet taxi and wheeled around to chase it off. Later, the same genet seemed to have found a more agreeable host, as it was pho-

tographed surfing a rhinoceros on a number of different nights.

Birds often follow large mammals to catch insects they flush up, and are sometimes seen riding on their backs. We presume that this genet is trying the same trick at night, and in some photos it seems to be peering over the larger animal's shoulders, watching or listening for small prey to scurry away from the heavy hooves. However, in other images the genet is not obviously hunting, looking as if it's just enjoying the ride.

This fishing cat isn't afraid to get wet to catch its meals. This animal caught a big fish and will eat well tonight in Kaziranga National Park, India.

Although typically a rodent predator, this snowy owl is caught snacking on chicks from a bird nest in the high Arctic.

Coyotes in the eastern United States are not efficient predators of adult deer, but they are active hunters of their young fawns. Here an eastern coyote is photographed carrying a fawn on a fallen log serving as a bridge over a swollen river in New Jersey.

A northern river otter enjoys a fish in front of a camera trap in Boulder, Colorado.

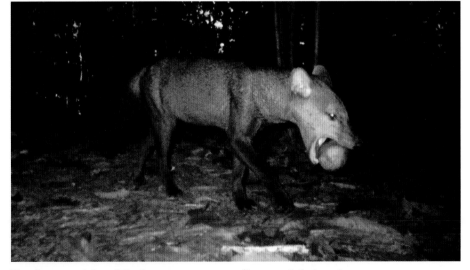

FOOD ON THE RUN

Predation is a rare event for any prey species—you can only be eaten once—but predators need to do it every day to eat. Inevitably, parts of these events are caught on cameras, giving us a glimpse into the vicious side of nature, and sometimes revealing some surprises.

The short-eared dog of the Amazon preys on small mammals but, as shown by this photo, also takes advantage of ripe fruit when it's available.

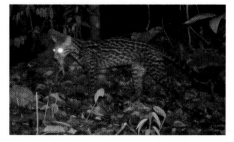

This ocelot from Caxiuanã, Brazil, was photographed carrying a tree frog.

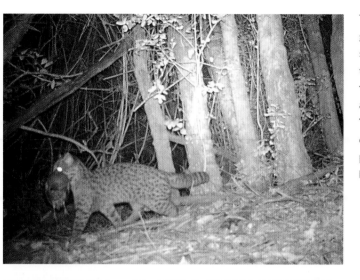

The kodkod (aka güiña) is the smallest cat in the Americas, found only in Chile and Argentina. This animal has captured a bird, probably a small heron or lapwing.

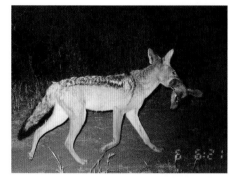

A jackal runs past the camera with the head of a dik-dik in its mouth, looking for a safe place to finish its meal.

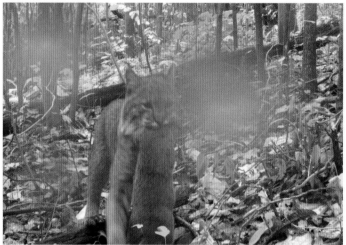

A gray squirrel turns into cat food for this bobcat on a colorful autumn day. Squirrels are most active during the fall, when they frantically hide nuts to eat later in the winter, exposing themselves to more risks from predators.

A forest hawk from Gabon flies off with a squirrel in its talons.

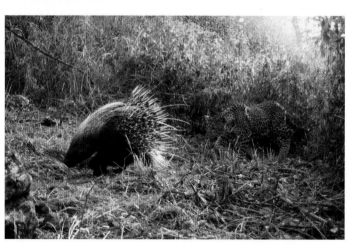

A leopard sneaks up on a crested porcupine in the Udzungwa Mountains of Tanzania. This would be a risky fight for the leopard; although leopards will try to kill porcupines if hungry enough, it doesn't always work out well for them. The leopard might just be curious about why the porcupine is walking around during the day, which is unusual for this nocturnal species and might signal a confused or sick animal that could be easier prey.

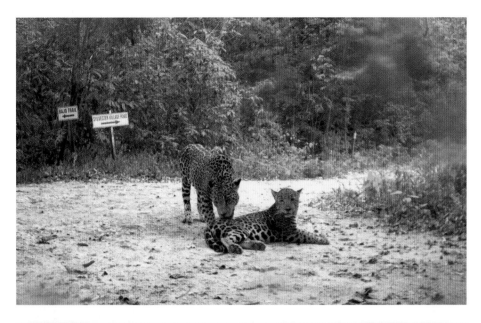

A pair of jaguars take a break between mating sessions at a trail intersection in Belize. Copulations only take a few seconds each but are repeated over a few days, accompanied by roars and growls, which certainly would have surprised anyone walking these trails on this particular morning. Jaguars are solitary animals, and adults are thought to only reunite for mating purposes. After about 100 days, the female will find a secluded place to give birth to a litter of one to four kittens.

A pair of wild pigs copulate among their herd mates in a protected area in Tennessee. Sows typically have five to six piglets per litter and can give birth twice per year, giving them one of the fastest reproduction rates of any large mammal. Frequent mating has helped this invasive species spread quickly, and they often become a pest species. They aggressively root through the leaf litter consuming seeds and seedlings, thus crippling the next generation of forest regeneration.

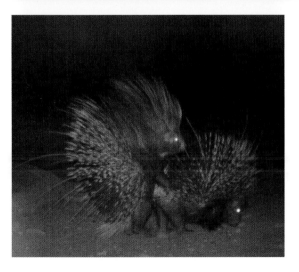

The quills of porcupines are designed to keep predators from getting too close to them, but they also make copulation a bit more complicated. This camera trap photo of two cape porcupines shows how they mate with minimal spine damage. Mating bouts in this species last a few minutes and are usually initiated by a female approaching a male. After about three months, the female will give birth to a litter of one to three porcupettes.

MATING

Camera traps sometimes invade the privacy of animals' sexual lives, although they don't seem to mind. These racy images can help us learn about the reproductive seasonality of a species and confirm breeding populations. The lack of concern most animals show for the presence of a camera confirms the noninvasive nature of this equipment.

A biologist's camera trap catches a poacher carrying a brush-tailed porcupine and tree pangolin through a national park in Gabon.

Illegal loggers carry a chain saw and giant basket to poach prized timber species from this rainforest in Panama.

Poachers in a Tennessee state park wear masks so the camera trap won't allow authorities to identify them. These men are poaching ginseng root by digging up a small understory plant, which can be seen stuffed into the shirt of the man to the left. Ginseng is grown commercially, but wild plants still fetch up to $800 per pound. This has fueled an illegal overharvest that threatens the survival of many wild ginseng populations in the Appalachian Mountains.

POACHERS

Hunting and trapping in North America, Europe, and Australia are carefully regulated and are not endangering any of the species they kill. However, illegal hunting and trapping in much of the rest of the world are the number one risk to the survival for most of the large animals shown in this book. These poachers are usually hunting not to put food on their own table, but to sell animals for profit. The local bushmeat trade in some countries fetches higher prices than domestic animals and motivates many to pick up their gun and snares and sneak into a national park. Any species that has the misfortune of being included in Chinese "traditional medicine" has an extra high price on its head. For example, rhino horn is now literally more valuable than gold. The high prices paid for some wildlife products have attracted the attention of international gangs and sophisticated international trade syndicates that ship wildlife products alongside drugs and weapons.

Saving animals from poachers requires a three-pronged approach. Decreasing demand would deflate the whole industry; this is especially important for products such as rhino horn, pangolin scales, and tiger bones, which have been shown to have no medicinal value. Second, fighting the international trade syndicates would remove the middlemen who rake in most of the profit and participate in other illegal activities as well. Finally, patrolling nature preserves is important to catch poachers in the act, to remove snares, and to deter future poaching. Camera traps, set by biologists or by park rangers, help park authorities locate poachers and, in some cases, identify them.

PHOTO CREDITS AND CITATIONS

INTRODUCTION

PHOTOS: (pp. 1–10) T. O'Brien/M. Kinnaird/WCS (zebra, leopard, rhino, elephant, and wild dog), TEAM Network's Korup survey (black-footed mongoose), Ongava Game Reserve (jackal and lion), American Museum of Natural History (Frank Chapman photos), Bivash Pandav/WII-Panthera (tiger with porcupine), WWF-India (macaque in sunset), Ruben Clements/Rimba (gaur), Laila Bahaa-el-din/Panthera (mandrill), TEAM Network of Conservation International funded by the Gordon and Betty Moore Foundation and in partnership with Wildlife Conservation Society in Bwindi (chimpanzee), TEAM Network Caxiuanã site (one-eyed jaguar), Rob Wallace, Guido Ayala, and Maria Viscarra/WCS (taruca), Xavier Hubert-Brierre (red river hogs). REFERENCES: Shiras 1913; Chapman 1927; Abbott & Coombs 1964; Jones & Raphael 1993; Karanth 1995; Kucera, Soukkala, & Zielinski 1995; Cutler & Swann 1999; Wegge, Pokheral, & Jnawali 2004; Pitra et al. 2006; O'Connell & Nichols 2010; Fleming et al. 2014.

THE CRITTERS

All mammal and fish species range maps come from the IUCN Red Data List, while bird maps are from Birdlife & NatureServe (2014).

PHOTOS: (p. 13) Andrew Spalton (leopard), TEAM Nouabalé-Ndoki National Park (NNN), Republic of Congo (chimpanzees), KevinSchafer.com (otter).

Tiger. PHOTOS: (p. 14) Sandesh Kadur. (p. 15) Wildlife Conservation Society/Russia (in snow), Bivash Pandav/WII-Panthera (overlooking village), Sandesh Kadur (eating rhino), Bivash Pandav/WII-Panthera (chasing sambar), Ullas Karanth/WCS (eating boar). (p. 16) Ullas Karanth/WCS (fat and skinny), WWF-India (muddy). (p. 17) WWF-India (stripes), Ruben Clements/Rimba (stripes), Ullas Karanth/WCS (stripes),

Michael Nichols (jumping). REFERENCES: Karanth et al. 2004, 2006; Datta, Anand, & Naniwadekar 2008; Linkie & Ridout 2011; Carter et al. 2012; Ngoprasert et al. 2012; Ramesh et al. 2012.

African Lion. PHOTOS: (p. 18) Ruaha Carnivore Project. (p. 19) Ongava Game Reserve (with cubs), Ruaha Carnivore Project (lion and people photos). (p. 20) Mamadou Daha Kane/Virginia Tech, Direction des Parcs Nationaux du Sénégal. REFERENCES: Tumenta et al. 2009; Burton et al. 2011; Henschel et al. 2014.

Leopard. PHOTOS: (p. 21) Ullas Karanth/WCS (Indian), Laila Bahaa-el-din/Panthera (Gabon), WCS/Institute of Biology and Soils (Amur), Andrew Spalton (Arabian). (p. 22) Ewaso lion project (two tree photos), Wildlife Conservation Society (Afghan leopard). (p. 23) TEAM Network Pasoh site (in forest), Ruben Clements/Rimba (close shot). (p. 24) TEAM NNN. REFERENCES: Kawanishi et al. 2010; Mondal et al. 2012; Athreya et al. 2013.

Snow Leopard. PHOTOS: (p. 25) S. Kachel/Panthera/Academy of Sciences Tajikistan/U. Delaware. (p. 26) Steve Winter (night and climbing), S. Kachel/Panthera/Academy of Sciences Tajikistan/U. Delaware (scenic). REFERENCES: Jackson et al. 2005; McCarthy et al. 2010.

Jaguar. PHOTOS: (p. 27) Rob Wallace, Guido Ayala, and Maria Viscarra/WCS. (p. 28) Helen Esser, Yorick Liefting, Patrick Jansen/Smithsonian Tropical Research Institute (with armadillo), Valeria Boron (Colombia), Joe Figel (Mexico), Joe Kolowski/Smithsonian Conservation Biology Institute (Peru), map data from Panthera. (p. 29) USFWS/UA/DHS. (p. 30) TEAM Network Caxiuanã site, a collaboration between Conservation International, the Missouri Botanical Garden, the Smithsonian Institution, and the Wildlife Conser-

vation Society, and partially funded by these institutions, the Gordon and Betty Moore Foundation, and other donors (Caxiuanã), courtesy of TEAM Network's Central Suriname site (Suriname). (p. 31) Rob Wallace, Guido Ayala, and Maria Viscarra/WCS (close-up), TEAM Network/Pontificia Universidad Católica del Ecuador (two of black jaguars), TEAM Network's Costa Rican site (Costa Rica). REFERENCES: Novack et al. 2005; Moreno, Kays, & Samudio 2006; Weckel, Giuliano, & Silver 2006; McCain & Childs 2008; Foster, Bart, & Doncaster 2010; Romero-Muñoz et al. 2010; Figel, Durán, & Bray 2011; Foster et al. 2013.

Cougar. PHOTOS: (p. 32) Sebastian Kennerknecht (California), Oliveira LFB, Hofmann GS & Coelho IP (Brazil). (p. 33) TEAM Network and the Brazilian National Institute for Amazonian Research, Manaus, Amazon State, Brazil (day), Parks Canada/Waterton Lakes National Park (with skunk), TEAM Network Caxiuanã site, a collaboration between Conservation International, the Missouri Botanical Garden, the Smithsonian Institution, and the Wildlife Conservation Society, and partially funded by these institutions, the Gordon and Betty Moore Foundation, and other donors (night). (p. 34) Mark Lotz/Florida Fish and Wildlife Conservation Commission (with cubs), Joe Riis (wounded), TEAM Network Caxiuanã site, a collaboration between Conservation International, the Missouri Botanical Garden, the Smithsonian Institution, and the Wildlife Conservation Society, and partially funded by these institutions, the Gordon and Betty Moore Foundation, and other donors (black-and-white). (p. 35) Mr. Lue Vang (Wisconsin), information for map from Adrian Wydeven, Wisconsin Department of Natural Resources. REFERENCES: Maehr et al. 2002; Kelly et al. 2008; Monroy-Vilchis et al. 2009; Romero-Muñoz et al. 2010; LaRue et al. 2012; Foster et al. 2013; Peebles et al. 2013; Maletzke et al. 2014.

Clouded Leopards. PHOTOS: (p. 36) Andreas Wilting (Sunda), Ruben Clements/Rimba (with binturong). (p. 37) Benoit Goossens (close-up), Dr. Susan Cheyne/OuTrop/WildCRU (climbing), Sebastian Kennerknecht (portrait). REFERENCES: Buckley-Beason et al. 2006; Datta, Anand, & Naniwadekar 2008; Ridout & Linkie 2009; Ngoprasert et al. 2012; Wilting et al. 2012; Wearn et al. 2013.

Cheetah. PHOTOS: (p. 38) T. O'Brien/M. Kinnaird/WCS. (p. 39) ICS/DoE/CACP/Panthera. REFERENCES: Farhadinia 2004; Farhadinia & Hemami 2010; Farhadinia et al. 2013.

Bobcat. PHOTOS: (p. 40) eMammal (in rain), Steve Shaffer (stalking). (p. 41) Erik Olson (on log), eMammal (ruff), USGS/Colorado State University (underpass), Sebastian Kennerknecht (cubs). REFERENCES: Cain et al. 2003; Ng et al. 2004; Larrucea et al. 2007b; Ordeñana & Crooks 2010; Lee et al. 2012; Rockhill, DePerno, & Powell 2013; Kays & Parsons 2014.

Chinese Mountain Cat. PHOTOS: (p. 42) Jim Sanderson. REFERENCES: He et al. 2004; Sanderson, Yufeng, & Naktsang 2010.

Domestic Cat. PHOTOS: (p. 43) Department of Parks and Wildlife, Science and Conservation Division, Manjimup, Western Australia (with phascogale), Helen Achurch/Encounter Bay Seabirds (with penguin). (p. 44) Roland Kays (New York), eMammal (Rock Creek Park), Mike Cove (Florida). REFERENCES: Medina et al. 2011; Wang & Fisher 2012; Loss, Will, & Marra 2013; Nogales et al. 2013.

Flat-headed Cat. PHOTOS: (p. 45) Andreas Wilting. (p. 46) Dr. Susan Cheyne/OuTrop/WildCRU. REFERENCES: Wilting et al. 2010.

Leopard Cat. PHOTOS: (p. 47) Sheng Li (in bamboo), Tim Laman (in mangroves), Andreas Wilting (with rat). REFERENCES: Johnson et al. 1999; Samejima et al. 2012; Lynam et al. 2013.

Marbled Cat. PHOTOS: (p. 48) Kashmira Kakati (two color photos), Oliver Wearn/SAFE project (black-and-white). REFERENCES: Lynam et al. 2013; Wearn et al. 2013.

African Golden Cat. PHOTOS: (p. 49) Laila Bahaa-el-din/Panthera (golden and gray morphs), David Mills/Panthera (melanistic). (p. 50) Laila Bahaa-el-din/Panthera (pair and three-legged cat), David Mills/Panthera (with monkey and with white scar). REFERENCES: Noss 1998; Brashares et al. 2004; Henschel et al. 2011; Mugerwa et al. 2012.

Jaguarundi. PHOTOS: (p. 51) Oliveira LFB, Hofmann GS & Coelho IP (top), Helen Esser, Yorick Liefting, Patrick Jansen/Smithsonian Tropical Research Institute (dark). (p. 52) courtesy of TEAM Network's Central Suriname site. REFERENCES: Konecny 1989; Michalski et al. 2006; Di Bitetti et al. 2010; Pereira et al. 2011; Ahumada, Hurtado, & Lizcano 2013; Segura, Prevosti, & Cassini 2013.

Ocelot. PHOTOS: (p. 53) Helen Esser, Yorick Liefting, Patrick Jansen/Smithsonian Tropical Research Institute (black-and-white), map data from Janecka and Tewes Caesar Kleberg Wildlife Research Institute and Panthera, Rob Wallace, Guido Ayala, and Maria Viscarra/WCS (flash). (p. 54) Patricia Alvarez-Loayza/Duke University/TEAM Network Manu (close-up), Joe Kolowski/Smithsonian Conservation Biology Institute (with armadillo), TEAM Network Caxiuanã site, a collaboration between Conservation International, the Missouri Botanical Garden, the Smithsonian Institution, and the Wildlife Conservation Society, and partially funded by these institutions, the Gordon and Betty Moore Foundation, and other donors (porcupine quills). REFERENCES: Haines et al. 2006; Moreno et al. 2006; Di Bitetti et al. 2008; Kays et al. 2011.

Fossa. PHOTOS: (p. 55) Zach Farris (top), Asia Murphy (bottom). REFERENCES: Gerber et al. 2010; Gerber, Karpanty, & Randrianantenaina 2012b.

Spotted Fanaloka. PHOTOS: (p. 56) Brian Gerber (two color photos), TEAM Network site at Centre ValBio, Ranomafana (black-and-white). REFERENCES: Gerber, Karpanty, & Randrianantenaina 2012a.

Ring-tailed Vontsira. PHOTOS: (p. 57) Brian Gerber (two color photos), TEAM Network site at Centre ValBio, Ranomafana (black-and-white). REFERENCES: Dunham 1998; Gerber et al. 2010, 2012a, 2012b.

Broad-striped Vontsira. PHOTOS: (p. 59) Brian Gerber. REFERENCES: Gerber et al. 2012a, 2012b.

Servaline Genet. PHOTOS: (p. 61) Laila Bahaa-el-din/Panthera (color), TEAM Network's Korup survey (two black-and-white photos). REFERENCES: Goldman & Winther-Hansen 2003; Pettorelli et al. 2010; Mugerwa et al. 2012.

Masked Palm Civet. PHOTOS: (p. 62) Sheng Li (color), WCS/TEAM Network Bukit Barisan Selatan National Park (montage). REFERENCES: Chen et al. 2009; Rustam, Yasuda, & Tsuyuki 2012; Sugiura et al. 2013, 2014.

Otter Civet. PHOTOS: (p. 63) Andreas Wilting (top and bottom), Hisashi Matsubayashi (middle). REFERENCES: Duckworth et al. 2008.

Hose's Civet. PHOTOS: (p. 64) John Mathai/HOSCAP Borneo. REFERENCES: Jennings et al. 2013.

Banded Civet. PHOTOS: (p. 66) Andreas Wilting. (p. 67) Oliver Wearn/SAFE project. REFERENCES: Hon, Azlan, & Duckworth 2008; Jennings et al. 2013.

Wolf. PHOTOS: (p. 68) Yellowstone Wolf Project/National Park Service (black), Canadian National Parks (skinny). (p. 69) D. Kuijper, K. Bubnicki, M. Churski/Mammal Research Institute/Polish Academy of Sciences (Polish wolves), Parks Canada/Banff National Park (with pups and with stick). (p. 70) Y. Illiopoulos, M. Petridou, K. Selinides/CALLISTO wildlife conservation society (Greek), Jaffar Ud Din (Pakistan), Sebastian

Kennerknecht (Yemen). REFERENCES: Kruuk 2002; Muhly et al. 2011; Iliopoulos, Youlatos, & Sgardelis 2013.

Coyote. PHOTOS: (p. 71) eMammal (top), James M. and Reconyx (with pups). (p. 72) Ashley Gramza (with cat), eMammal (pair), Gary Roemer, Department of Fish, Wildlife & Conservation Ecology, New Mexico State University (New Mexico), eMammal (with deer). (p. 73) eMammal (North Carolina), Ricardo Moreno and Samuel Valdez, Yaguará Panamá-Sociedad Panameña de Biología (Panama), Roland Kays (New York). REFERENCES: Gompper et al. 2006; Larrucea et al. 2007a; Goad et al. 2014; Kays & Parsons 2014; Méndez-Carvajal & Moreno 2014.

Dingo. PHOTOS: (p. 74) Paul Meek (rainforest), Guy Ballard (with wallaby). (p. 75) David Graham. REFERENCES: Wang & Fisher 2012; Allen et al. 2013; Hayward & Marlow 2014.

Dhole. PHOTOS: (p. 76) Girish Punjabi/ www.projectwaghoba.in (pack), Ruben Clements/Rimba (close-up). REFERENCES: Jenks et al. 2011; Ramesh et al. 2012; Steinmetz, Seuaturien, & Chutipong 2013; Srivathsa et al. 2014.

Red Fox. PHOTOS: (p. 77) eMammal (on log), US Forest Service, Pacific Southwest Region (Sierra Nevada Mountains). (p. 78) Kyle Moore (United Kingdom), David Graham (with echidna). REFERENCES: Robley et al. 2014.

Bush Dog. PHOTOS: (p. 79) Roberto Fusco Costa/Instituto de Pesquisas Cananéia (Brazil), Benoit de Thoisy (river), TEAM Network/Pontificia Universidad Católica del Ecuador (singing). REFERENCES: Michalski 2010; Dematteo et al. 2012.

Short-eared Dog. PHOTOS: (p. 80) Rob Wallace, Guido Ayala, and Maria Viscarra/WCS. REFERENCES: Michalski 2010; Pimenta et al. 2013.

Black Bear. PHOTOS: (p. 81) eMammal (close-up), Erik Olson (with mosquitoes). (p. 82) Parks Canada/Kootenay National Park (family), eMammal (on sapling). REFERENCES: Switalski & Nelson 2011.

Brown Bear. PHOTOS: (p. 83) Parks Canada/Banff National Park (at river), Alberta Innovates/Technology Futures (family). (p. 84) Parks Canada/Banff National Park (in snow), Ine Dorresteijn/ Leuphana University (right and bottom). REFERENCES: Fisher, Wheatley, & Mackenzie 2014.

Giant Panda. PHOTOS: (p. 85) Sheng Li. REFERENCES: Li et al. 2010b; Liu et al. 2013.

Spectacled Bear. PHOTOS: (p. 86) Becky Zug. REFERENCES: Garshelis 2011; Schloegel et al. 2011.

Sun Bear. PHOTOS: (p. 87) Ruben Clements/Rimba. (p. 88) Oliver Wearn/SAFE project. REFERENCES: Te, Servheen, & Ambu 2004; Wong et al. 2005; Htun 2006; Linkie et al. 2007; Nazeri et al. 2012; Harrison et al. 2013.

Wolverine. PHOTOS: (p. 89) Peter Mather (night), US Forest Service/Oregon State University/Katie Moriarty (California). (p. 90) Audrey Magoun. REFERENCES: Magoun et al. 2005; Moriarty et al. 2009; Royle et al. 2011; Inman et al. 2012.

Fisher. PHOTOS: (p. 91) Roland Kays and Scott LaPoint (New York), California Fisher Translocation Project (California). (p. 92) California Fisher Translocation Project. REFERENCES: LaPoint et al. 2013; LaPoint, Belant, & Kays 2014.

Tayra. PHOTOS: (p. 93) TEAM Network/ Pontificia Universidad Católica del Ecuador (hunting), Helen Esser, Yorick Liefting, Patrick Jansen/Smithsonian Tropical Research Institute (on tree). (p. 94) Patricia Alvarez-Loayza/Duke University/TEAM Network Manu (climbing), Fernando Soley (with plantain). REFERENCES: Soley & Alvarado-Diaz 2011.

Malay Weasel. PHOTOS: (p. 95) Andrew Hearn/WildCRU (running), Andrew Hearn and Joanna Ross (close-up). REFERENCES: Ross, Hearn, & Macdonald 2013.

African Bush Elephant. PHOTOS: (pp. 96–97) T. O'Brien/M. Kinnaird/WCS. REFERENCES: Kinnaird & O'Brien 2012; Nyaligu & Weeks 2013; Tambling et al. 2013.

African Forest Elephant. PHOTOS: (p. 98) Michael Nichols (dark), Xavier Hubert-Brierre (river). (p. 99) Laila Bahaa-el-din/Panthera (fighting), Michael Nichols (in river), TEAM Network of Conservation International funded by the Gordon and Betty Moore Foundation and in partnership with Wildlife Conservation Society in Bwindi (trunk out). REFERENCES: Babweteera, Savill, & Brown 2007; Head et al. 2013; Gessner, Buchwald, & Wittemyer 2014.

Asian Elephant. PHOTOS: (p. 100) Bivash Pandav/WII-Panthera (tusker), Hisashi Matsubayashi (salt lick). (p. 101) Kate Jenks (fighting), Andreas Wilting (feet), Benoit Goossens (profile). REFERENCES: Kinnaird et al. 2003; Grassman, Tewes, & Silvy 2005; Varma, Pittet, & Jamadagni 2006; Gray & Phan 2011; Jenks et al. 2011.

Black Rhino. PHOTOS: (p. 103) T. O'Brien/ M. Kinnaird/WCS. (p. 104) Ongava Game Reserve.

Javan Rhino. PHOTOS: (p. 105) WWF/ CTNPCP/Mike Baltzer. (p. 106) WWF/ CTNPCP/Mike Baltzer (in wallow), Foead and Yahya/WWF/PHKA (head up). REFERENCES: Hariyadi et al. 2011; Brook et al. 2014.

Brazilian Tapir. PHOTOS: (p. 107) Oliveira LFB, Hofmann GS & Coelho IP. (p. 108) Oliveira LFB, Hofmann GS & Coelho IP (at salt lick), courtesy of TEAM Network's Central Suriname site (black-and-white). REFERENCES: Noss et al. 2003; Tobler et al. 2013; Cruz et al. 2014.

Malayan Tapir. PHOTOS: (p. 109) Ruben Clements/Rimba (top two), Matt Linkie/Fauna & Flora International-DICE (bottom). REFERENCES: Holden, Yanuar, & Martyr 2003; Kinnaird et al. 2003; Clements et al. 2012; Lynam et al. 2012; Rayan et al. 2012; Linkie et al. 2013.

Bearded Pig. PHOTOS: (pp. 110–111) Oliver Wearn/SAFE project. REFERENCES: Wong et al. 2005; Brodie & Giordano 2013.

Pygmy Hippopotamus. PHOTOS: (p. 112) April Conway/University of Georgia Pygmy Hippo Project. (p. 113) Ben Collen/ZSL/FFI (four-image sequence), April Conway/University of Georgia Pygmy Hippo Project (yawning). REFERENCES: Conway 2013.

Giant Sable Antelope. PHOTOS: (pp. 114–115) Pedro Vaz Pinto. REFERENCES: Pitra et al. 2006.

Tamaraw. PHOTOS: (p. 116) WWF-Philippines. REFERENCES: Custodio, Lepiten, & Heaney 1996.

Asiatic Wild Water Buffalo. PHOTOS: (p. 117) Ullas Karanth/WCS. (p. 118) WWF Cambodia/DWB-FA. REFERENCES: Hedges et al. 2008; Gray et al. 2012.

Alpine Ibex. PHOTOS: (pp. 119–120) Robin Sandfort. REFERENCES: Aulagnier et al. 2008.

Southern Pudú. PHOTOS: (pp. 121–122) Eduardo A. Silva-Rodríguez. REFERENCES: Silva-Rodríguez et al. 2009; Silva-Rodríguez & Sieving 2012.

White-tailed Deer. PHOTOS: (p. 123) eMammal (buck), Reconyx and James M. (albino). (p. 124) eMammal (antlers, broken antler, and fawns), Hailey and Logan Lehrer (with flying squirrel). REFERENCES: Kelly & Holub 2008; Weckel, Rockwell, & Secret 2011; Lashley et al. 2014; Magle et al. 2014.

Chimpanzee. PHOTOS: (pp. 125–126) TEAM NNN, Republic of Congo. (p. 127) TEAM NNN, Republic of Congo (pout face), Krief/Sebitoli Chimpanzee Project

(crop raiding). (p. 128) Krief/Sebitoli Chimpanzee Project (crop raiding), TEAM NNN, Republic of Congo (display). REFERENCES: Head et al. 2012, 2013; Junker et al. 2012; Krief et al. 2014.

Western Gorilla. PHOTOS: (p. 129) Laila Bahaa-el-din/Panthera (silverback male), TEAM NNN, Republic of Congo (two black-and-white photos). (p. 130) Xavier Hubert-Brierre (with mirror), TEAM NNN, Republic of Congo (three black-and-white photos). REFERENCES: Walsh et al. 2008; Head et al. 2012, 2013; Genton et al. 2014.

Bornean Orangutan. PHOTOS: (pp. 131–132) Oliver Wearn/SAFE project. REFERENCES: Loken, Spehar, & Rayadin 2013; Ancrenaz et al. 2014.

Golden Snub-nosed Monkey. PHOTOS: (pp. 133–134) Sheng Li. REFERENCES: Munoz 1999.

Pig-tailed Macaque. PHOTOS: (p. 135) Oliver Wearn/SAFE project. (p. 136) Andreas Wilting (in sunbeam), Oliver Wearn/SAFE project (on log). REFERENCES: O'Brien, Kinnaird, & Wibisono 2003; Numata et al. 2005; Linkie & Ridout 2011; Brodie et al. 2014.

Aardvark. PHOTOS: (p. 137) T. O'Brien/M. Kinnaird/WCS (Kenya), Laila Bahaa-el-din/Panthera (Gabon). (p. 138) Andrei Snyman at Mashatu Game Reserve, Botswana. REFERENCES: Kinnaird & O'Brien 2012.

Giant Armadillo. PHOTOS: (p. 139) KevinSchafer.com. (p. 140) courtesy of TEAM Network's Central Suriname site (close-up), TEAM Network Caxiuanã site, a collaboration between Conservation International, the Missouri Botanical Garden, the Smithsonian Institution, and the Wildlife Conservation Society, and partially funded by these institutions, the Gordon and Betty Moore Foundation, and other donors (profile). REFERENCES: Noss, Peña, & Rumiz 2004; Silveira et al. 2009; Srbek-Araujo et al. 2009; Desbiez & Kluyber 2013.

Giant Anteater. PHOTOS: (p. 141) Rob Wallace, Guido Ayala, and Maria Viscarra/WCS. (p. 142) Rob Wallace, Guido Ayala, and Maria Viscarra/WCS (in rainforest), Oliveira LFB, Hofmann GS & Coelho IP (in grass). REFERENCES: Medri & Mourão 2005; de Azevedo & Murray 2007; Cavalcanti & Gese 2010; Foster et al. 2013; Gonthier & Castañeda 2013; Miranda, Bertassoni, & Abba 2014.

Giant Pangolin. PHOTOS: (p. 143) Laila Bahaa-el-din/Panthera. (p. 144) Xavier Hubert-Brierre (on trail), Laila Bahaa-el-din/Panthera (balled up). REFERENCES: Waterman et al. 2014.

Wombat. PHOTOS: (pp. 145–146) Georgeanna Story. REFERENCES: Borchard & Wright 2010; Borchard, Eldridge, & Wright 2012.

Tasmanian Devil. PHOTOS: (p. 147) Heath Holden. (p. 148) Phil Wise/Save the Tasmanian Devil. REFERENCES: Coupland & Anthony 2007; Hawkins et al. 2008; Murchison et al. 2010; Anthony 2011.

Sumatran Striped Rabbit. PHOTOS: (p. 149) T. O'Brien/M. Kinnaird/WCS. (p. 150) J. L. McCarthy. REFERENCES: McCarthy et al. 2012.

Thomas's Flying Squirrel. PHOTOS: (p. 151) Dave Augeri. Artwork: (p. 152) Inge van Noortwijk as published in Meijaard, Kitchener, & Smeenk (2006) with permission from John Wiley and Sons.

Common Vampire Bat. PHOTOS: (p. 153) Renata Pitman (on cougar), Helen Esser, Yorick Liefting, Patrick Jansen/Smithsonian Tropical Research Institute (with tamandua). (p. 154) Helen Esser, Yorick Liefting, Patrick Jansen/Smithsonian Tropical Research Institute.

Sumatran Ground Cuckoo. PHOTOS: (p. 155) M. Linkie/DICE/FFI. (p. 156) Wildlife Conservation Society (blurry), M. Linkie/DICE/FFI (displaying). REFERENCES: Zetra et al. 2002.

Black Cod. PHOTOS: (pp. 157–158) David Harasti. REFERENCES: Harasti et al. 2014.

ANIMAL NEIGHBORHOOD WATCH

All original artwork is by Eric Knisley, North Carolina Museum of Natural Sciences.

PHOTOS: (p. 159) Benoit Goossens (macaques). (p. 160) Ongava Game Reserve (rhino), Mike Cove (raccoon), Jaffar Ud Din (jackals), Oliveira LFB, Hofmann GS & Coelho IP (stork).

Chinese Mountains. PHOTOS: (pp. 162–163) Sheng Li. REFERENCES: Li et al. 2010a, 2010b, 2010c, 2012.

Panama Canal Islands. PHOTOS: (pp. 164–167) Helen Esser, Yorick Liefting, and Patrick Jansen/Smithsonian Tropical Research Institute. REFERENCES: Esser 2010.

Australian Rocky Reef Fish. PHOTOS: (pp. 169–170) David Harasti. REFERENCES: Malcolm et al. 2007.

Rainforest Canopies. PHOTOS: (pp. 171–172) Tremaine Gregory. (p. 173) Tremaine Gregory (kinkajou and night monkeys), Kevin McLean (sloth). REFERENCES: Gregory et al. 2014.

The Wildlife of Tokyo. PHOTOS: (p. 174) Masayuki Saito. (p. 175) Masayuki Saito (masked palm civet, Japanese hare, and raccoon dog), eMammal (raccoon). (p. 176) Masayuki Saito. REFERENCES: Saito & Koike 2013; Soga & Koike 2013.

America's Urban Predators. PHOTOS: (p. 178) Ashley Gramza (cougar), Kevin Crooks (coyote). (p. 179) Sebastian Kennerknecht (skunk and opossum), Justin Brown (fox), Roland Kays and Scott LaPoint (fisher). REFERENCES: Crooks & Soule 1999; Crooks 2002; Gehrt, Anchor, & White 2009; Ordeñana & Crooks 2010; LaPoint et al. 2013; Kays & Parsons 2014.

The Foggy, Forested Hills of Yemen. PHOTOS: (p. 181) Foundation for Endangered Wildlife of Yemen and CEDT. (p. 182) Sebastian Kennerknecht (caracal facing camera), Foundation for Endangered Wildlife of Yemen and CEDT (caracal in hills and Indian crested porcupine). REFERENCES: Khorozyan et al. 2014.

Cattle and Wildlife in Africa. PHOTOS: (pp. 184–187) T. O'Brien/M. Kinnaird/WCS. REFERENCES: Kinnaird & O'Brien 2012.

Rocky Mountain Trails. PHOTOS: (p. 189) Parks Canada/Banff National Park (bear and wolf), Parks Canada/Waterton Lakes National Park (elk). (p. 190) Parks Canada/Waterton Lakes National Park (wolf pack and elk herd). Parks Canada/Banff National Park (cougar). REFERENCES: Muhly et al. 2011.

America's Hunting Grounds. PHOTOS: (pp. 192–193) eMammal.

Gaps in the Polish Woods. PHOTOS: (pp. 195–196) D. Kuijper, K. Bubnicki, M. Churski/Mammal Research Institute/Polish Academy of Sciences. REFERENCES: Kuijper et al. 2009.

Oil Palm Plantations. PHOTOS: (p. 198) PT. SSS Silmi et al. (leopard cat and cat), Maddox/ZSL (macaque and boar). (p. 199) T. O'Brien/M. Kinnaird/WCS (sun bear), Kate Jenks (dhole), Andreas Wilting (clouded leopard). (p. 200) eMammal (muntjac), Maddox/ZSL (tiger, tapir, sambar). REFERENCES: Maddox et al. 2007; Silmi, Anggara, & Dahlen 2013.

CAUGHT IN THE ACT

PHOTOS: (p. 202) Sebastian Kennerknecht (leopard), Marcella Kelley (cougar), eMammal (bear), Oliveira LFB, Hofmann GS & Coelho IP (vultures).

Holes in the Ground. PHOTOS: (p. 202) Christian Ziegler (bulldog bats). (p. 203) Christian Ziegler (Gambian pouched rat), Roland Kays, Patrick Jansen, and Willem-Jan Emsens/Smithsonian Tropical Research Institute (agouti and ocelot). REFERENCES: Emsens et al. 2013; Suselbeek et al. 2014.

Water Holes. PHOTOS: (p. 204) Lucas Hall (kit foxes and sheep), Ongava Game Reserve (zebras). (p. 205) Ongava Game Reserve. REFERENCES: Hall et al. 2013.

Movement Corridors. PHOTOS: (p. 206) Roland Kays and Scott LaPoint. (p. 207) Joe Riis. REFERENCES: LaPoint et al. 2013.

Treetop Corridors. PHOTOS: (p. 208) Tremaine Gregory (sloth and tamarin), Kevin McLean (porcupine). (p. 209) Tim Laman (kangaroo), Kevin McLean (capuchin). REFERENCES: Gregory et al. 2014; McLean 2015.

Road Underpasses. PHOTOS: (p. 210) Tony Clevenger (cougars), Ashley Gramza (bears). (p. 211) Tony Clevenger. (p. 212) Gustavo Lorenzana and Rogelio Bautista (cougar), Tony Clevenger (bear). (p. 213) Tony Clevenger. REFERENCES: Clevenger & Waltho 2000, 2005; Chruszcz et al. 2003; Clevenger, Chruszcz, & Gunson 2003; Riley et al. 2006; Clevenger, Ford, & Sawaya 2009; Sawaya, Kalinowski, & Clevenger 2014.

Electromats. PHOTOS: (p. 214) John Perrine.

Fence Escape Routes. PHOTOS: (p. 214) John Perrine (black-tailed deer). (p. 215) John Perrine (black-tailed deer), Naankuse Foundation (cheetah and eland). REFERENCES: Weise et al. 2014.

Highway Rope Bridges. PHOTOS: (p. 216) Fernanda Teixeira (howler monkey), B. Taylor & R. Goldingay/Southern Cross University (all others). REFERENCES: Weston 2003; Teixeira et al. 2013.

Glide Poles. PHOTOS: (p. 217) Chris Kelly, NC Wildlife commission (North Carolina), B. Taylor & R. Goldingay/Southern Cross University (Australia). REFERENCES: Kelly, Diggins, & Lawrence 2013.

Nest Predators. PHOTOS: (p. 218) Dejan Stojanovic. (p. 219) Scott J. Chiavacci/Arkansas State University. (pp. 220–221) Joe Liebezeit/Wildlife Conservation Society. REFERENCES: Liebezeit 2013; Chiavacci, Bader, & Bednarz 2014; Stojanovic et al. 2014.

Nest Protectors. PHOTOS: (p. 222) Gregory Skupien (black-and-white alligator photos), Mike Cove (color alligator photo). (p. 223) Torrey Rodgers. REFERENCES: Mazzotti 1989.

Carcasses. PHOTOS: (p. 224) Steven J. Shaffer/Tuscarora State Forest/Appalachian Eagles project. (p. 225) Delaware-Otsego Audubon Society/Appalachian Eagle project (eagle chase and upside-down hawk), Chuck Waggy, WV Division of Natural Resources (West Virginia). (p. 226) Chuck Waggy/WV Division of Natural Resources (raven attacks), Bill Hanson (eagle fight), Meadowcroft Rockshelter and Historic Village/Appalachian Eagles project (hawks on ground). REFERENCES: Blázquez et al. 2009; Katzner & Rodrigue 2013.

Mineral Licks. PHOTOS: (p. 227) Oliveira LFB, Hofmann GS & Coelho IP. (p. 228) Oliveira LFB, Hofmann GS & Coelho IP (peccaries and howler monkey), John Blake/University of Florida/Tiputini Biodiversity Station (paca, spider monkey, and deer). (p. 229) John Blake/University of Florida/Tiputini Biodiversity Station. REFERENCES: Kreulen 1985; Kaspari, Yanoviak, & Dudley 2008; Blake

et al. 2010, 2011; Dudley, Kaspari, & Yanoviak 2012; Blake, Mosquera, & Salvador 2013; Link & Di Fiore 2013.

Fruiting Trees. PHOTOS: (p. 230) Christian Ziegler (galago), Roland Kays and Patrick Jansen/Smithsonian Tropical Research Institute (kinkajou), Xavier Hubert-Brierre (mandrill). (p. 231) Soumya Prasad. REFERENCES: Prasad, Pittet, & Sukumar 2010.

Bush versus Elephant. PHOTOS: (pp. 232–233) Robert Pringle. REFERENCES: Pringle et al. 2014.

Buried Seeds. PHOTOS: (p. 234) Christian Ziegler (with ripe fruit), Ben Hirsch, Patrick Jansen, and Roland Kays/Smithsonian Tropical Research Institute (all others). REFERENCES: Hirsch et al. 2012; Jansen et al. 2012.

Animal Robots. PHOTOS: (pp. 235–236) Roland Kays.

Animal Models. PHOTOS: (p. 237) Beatriz Aurora Willink. REFERENCES: Willink 2014.

Surfing Genet. PHOTOS: (p. 238) Wildlife ACT.

Food on the Run. PHOTOS: (p. 239) Joe Liebezeit/Wildlife Conservation Society (owl), WWF-India (fishing cat), City of Boulder Open Space and Mountain Parks (otter), Renata Pitman (short-eared dog), Mike Muller/New Jersey (coyote). (p. 240) TEAM Network Caxiuanã site, a collaboration between Conservation International, the Missouri Botanical Garden, the Smithsonian Institution, and the Wildlife Conservation Society, and partially funded by these institutions, the Gordon and Betty Moore Foundation, and other donors (ocelot), Nicolás Gálvez (kodkod), eMammal project (bobcat), Rasmus Havmøller (leopard), Laila Bahaa-el-din/Panthera (hawk), T. O'Brien/M. Kinnaird/WCS (jackal).

Mating. PHOTOS: (p. 241) Marcella Kelley (jaguars), eMammal (pigs), Ongava Game Reserve (porcupines). REFERENCES: Seymour 1989; Barthelmess 2006.

Poachers. PHOTOS: (p. 242) Laila Bahaa-el-din/Panthera (Gabon), Helen Esser, Yorick Liefting, Patrick Jansen/Smithsonian Tropical Research Institute (Panama), eMammal (Tennessee).

LITERATURE CITED

Abbott, H. G. B., and A. W. Coombs. 1964. A photoelectric 35-MM camera device for recording animal behavior. Journal of Mammalogy **45**:327–330.

Ahumada, J. A., J. Hurtado, and D. Lizcano. 2013. Monitoring the status and trends of tropical forest terrestrial vertebrate communities from camera trap data: A tool for conservation. PLoS ONE **8**:e73707.

Allen, B. L., P. J. S. Fleming, L. R. Allen, and G. Ballard. 2013. As clear as mud: A critical review of evidence for the ecological roles of Australian dingoes. Biological Conservation **159**:158–174.

Ancrenaz, M., et al. 2014. Coming down from the trees: Is terrestrial activity in Bornean orangutans natural or disturbance driven? Scientific Reports **4**:4024.

Anthony, W. 2011. Devils of the Alpine: Field monitoring project—June 2011.

Athreya, V., M. Odden, J. D. C. Linnell, J. Krishnaswamy, and U. Karanth. 2013. Big cats in our backyards: Persistence of large carnivores in a human dominated landscape in India. PLoS ONE **8**:e57872.

Aulagnier, S., A. Kranz, S. Lovari, T. Jdeidi, M. Masseti, I. Nader, K. de Smet, and F. Cuzin. 2008. Capra ibex. Available from www.iucnredlist.org.

Babweteera, F., P. Savill, and N. Brown. 2007. *Balanites wilsoniana*: Regeneration with and without elephants. Biological Conservation **134**:40–47.

Barthelmess, E. L. 2006. *Hystrix africaeaustralis*. Mammalian Species **788**:1–7.

Birdlife, and NatureServe. 2014. Bird species distribution maps of the world. BirdLife International, Cambridge, UK, and NatureServe, Arlington, VA.

Blake, J., J. Guerra, D. Mosquera, R. Torres, B. Loiselle, and D. Romo. 2010. Use of mineral licks by white-bellied spider monkeys (*Ateles belzebuth*) and red howler monkeys (*Alouatta seniculus*) in eastern Ecuador. International Journal of Primatology **31**:471–483.

Blake, J. G., D. Mosquera, and J. Salvador. 2013. Use of mineral licks by mammals and birds in hunted and non-hunted areas of Yasuní National Park, Ecuador. Animal Conservation **16**:430–437.

Blake, J. G., D. M. J. Romo, G. David, B. A. Loiselle, and S. Kelly. 2011. Mineral licks as diversity hotspots in lowland forest of eastern Ecuador. Diversity **3**:217–234.

Blázquez, M., J. A. Sánchez-Zapata, F. Botella, M. Carrete, and S. Eguía. 2009. Spatio-temporal segregation of facultative avian scavengers at ungulate carcasses. Acta Oecologica **35**:645–650.

Borchard, P., D. J. Eldridge, and I. A. Wright. 2012. Sarcoptes mange (*Sarcoptes scabiei*) increases diurnal activity of bare-nosed wombats (*Vombatus ursinus*) in an agricultural riparian environment. Mammalian Biology—Zeitschrift für Säugetierkunde **77**:244–248.

Borchard, P., and I. A. Wright. 2010. Using camera-trap data to model habitat use by bare-nosed wombats (*Vombatus ursinus*) and cattle (*Bos taurus*) in a south-eastern Australian agricultural riparian ecosystem. Australian Mammalogy **32**:16–22.

Brashares, J. S., P. Arcese, M. K. Sam, P. B. Coppolillo, A. R. E. Sinclair, and A. Balmford. 2004. Bushmeat hunting, wildlife declines, and fish supply in West Africa. Science **306**:1180–1183.

Brodie, J. F., and A. Giordano. 2013. Lack of trophic release with large mammal predators and prey in Borneo. Biological Conservation **50**:295–305.

Brodie, J. F., A. J. Giordano, B. Dickson, M. Hebblewhite, H. Bernard, J. Mohd-Azlan, J. Anderson, and L. Ambu. 2014. Evaluating multispecies landscape connectivity in a threatened tropical mammal community. Conservation Biology **29**:1523–1739.

Brook, S. M., N. Dudley, S. P. Mahood, G. Polet, A. C. Williams, J. W. Duckworth, T. Van Ngoc, and B. Long. 2014. Lessons learned from the loss of a flagship: The extinction of the Javan rhinoceros *Rhinoceros sondaicus annamiticus* from Vietnam. Biological Conservation **174**:21–29.

Buckley-Beason, V. A., et al. 2006. Molecular evidence for species-level distinctions in clouded leopards. Current Biology **16**:2371–2376.

Burton, A. C., E. B. Buedi, C. Balangtaa, D. G. Kpelle, M. K. Sam, and J. S. Brashares. 2011. The decline of lions in Ghana's Mole National Park. African Journal of Ecology **49**:122–126.

Cain, A. T., V. R. Tuovila, D. G. Hewitt, and M. E. Tewes. 2003. Effects of a highway and mitigation projects on bobcats in Southern Texas. Biological Conservation **114**:189–197.

Carter, N. H., B. K. Shrestha, J. B. Karki, N. Man, B. Pradhan, and J. Liu. 2012. Coexistence between wildlife and humans at fine spatial scales. Proceedings of the National Academy of Science, USA **109**:15360–15365.

Cavalcanti, S. M. C., and E. M. Gese. 2010. Kill rates and predation patterns of jaguars (*Panthera onca*) in the southern Pantanal, Brazil. Journal of Mammalogy **91**:722–736.

Chapman, F. M. 1927. Who treads our trails? National Geographic Magazine **52**:341–345.

Chen, M. T., M. E. Tewes, K. J. Pei, and L. I. Grassman. 2009. Activity patterns and habitat use of sympatric small carnivores in southern Taiwan. Mammalia **73**:20–26.

Chiavacci, S. J., T. J. Bader, and J. C. Bednarz. 2014. Preferred nest site characteristics reduce predator-specific predation risk in a canopy-nesting raptor. Journal of Wildlife Management **78**:1022–1032.

Chruszcz, B., A. P. Clevenger, K. E. Gunson, and M. L. Gibeau. 2003. Relationships among grizzly bears, highways, and habitat in the Banff-Bow Valley, Alberta, Canada. Canadian Journal of Zoology **81**:1378–1391.

Clements, G. R., D. M. Rayan, S. A. Aziz, K. Kawanishi, C. Traeholt, D. Magintan, M. F. A. Yazi, and R. Tingley. 2012. Predicting the distribution of the Asian tapir in Peninsular Malaysia using maximum entropy modeling. Integrative Zoology **7**:400–406.

Clevenger, A. P., B. Chruszcz, and K. E. Gunson. 2003. Spatial patterns and factors influencing small vertebrate fauna road-kill aggregations. Biological Conservation **109**:15–26.

Clevenger, A. P., A. T. Ford, and M. A. Sawaya. 2009. Banff wildlife crossings project: Integrating science and education in restoring population connectivity across transportation corridors. Final Report to Parks Canada Agency. Radium Hot Springs, British Columbia.

Clevenger, A. P., and N. Waltho. 2000. Factors influencing the effectiveness of wildlife underpasses in Banff National Park, Alberta, Canada. Conservation Biology **14**:47–56.

Clevenger, A. P., and N. Waltho. 2005. Performance indices to identify attributes of highway crossing structures facilitating movement of large mammals. Biological Conservation **21**:453–464.

Conway, A. L. 2013. Conservation of the pygmy hippopotamus (*Choeropsis liberiensis*) in Sierra Leone, West Africa. PhD diss., University of Georgia.

Coupland, C., and W. Anthony. 2007. Devils of the alpine project: Field monitoring program. Tasmanian Naturalist **129**:65–81.

Crooks, K. R. 2002. Relative sensitivities of mammalian carnivores to habitat fragmentation. Conservation Biology **16**:488–502.

Crooks, K. R., and M. E. Soule. 1999. Mesopredator release and avifaunal extinctions in a fragmented system. Nature **400**:563–566.

Cruz, P., A. Paviolo, R. F. Bó, J. J. Thompson, and M. S. Di Bitetti. 2014. Daily activity patterns and habitat use of the lowland

tapir (*Tapirus terrestris*) in the Atlantic Forest. Mammalian Biology—Zeitschrift für Säugetierkunde **79**:376–383.

Custodio, C. C., M. V. Lepiten, and L. R. Heaney. 1996. Bubalus mindorensis. Mammalian Species **520**:1–5.

Cutler, T. L., and D. E. Swann. 1999. Using remote photography in wildlife ecology: A review. Wildlife Society Bulletin **27**:571–581.

Datta, A., M. O. Anand, and R. Naniwadekar. 2008. Empty forests: Large carnivore and prey abundance in Namdapha National Park, north-east India. Biological Conservation **141**:1429–1435.

de Azevedo, F. C. C., and D. L. Murray. 2007. Spatial organization and food habits of jaguars (*Panthera onca*) in a floodplain forest. Biological Conservation **137**:391–402.

Dematteo, K. E., M. A. Rinas, M. M. Sede, B. Davenport, F. Carina, K. Lovett, P. G. Parker, and S. Louis. 2012. Detection dogs: An effective technique for bush dog surveys. Journal of Wildlife Management **73**:1436–1440.

Desbiez, A. L. J., and D. Kluyber. 2013. The role of giant armadillos (*Priodontes maximus*) as physical ecosystem engineers. Biotropica **45**:537–540.

Di Bitetti, M. S., C. D. De Angelo, Y. E. Di Blanco, and A. Paviolo. 2010. Niche partitioning and species coexistence in a Neotropical felid assemblage. Acta Oecologica **36**:403–412.

Di Bitetti, M. S., A. Paviolo, C. D. De Angelo, and Y. E. Di Blanco. 2008. Local and continental correlates of the abundance of a neotropical cat, the ocelot (*Leopardus pardalis*). Journal of Tropical Ecology **24**:189–200.

Duckworth, J.W., Sebastian, T., Jennings, A. & Veron, G. 2008. *Cynogale bennettii*. Available from www.iucnredlist.org.

Dudley, R., M. Kaspari, and S. P. Yanoviak. 2012. Lust for salt in the western Amazon. Biotropica **44**:6–9.

Dunham, A. E. 1998. Notes on the behaviour of the ring-tailed mongoose, *Galidia elegans*, at Ranomafana National Park, Madagascar. Small Carnivore Conservation **19**:21–23.

Emsens, W. J., L. Suselbeek, A. Winkelhagen, B. Hirsch, R. Kays, and P. A. Jansen. 2013. Effects of food availability on space and refuge use by the Central American agouti (*Dasyprocta punctata*). Biotropica **45**:88–93.

Esser, H. J. 2010. Community ecology of ticks and their hosts in tropical moist forest fragments. MA thesis, Wageningen University.

Farhadinia, M., and M.-R. Hemami. 2010. Prey selection by the critically endangered Asiatic cheetah in central Iran. Journal of Natural History **44**:1239–1249.

Farhadinia, M. S. 2004. The last stronghold: Cheetah in Iran. Cat News **40**:11–14.

Farhadinia, M. S., H. Akbari, S.-J. Mousavi, M. Eslami, M. Azizi, J. Shokouhi, N. Gholikhani, and F. Hosseini-Zavarei. 2013. Exceptionally long movements of the Asiatic cheetah *Acinonyx jubatus venaticus* across multiple arid reserves in central Iran. Oryx **47**:427–430.

Figel, J. J., E. Durán, and D. B. Bray. 2011. Conservation of the jaguar *Panthera onca* in a community-dominated landscape in montane forests in Oaxaca, Mexico. Oryx **45**:554–560.

Fisher, J. T., M. Wheatley, and D. Mackenzie. 2014. Spatial patterns of breeding success of grizzly bears derived from hierarchical multistate models. Conservation Biology **28**:1249–1259.

Fleming, P., P. Meek, G. Ballard, P. Banks, A. Claridge, J. Sanderson, and D. Swann. 2014. Camera trapping: Wildlife management and research. Clayton North, Victoria: CSIRO.

Foster, R. J., J. H. Bart, and C. P. Doncaster. 2010. Habitat use by sympatric jaguars and pumas across a gradient of human disturbance in Belize. Biotropica **42**:724–731.

Foster, V. C., P. Sarmento, R. Sollmann, N. Tôrres, A. T. A. Jácomo, N. Negrões, C. Fonseca, and L. Silveira. 2013. Jaguar and puma activity patterns and predator-prey interactions in four Brazilian biomes. Biotropica **45**:373–379.

Garshelis, D. L. 2011. Andean bear density and abundance estimates: How reliable and useful are they? Ursus **22**:47–64.

Gehrt, S. D., C. Anchor, and L. A. White. 2009. Home range and landscape use of coyotes in a metropolitan landscape: Conflict or coexistence? Journal of Mammalogy **90**:1045–1057.

Genton, C., A. Pierre, R. Cristescu, F. Lévréro, S. Gatti, J. S. Pierre, N. Ménard, and P. Le Gouar. 2014. How Ebola impacts social dynamics in gorillas: A multistate modelling approach. Journal of Animal Ecology **84**:166–176.

Gerber, B., S. M. Karpanty, C. Crawford, M. Kotschwar, and J. Randrianantenaina. 2010. An assessment of carnivore relative abundance and density in the eastern rainforests of Madagascar using remotely-triggered camera traps. Oryx **44**:219–222.

Gerber, B. D., S. M. Karpanty, and J. Randrianantenaina. 2012a. Activity patterns of carnivores in the rain forests of Madagascar: Implications for species coexistence. Journal of Mammalogy **93**:667–676.

Gerber, B. D., S. M. Karpanty, and J. Randrianantenaina. 2012b. The impact of forest logging and fragmentation on carnivore species composition, density and occupancy in Madagascar's rainforests. Oryx **46**:414–422.

Gessner, J., R. Buchwald, and G. Wittemyer. 2014. Assessing species occurrence and species-specific use patterns of bais (forest clearings) in Central Africa with camera traps. African Journal of Ecology **52**:59–68.

Goad, E. H., L. Pejchar, S. E. Reed, and R. L. Knight. 2014. Habitat use by mammals varies along an exurban development gradient in northern Colorado. Biological Conservation **176**:172–182.

Goldman, H. V., and J. Winther-Hansen. 2003. The small carnivores of Unguja: Results of a photo-trapping survey in Jozani Forest Reserve, Zanzibar, Tanzania. Tromso, Norway: Norwegian Polar Institute.

Gompper, M. E., R. W. Kays, J. C. Ray, S. D. Lapoint, D. A. Bogan, and J. R. A. Cryan. 2006. A comparison of non-invasive techniques to survey carnivore communities in northeastern North America. Wildlife Society Bulletin **34**:1142–1151.

Gonthier, D. J., and F. E. Castañeda. 2013. Large- and medium-sized mammal survey using camera traps in the Sikre River in the Río Plátano biosphere reserve, Honduras. Tropical Conservation Science **6**:584–591.

Grassman, L. I., Jr., M. E. Tewes, and N. J. Silvy. 2005. From the field: Armoring the Camtrakker camera-trap in a tropical Asian forest. Wildlife Society Bulletin **33**:349–352.

Gray, T. N. E., and C. Phan. 2011. Habitat preferences and activity patterns of the larger mammal community in Phnom Prich Wildlife Sanctuary, Cambodia. Raffles Bulletin of Zoology **59**:311–318.

Gray, T. N. E., O. U. Rattanak, H. U. Y. Keavuth, P. I. N. Chanrattana, and A. L. Maxwell. 2012. The status of large mammals in eastern Cambodia: A review of camera trapping data 1999–2007. Cambodian Journal of Natural History **1**:42–55.

Gregory, T., F. Carrasco Rueda, J. Deichmann, J. Kolowski, and A. Alonso. 2014. Arboreal camera trapping: Taking a proven method to new heights. Methods in Ecology and Evolution **5**:443–451.

Haines, R. M., J. E. Janecka, M. E. Tewes, L. I. Grassman Jr., and P. Morton. 2006. The importance of private lands for ocelot *Leopardus pardalis* conservation in the United States. Oryx **40**:90–94.

Hall, L. K., R. T. Larsen, R. N. Knight, K. D. Bunnell, and B. R. McMillan. 2013. Water developments and canids in two North American deserts: A test of the indirect effect of water hypothesis. PLoS ONE **8**:e67800.

Harasti, D., C. Gallen, H. Malcolm, P. Tegart, and B. Hughes. 2014. Where are the little ones: Distribution and abundance of the threatened serranid *Epinephelus daemelii* (Günther, 1876) in intertidal habitats in New South Wales, Australia. Journal of Applied Ichthyology **30**:1007–1015.

Hariyadi, A. R. S., A. Priambudi, R. Setiawan, D. Daryan, A. Yayus, and H. Purnama.

2011. Estimating the population structure of Javan rhinos (*Rhinoceros sondaicus*) in Ujung Kulon National Park using the mark-recapture method based on video and camera trap identification. Pachyderm **49**:90–99.

Harrison, R. D., S. Tan, J. B. Plotkin, F. Slik, M. Detto, T. Brenes, A. Itoh, and S. J. Davies. 2013. Consequences of defaunation for a tropical tree community. Ecology Letters **16**:687–694.

Hawkins, C. E., H. McCallum, N. Mooney, M. Jones, and M. Holdsworth. 2008. *Sarcophilus harrisii*. Available from www.iucnredlist.org.

Hayward, M. W., and N. Marlow. 2014. Will dingoes really conserve wildlife and can our methods tell? Journal of Applied Ecology **51**:835–838.

He, L., R. García-Perea, M. Li, and F. Wei. 2004. Distribution and conservation status of the endemic Chinese mountain cat *Felis bieti*. Oryx **38**:55–61.

Head, J. S., C. Boesch, M. M. Robbins, L. I. Rabanal, L. Makaga, and H. S. Kühl. 2013. Effective sociodemographic population assessment of elusive species in ecology and conservation management. Ecology and Evolution **3**:2903–2916.

Head, J. S., M. M. Robbins, R. Mundry, L. Makaga, and C. Boesch. 2012. Remote video-camera traps measure habitat use and competitive exclusion among sympatric chimpanzee, gorilla and elephant in Loango National Park, Gabon. Journal of Tropical Ecology **28**:571–583.

Hedges, S., S. Baral, R. J. Timmins, and J. W. Duckworth. 2008. *Bubalus arnee*. Available from www.iucnredlist.org.

Henschel, P., L. Coad, C. Burton, B. Chataigner, A. Dunn, D. MacDonald, Y. Saidu, and L. T. B. Hunter. 2014. The lion in West Africa is critically endangered. PLoS ONE **9**:e83500.

Henschel, P., L. T. B. Hunter, L. Coad, K. A. Abernethy, and M. Mühlenberg. 2011. Leopard prey choice in the Congo Basin rainforest suggests exploitative competition with human bushmeat hunters. Journal of Zoology **285**:11–20.

Hirsch, B. T., R. Kays, V. E. Pereira, and P. A. Jansen. 2012. Directed seed dispersal towards areas with low conspecific tree density by a scatter-hoarding rodent. Ecology Letters **15**:1423–1429.

Holden, J., A. Yanuar, and D. J. Martyr. 2003. The Asian tapir in Kerinci Seblat National Park, Sumatra: Evidence collected through photo-trapping. Oryx **37**:34–40.

Hon, J., M. J. Azlan, and J. W. Duckworth. 2008. *Hemigalus derbyanus*. Available from www.iucnredlist.org.

Htun, S. 2006. The status and conservation of bears in Myanmar. In Understanding Asian bears to secure their future, 45–49. Ibaraki: Japan Bear Network.

Iliopoulos, Y., D. Youlatos, and S. Sgardelis. 2013. Wolf pack rendezvous site selection in Greece is mainly affected by anthropogenic landscape features. European Journal of Wildlife Research **60**:23–34.

Inman, R. M., A. J. Magoun, J. Persson, and J. Mattisson. 2012. The wolverine's niche: Linking reproductive chronology, caching, competition, and climate. Journal of Mammalogy **93**:634–644.

Jackson, R. M., J. D. Roe, R. Wangchuck, and D. O. Hunter. 2005. Surveying snow leopard populations with emphasis on camera trapping: A handbook. Snow Leopard Conservancy, Sonoma, CA.

Jansen, P. A., B. T. Hirsch, W. Emsens, V. Zamora-Gutierrez, M. Wikelski, and R. Kays. 2012. Thieving rodents as substitute dispersers of megafaunal seeds. Proceedings of the National Academy of Science, USA **109**:12610–12615.

Jenks, K. E., P. Chanteap, K. Damrongchainarong, P. Cutter, P. Cutter, T. Redford, A. J. Lynam, J. Howard, and P. Leimgruber. 2011. Using relative abundance indices from camera-trapping to test wildlife conservation hypotheses— an example from Khao Yai National Park, Thailand. Tropical Conservation Science **4**:113–131.

Jennings, A. P., J. Mathai, J. Brodie, A. J. Giordano, and G. Veron. 2013. Predicted distributions and conservation status of two threatened Southeast Asian small carnivores: The banded civet and Hose's civet. Mammalia **77**:261–271.

Johnson, W. E., et al. 1999. Molecular genetic characterization of two insular Asian cat species, Bornean Bay cat and Iriomote cat. In Evolutionary theory and process: Modern perspectives, papers in honour of Evivatar Nevo, 223–248. Dordrecht: Kluwer.

Jones, L. L. C., and M. G. Raphael. 1993. Inexpensive camera systems for detecting martens, fishers, and other animals: Guidelines for use and standardization. General Technical Report of the Pacific Northwest Research Station of the US Forest Service **PNW-GTR-30**.

Junker, J., et al. 2012. Recent decline in suitable environmental conditions for African great apes. Diversity and Distributions **18**:1077–1091.

Karanth, K. U. 1995. Estimating tiger *Panthera tigris* populations from camera-trap data using capture-recapture models. Biological Conservation **71**:333–338.

Karanth, K. U., J. D. Nichols, N. S. Kumar, and J. E. Hines. 2006. Assessing tiger population dynamics using photographic capture-recapture sampling. Ecology **87**:2925–2937.

Karanth, K. U., J. D. Nichols, N. S. Kumar, W. A. Link, and J. E. Hines. 2004. Tigers and their prey: Predicting carnivore densities from prey abundance. Proceedings of the National Academy of Sciences, USA **101**:4854–4858.

Kaspari, M., S. P. Yanoviak, and R. Dudley. 2008. On the biogeography of salt limitation: A study of ant communities. Proceedings of the National Academy of Sciences, USA **105**:17848–17851.

Katzner, T. E., and J. L. Rodrigue. 2013. Appalacian Eagles annual report: Camera trapping studies of wildlife demography in eastern North America. Annual Report v. 2013.1. Downloaded from www.appalachianeagles.org.

Kawanishi, K., A. M. E. Sunquist, A. E. Eizirik, A. A. J. Lynam, A. D. Ngoprasert, A. W. N. W. Shahruddin, A. D. M. Rayan, A. D. S. K. Sharma, and A. R. Steinmetz. 2010. Near fixation of melanism in leopards of the Malay Peninsula. Journal of Zoology **282**:201–206.

Kays, R., and A. W. Parsons. 2014. Mammals in and around suburban yards, and the attraction of chicken coops. Urban Ecosystems **17**:691–705.

Kays, R., S. Tilak, B. Kranstauber, P. A. Jansen, C. Carbone, M. Rowcliffe, T. Fountain, J. Eggert, and Z. He. 2011. Monitoring wild animal communities with arrays of motion sensitive camera traps. International Journal of Research and Reviews in Wireless Sensor Networks **1**:19–29.

Kelly, C. A., C. A. Diggins, and A. J. Lawrence. 2013. Crossing structures reconnect federally endangered flying squirrel populations divided for 20 years by road barrier. Wildlife Society Bulletin **37**:375–379.

Kelly, M. J., and E. L. Holub. 2008. Camera trapping of carnivores: Trap success among camera types and across species, and habitat selection by species, on Salt Pond Mountain, Giles County, Virginia. Northeastern Naturalist **15**:249–262.

Kelly, M. J., A. J. Noss, M. S. Di Bitetti, L. Maffei, R. L. Arispe, A. Paviolo, C. D. De Angelo, and Y. E. Di Blanco. 2008. Estimating puma densities from camera trapping across three study sites: Bolivia, Argentina, and Belize. Journal of Mammalogy **89**:408–418.

Khorozyan, I., D. Stanton, M. Mohammed, W. Al-Ra'il, and M. Pittet. 2014. Patterns of co-existence between humans and mammals in Yemen: Some species thrive while others are nearly extinct. Biodiversity and Conservation **23**:1995–2013.

Kinnaird, M. F., and T. G. O'Brien. 2012. Effects of private-land use, livestock management, and human tolerance on diversity, distribution, and abundance of large African mammals. Conservation Biology **26**:1026–1039.

Kinnaird, M. F., E. W. Sanderson, T. G. O'Brien, H. T. Wibisono, and G. Woolmer. 2003. Deforestation trends in a tropical landscape and implications for endangered large mammals. Conservation Biology **17**:245–257.

Konecny, M. J. 1989. Movement patterns and food habits of four sympatric carnivore

species in Belize, Central America. In Advances in neotropical mammalogy, ed. K. H. Redford and J. F. Eisenberg, 243–264. Gainsville, FL: Sandhill Crane Press.

Kreulen, D. A. 1985. Lick use by large herbivores: A review of benefits and banes of soil consumption. Mammal Review 15:107–123.

Krief, S., M. Cibot, S. Bortolamiol, A. Seguya, J.-M. Krief, and S. Masi. 2014. Wild chimpanzees on the edge: Nocturnal activities in croplands. PLoS ONE 9:e109925.

Kruuk, H. 2002. Hunter and hunted: Relationships between carnivores and people. Cambridge: Cambridge University Press.

Kucera, T. E., A. M. Soukkala, and W. J. Zielinski. 1995. Photographic bait stations. In American marten, fisher, lynx, and wolverine: Survey methods for their detection, ed. W. J. Zielinski and T. E. Kucera, 25–66. Albany, CA: Pacific Southwest Research Station, Forest Service, US Department of Agriculture.

Kuijper, D. P., G. M. Cromsigt, M. Churski, B. Adam, B. Je, and W. Je. 2009. Do ungulates preferentially feed in forest gaps in European temperate forest? Forest Ecology and Management 258:1528–1535.

LaPoint, S., P. Gallery, M. Wikelski, and R. Kays. 2013. Animal behavior, cost-based corridor models, and real corridors. Landscape Ecology 28:1615–1630.

LaPoint, S. D., J. L. Belant, and R. W. Kays. 2014. Mesopredator release facilitates range expansion in fisher. Animal Conservation 18:50–61.

Larrucea, E. S., P. F. Brussard, M. M. Jaeger, and R. H. Barrett. 2007a. Cameras, coyotes, and the assumption of equal detectability. Journal of Wildlife Management 71:1682–1689.

Larrucea, E. S., G. Serra, M. M. Jaeger, and R. H. Barrett. 2007b. Censusing bobcats using remote cameras. Western North American Naturalist 67:538–548.

LaRue, M. A., C. K. Nielsen, M. Dowling, K. Miller, B. Wilson, H. Shaw, and C. R. Anderson. 2012. Cougars are recolonizing the midwest: Analysis of cougar confirmations during 1990–2008. Journal of Wildlife Management 76:1364–1369.

Lashley, M. A., M. C. Chitwood, M. T. Biggerstaff, D. L. Morina, C. E. Moorman, and C. S. Deperno. 2014. White-tailed deer vigilance: The influence of social and environmental factors. PloS ONE 9:e90652.

Lee, J. S., E. W. Ruell, E. E. Boydston, L. M. Lyren, R. S. Alonso, J. L. Troyer, K. R. Crooks, and S. Vandewoude. 2012. Gene flow and pathogen transmission among bobcats (Lynx rufus) in a fragmented urban landscape. Molecular Ecology 21:1617–1631.

Li, S., W. J. McShea, D. Wang, J. Huang, and L. Shao. 2012. A direct comparison of camera-trapping and sign transects for monitoring wildlife in the Wanglang National Nature Reserve, China. Wildlife Society Bulletin 36:538–545.

Li, S., W. J. Mcshea, D. Wang, L. Shao, and S. Xiaogang. 2010a. The use of infrared-triggered cameras for surveying phasianids in Sichuan Province, China. Ibis 152:299–309.

Li, S., D. Wang, X. Gu, and W. McShea. 2010b. Beyond pandas, the need for a standardized monitoring protocol for large mammals in Chinese nature reserves. Biodiversity and Conservation 19:3195–3206.

Li, S., D. Wang, Z. Lu, and W. J. McShea. 2010c. Cats living with pandas. Cat News 52:20–23.

Liebezeit, J. 2013. Report to WCS: Identification of shorebird and passerine nest predators at a remote site in the Northeast National Petroleum Reserve-Alaska and in the Prudhoe Bay oil field. New York: Wildlife Conservation Society.

Link, A., and A. Di Fiore. 2013. Effects of predation risk on the grouping patterns of white-bellied spider monkeys (Ateles belzebuth belzebuth) in Western Amazonia. American Journal of Physical Anthropology 150:579–590.

Linkie, M., Y. Dinata, A. Nugroho, and I. A. Haidir. 2007. Estimating occupancy of a data deficient mammalian species living in tropical rainforests: Sun bears in the Kerinci Seblat region, Sumatra. Biological Conservation 137:20–27.

Linkie, M., et al. 2013. Cryptic mammals caught on camera: Assessing the utility of range wide camera trap data for conserving the endangered Asian tapir. Biological Conservation 162:107–115.

Linkie, M., and M. S. Ridout. 2011. Assessing tiger-prey interactions in Sumatran rainforests. Journal of Zoology 284:224–229.

Liu, X., P. Wu, M. Songer, Q. Cai, X. He, Y. Zhu, and X. Shao. 2013. Monitoring wildlife abundance and diversity with infra-red camera traps in Guanyinshan Nature Reserve of Shaanxi Province, China. Ecological Indicators 33:121–128.

Loken, B., S. Spehar, and Y. Rayadin. 2013. Terrestriality in the bornean orangutan (Pongo pygmaeus morio) and implications for their ecology and conservation. American Journal of Primatology 75:1129–1138.

Loss, S. R., T. Will, and P. P. Marra. 2013. The impact of free-ranging domestic cats on wildlife of the United States. Nature Communications 4:1396.

Lynam, A. J., et al. 2012. Comparative sensitivity to environmental variation and human disturbance of Asian tapirs (Tapirus indicus) and other wild ungulates in Thailand. Integrative Zoology 7:389-399.

Lynam, A. J., K. E. Jenks, R. Steinmetz, and D. H. Reed. 2013. Terrestrial activity patterns of wild cats from camera-trapping. Raffles Bulletin of Zoology 61:407–415.

Maddox, T., J. Province, E. Gemita, and A. Salampessy. 2007. The conservation of tigers and other wildlife in oil palm plantations. ZSL Conservation Report 7:1–66.

Maehr, D. S., E. D. Land, D. B. Shindle, O. L. Bass, and T. S. Hoctor. 2002. Florida panther dispersal and conservation. Biological Conservation 106:187–197.

Magle, S. B., L. S. Simoni, E. W. Lehrer, and J. S. Brown. 2014. Urban predator-prey association: Coyote and deer distributions in the Chicago metropolitan area. Urban Ecosystems 17:875–891.

Magoun, A., N. Dawson, R. Klafki, J. Bowman, and J. Ray. 2005. A method of identifying individual wolverines using remote cameras. 1st International Symposium on Wolverine Research and Management, Jokkmokk, Sweden.

Malcolm, H., W. Gladstone, S. Lindfield, J. Wraith, and T. Lynch. 2007. Spatial and temporal variation in reef fish assemblages of marine parks in New South Wales, Australia: Baited video observations. Marine Ecology Progress Series 350:277–290.

Maletzke, B. T., R. Wielgus, G. M. Koehler, M. Swanson, H. Cooley, and J. R. Alldredge. 2014. Effects of hunting on cougar spatial organization. Ecology and Evolution 4:2178–2185.

Mazzotti, F. J. 1989. Factors affecting the nesting success of the American crocodile, Crocodylus acutus, in Florida Bay. Bulletin of Marine Science 44:220–228.

McCain, E., and J. Childs. 2008. Evidence of resident jaguars (Panthera onca) in the southwestern United States and the implications for conservation. Journal of Mammalogy 89:1–10.

McCarthy, J. L., T. K. Fuller, K. P. McCarthy, H. T. Wibisono, and M. C. Livolsi. 2012. Using camera trap photos and direct sightings to identify possible refugia for the vulnerable Sumatran striped rabbit Nesolagus netscheri. Oryx 46:438–441.

McCarthy, J. L., K. P. McCarthy, T. K. Fuller, and T. M. McCarthy. 2010. Assessing variation in wildlife biodiversity in the Tien Shan Mountains of Kyrgyzstan using ancillary camera-trap photos. Mountain Research and Development 30:295–301.

McLean, K. A. 2015. Movement ecology and biodiversity monitoring in Neotropical forest canopies. PhD diss., Yale University.

Medina, F. M., E. Bonnaud, E. Vidal, B. R. Tershy, E. S. Zavaleta, C. Josh Donlan, B. S. Keitt, M. Corre, S. V. Horwath, and M. Nogales. 2011. A global review of the impacts of invasive cats on island endangered vertebrates. Global Change Biology 17:3503–3510.

Medri, Í. M., and G. Mourão. 2005. A brief note on the sleeping habits of the giant anteater—*Myrmecophaga tridactyla* Linnaeus (Xenarthra, Myrmecophagidae). Revista Brasileira de Zoologia 22:1213–1215.

Meijaard, E., A. C. Kitchener, and C. Smeenk. 2006. "New Bornean carnivore" is most likely a little known flying squirrel. Mammal Review 36:318–324.

Méndez-Carvajal, P., and R. Moreno. 2014. Mammalia, Carnivora, Canidae, *Canis latrans* (Say, 1823): Actual distribution in Panama. Check List 10:376–379.

Michalski, F. 2010. The bush dog *Speothos venaticus* and short-eared dog *Atelocynus microtis* in a fragmented landscape in southern Amazonia. Oryx 44:300–303.

Michalski, F., G. C. Peter, O. Tadeu Gomes de, and F. Marta Elena. 2006. Notes on home range and habitat use of three small carnivore species in a disturbed vegetation mosaic of southeastern Brazil. Mammalia 70:52–57.

Miranda, F., A. Bertassoni, and A. M. Abba. 2014. *Myrmecophaga tridactyla*. Available from www.iucnredlist.org.

Mondal, K., S. Gupta, S. Bhattacharjee, Q. Qureshi, and K. Sankar. 2012. Response of leopards to re-introduced tigers in Sariska Tiger Reserve, Western India. International Journal of Biodiversity and Conservation 4:228–236.

Monroy-Vilchis, O., C. Rodríguez-Soto, M. Zarco-González, and V. Urios. 2009. Cougar and jaguar habitat use and activity patterns in central Mexico. Animal Biology 59:145–157.

Moreno, R. S., R. W. Kays, and R. Samudio Jr. 2006. Competitive release in diets of ocelot (*Leopardus pardalis*) and puma (*Puma concolor*) after jaguar (*Panthera onca*) decline. Journal of Mammalogy 87:808–816.

Moriarty, K. M., W. J. Zielinski, A. G. Gonzales, T. E. Dawson, K. M. Boatner, C. A. Wilson, F. V. Schlexer, K. L. Pilgrim, J. P. Copeland, and M. K. Schwartz. 2009. Wolverine confirmation in California after nearly a century: native or long-distance immigrant? Northwest Science 83:154–162.

Mugerwa, B., D. Sheil, P. Ssekiranda, M. Van Heist, and P. Ezuma. 2012. A camera trap assessment of terrestrial vertebrates in Bwindi Impenetrable National Park, Uganda. African Journal of Ecology 51:21–31.

Muhly, T. B., C. Semeniuk, A. Massolo, L. Hickman, and M. Musiani. 2011. Human activity helps prey win the predator-prey space race. PloS ONE 6:e17050.

Munoz, P. 1999. Animal Diversity Web: *Rhinopithecus roxellana* golden snub-nosed monkey. Available from http://animaldiversity.org.

Murchison, E. P., et al. 2010. The Tasmanian devil transcriptome reveals schwann cell origins of a clonally transmissible cancer. Science 327:84–87.

Nazeri, M., K. Jusoff, N. Madani, A. R. Mahmud, A. R. Bahman, and L. Kumar. 2012. Occurrence of three felids across a network of protected areas in Thailand: Prey, intraguild, and habitat associations. PLoS ONE 7:e48104.

Ng, S. J., J. W. Dole, R. M. Sauvajot, S. P. D. Riley, and T. J. Valone. 2004. Use of highway undercrossings by wildlife in Southern California. Biological Conservation 115:499–507.

Ngoprasert, D., et al. 2012. Occurrence of three felids across a network of protected areas in Thailand: Prey, intraguild, and habitat associations. Biotropica 44:810–817.

Nogales, M., E. Vidal, F. M. Medina, E. Bonnaud, B. R. Tershy, and K. J. Campbell. 2013. Feral cats and biodiversity conservation. BioScience 63:804–810.

Noss, A. J. 1998. Cable snares and bushmeat markets in a central African forest. Environmental Conservation 25:228–233.

Noss, A. J., R. L. Cuéllar, J. Barrientos, L. Maffei, E. Cuéllar, R. Arispe, D. Rúmiz, and K. Rivero. 2003. A camera trapping and radio telemetry study of *Tapirus terrestris* in Bolivian dry forests. Tapir Conservation 12:24–32.

Noss, A. J., R. Peña, and D. I. Rumiz. 2004. Camera trapping *Priodontes maximus* in the dry forests of Santa Cruz, Bolivia. Endangered Species Update 21:43–52.

Novack, A. J., M. B. Main, M. E. Sunquist, and R. F. Labisky. 2005. Foraging ecology of jaguar (*Panthera onca*) and puma (*Puma concolor*) in hunted and non-hunted sites within the Maya Biosphere Reserve, Guatemala. Journal of Zoology 267:167–178.

Numata, S., T. Okuda, T. Sugimoto, S. Nishimura, K. Yoshida, E.-S. Quah, M. Yasuda, K. Muangkhum, and N. S. Noor. 2005. Camera trapping: A non-invasive approach as an additional tool in the study of mammals in Pasoh Forest Reserve and adjacent fragmented areas in Peninsular Malaysia. Malayan Nature Journal 57:29–45.

Nyaligu, M. O., and S. Weeks. 2013. An elephant corridor in a fragmented conservation landscape: Preventing the isolation of Mount Kenya National Park and National Reserve 19:91–102.

O'Brien, T. G., M. F. Kinnaird, and H. T. Wibisono. 2003. Crouching tigers, hidden prey: Sumatran tiger and prey populations in a tropical forest landscape. Animal Conservation 6:131–139.

O'Connell, A., and J. Nichols. 2010. Camera traps in animal ecology: Methods and analyses. New York: Springer.

Ordeñana, M., and K. Crooks. 2010. Effects of urbanization on carnivore species distribution and richness. Journal of Mammalogy 91:1322–1331.

Peebles, K. A., R. B. Wielgus, B. T. Maletzke, and M. E. Swanson. 2013. Effects of remedial sport hunting on cougar complaints and livestock depredations. PLoS ONE 8:e79713.

Pereira, J. A., M. S. Di Bitetti, N. G. Fracassi, A. Paviolo, C. D. De Angelo, Y. E. Di Blanco, and A. J. Novaro. 2011. Population density of Geoffroy's cat in scrublands of central Argentina. Journal of Zoology 283:37-44.

Pettorelli, N., A. L. Lobora, M. J. Msuha, C. Foley, and S. M. Durant. 2010. Carnivore biodiversity in Tanzania: Revealing the distribution patterns of secretive mammals using camera traps. Animal Conservation 13:131–139.

Pimenta, C. S., F. A. Meirelles, E. M. von Muhlen, and E. M. Venticinque. 2013. Camera-trapping wild carnivores in central Amazonia: Implications for conservation and management in sustainable-use reserves. Meeting of the Association for Tropical Biology and Conservation 50:P1f-3.

Pitra, C., P. VazPinto, B. W. J. O'Keeffe, S. Willows-Munro, B. Jansen van Vuuren, and T. J. Robinson. 2006. DNA-led rediscovery of the giant sable antelope in Angola. European Journal of Wildlife Research 52:145–152.

Prasad, S., A. Pittet, and R. Sukumar. 2010. Who really ate the fruit? A novel approach to camera trapping for quantifying frugivory by ruminants. Ecology Research 25:225–231.

Pringle, R. M., J. R. Goheen, T. M. Palmer, G. K. Charles, E. DeFranco, R. Hohbein, A. T. Ford, and C. E. Tarnita. 2014. Low functional redundancy among mammalian browsers in regulating an encroaching shrub (*Solanum campylacanthum*) in African savannah. Proceedings of the Royal Society B 281:20140390.

Ramesh, T., R. Kalle, K. Sankar, and Q. Qureshi. 2012. Spatio-temporal partitioning among large carnivores in relation to major prey species in Western Ghats. Journal of Zoology 287:269–275.

Rayan, D. M., S. W. Mohamad, L. Dorward, S. A. Aziz, G. R. Clements, W. C. T. Christopher, C. Traeholt, and D. Magintan. 2012. Estimating the population density of the Asian tapir (*Tapirus indicus*) in a selectively logged forest in Peninsular Malaysia. Integrative Zoology 7:373–380.

Ridout, M. S., and M. Linkie. 2009. Estimating overlap of daily activity patterns from camera trap data. Journal of Agricultural, Biological and Environmental Statistics 14:322–337.

Riley, S. P. D., J. P. Pollinger, R. M. Sauvajot, E. C. York, C. Bromley, T. K. Fuller, and R. K. Wayne. 2006. A Southern California freeway is a physical and social barrier to gene flow in carnivores. Molecular Ecology 15:1733–1741.

Robley, A., A. M. Gormley, D. M. Forsyth, and B. Triggs. 2014. Long-term and large-scale control of the introduced red fox increases native mammal occupancy in Australian forests. Biological Conservation **180**:262–269.

Rockhill, A. P., C. S. DePerno, and R. A. Powell. 2013. The effect of illumination and time of day on movements of bobcats (*Lynx rufus*). PLoS ONE **8**:e69213.

Romero-Muñoz, A., L. Maffei, E. Cuéllar, and A. J. Noss. 2010. Temporal separation between jaguar and puma in the dry forests of southern Bolivia. Journal of Tropical Ecology **26**:303–311.

Ross, J., A. J. Hearn, and D. W. Macdonald. 2013. Recent camera-trap records of Malay Weasel *Mustela nudipes* in Sabah, Malaysian Borneo. Small Carnivore Conservation **49**:20–24.

Royle, J. A., A. J. Magoun, B. Gardner, P. Valkenburg, and R. E. Lowell. 2011. Density estimation in a wolverine population using spatial capture-recapture models. Journal of Wildlife Management **75**:604–611.

Rustam, M. Yasuda, and S. Tsuyuki. 2012. Comparison of mammalian communities in a human-disturbed tropical landscape in East Kalimantan, Indonesia. Mammal Study **37**:299–311.

Saito, M., and F. Koike. 2013. Distribution of wild mammal assemblages along an urban-rural-forest landscape gradient in warm-temperate East Asia. PloS ONE **8**:e65464.

Samejima, H., R. Ong, P. Lagan, and K. Kitayama. 2012. Camera-trapping rates of mammals and birds in a Bornean tropical rainforest under sustainable forest management. Forest Ecology and Management **270**:248–256.

Sanderson, J., Y. Yufeng, and D. Naktsang. 2010. Of the only endemic cat species in China: The Chinese mountain cat—*Felis bieti*. Cat News **Special Issue 5**:18–21.

Sawaya, M. A., S. T. Kalinowski, and A. P. Clevenger. 2014. Genetic connectivity for two bear species at wildlife crossing structures in Banff National Park. Proceedings of the Royal Society B **281**:20131705.

Schloegel, C., F. C. Tropical, T. Jones, B. Zug, L. Achig, and A. Treves. 2011. Don Oso program develops participatory monitoring protocol for Andean bears in Southern Sangay National Park. International Bear News **20**:23–25.

Segura, V., F. Prevosti, and G. Cassini. 2013. Cranial ontogeny in the Puma lineage, *Puma concolor, Herpailurus yagouaroundi*, and *Acinonyx jubatus* (Carnivora: Felidae): A three-dimensional geometric morphometric approach. Zoological Journal of the Linnean Society **169**:235–250.

Seymour, K. L. 1989. *Panthera onca*. Mammalian Species **340**:1–9.

Shiras, G. I. 1913. Wild animals that took their own pictures by day and by night. National Geographic Magazine **7**:763–834.

Silmi, M., S. Anggara, and B. Dahlen. 2013. Using leopard cats (*Prionailurus bengalensis*) as biological pest control of rats in a palm oil plantation. Journal of Indonesian Natural History **1**:31–36.

Silva-Rodríguez, E. A., and K. E. Sieving. 2012. Domestic dogs shape the landscape-scale distribution of a threatened forest ungulate. Biological Conservation **150**:103–110.

Silva-Rodríguez, E. A., C. Verdugo, O. A. Aleuy, J. G. Sanderson, G. R. Ortega-Solís, F. Osorio-Zúñiga, and D. González-Acuña. 2009. Evaluating mortality sources for the Vulnerable pudu *Pudu puda* in Chile: Implications for the conservation of a threatened deer. Oryx **44**:97–103.

Silveira, L., A. T. de Almeida Jácomo, M. M. Furtado, N. M. Torres, R. Sollmann, and C. Vynne. 2009. Ecology of the giant armadillo (*Priodontes maximus*) in the grasslands of Central Brazil. Edentata **8–10**:25–34.

Soga, M., and S. Koike. 2013. Large forest patches promote breeding success of a terrestrial mammal in urban landscapes. PloS ONE **8**:e51802.

Soley, F., and I. Alvarado-Diaz. 2011. Prospective thinking in a mustelid? *Eira barbara* (Carnivora) cache unripe fruits to consume them once ripened. Naturwissenschaften **98**:693–698.

Srbek-Araujo, A. C., L. M. Scoss, A. Hirsch, and A. G. Chiarello. 2009. Records of the giant-armadillo *Priodontes maximus* (Cingulata: Dasypodidae) in the Atlantic Forest: Are Minas Gerais and Espírito Santo the last strongholds of the species? Zoologia **26**:461–468.

Srivathsa, A., K. K. Karanth, D. Jathanna, N. S. Kumar, and K. U. Karanth. 2014. On a dhole trail: Examining ecological and anthropogenic correlates of dhole habitat occupancy in the Western Ghats of India. PLoS ONE **9**:e98803.

Steinmetz, R., N. Seuaturien, and W. Chutipong. 2013. Tigers, leopards, and dholes in a half-empty forest: Assessing species interactions in a guild of threatened carnivores. Biological Conservation **163**:68–78.

Stojanovic, D., M. H. Webb, R. Alderman, L. L. Porfirio, and R. Heinsohn. 2014. Discovery of a novel predator reveals extreme but highly variable mortality for an endangered migratory bird. Diversity and Distributions **20**:1200–1207.

Sugiura, S., R. Tanaka, H. Taki, and N. Kanzaki. 2013. Differential responses of scavenging arthropods and vertebrates to forest loss maintain ecosystem function in a heterogeneous landscape. Biological Conservation **159**:206–213.

Sugiura, S., R. Tanaka, H. Taki, and N. Kanzaki. 2014. The use of camera traps to identify the set of scavengers preying on the carcass of a golden snub-nosed monkey (*Rhinopithecus roxellana*). PLoS ONE **9**:e87318.

Suselbeek, L., W.-J. Emsens, B. T. Hirsch, R. Kays, J. M. Rowcliffe, V. Zamora-Gutierrez, and P. A. Jansen. 2014. Food acquisition and predator avoidance in a Neotropical rodent. Animal Behaviour **88**:41–48.

Switalski, T. A., and C. R. Nelson. 2011. Efficacy of road removal for restoring wildlife habitat: Black bear in the Northern Rocky Mountains, USA. Biological Conservation **144**:2666–2673.

Tambling, C. J., L. Minnie, J. Adendorff, and G. I. H. Kerley. 2013. Elephants facilitate impact of large predators on small ungulate prey species. Basic and Applied Ecology **14**:694–701.

Te, W. S., C. W. Servheen, and L. Ambu. 2004. Home range, movement and activity patterns, and bedding sites of Malayan sun bears *Helarctos malayanus* in the Rainforest of Borneo. Biological Conservation **119**:169–181.

Teixeira, F. Z., R. C. Printes, J. C. G. Fagundes, A. C. Alonso, and A. Kindel. 2013. Canopy bridges as road overpasses for wildlife in urban fragmented landscapes. Biota Neotrop **13**:117–123.

Tobler, M. W., F. Hibert, L. Debeir, and C. Richard-Hansen. 2013. Estimates of density and sustainable harvest of the lowland tapir *Tapirus terrestris* in the Amazon of French Guiana using a Bayesian spatially explicit capture-recapture model. Oryx **48**:410–419.

Tumenta, P. N., J. S. Kok, J. C. Van Rijssel, R. Buij, B. M. Croes, P. J. Funston, H. H. De Iongh, and H. A. U. De Haes. 2009. Threat of rapid extermination of the lion (*Panthera leo leo*) in Waza National Park, Northern Cameroon. African Journal of Ecology **48**:888–894.

Varma, S., A. Pittet, and H. S. Jamadagni. 2006. Experimenting usage of camera-traps for population dynamics study of the Asian elephant *Elephas maximus* in southern India. Current Science **91**:324–331.

Walsh, P. D., C. E. G. Tutin, J. F. Oates, J. E. M. Baillie, F. Maisels, E. J. Stokes, S. Gatti, R. A. Bergl, J. Sunderland-Groves, and A. Dunn. 2008. *Gorilla gorilla*. Available from www.iucnredlist.org.

Wang, Y., and D. O. Fisher. 2012. Dingoes affect activity of feral cats, but do not exclude them from the habitat of an endangered macropod. Wildlife Research **39**:611–620.

Waterman, C., D. Pietersen, L. Hywood, P. Rankin, and D. Soewu. 2014. *Smutsia gigantea*. Available from www.iucnredlist.org.

Wearn, O. R., J. M. Rowcliffe, C. Carbone, H. Bernard, and R. M. Ewers. 2013. Assessing the status of wild felids in a highly-disturbed commercial forest reserve in Borneo and the implications

for camera trap survey design. PLoS ONE **8**:1–9.

Weckel, M., W. Giuliano, and S. Silver. 2006. Jaguar (*Panthera onca*) feeding ecology: Distribution of predator and prey through time and space. Journal of Zoology **270**:25–30.

Weckel, M., R. F. Rockwell, and F. Secret. 2011. A modification of Jacobson et al.'s (1997) individual branch-antlered male method for censusing white-tailed deer. Wildlife Society Bulletin **35**:445–451.

Wegge, P., C. P. Pokheral, and S. R. Jnawali. 2004. Effects of trapping effort and trap shyness on estimates of tiger abundance from camera trap studies. Animal Conservation **7**:251–256.

Weise, F. J., Q. Wessels, S. Munro, and M. Solberg. 2014. Using artificial passageways to facilitate the movement of wildlife on Namibian farmland **44**:161–166.

Weston, N. 2003. The provision of canopy bridges to reduce the effects of linear barriers on arboreal mammals in the Wet Tropics of northeastern Queensland. MA thesis, James Cook University of North Queensland.

Willink, B. 2014. The interplay between multiple predators and prey colour divergence. Biological Journal of the Linean Society **113**:580–589.

Wilting, A., A. Cord, A. J. Hearn, D. Hesse, and A. Mohamed. 2010. Modelling the species distribution of flat-headed cats (*Prionailurus planiceps*), an endangered South-East Asian small velid. PLoS ONE **5**:e9612.

Wilting, A., A. Mohamed, L. N. Ambu, P. Lagan, S. Mannan, H. Hofer, and R. Sollmann. 2012. Density of the Vulnerable Sunda clouded leopard *Neofelis diardi* in two commercial forest reserves in Sabah, Malaysian Borneo. Oryx **46**:423–426.

Wong, S. T., C. Servheen, L. Ambu, and A. Norhayati. 2005. Impacts of fruit production cycles on Malayan sun bears and bearded pigs in lowland tropical forest of Sabah, Malaysian Borneo. Journal of Tropical Ecology **21**:627–639.

Zetra, B., A. Rafiastanto, W. M. Rombang, and C. R. Trainor. 2002. Rediscovery of the critically endangered Sumatran Ground Cuckoo *Carpococcyx viridis*. Forktail **18**:63–65.

INDEX